Neither stands this *Art of Shadowes* in any *darke* or *inferiour* place; for by them are we led on to many *rare and sublime speculations*.

HENRY GELLIBRAND, 1635[1]

The greater is the circle of light, the greater is the boundary of darkness by which it is confined. But, notwithstanding this, the more light we get, the more thankful we ought to be. For by this means we have the greater range for satisfactory contemplation.

JOSEPH PRIESTLEY, 1790[2]

In scientific matters we must do the reverse of what is done in art. An artist should never present a work to the public before it is finished because it is difficult for others to advise or help him with its production . . . in science, on the other hand, it is useful to publish every bit of empirical evidence, even every conjecture; indeed, no scientific edifice should be built until the plan and materials of its structure have been widely known, judged and sifted.

JOHANN GOETHE, 1829[3]

[1] Introduction by Henry Gellibrand of Gresham College, 6 June 1635, to John Wells' *Sciographia, or the Art of Shadowes* (London: printed by Thomas Harper, 1635)

[2] Joseph Priestley, *Experiments and Observations on Different Kinds of Air, and other Branches of Natural Philosophy, Connected with the Subject* (Birmingham: printed by Thomas Pearson, 1790), v.1, pp. xiv–xviii.

[3] Johann Goethe, "The Experiment as Mediator Between Object and Subject," translated in *Goethe Edition; Scientific Studies*, edited and translated by Douglas Miller (New York: Suhrkamp Publishers, 1988), v. 12, p. 13.

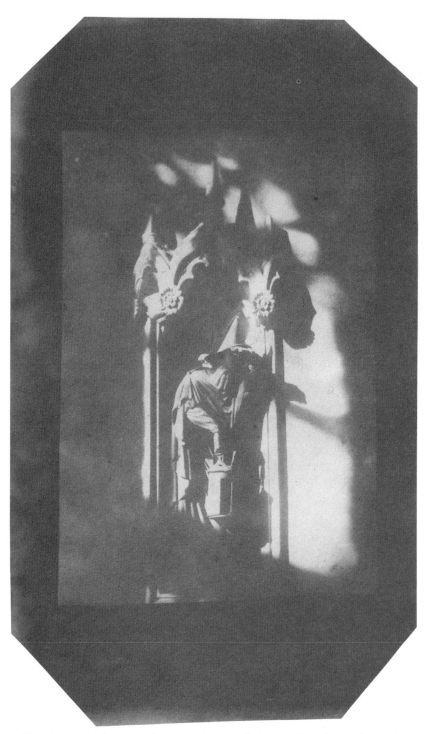

William Henry Fox Talbot. *Statue of Diogenes in the Great Hall of Lacock Abbey*. Salt print from a calotype negative. Winter 1840–1. 12.3 × 8.8 cm. image on 18.5 × 11.3 cm. paper. The National Museum of Photography Film and Television.

Out of the Shadows

Herschel, Talbot, & the Invention of Photography

Larry J. Schaaf

1992
Yale University Press
New Haven & London

Set in Monophoto Van Dijck by Servis Filmsetting Ltd, Manchester
Printed by Stamperia Valdonega SRL, Verona, Italy

Library of Congress Cataloging-in-Publication Data

Schaaf, Larry J. (Larry John), 1947–
 Out of the shadows : Herschel, Talbot, & the invention of
photography / Larry J. Schaaf.
 p. cm.
 Includes index.
 ISBN 0-300-05705-9 (cloth)
 1. Photography—England—History—19th century, 2. Herschel,
John, Sir. 3. Talbot, William Henry Fox, 1800–1877. I. Title.
TR57.S32 1992 91-51108
770'.9'034—dc20 CIP

Contents

This book is dedicated to two women who preserved the memories of the creators of photography. I spent many pleasant and exciting days with Eileen Shorland, the great-granddaughter of Sir John Herschel, and it was she who breathed life into the accounts of this great man. While there was never the opportunity for me to meet Matilda Talbot in person, I have come to feel that I almost knew her through her letters and particularly through her untiring recognition of the considerable accomplishments of her grandfather, Henry Talbot.

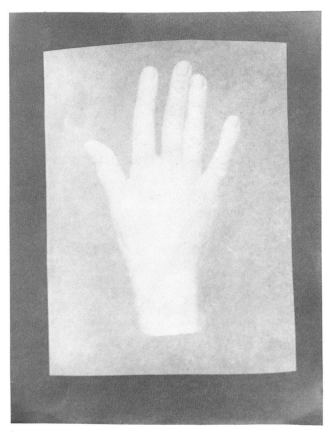

William Henry Fox Talbot. *Hand.* Salt print from a calotype negative. Ca. 1841. 8.6 × 6.8 cm. image on 10.9 × 8.6 cm. paper. The National Museum of Photography Film and Television.

The illustrations which add so much to this volume were made possible by the generosity of Manfred Heiting, along with the co-operation of the National Museum of Photography Film and Television.

Acknowledgements

THIS BOOK IS based on my doctoral thesis for the Department of Art History of the University of St Andrews; it is to my advisor and friend, Martin Kemp, that I owe its completion. A very special period of my life was set by him under the Carnegie Fellowship at the University. Robert Smart and Geoffrey Hargreaves made library resources freely available. Tom Normand was a valuable help; Dawn Waddell made it all work (then and now). Nigel Thorp, a scholar I met during this period, has had more influence than perhaps he himself realizes. And it is to his daughter, Arabella, that credit for the title of this book belongs.

Facets of these issues have been explored in my previous publications; the present work is as much a synthesis of scattered earlier writings as a refinement based on ever-widening points of examination. External circumstances led me to The University of Texas at Austin in 1970 and hence to the discovery of the Gernsheim Collection. This soon lured me into exploring the broader resources of the Humanities Research Center. Their manuscript holdings on Herschel were (and remain) seductive. Generous grants enabled me to take my first trips to Britain in the late 1970s to study Sir John Herschel. Events of the 1980s finally awakened my interest in Henry Talbot. Along the way, I have been stimulated by access to many collections and particularly by the contact with the thoughts of many people. I have accumulated many debts that will probably remain unpaid. Although the following list is certain to be incomplete, it is meant as heartfelt recognition and thanks to all those who have helped.

It is to my former colleague, J.B. Colson, that I owe my introduction to photographic history and my first interpretation of the Gernsheim Collection; Joe Colthorp and Roy Flukinger made exploration of its riches possible. In the manuscript and book holdings of the Humanities Research Center, Ellen Dunlap, Cathy Henderson and John Kirkpatrick met innumerable requests. Early trips to England were supported by grants from the National Endowment for the Humanities and the University Research Institute. Heinz and Bridget Henisch encouraged publication of the results of this early work in the *History of Photography* journal. An appreciation of the range of the history of science was gained during graduate study at the Johns Hopkins University; the spare elegance of Russell McCormmach's writing and expression will ever be with me. The period in Baltimore was significant in many other ways. Victor Luftig and Nancy McCall provided vital support. Charles Mann, always a delight, has opened many doors for me. One of these led to the late Lynn Hart, who afterwards made the resources of the Peabody Library freely available. The influence of this nineteenth-century gem on my thinking is incalculable and Phoebe Stanton has done much to enliven it. It is also through

the Peabody Archives that I met Elizabeth, now my wife, and a resolute supporter of my research.

I freely acknowledge my debt to Sir John Herschel, through his writings, for his training in the value of inductive reasoning. My interest in Talbot was stimulated by Hans P. Kraus, Jr, a good friend and tough critic, who has been immensely helpful in all aspects of my research. Roger Taylor and Colin Ford of the National Museum of Photography Film and Television in Bradford made more original Talbots available to me, under better circumstances, than I could ever have imagined possible. Previous to this, when the collections were at the Science Museum in London, John Ward unfailingly made them available, whatever the circumstances.

The late Eileen Shorland, great-granddaughter of Sir John Herschel, was one of my earliest and most delightful contacts in England. Her enthusiasm was always infectious. John and Esther Herschel-Shorland have since freely shared the Herschel family archives, continuing a tradition and a privilege I have enjoyed from Herschel's descendants now for many years. The main repository of Herschel's papers is in the Archives of the Royal Society in London, and they have suffered the brunt of my requests. Leslie Townsend, Norman Robinson, and most recently, Sheila Edwards, have been kept very busy. Equally, the descendants of Henry Talbot, Anthony and Janet Burnett Brown, have made Lacock Abbey seem almost a home away from home. Their very generous support has brought alive a vision of Talbot's environment and has much enriched my understanding of him. Some of my happiest times in England have been at the Fox Talbot Museum at Lacock, where Talbot's legacy is deposited. Bob Lassam never found any request too much; Mike Gray is now extending his work.

Lastly, it was the London staff of Yale University Press who turned the idea of this book into a reality. I would like to thank John Nicoll, commissioning editor, whose tough but fair comments helped to improve my original thoughts on the book – without losing sight of my original concept. Mary Carruthers has been largely responsible for executing the final layout of the book. Special thanks are deserved by Marina Cianfanelli of the editorial department, who has kept everyone in touch and everything running smoothly.

Other individuals to whom I owe special thanks include: David Allison; Frank Armstrong; H.J.P. Arnold; Gordon Baldwin; Nicholas Barker; Tom Beck; Carl Bergquist; Terry Binns; Bruno Bischofberger; Gavin Bridson; David Bruce; William Buchanan; Gail Buckland; Peter Bunnell; Gunter Buttman; Alan Clark; Susan-Jane Clement; Brian Coe; E.T. Conybeare; Ken Craven; Sandra Cumming; P.H. Dale; Wayne Danielson; Michael Darby; Andrew C.F. David; Alan Davies; Ray Desmond; Sean Devlin; Judith Diment; Frances Dimond; David Dorward; Gina Douglass; Jim Dozier; Janet Dudley; Peter and Margaret Eaton; Richard Edmeades; H. Elkhadem; Val and Jane Ellis; Phillip Escreet; Andrew Eskind; David Evans; Jay Fisher; Lee Fontanella; Pat Fox; Graeme Fyffe; Philippe Garner; Christine Gascoigne; Helmut Gernsheim; Arthur Gill; Robin Gillanders; Lucien Goldschmidt; Greg Good; Elizabeth Graham; Richard Greffe; Sally Grover; A.E. Gunther; Julia Van Haaften; Maria Hambourg; Bonnie Hardwick; Margaret Harker; Mark Haworth-Booth; Christine Heap; Marjorie Hill; Sinclair Hitchings; William Hodges; Harrison and Jean Horblit; Graham Howe; André Jammes; Paul Jay; Alan and Susan Johnston; Murray and Kate Johnston; Herbert and Lucie Jones; Iwan Jones; Trevor Kaye; Nancy Keeler; John R. Kenyon; Hardwicke Knight; Margarethe Kuntner; Keith Laidler; Thomas Lange; Julie Lawson; Sally Leach; Russell Lee; Valerie Lloyd; Christina Lodder; Chester Loeb; Fred Luther; David Mabberley; Angus McDonald; Bernard McTigue; Bernard Marbot; Brian May; Douglas Matthews; Robert Meyer; Sir Oliver Millar; Harry Milligan; Ian and Angela Moor; Keith Moore; Richard Morris; Alison Morrison-Low; James Mosely; Mike Murphy; Weston Naef; Graham Nash; Paul Needham; Beaumont Newhall; Dirk Nishen; Eugene Ostroff; David Painting; Richard Pearce-Moses; Cheryl Piggot; Sandra Phillips; Gaby Porter; James Price; Michael Pritchard; Peter and Ann Riddell; Harold Riley; Derek Robinson; Pamela Roberts; Giles Robertson; Grant Romer; Dale Roylance; Richard Rudisill; Mary Sampson; Dorothy Schultze; Tony Simcock; Alan Simpson; Helen Smailes; David A. Smith; Graham Smith; Fred Spira; Will Stapp; Norma Stevens; Sara Stevenson; Lindsey Stewart; Roger Stoddard; Carol Stott; Louise Stover; Rachel Stuhlman; David Sturdy; Suzanne Tagg; Dwight Teeter; Sean Thackrey; Pat Thomas; David Thomas; Chris Titterington; David Travis; Richard Travis; Michael Twyman; Anna Venturi; John Ward; Brian Warner; Helen Webb; Edith White; Steven White; John Wilson; R. Derek Wood; Fred Woodward; David Wooters; Elspeth Yeo. And many others!

Other institutions that have made their collections available for study include: Aberdeen University Library, Scotland; Agfa Foto-Historama, Wallraf-Richartz Museum/ Museum Ludwig, Cologne; Art Institute of Chicago; Ashmolean Museum, Oxford; Bath Reference Library, England; Biblioteca Nationale Centrale, Florence; Birr Scientific Heritage Foundation, Birr, Ireland; Blackheath Local History Library, England; Bodleian Library, Oxford; Bowdoin College Library, Brunswick, Maine; Brighton Area Library, England; British Association for the Advancement of Science, London; British Library, London; British Museum, London; British Museum (Natural History), London; British Records Association, London; Buckinghamshire Record Office, Eng-

land; Cambridge University Library; Devonshire Collections, Chatsworth House, Bakewell, England; Eccles Central Area Library, England; Edinburgh Central Library, Scotland; Edinburgh City Archives; Edinburgh Photographic Society; Edinburgh University Library; Eisenhower Library, Johns Hopkins University, Baltimore; Eton College, England; Folger Shakespeare Library, Washington, D.C.; George Eastman House, Rochester, New York; J. Paul Getty Museum, Santa Monica, California; Glasgow University Library; Guildhall Library, London; Höhere Graphische Bundes-Lehr-und Versuchsanstalt, Vienna; Houghton Library, Cambridge, Massachusetts; Huntington Library, San Marino, California; Hydrographer of the Navy, Taunton, England; Kings College Library, London; Kodak Museum, Harrow, England (formerly); Kresge Physical Science Library, Dartmouth College; The Lilly Library, Indiana University; Kent County Archives, England; Library of Congress, Washington, D.C.; Linnean Society, London; London Library, London; Manchester Central Library, England; Metropolitan Museum of Art, New York.; University of Minnesota, Minneapolis; Mitchell Library, Glasgow; Musée Nicéphore Niépce, Chalon-sur-Sâone, France; Museum of the History of Science, Oxford; National Museum of Photography Film and Television, Bradford, England; National Library of Scotland, Edinburgh; National Library of Wales, Aberystwyth, Dyfed; National Maritime Museum, London; National Museum of Wales, Cardiff; National Portrait Gallery, London; National Register of Archives, London; National Register of Archives for Scotland, Edinburgh; New York Public Library, New York; Offaly County Library, Ireland; Pattee Library, Penn State University, State College, Pennsylvania; Perry Castañeda Library, The University of Texas at Austin; Pierpont Morgan Library, New York; Princeton University Library, Princeton, New Jersey; Public Record Office, Kew; Reading Central Library, England; Reading Museum and Art Gallery, England; Reading University Library, England; Rhode Island School of Design, Museum of Art; Richmond Public Library, England; Royal Archives, Windsor; Royal Astronomical Society, London; Royal Botanic Garden, Edinburgh; Royal Botanic Gardens, Kew, England; Royal Geographical Society, London; Royal Greenwich Observatory, Herstmonceux (formerly); Royal Institution of Great Britain, London; Royal Museum of Scotland, Edinburgh; Royal Observatory, Edinburgh; Royal Photographic Society, Bath; Royal Society of Arts, London; Royal Society of Edinburgh; John Rylands Library, Manchester; St Bride Printing Library, London; St John's College, Cambridge; Science Museum, London; Science Museum Library, London; Scottish National Portrait Gallery, Edinburgh; Scottish Record Office, Edinburgh; Seaver Center for Western History Research, Los Angeles, California; Smithsonian Institution, Washington, D.C.; Somerville College, Oxford; Strathclyde Regional Archives, Glasgow; Surrey Record Office, England; Stationer's Hall, London; Trinity College Library, Cambridge; Trinity College Library, Dublin; UCLA Research Library, Los Angeles; University College Library, London; Wellcome Foundation Library, London; Victoria & Albert Museum, London; York Central Library, England; York County Archives, England.

"LIGHT WAS MY first love!" exclaimed Sir John Herschel. "I have captured a shadow!" countered Henry Talbot. Two men, equal in many ways, radically different in others, confronted the new art of photography with a measure of awe and delight. Scientific colleagues and distant friends long before the discovery of photography, they instantly became collaborators upon its announcement. Their enthusiasm and sense of discovery was the same, their paths were intertwined, but the outcome was very different. Both were scientists with special interests in chemistry and light. Herschel was also a highly skilled draughtsman, a skill notably lacking in Talbot. Indeed, it was this deficiency that motivated Talbot to invent photography. Photography, in turn, taught Talbot how to see. Paradoxically, Herschel, already an artist, applied photography very little to image making. Yet his technical contributions were so fundamental that some remain the basis of photographic practice to this day.

This is a chronicle of the invention of an art – and equally, of the art of invention. The initial astonishment at the new art of photography was quickly followed by an explosive growth in the medium. This suggests a linear evolution starting with an unexpected breakthrough, but in fact, there was none. Both the camera and the necessary chemistry had coexisted for some time. It was the motivation to produce a photograph that was the most important factor in this equation. The crucial question is <u>why</u>, rather than <u>how</u>, photography finally was invented. Why did this idea wait until 1839 to exert its spell? Once invented, why did its course of development proceed as apparently chaotically as it did?

The answer, I feel, lies in very human terms. It will be argued that the weather, petty politics, mothers, and rheumatism had as much to do with the invention and progress of photography as did any physical or artistic concern. Both Herschel and Talbot were caught up in complex lives of which photography (sometimes to their bitter regret), was only a part. In each, there was a combination of art and of science, of eighteenth-century romance and of nineteenth-century progress, of marvel and of perception. Science and art, most often placed in opposition today, were inextricably linked for these men. Herschel's eclecticism has been out of step with the thrust of historians of science for many years; only recently have there been indications that this situation is being corrected. Talbot's photographs have been widely reproduced, but little has been published about the man himself.

The present study explores the relationship between Herschel and Talbot up until 1844. This covers the so-called 'pre-history' of photography and the first five years of its public existence. For Herschel to dominate the first chapter is just. Even to his contemporaries, Sir John was "such a model

of the accomplished philosopher ... as can rarely be found beyond the regions of fiction." Herschel's timeless and gracefully written works expressed a broad view of the role of science and the role of the individual in society. Equally, for Talbot to dominate the last chapter is only right. By then, photography as an art had come to the fore – and Henry Talbot was the first artist to be fostered by photography. Many of Herschel's and Talbot's contemporaries bore on their actions, of course, but these have been introduced only to the extent necessary. Reference to secondary literature has been minimized. Instead, to the greatest extent possible, this study draws on the unusually detailed manuscript resources that have been preserved. The approach I have employed largely emphasizes the process of invention as it was perceived by Herschel and Talbot, uncolored by subsequent events. Photography has become so commonplace and pervasive in our society that it is sometimes difficult to feel the magic that the inventors experienced, yet photography certainly was magical in its effect. In addition to the beautiful testimony of still-surviving photographs now a century and a half old, thousands of letters, scores of diaries, several significant research notebooks, and various drafts of publications survive for both Talbot and Herschel. Surely their contributions to photography are some of the best documented creations in the worlds of science and of art. Both men were rightly proud of their contributions and aware of the rapid evolution of the world in which they lived. Succeeding generations of descendants have never wavered in their devotion to preserving this legacy. Both families were blessed with stable family structures that protected the integrity of their archives until the middle of the twentieth century. By then, institutional and societal awareness of the historical value of this material was on the rise, until today when these archives are seen as cornerstone collections. The research potential of this rich vein of material has barely been tapped. To the extent that the rostering of source material cited herein provides a stimulus for future research, this study will be a success.

Herschel's and Talbot's letters are quoted in verbatim transcriptions as carefully as possible; in nearly every case, the transcription has been made from the original letter. No attempt has been made to 'correct' the text to modern practice or to 'enhance' it in any way. Abbreviations and contractions have not been expanded. Non-standard spellings and the variable punctuation so commonly used by these two men have been preserved. ~~Cancelled text~~, superscripting, and underlining have been duplicated as much as typography will allow. The thorn has been preserved. The only silent emendations are that line divisions and spacing have not been adhered to, the handwritten _a_ has been converted to &, interlineations have been incorporated, the length of dashes

has been regularized, and leading capitals have been converted when they have been placed in the middle of a sentence. Ellipses signal deleted material inside or at the end of a sentence; they have not been used at the beginning of a phrase.

Most manuscript material quoted is from four major collections – represented by symbols in the footnotes. FTM is the Fox Talbot Museum, Lacock, where many of the Talbot family's papers have been deposited. HRHRC is the Harry Ransom Humanities Research Center, The University of Texas at Austin. NMPFT stands for the National Museum of Photography Film and Television, Bradford. The vast majority of the manuscripts there are on deposit from the Science Museum Library, London; in cases where the material is still held in London, it is so credited. A few items at Bradford are from the former Kodak Museum and are so identified. RSL is the Royal Society of London. Unless otherwise indicated, the originals of letters from Herschel to Talbot are in the NMPFT; those from Talbot to Herschel are in the RSL.

The accurate translation of these early photographs into printer's ink poses numerous challenges. The original diversity of chemicals and working procedures – subsequently modified by the vagaries of time – has evolved into a multiplicity of complex and subtle tones and colors. Many of these original photographs are extremely vulnerable, so any reproduction process must take account of the strain it might put on the actual object. Most of the illustrations in this book have been reproduced from large format color transparencies, printed in several duotone and four-color printing processes on a paper similar in surface to that employed by Herschel and Talbot. While the individual colors and tonal values of some photographs have inevitably been distorted, the total impression of the plates should be true to the spirit of the variety of the originals. As Henry Talbot explained about the photographs in his _Pencil of Nature_,

> there is some variety in the tint which they present.... These tints, however, might undoubtedly be brought nearer to uniformity, if any great advantage appeared likely to result: but, several persons of taste having been consulted on the point, viz. which tint on the whole deserved a preference, it was found that their opinions offered nothing approaching to unanimity, and therefore, as the process presents us spontaneously with a variety of shades of colour, it was thought best to admit whichever appeared pleasing to the eye, without aiming at an uniformity which is hardly obtainable. And with these brief observations I commend the pictures to the indulgence of the Gentle Reader.

Larry J. Schaaf Baltimore, Maryland. October 1991

I The Boundaries of Fiction: John Herschel, Henry Talbot, & 19th Century Science

IN A DIRECT appeal to nature, John Herschel turned to the classic grand tour, probing his emerging views on the formative processes of the earth. "Travelling, in the way I travel, is a real intellectual luxury – it is eating little & often – a continued feast," Herschel exclaimed joyfully to a friend.[1] His continental travels provided opportunities to forge scientific links as well. On one such trip, in September 1824, Herschel journeyed to Munich to meet the optical glass maker, Joseph von Fraunhofer. Whilst there, he had a fateful meeting:

> I fell in here with a very agreeable & gentlemanly man a Captain Feilding, who with his wife (Lady Elizabeth Feilding) & his son (a Cambridge man) and his two daughters have been residing here some time, after travelling about the Continent for a good while and residing first at one place & then at another.[2]

The son, the "Cambridge man," was William Henry Fox Talbot. Less than a decade after this serendipitous encounter, Henry Talbot would conceive of the art of photography. When the new art was revealed to the public in 1839, John Herschel would emerge as a major contributor of technique. More importantly, Herschel would prove to be a critical source of support in Talbot's desperate battle to establish his vision of the art, a battle fought against a better organized and highly aggressive French competitor.

Returning to England after their introduction in Munich, Herschel and Talbot met frequently to share scientific discussions. Herschel's diary entry for 3 January 1826 is typical: "Talbot called ... stayed from 2 till 5, much talk about Light."[3] And much talk about light there would be! It was light that tied the two men together in their research. Light's corollary, the mysterious shadow, was to be Talbot's consort in photography. And Herschel would again turn the tables by fashioning photography into a powerful tool for studying light itself. Herschel, the only child of a famous scientific family, was destined from birth to become a commanding figure in the world of science. Talbot, eight years his junior, represented the best of the intellectual British landowner in a century of enormous social and technological change. Each was proud to be identified as an amateur scientist (amateur in the sense of one who truly loves a subject). Each was a man with one foot in the eighteenth and one in the nineteenth centuries.

John Frederick William Herschel was a most extraordinary individual in an extraordinary epoch. His father, the astronomer William Herschel, fired the public's imagination in a way almost impossible for us to appreciate in our scientifically-jaded present day. William's discovery of the planet Uranus shattered mankind's classical conception of the universe. Joseph Priestley observed that Herschel's

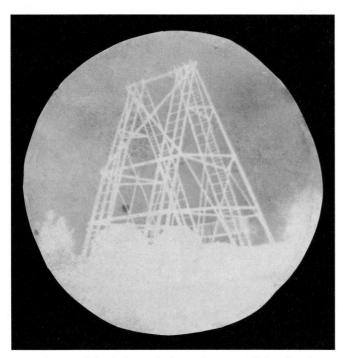

1. Sir John Herschel. *The framework of Sir William Herschel's forty-foot telescope.* Silver-based paper negative. Summer 1839. 9.8 cm. diameter. The Museum of the History of Science, Oxford.

late discoveries, in, and beyond, the bounds of the solar system . . . are peculiarly calculated to inspire an ardent desire of seeing so great a scene a little more unfolded. Such discoveries as these, give us a higher idea of the value of our being, by raising our ideas of the system of which we are a part . . .[4]

His son was to accomplish some of the same for photography.

The family name of Herschel and the term science were interchangeable words, both to the man on the street and throughout the world scientific community. William Herschel's forty-foot telescope at Slough, within sight and under the patronage of Windsor Castle, was the pre-eminent symbol of a new age of science (and too often, as well, an unwelcome signpost to a reclusive household). John, born in 1792, grew up in the shadow of this wondrous machine, in an intellectually rich environment that fully developed his innate abilities. These talents were considerable. Even before the young Queen Victoria took her throne, Sir John Herschel became the very embodiment of science. By the time Herschel would be buried next to Sir Isaac Newton in Westminster Abbey in 1871, the comparison between the two men would already be firmly fixed in the public mind. The Royal Society lamented that "British science has sustained a loss greater than any which it has suffered since

the death of Newton, and one not likely to be soon replaced."[5]

While still a student, Herschel radically changed the course of mathematical study throughout Britain. At the age of twenty-one, he was elected (on merit, not because of his famous father) a Fellow of the Royal Society. He was to publish more than 150 scientific papers and many books in his lifetime. Frequently honored by the world's scientific groups, he was knighted in 1831 and achieved his baronetcy in 1838. Following his father, John Herschel made significant contributions to stellar astronomy. Like Newton, he became Master of the Mint, enduring immense personal sacrifice to institute important scientific reforms.

Yet at the center of all this public acclaim stood a magnificent humanist of diverse talents and interests, a man of universally generous thoughts and behavior. Herschel was "as truly a philosopher as any we may ever hope to see, ornamenting and instructing all who came within his influence."[6] He lived by the ambition (not unreasonable in his time) that one individual might grasp the entire universe of knowledge. He proceeded quite far in this course and the quality and scope of his achievements make him an intimidating subject for a modern biographer.[7] Even within his lifetime he was recognized as a national treasure from an era already yielding to the unrelenting forces of industrialization:

The tendency, and almost the necessity, of modern scientific study is strongly in favor of an exclusive devotion to some narrow specialty. Dissipation of energy is conditioned on superficiality, and the universal genius is regarded with suspicion. Nevertheless, the example of Herschel is an exhortation and an encouragement to the most liberal culture, by showing how many things can be done, and done well. . . .[8]

John Herschel was a conspicuously sensitive person; had it not been for his obvious strength of will, one would call him almost fragile. In 1843, when the public Sir John was at the peak of his scientific fame, Maria Edgeworth revealed another side of the man:

Refined he is highly in sentiment and conversation and sensitive far far too much for health or happiness – mimosa sensitiveness that shrinks from every touch not merely of blame, but even from the very intimacy he most wishes to have. . . . I can only say it was not so with us. The light within burst through the dark visage and in 4 days we learned more of his character than I have done with others in 4 years – and there was more to learn. He is on the verge of the dreadful danger of over wrought intellect – over excited sensibility . . . and even of later times when vexed

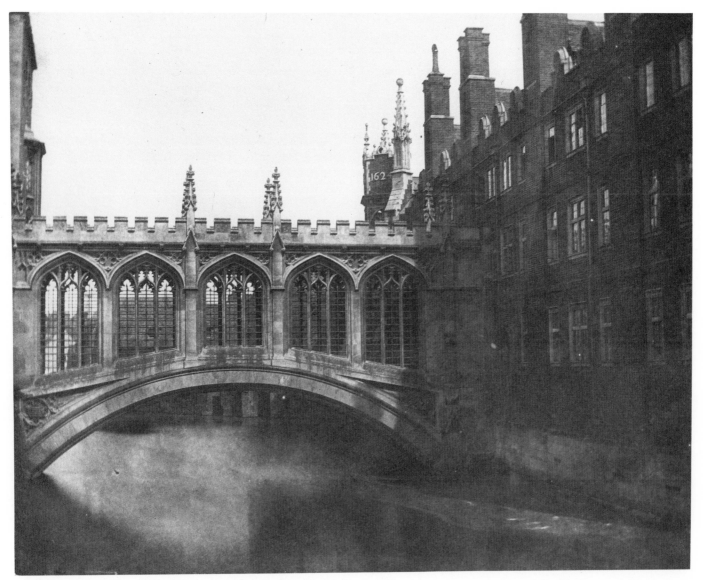

2. William Henry Fox Talbot. *Bridge of Sighs*, *St Johns College*, *Cambridge*. Salt print from a calotype negative. Ca. 1843. Both Herschel and Talbot attended Cambridge at a time when the Universities were just beginning to refresh themselves after generations of stasis. Both received excellent classical educations. The friends they made would emerge as some of the most accomplished scientists and most powerful politicians of Victorian England. 16.3 × 20.7 cm. The National Museum of Photography Film and Television.

in friendship or when scientific things go wrong he betakes himself to darkness and solitude and in abstractions shuts himself up from the external universe. Very very dangerous! Solitary confinement even to the innocent – and even to the stupid a very hazardous experiment![9]

Most of John Herschel's early education came from private tutors. His Aunt Caroline, a noted astronomer herself, took the young man into her home for experiments and scientific talk. A wide range of stimulating and interesting people called on William Herschel's house. Often accompanied by John, the Herschels were hosted by Napoleon, the King of England, and virtually any member of the scientific community who could persuade them to attend. The likely source of John's musical abilities seems obvious; before astronomy took over, William Herschel had been the organist at Bath. It is less clear who nurtured John's talents with the poet's pen and the draughtsman's pencil, but he had become an accomplished draughtsman while still a child. By the time John Herschel entered Cambridge at the age of seventeen, his Aunt Caroline remembered that "he was a good Poet ... a good Pianoforte player, afterwards an Excellent Flute. Drawing. I heard Hauptman Müller wishing to have but one of John's Talents, viz. that of Drawing."[10] Herschel's formal education went equally well. In 1813, in St John's College, Cambridge, Herschel exclaimed to his fellow student and close friend Charles Babbage, "how ardently I wish I had ten lives, or that capacity, that enviable capacity of husbanding every atom of time, which some possess, and which enables them to do ten times as much in one life."[11] Part of this zeal came from the profound changes then taking place in the teaching of mathematics. Through the formation of the Cambridge Analytical Society, the young Herschel and his friends actually influenced the whole approach to mathematics in Britain![12] They advocated (and eventually won) adoption of the radically advanced system then emerging on the continent. So effective was this revolution that a few years later Lady Elisabeth wrote to her son, Henry Talbot, that "you seem so mathematically inclined that I ought en bonne mere to send you to Oxford to counteract it that you may not grow into a Rhomboidal shape, walk elliptically, or go off in a tangent, all which evils are imminent if you go to Cambridge."[13]

Herschel achieved the highest honors at Cambridge in getting his BA in 1813; he was Smith's Prizeman and first Wrangler (top of his class).[14] Within months, he was elected a Fellow of the Royal Society. John Herschel had already achieved more as a student than many men would expect in a whole lifetime, but he became increasingly unsatisfied. His premature sense of failure and disillusionment perhaps was natural in a young genius, still immature in many respects,

whose youthful vision had yet to extend sufficiently far into the future. For a period of five years after Cambridge, he floundered with no sense of direction. Part of the difficulty was the mundane need to earn his living. Traditionally, the clergy had free time for philosophical pursuits and his father assumed (probably wrongly) that becoming a man of the cloth would be the best course. John elected instead to enter the profession of law and at the start of 1814, moved to London to read for the bar. It was a cynical decision. He confided to a Cambridge friend that

I am going to enter at Lincoln's Inn. I do not think you ever imagined me serious in my threatening to take this step, but so it is. I never was more in earnest. God send quarrels among the good people of this nation, and pour forth the bitter vials of litigation like water on every side – and above all may the spirit of scandal and indiscriminate detraction walk abroad, so that we lawyers may never want work. Amen ... For my part I now lay it down as a rule, never to care for anything.[15]

Herschel was not being honest with himself. This in no way represented his true character and the study of man's laws rather than nature's soon proved to be less palatable than Herschel hoped. Just six months later, visiting Slough, he again wrote to his friend that "I have lived long enough I find. What should such a poor snivelling democratic dog do in this aristocratic world? I found all the population in Town frantic & in high monarchy humour – & arriving here, I found – just the same, & so it is every where." But science kept tempting him away. By September in the first year of his legal studies, Herschel wrote to Babbage, eagerly wanting to

tell you what I have been doing in a Chemical way. I have increased my apparatus at last to possess the means of making respectable experiments ... I have likewise discovered a shop in town where I get materials at half and often a third of Watson's prices....

The next day, Herschel continued guiltily

Enough of chemistry.... Action is the word now, for both of us – an honourable and manly exertion. I am come up here solely for the purpose of reading law, and am really studying it with avidity (you will not think so by what I have written). I am determined, as the profession is of my own chusing much against the wish of my parents, – that I will pursue it in good earnest.[16]

But these legal studies would last only the year. They were too far out of step with his true interests. In a later diary, paraphrasing Aristotle, Herschel delighted to record an "epitaph on an attorney: he lived without causes & died without effects."[17]

Returning to Cambridge, this time as a tutor, Herschel soon found formal teaching hopelessly unsatisfying. In stark contrast to his success, especially in mathematics, during his student days, just three years later in the summer of 1816 Herschel had lost his direction and was seeking Babbage's help in finding any alternative to university life:

> I hear you have been writing papers for this new journal of the Royal Institution. Who are the Editors of it? Will they pay one for writing? or do you know any body that will? I should like to get to write articles for some of these Encyclopaedias if I could which are on the tapis at present, or employed by some newspaper Editor to cry down the prince, or by some lottery office keeper or Quack Doctor to write for or lastly to indict hymns for a Methodist meeting. If you know of anything of this sort write me word. In a word I want to get money <u>and reputation at the same time</u>, and to give up cramming pupils, which is a bore & does one no credit but very much to the contrary.[18]

William Herschel, now approaching his eightieth year, was no longer able to take an active role in astronomical observation. In opening up the universe for mankind, the elder astronomer extended the horizons beyond his own reach; understandably, he wished that his son would carry on his work. While the son always had the highest respect for his father's accomplishments, astronomy had not yet become a compelling passion for him. Still, he was no longer forcefully motivated in any particular direction, and John's filial affection was quite strong. During a holiday trip to Devonshire in the summer of 1816 to visit his father's old friend, Sir William Watson, John Herschel accepted his father's wish. In resignation, he wrote to Babbage that "I am going, under my Father's directions, to take up the series of his observations where he has left them." At the time, his course was dictated solely by loyalty. Herschel confessed plaintively to Babbage that he would

> go to Cambridge on Monday where I mean to stay but just time enough to pack up my books and bid a long – perhaps a last farewell to the University . . . which I can never look back to without a full conviction that there is nothing better in store for me and that whatever may hereafter become of me, about which I care very little, I have skimmed the cream of my days already. I always used to abuse Cambridge as you well know with very little mercy or measure, but upon my soul, now I am about to leave it, my heart dies within me.[19]

During the months of angst that followed at Slough, John Herschel underwent a slow but radical change in philosophy. Outwardly in the midst of despair, inwardly a transformation was taking place that had been triggered two years earlier.

Even though Herschel's legal studies had ended indecisively, the brief stint in London proved to be anything but a failure. He came under the influence of William Hyde Wollaston, an outstanding scientist of wide-ranging interests who

> completely fascinated him by the breadth and accuracy of his scientific pursuits, and fostered, if not awakened, in him that dormant taste for Chemistry and general Physics which wanted but the magic touch of such a mind, to kindle into the intellectual passion of a life.[20]

Wollaston's wealth came from exclusive knowledge of how to manufacture platinum in a useable form; the benefits of this monopoly were later to be distributed in scientific philanthropy. He specialized in chemical analysis, working so elegantly and mastering quantities so minute, that his entire laboratory resided on a tea tray.[21] Wollaston stimulated John Herschel's curiosity by the elegance of his chemical experiments. Observation of nature became more compelling than philosophical musings to John Herschel and he began to take a fresh look at his father's accomplishments as well. The abstract appeal of Aristotelian logic, so appropriate to mathematics, began to give way to the real textbook of nature. In fact, by the time John Herschel would publish his highly influential *Preliminary Discourse* in 1830, he had become positively disparaging of the classical approach of the Greek philosophers:

> we are struck with the remarkable contrast between their powers of acute and subtle disputation, their extra-ordinary success in abstract reasoning, and their intimate familiarity with subjects purely intellectual, on the one hand; and, on the other, with their loose and careless consideration of external nature, their grossly illogical deductions of principles of sweeping generality from few and ill-observed facts, in some cases; and their reckless assumption of abstract principles having no foundation but in their own imaginations. . . . In this war of words the study of nature was neglected, and an humble and patient enquiry after facts altogether despised. . . . It was the radical error of the Greek philosophy to imagine that the same method which proved so eminently successful in mathematical, would be equally so in physical enquiries, and that, by setting out from a few simple and almost self-evident notions, or *axioms*, every thing could be reasoned out.[22]

In common with many of his contemporaries, the young John Herschel had found a spiritual leader in Francis Bacon. Baconian inductive reasoning came to direct Herschel's life and his research became propelled by a firm belief that to understand a general law, "the first step is to accumulate a sufficient quantity of well ascertained facts, or recorded

instances, bearing on the point in question. Common sense dictates this, as affording us the means of examining the same subject in several points of view."[23] The inescapable truth of nature emerged as Herschel's intellectual quest. By 1818, Herschel's sense of curiosity was being re-awakened. Shining clear in his letters to Babbage was a sense of excitement newly restored to his spirits: "I have not been very mathematical of late. Chemistry & optics have taken up my time."[24] The two Williams, Herschel and Wollaston, were brilliant and creative researchers in physical optics. Under their combined influence, John Herschel turned increasingly to a study of light and optics. But of all the experimental sciences, for him

> the wonderful and sudden transformations with which chemistry is conversant, the violent activity often assumed by substances usually considered the most inert and sluggish, and, above all, the insight it gives into the nature of innumerable operations which we see daily carried on around us, have contributed to render it the most popular, as it is one of the most extensively useful, of the sciences; and we shall, accordingly, find none which have sprung forward, during the last century, with such extraordinary vigour, and have had such extensive influence in promoting corresponding progress in others. One of the chief causes of its popularity is, perhaps, to be sought for in this, that it is, of all the sciences, perhaps, the most completely an experimental one.... The simple process of inductive generalization, grounded on the examination of numerous facts, all of them presenting considerable intrinsic interest, has sufficed, in most instances, to lead, by a clear and direct road, to its highest laws yet known.[25]

In 1839, when Henry Talbot presented his first paper on the new art of photography, he was to give specific credit for his success to the system that Herschel had promoted:

> This remarkable phenomenon, of whatever value it may turn out in its application to the arts, will at least be accepted as a new proof of the value of the inductive methods of modern science, which by noticing the occurrence of unusual circumstances (which accident perhaps first manifests itself in some small degree), and by following them up with experiments, and varying the conditions of these until the true law of nature which they express is apprehended, conducts us at length to consequences altogether unexpected, remote from usual experience, and contrary to almost universal belief.[26]

It is not surprising that Herschel himself was to employ the inductive method in his later work in photography. But in 1820, he was still forming his ideas. To Babbage, Herschel wrote:

> I have been chemurising or perhaps I should say preparing to chemurise a good deal. Indeed I have done little else, except roam the country on horseback, which I generally do five or 6 hours per diem. This morning I visited a very strange old place ... which remains in the same state almost precisely in which it was in the reign of Hy VI. It has rather excited (or revived) a dormant taste for antiquarian knowledge in my chaos of a brain.[27]

Herschel's new spirits were so infectious that Babbage found that just a "visit to Slough ... has contributed to revive my Chemico-mania."[28]

Wollaston's creative mind had yet another influence on both John Herschel and Henry Talbot. Paradoxically, a Wollaston invention that had no application to photography – the *camera lucida* – actually precipitated the invention of the new art in Henry Talbot's hands. It was a drawing instrument of exquisite simplicity. Later, compounding the paradox, the diminutive camera lucida drove Henry Talbot into photography, while continuing to lure John Herschel away from practice of the new art.

Even before photography, the camera lucida would become a favored tool in Herschel's field research. By 1821, all the necessary elements were in place to prepare John Herschel for his first grand tour. Herschel's interest in chemistry had led him into mineralogy and hence into the study of geology. These disciplines were so closely inter-related at the time as to be almost one. Wollaston, John's mentor, had been a pioneer of geology (and the invention of the camera lucida was actually prompted by one of Wollaston's geological jaunts). Surprisingly, the immediate impetus for Herschel's first grand tour was not really a matter of science, but rather one of the heart. Nearly thirty years old, his first engagement to be married was suddenly broken off. Maria Edgeworth later recalled that "in his earlier life when disappointed in love he shut himself up in darkness for I don't know how many weeks and would not let mortals see him...."[29] Charles Babbage took his grieving friend off to the continent to forget.

The grand tour, an essential component of a gentleman's education in earlier periods, had declined in reputation by Herschel's and Talbot's generation. Largely suspended during the Napoleonic era, afterwards artists and poets replaced the gentlemen of culture who had sought out the intellectual and material treasures of foreign lands. Only a few, Herschel and Talbot amongst them, were scientific travellers. In setting out to see the world (and to forget his personal tragedy), Herschel sought to size up nature, to measure her and to understand her. Seeking to contribute as many basic facts as possible to the store of human knowledge, Herschel arrived in France in the summer of 1821, armed with

3. Sir John Herschel. *Bonneville near Geneva, on the road to Chamonix.* Pencil camera lucida drawing. 13 August 1821. Foreign travels were important to the intellectual development of both Herschel and Talbot. Ever since he was a child, John Herschel was an accomplished draughtsman; long before photography, he was able to make good use of an optical aid to record his journeys. 19.2 × 27.9 cm. Collection of the J. Paul Getty Museum, Malibu, California; Gift of Graham and Susan Nash.

a 'philosophical travelling kit.' With this portable laboratory, he had the means to collect specimens, perform chemical analysis, measure the land and the air, and to record it all with a camera lucida and other drawing instruments.[30] In detailed letters, Herschel kept his family informed of the progress: "we proceeded the first day 35 miles on mules up ... one of the most magnificent pieces of Alpine Scenery it is possible to conceive, by a road your nerves would have agreed very ill with." Assailing what he thought was Mount Rosa (it later turned out to be Breithorn), Herschel sought to go where no Englishman had preceded him:

after 5 hours hard walking knee deep in snow, we reached the ridge of the mountain and looked over the precipice at least 9000 feet in the valley of Zermatt whence we came. The highest crest of the mountain now only remained to climb. It was tremendous, being literally a sharp edge of snow along which a cat might have walked. Our four guides from Zermatt here refused to go a step further, only Coutet & an old man whom we had engaged at Breil would proceed.[31]

Characteristically, John Herschel himself proceeded with them. He and his party coursed through France, Switzerland, and Northern Italy, easily blending scientific experiments with frank appreciation of the range of nature's delights. He broadened his personal contacts as well. In Paris, Geneva, and other centers of activity, the Herschel family name gave him a ready reception in scientific and cultural circles. John Herschel's agile mind and congenial character insured that he was soon accepted on his own merits; so impressed were most savants on meeting him that the connections made on this and subsequent journeys were to serve Herschel throughout his professional life. But it was nature that impressed John

Herschel the most.[32] In this, his first trip abroad, he happily confessed that "I should imagine it must fall to the lot of very few to traverse . . . under circumstances so favourable to the development of poetical & picturesque beauties."[33]

John Herschel probably would have been content to wander through a world that only he populated. In the same way that Herschel's prose frequently mirrored Newton's, his poetry rang accord with that of Wordsworth:

> How sweet at each turn of the mountain
> The shepherd's hut but rises to view
> Within its grass & its knoll & its fountain!
> Oh would I had nothing to do
> But to spend my life here in dreaming
> Of all that these vallies conceal
> And forget this bad world & its scheming
> Its struggles, its woe, and its weal
> Should my heart e'er be bursting with anguish
> And fortune frown dark on my path
> For a scene such as this I might languish
> And gasp for this sweet mountain air.[34]

John Herschel's pencil was kept busy as well. He wrote to his mother in 1821 that "I shall hope for much pleasure in shewing you the sketches I have made during this & other excursions. Being done with the Camera Lucida, they may be relied on as accurate."[35] Typically, these drawings emphasized nature and were a part of his overall plan of observation of the world. His letters and notebooks are sprinkled with off-hand comments confirming that his drawing instrument was a comfortable companion:

> Stopped & diverged a little from the road to see the Fall of Chede . . . it is finely situated, and being early in the morning, & the sun being in the proper situation, a fine rainbow was exhibited in it, producing an effect equally singular and beautiful . . . took a Camera Lucida sketch of it.[36]

Banished was the feeling of uncertainty that had plagued Herschel in the period after Cambridge. When a prestigious teaching post was offered to him shortly after returning from this trip, Herschel looked back on his University days and confessed to Babbage that

> a larger world & more varied scene are necessary for my happiness, & as far as mere science is concerned, I had rather pass my days among those who are advancing eagerly & rapidly & running a race with ardour, than in goading up hill the sluggish paces of any established institution under the Sun.[37]

The following year, 1822, Herschel set out with his old friend, the lawyer James Grahame, through Belgium and Holland. Having thoroughly tested his camera lucida on nature, he applied it with equal success to architecture. But this journey was tragically cut short by news of the death of William Herschel. Only in recent years had father and son come fully together. In what must have been an immense source of satisfaction to them both, William had lived to see John embrace a way of life in observational science. For the son, while the loss of the companionship of his father was enormous, had gained in later years a clear sense of direction and was now supremely content with his path in life. His financial position was assured and his philosophical mandate was clear. He would never again lose the edge of excitement. Only John Herschel's personal life was unfulfilled. Charles Babbage, his closest friend, had married well (even if over the strenuous objections of his father). Some of Herschel's finest camera lucida sketches from their 1821 journey together were given to Georgiana Babbage; the couple's first child was honored with Herschel's name. Faced with this image of marital happiness, John Herschel made a second mis-step. A marriage proposal to a Miss Langton went tragically wrong. Months of distasteful negotiations with her family led to the brink of a duel.

Another continental trip (this time with only a servant) was to be the cure for his second broken heart. After a brief spate of scientific reunions in Paris in April 1824, Herschel set out for Italy. Thoughts of his troubles at home were soon crowded out by new experiences. Strangely, Italy had not appealed to Herschel when he had visited in 1821. This time it not only won him over, but wrested Herschel from his personal difficulties as well. Barely a month later, writing from Florence to James Grahame, he was able to say that

> my mind is tranquil & I have fully succeeded in combating the recollection of past events. Indeed I have been so fully occupied with the present, as to leave little room for their intrusion—for this purpose there is no recipe like travelling. I was mistaken in my impressions of Italy & ye Italian Character. I now see much to approve in it. I find them kind, open, & friendly, & natural.[38]

Herschel's 1824 tour was directed by two major scientific enquiries. One was amassing readings from an instrument that he had devised for measuring the solar flux, the *actinometer*. He was particularly anxious to employ it at higher altitudes, an application that fit in well with his primary mission. Like many of his contemporaries, Herschel was gripped by the swirling controversies about geology that were coming to a head.[39] The only way for Herschel to make up his mind between the conflicting theories was through direct observation of nature. This led him to some of the most difficult terrain he had yet travelled. From the crater of Vesuvius he related to his mother that

as there is no possibility of descending to the bottom, or even ever so small a distance down the sides, I could not ascertain its depth.... I ascended to the highest peak called the Palo–this point looks down on the valley– ... and after witnessing M. Covelli's experiments, taking a drawing of the Crater with the Camera Lucida ... descended at a full gallop, among the craters.[40]

Sicily proved to be the biggest challenge and was perhaps the most richly rewarding. At 1:30 in the morning, under a brilliant starlit sky on the volcanic peak of Mount Etna, he wrote to Babbage

very comfortably from Gemellaro's hut on the top of Etna with my guide snoring in his adjoining room and a formidable apparition of instruments and eatables besides me. I brought up a bed but it is full of fleas and as there is no mat to be had and the night is beautiful I shall divide my time till day light between my instruments & my friends.[41]

Geology was not the only enterprise that filled Herschel's mind on his 1824 trip. Sir William Watson, his father's old friend, had charged John Herschel with stories of the ancients. In a letter to Watson, Herschel reflected that

in such melancholy solitudes are ye principal remains of Sicilian antiquity situated – from the noble remains of ye Temple at Segestum, not a cottage can be discerned & hardly a tree or anything green. It stands surrounded with dry thistles in ye bosom of a lofty hill – on an opposite mountain is an amphitheatre, while the plain between, where once stood a flourishing city, seems as if the voices of man had never been heard there. . . . It is indeed the beauty of desolation, for finer architectural remains can hardly be imagined.[42]

Herschel's camera lucida was now a fully matured tool in his hands. Judging by the quantity of surviving drawings, his 1824 journey may be considered the peak of his production with the instrument. While maintaining his previously high pictorial standard, Herschel began to introduce additional details of specific scientific interest. He began to sketch selectively, sometimes concentrating the detail in some areas while only briefly suggesting the surround. When he took his first journey in 1821, all was new. Engravings of the major sites were readily available from printsellers, but were often fanciful. It was natural for Herschel to employ his camera lucida to record more complete and accurate pictures. Now, with some experience, details began to take on extra importance. It is also possible that his vision was shifted by a new version of the camera lucida, one he was introduced to on this 1824 journey. He wrote to his mother that

I passed two days at Modena in very interesting company – that of M. Amici, a man of sound science and an artist of the very first class. I mean an artist who works for the sake of science and with whom (as I can speak from my own knowledge) profit is a secondary consideration.[43]

John Herschel departed Italy for an intellectual ramble homewards through the patchwork of Tyrol and Bavaria. The restlessness of earlier days was long since past, and to James Grahame, Herschel revealed that

I would not wish a day of my life back but to use it better for I would not exchange the sober tranquility of my present state of mind for either the careless ignorant innocence of childhood – or the romance of 18 – or the tumult of passion at any age whatever. That is a conclusion worth arriving at at least.[44]

Fresh from this highly successful journey, it was in this ebullient frame of mind that John Herschel first met Henry Talbot in Munich. His portfolio of camera lucida sketches was especially rich. Such camera lucida drawings were no strangers to Talbot, nor were the scientific questions that they posed nor the observations that they recorded. Herschel stayed for a week in Munich. His phrasing that he "fell in" with Talbot and his family suggests that they spent much of this time together. If for no other reason than to illustrate where he had been and what he had seen, Herschel must have shown the drawings to Talbot, Captain Feilding, and Lady Elisabeth (herself a competent sketcher).

Henry Talbot was born with wanderlust and cultivated into a polymath.[45] Born at Melbury, in Dorset, in 1800 to Lady Elisabeth (née Elisabeth Theresa Fox-Strangways), his father, William Davenport Talbot, a military man, succumbed to illness when Henry was only five months old. The family fortunes were run down, their Wiltshire home of Lacock Abbey had long since been let out, and Lady Elisabeth and her son took to living in a succession of family houses.[46] After the experience of his childhood, the adult Henry Talbot never stayed in one place long for the rest of his life. Lacock Abbey and his mother's London residence in Sackville Street were to become his bases, but much of his time was to be spent elsewhere. At the age of eight, Talbot "cast up the number of miles I have travelled in my life to be 3219 & this is the three thousand and fifty second day of my life."[47] This seeming parity of days and miles was one he was to maintain. One home for Lady Elisabeth and Henry was at Bowood, in Wiltshire not far from Lacock Abbey, as Elisabeth's sister, Louisa Emma, had married the third Marquis of Lansdowne. It was a house with substantial scientific heritage. The first Marquis of Lansdowne had retained Dr Joseph Priestley as a librarian or 'literary companion.' It was in a modest room at

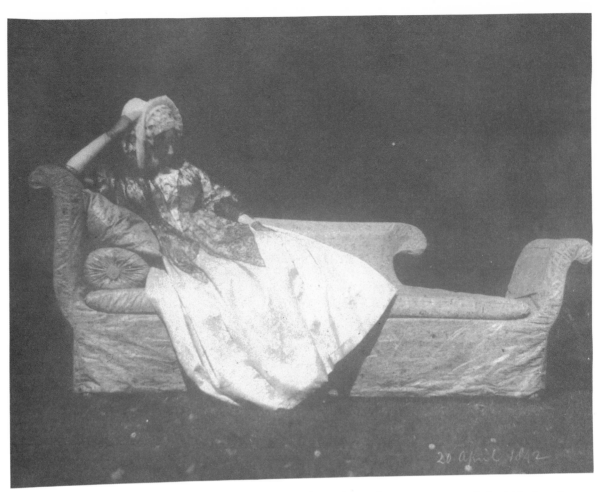

4. William Henry Fox Talbot. *Lady Elisabeth Feilding on her chaise lounge*. Salt print from a calotype negative. 20 April 1842. Talbot's mother was a lively, opinionated, artistic, intelligent woman who had great ambitions for her son. Since Henry Talbot was an intensely private person, it was Lady Elisabeth's prodding and support that made many of his public efforts possible. 12.3 × 16.1 cm. The National Museum of Photography Film and Television.

Bowood (one undoubtedly in which the young Henry Talbot was to play), that Priestley discovered *dephlogisticated air* – oxygen – in 1774. So little time separated this cornerstone of modern chemistry from the period in which Talbot made his first photographic experiments!

Just as Herschel's Aunt Caroline remained an influence on him throughout her life, Henry Talbot had a female role model, an even stronger one, in Lady Elisabeth. The daughter of the Earl of Ilchester, it was from her family name that Henry acquired the "Fox" so often associated with his surname (while Fox Talbot rolls off the tongue so easily that it is almost universally used for his name today, in fact he was known to family and friends nearly always as Henry; he signed his letters "H.F. Talbot" or "Henry F. Talbot" far more often than "H. Fox Talbot").[48] Lady Elisabeth was the single most important person in Talbot's personal and professional life. Well educated, fluent in several languages,

and possessed of an agile mind, her helpful social connections and drive to see her son achieve fame (one which he did not always share) demonstrably influenced Henry's public approach to photography. Her artistic attainments surely influenced his vision. The numerous letters between Lady Elisabeth and her son often seem to emphasize her domineering spirit. But they are a most illuminating source of information on Henry Talbot's life and his career.

When Talbot's mother re-married in 1804, it was to Captain (later Rear Admiral) Charles Feilding, R.N., who genuinely befriended his stepson, even though he spent much time at sea. Lady Elisabeth gave her new husband full (and probably too-generous) recognition for guiding Henry; when her son reached his twenty-first birthday, she said to him that

To myself I take no credit for this, it is due to the person who (with fortunately a head for business complicated

even as yours <u>then</u> was) from the first moment he ever saw you, took an affectionate interest in all your affairs only to be equalled by a parent, & who has made it up to you in Care & zeal, for the loss of one – if anything can. He will always be ready to explain or advise should you want either, but otherwise will not henceforth interfere. For myself I shall reserve the right <u>which Nature gives me</u>, of suggesting any thing which from your youth & inexperience may not occur to you.[49]

And exercise that right she did! Never one to mince words, Lady Elisabeth continued through her life to supply an ambition and a power to Henry that may not have been central to his nature. She openly confessed to her son that "you cannot judge of the rapture with which I first beheld you," but this enchantment went even beyond a mother's natural love for a child.[50] Lady Elisabeth knew that Henry Talbot was an exceptional individual and that he was destined for great accomplishments. She did everything in her power (which was quite considerable) to assure Henry's success – especially in shielding him from his own worst traits.

A schoolmaster's assessment, made of Henry Talbot when he was eight years old, was telling: "I have not a moment's hesitation in pronouncing him to be of very superior capacity & such, as will make all his Business quite easy on himself & those who are to instruct him." Superior though he was in many areas, Talbot's business was often to prove most uneasy. The conclusion of this report might as well have been written of Talbot as an adult: "that steady, uniform persevering unwearied attention, which moves slowly but surely to his end he has yet to learn. . . ."[51] And never would he learn it! Talbot's certainly was a brilliant mind fully deserving of Lady Elisabeth's ambitions. Like Herschel, his interests spanned diverse disciplines. But there is an overall organization and consistency evidenced in Herschel's chronicle notably lacking in Talbot's. Reading Talbot's research notes is like having an exhilarating conversation with a long-lost friend; interesting subjects flash on and off stage with great rapidity. Talbot's son observed that his father's "mind was essentially original . . . he disliked laborious application in beaten paths."[52] Henry Talbot interleaved the recording of experiments accomplished with speculations about possible future ones. Over the years, he kept several series of notebooks at once (sometimes overlapping) that had little of the character of a rigorously organized research program. It might be better to term them commonplace books, for they represent a fascinating stream-of-consciousness log of a fertile mind ranging freely over a variety of puzzles. Two of these notebooks cover much of his early work in photography.[53]

Talbot's childhood, to whatever extent it was modulated by the lack of a permanent home, remained rich in experience.

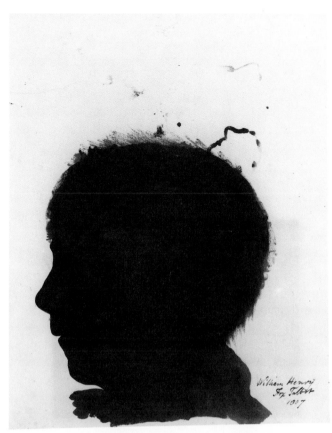

5. Anonymous. *Silhouette portrait of William Henry Fox Talbot as a child.* Dated 1807; on paper watermarked 1810. There were many in Talbot's extended family with the artistic ability to have made this; it was in the collection of the family of his cousin Kit, Christopher Rice Mansell Talbot, in Wales. 38.0 × 30.6 cm. Hans P. Kraus, Jr. Collection.

Talbot received drawing lessons, amongst other tutelage, but they would prove insufficient for his later needs.[54] Lady Elisabeth began recording his comments when he was just six years old; at the age of eight, after visiting various novelties, Henry "went to the Panorama of Dublin & Gibraltar. Thought they were so exactly like nature that if there were not iron rails to keep people off they would run about on the rock of Gibraltar & knock themselves against the side of the room on which it was presented."[55] After receiving a solid grounding at a small school for boys in Sussex, Henry entered Harrow School in 1811. Fortunately, young Talbot was assigned to the house of the headmaster, George Butler, an accomplished intellectual with an interest in the sciences.[56] The encouragement worked, for in 1812 Henry wrote to his mother that "you can have no idea with what vigour I pursue my favourite science of chemistry here . . . which at present engrosses all my attention. . . . Chemistry is what I cannot get tired of."[57] As is often the case when dealing with young prodigies, however, Butler found both rewards and trials in

encouraging Henry. As Lady Elisabeth reported to her sister,

as he can no longer continue his experiments in Dr. Butler's House, he resorts to a good-natured Blacksmith who lets him explode as much as he pleases. He makes 'Pulvis fulminans', and I am quite nervous at the thought of the risks he must run with Nitre and Sulphur and Potash. He has been trying to gild steel with a solution of Nitromuriate of Gold. This was the fatal experiment which blew him up at Dr. Butler's as it exploded with the noise of a pistol and attacked the olfactory nerves of the whole Household. Dr. B. was alarmed and declared that the Sun Fire Office would not ensure his house for a single day.[58]

In spite of such mishaps, Henry Talbot excelled at Harrow. Many of his adult interests were cultured, if not formed, during that period. He took up the family passion of botany, compiling an index of the local flora, and won a number of prizes for his work in mathematics. Leaving at the age of fifteen, Talbot was briefly (and unsatisfactorily) tutored in Yorkshire, made the first of his trips abroad, and spent another period with a tutor in Lincolnshire. To mathematics and botany, he added what would become life-long interests of astronomy and optics.

For once, Lady Elisabeth's concerns did not prevail. In spite of her reservations about Henry's concentration on mathematics, and he entered Trinity College, Cambridge in 1817. Talbot took a first class in each of his first three years' examinations. In 1820, it was apparent that Lady Elisabeth's facility with languages had had results; her son took the Porson University Prize for his mastery of Greek verse. In 1821, Henry Talbot was placed twelfth on the final examinations but won second place in the Chancellor's Classical Medals. From Henry Talbot's point of view, these honors were won by hard work in the face of excellent competition. It is equally apparent that Captain and Lady Feilding had higher expectations for him and showed some measure of disappointment that he did not come in first in all categories.

The period after Cambridge was primarily one of foreign travels for Talbot. In both Herschel and Talbot, the financial support and predisposition of their families became a form of scientific patronage that encouraged their wanderings and eclectic interests. The Feildings were abroad more than at home and their son willingly adopted this style of living and of learning. In 1826, the tenants unexpectedly vacated Lacock Abbey due to ill health and Henry Talbot was finally able to make this Wiltshire family home his base.[59] Lady Elisabeth took to Lacock more and more over the years, constantly adjusting the landscape to her taste and not infrequently advising her son on his management of the place.[60] In spite of

the fact that its fabric and contents were to be the subject of many of his later photographs, Henry Talbot was slower to warm to Lacock. In 1824, he had written to Captain Feilding that, although,

the view from the top of Bowden hill struck me very much – I was rather disappointed in the Avon, but I have no doubt that in summer it is a very rural stream. The Abbey I think a fine old pile, the front next the road is unfortunately much the plainest and defaced with modern windows irregularly placed.[61]

As late as 1835, Henry alarmed his mother with a confession that

if I was rich I should not think of letting Lacock, but as I cannot afford two country houses it becomes a more difficult question. It is a residence not well suited to me; I like high and dry, rather than low and damp. My wish to live somewhere else keeps increasing.... What I should like would be, could I afford it, to live somewhere else & visit Lacock now and then, in the summer.[62]

However, perhaps in deference to Lady Elisabeth's wishes, Lacock was to be his main residence until after her death in 1846. After that, Edinburgh was to be a more frequent home.

Influenced by the reforms sweeping Britain in the early 1830s, Henry Talbot delved briefly into politics, but scientific and philosophical enquiry were soon restored as his major interests. Talbot's special accomplishments were in mathematics and crystallography. Botany was a passion. Assyriology, optics, etymology, and theoretical physics were some of his other specialties. At twenty-two years of age, he was made a Fellow of the Astronomical Society (later, the Royal Astronomical Society); by the age of thirty-one had been made a Fellow of the Royal Society of London. Until his marriage shortly after then, Henry Talbot routinely travelled with his mother and Captain Feilding. Unlike Herschel's adventurous expeditions, Talbot's travels generally had more the character of extended periods of residing abroad. An 1826 trip Talbot made to Corfu perhaps came the closest to the type of philosophical exploration that Herschel was doing.

Lady Elisabeth was possessed of above average proficiency in sketching; she also made some paintings and lithographs.[63] Surely, some of her works were made in Henry's presence, and just as surely, he must have absorbed at least some concept of the power of visual expression, and perhaps even some picture ideas as well. Henry's life-long interest in the picturesque was clearly shaped by his mother's preferences. He wrote to his mother in 1826 that "I wonder you never talked more of Ancona, which is a most picturesque town, & you might sketch here without end."[64] Other artistic influences surrounded him. A close family friend, George

Montgomerie, provided many sketches for the family's albums. However, an even more direct artistic influence on Henry Talbot is indicated. Two half-sisters for Henry were born in his mother's new marriage and the three siblings remained very close throughout life. Henrietta Horatia Maria (known usually as Horatia) was more the romantic and Caroline Augusta more a reflection of their mother. Like Lady Elisabeth, Caroline was the most interested in the visual arts and became the most active draughtsman in the family. In 1828, Caroline was persuaded by the family friend, Thomas Moore, to illustrate his *Legendary Ballads*.[65] As will be seen, Henry was on a sketching expedition with Caroline when he conceived of photography. She married Lord Valletort, the Earl of Mount Edgcumbe, and became a lady-in-waiting to the queen. Caroline's connections helped her brother gain access to the royal circle (although the practical effects of this were minimal).

The presence of Lady Elisabeth's younger half-brother, the fourth Earl of Ilchester, William Thomas Horner Fox-Strangways, can be felt throughout Talbot's work. Fox-Strangways' tongue was only slightly less sharp than his sister's, but his advice was equally sound, and he advised his nephew in no uncertain terms. His attainments in botany and geology led to his Fellowship in the Royal Society; later, he was the one who proposed Henry Talbot for this honor. Fox-Strangways built up a substantial collection of Italian paintings, eventually giving them to the newly-formed Ashmolean Museum at Oxford. He exhibited a perceptive understanding of the value of photography. Fox-Strangways privately claimed (quite believably) to have suggested the basic idea for Henry Talbot's seminal book, *The Pencil of Nature*. A career diplomat, Fox-Strangways in his travels made sure that his extensive network of contacts was aware of Talbot's new art. He even arranged for Henry Talbot's first daguerreotype camera to be slipped into the diplomatic pouch as soon as it became available in France. If one were to look for a model for Henry Talbot (scientifically rather than socially!), one would have to look no farther than his uncle.

John Herschel first met Talbot at a time when his own life was becoming increasingly complex. When Herschel returned to England in the autumn of 1824, it was to election as Secretary of the Royal Society. Within two years, he would become President of the Astronomical Society (later, the Royal Astronomical Society), a group that he had helped form in 1820. These were turbulent times within British scientific circles, however, and the political maneuverings and personal clashes repelled the sensitive John Herschel. His escapes in solitude to the continent, however brief, were important to his personal well-being, and they were also productive for him scientifically. By the time of a return journey in 1826, Herschel felt confident that he had grasped the underlying formative processes of the earth. He wrote to Babbage that

> the Vulcanos in this country are <u>superb</u>. Today I walked up the <u>Coupe</u> (Crater) of Aisa or Ayzac which is close by Entraigues and from which has issued most evidently all the Basaltic Lava . . . <u>filled the whole of a granite valley</u> up to a given level – and this valley has been again scooped; certainly not by <u>Diluvian</u> (i.e. violent & sudden causes) but by the slow action of causes now in operation. My ramble this Summer has made me an ultra-Huttonian. . . . I have bagged vulcanos this season as other men bag partridges. . . .[66]

Herschel's resignation as Secretary of the Royal Society in 1827 and as President of the Astronomical Society in 1829 freed him from the most onerous of his administrative and social burdens; he declared that "I am perfectly sick of the life a <u>savant by profession</u> which leads to nothing but quarrels & misunderstandings in which every one's temper is soured and no ones real interests are advanced."[67] Even as Herschel was withdrawing from official associations, he was making ever more significant contributions to science's basic foundations. By 1830 he had published sixty scientific papers, an impressive record even if it had been for an entire lifetime (which it was far from being).[68] In addition to the record of immense personal achievements in science, these papers contributed something less tangible but perhaps even more important. In his writings, John Herschel had the peculiar gift to

> combine with his special studies a breadth of view and power of expression. . . . We have called Sir John Herschel the Homer of science because he was its highest poet. It is the poet's function to move the soul – rousing the emotions, animating the affections, and inspiring the imagination; and all this Herschel did on almost every page of his writings . . . he has drawn beautiful pictures of nature's doings – so beautiful that they have disposed two generations to find their recreation and joy in science.[69]

Herschel wrote with elegance and grace in a style that brought the most complex of thoughts within the grasp of any educated person. The astronomer, Richard Proctor, marvelled that "how few . . . like him, could so touch the dry bones of fact that they became clothed at once with life and beauty!"[70]

One of the most influential of these early articles was, appropriately enough, his contribution on "Light" for the *Encyclopaedia Metropolitana*.[71] Lest a modern reader dismiss this as a mere encyclopedia article, the 240 plus pages of this essay could just as easily have formed a book. And a substantial book it would have been at that. At the time

6. William Henry Fox Talbot. *Lacock Abbey, reflected in the Avon.* Salt print from a photogenic drawing or a calotype negative. Ca. 1840–1. The availability of a country house, spacious and equipped with extensive kitchens and workshops, along with the leisure time that it implied, had a marked influence on Talbot's ability to experiment. While this was a subject to which he would turn repeatedly, the earliest reference to an image with this title was in May 1840. 16.1 × 19.2 cm. image on 18.4 × 22.9 cm. paper. The National Museum of Photography Film and Television.

7. Alfred E. Chalon. *Margaret "Maggie" Brodie Stewart*, 1829, on the eve of her wedding to John Herschel. Miniature Painting. Although only half the age of her future husband, Margaret's intelligence and wit were an important source of support for the scientist. They were to share fully artistic endeavours, adventurous expeditions, and discussion of subjects of all sorts. 12 × 10 cm. John Herschel-Shorland.

8. Alfred E. Chalon. *John Herschel*, 1829. Miniature Painting. 12 × 10 cm. John Herschel-Shorland.

Herschel wrote "Light," the fundamental theories about this phenomenon were in turmoil. Sir Isaac Newton's corpuscular theory was being challenged by the newer undulatory or wave theory. Amongst others, Augustin Fresnel in France and Dr. Thomas Young in England were most prominent establishing its structure. Herschel's "Light" recognized both the limitations and the advantages of the wave theory; on the whole, he argued for its acceptance.[72] A considerable amount of Herschel's own original research was presented in this article. Amidst all the intricate mathematical proofs and complex physical interpretations (for this was one of his most technical writings), Herschel never once lost his ability to marvel. In his introductory remarks, he exclaimed that

> sight is the most perfect of our senses; the most various and accurate in the information it affords us; and the most delightful in its exercise. Apart from all considerations of utility, the mere perception of light is in itself a source of enjoyment. . . . When to this we join the exact perception of form and motion, the wondrous richness and variety of colour, and the ubiquity conferred upon us by just impressions of situation and distance, we are lost in amazement and gratitude.

Rapidly approaching the age of forty, John Herschel might well have become a recluse. But in spite of two disastrously failed attempts at marriage, he still longed for intimacy – for someone with whom he could share the rediscovered joys of his scientific life. His Scottish friend, James Grahame, came to his rescue. In a frankly engineered match, he introduced Herschel to the family circle of Emilia Calder Stewart, the widow of Dr Alexander Stewart, a Gaelic scholar and a mathematician. The large and cheerful family filled a void in John Herschel's life. Before long, the youngest daughter, Margaret Brodie, caught his eye. Beautiful and possessed of a sweet countenance, she was at nineteen only half his age. But Maggie was a highly intelligent and determined young woman fully capable of sharing Herschel's intellectual interests. In September 1828, Herschel met up with Grahame and "rowed with him . . . by moonlight to Netley Abbey" to discuss his impending proposal to Margaret. As Herschel recalled it, the friends "passed an hour in a close & whispered confidence in the main aisle under the ash trees with the stars looking in above. An unearthly scene!"[73]

On 3 March 1829, John and Maggie were married. Theirs was a near perfect partnership and an unending source of joy for both of them. During their honeymoon in Warwickshire, at a hotel in Leamington, John Herschel gave Maggie her first lessons with the camera lucida. Tellingly, they discussed its optical principles as well as how to use the instrument! Maggie was already a reasonably accomplished sketcher and watercolorist. She mastered the camera lucida handily and the productions of this instrument were thereafter shared by them. That summer the Herschels took their first continental tour together. Margaret proved to be a fine and sturdy traveller, eager to share her husband's more adventurous side. John proudly boasted that they went "plunging through mud, stones, mountainous ruts & gulphs with a vortex of mud & water flying about on all sides it was like working thro' Chaos."[74] In an exuberant and joyous burst to his mother, Herschel exclaimed that "we go about sketching, reading, & hammering the hills, flute playing &c. &c."[75]

The exhilarating tone for Herschel's relationship with Maggie was set on this 1829 journey. During it, they were accompanied by Margaret's fifteen-year-old brother. Herschel reported that "Johnnie & I are running a race which shall sketch most – he draws very nicely & with practice from Nature will acquire 'freedom of hand' in abundance."[76] More than two decades later, when photography was beginning to ripen as an art, John Stewart would emerge as an exceptionally talented photographic artist, with both his technical skills and his pictorial sense shaped by contact with his brother-in-law. Maggie's other brothers, men of commerce, aided Herschel in obtaining supplies and transport. The shared mixture of science, nature, art, and music led to an intellectual fulfillment that continued through the Herschels' long life together. Maria Edgeworth, concerned about John Herschel's sensitive nature, observed that Maggie Herschel was

well aware of the precarious state of health and the delicate dealing necessary with such nerves. She is a most amiable highly cultivated, unpresuming sensible woman who does all that can be done by affection and intelligence and sympathy and care or efforts to divert his mind and draw him from intense application and divert him from all painful thoughts. . . ."[77]

Beyond this loving support, Maggie was to take an active interest in her husband's science and art. She was rarely a full partner (except in camera lucida drawings), but often they read the same books and their discussions went well beyond mere parlour conversation.[78] John Herschel had been exposed to a strong and competent woman in his Aunt Caroline right from the start of his thinking in science. In turn, Herschel's support of women was outstanding in an age when this was

hardly fashionable. The author Maria Edgeworth, the botanist Anna Atkins, the scientific writer Mary Somerville, and the photographer Julia Margaret Cameron were only a few of the diverse and brilliant women who drew genuine support and respect from him.

John Herschel, a very human person with a good sense of humor, now had someone with whom to share his thoughts and his frustrations. Within a year of his marriage, he embarked on the writing of his first book, a volume expressing his philosophy of nature and science. In the early stages, he wrote to Maggie that

I have found a flaming passage in Cicero which will suit me to a t for a motto to my "Discourse on Science" that is to be, and has rather electrified me, so that I am all in a ferment – going about the garden looking how the trees grow and threatening what fiery things I shall (one day) write. Two stars last night and sat up till two, waiting for them. Ditto the night before – sick of star-gazing – mean to break the telescopes and break the mirrors.[79]

Herschel's *Preliminary Discourse on the Study of Natural Philosophy* proved to be a tremendously influential work during his lifetime. For us today, understanding this work, its tone and its philosophy, is essential to appreciating Herschel's later approach to photography. In 1859, Charles Darwin sent a copy of his newly-published *Origin of the Species* to Herschel, along with the tribute:

I cannot resist the temptation of shewing in this feeble manner my respect, & the deep obligation, that I owe to your Introduction to Natural Philosophy. Scarcely anything in my life made so deep an impression on me: it made me wish to try to add my mite to the accumulated stores of natural knowledge.[80]

Herschel outlined in his book an integrated approach to comprehending the world:

What we have all along most earnestly desired to impress on the student is, that natural philosophy is essentially united in all its departments, through all which one spirit reigns and one method of enquiry applies. It cannot, however, be studied as a whole, without subdivision into parts. . . .[81]

A brilliant mathematician, Herschel understood the value of abstract reasoning:

a certain moderate degree of acquaintance with abstract science is highly desirable to one who would make any considerable progress in physics. As the universe exists in time and place; and as motion, velocity, quantity, number, and order, are main elements of our knowledge of external things, an acquaintance with these, abstractly considered,

(that is to say, independent of any consideration of the particular things moved, measured, counted, or arranged,) must evidently be a useful preparation for the more complex study of nature....[82]

He also found abstract science to be

> highly desirable in general education, if not indispensably necessary, to impress on us the distinction between strict and vague reasoning, to show us what demonstration really *is*, and to give us thereby a full and intimate sense of the nature and strength of the evidence on which our knowledge of the actual system of nature, and the laws of natural phenomena, rests.[83]

However, the main point of his *Preliminary Discourse*, and the controlling philosophy of Herschel's life, was the Baconian ideal that

> natural philosophy consists entirely of a series of inductive generalizations, commencing with the most circumstantially stated particulars, and carried up to universal laws, or axioms ... and of a corresponding series of inverted reasoning from generals to particulars, by which these axioms are traced back into their remotest consequences, and all particular propositions deduced from them.... In the course of this descent to particulars, we must of necessity encounter all those facts on which the arts and works that tend to the accommodation of human life depend, and acquire thereby the command of an unlimited practice, and a disposal of the powers of nature co-extensive with those powers themselves.[84]

The real key to Baconian philosophy was the realization that problems beyond the scale of a single person's comprehension could be solved by cumulative efforts of many researchers. This fit well into Herschel's concept of the emerging nineteenth century society. Science was not merely an endeavour of the elite, but rather a pleasure open to all who took an interest. Education was an important corollary of discovery.

> To avail ourselves as far as possible of the advantages which a division of labour may afford for the collection of facts, by the industry and activity which the general diffusion of information, in the present age, brings into exercise, is an object of great importance. There is scarcely any well-informed person, who, if he has but the will, has not also the power to add something essential to the general stock of knowledge, if he will only observe regularly and methodically some particular class of facts which may most excite his attention, or which his situation may best enable him to study with effect.... In short, there is no branch of science whatever in which, at

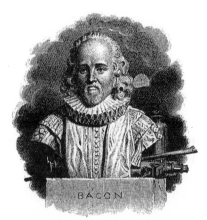

9. John F.W. Herschel. Title page to *A Preliminary Discourse on the Study of Natural Philosophy*. 1830. Heavily influenced by the writings of Francis Bacon, Herschel became the spokesman for inductive reasoning. Nowhere was the joy of a scientific life expressed more eloquently, or more persuasively, than in this long-lived volume. Private Collection, America.

least, if useful and sensible queries were distinctly proposed, an immense mass of valuable information might not be collected from those who, in their various lines of life, at home or abroad, stationary or in travel, would gladly avail themselves of opportunities of being useful.[85]

Herschel sought a harmony and a simplicity in the universe. His *Preliminary Discourse* was an attempt to make sense of an increasingly complex world. In spite of its title, it remains an immensely readable book today, largely because the advice in it is so basic and so sound. Many of our challenges are logical extensions of what Herschel observed as industrialized society was forming. Arguing persuasively for the value of scientific observation to modern life, Herschel pointed out that

> it is not one of the least advantages of these pursuits, which, however, they possess in common with every class of intellectual pleasures, that they are altogether independent of external circumstances, and are to be enjoyed in every situation in which a man can be placed in life.... They may be enjoyed, too, in the intervals of the most active business; and the calm and dispassionate interest with which they fill the mind renders them a most delightful retreat from the agitations and dissensions of the world, and from the conflict of passions, prejudices, and interests in which the man of business finds himself continually involved.[86]

In recognition of an already full life of scientific contribution, John Herschel was knighted in 1831. Herschel's publications recorded his significant work in optics, chemistry, light, astronomy, mathematics, and sound. The testimony of these formal publications did not reveal additional work in virtually all areas of science, from botany to geology. His well-earned scientific reputation was secure, he had received many awards, and he had already published a number of his most elegant writings. Many British and foreign scientific bodies honored themselves by electing him to their rolls. His opinions held sway in virtually every scientific body – never because of his personal ambitions to prevail, but always compelling because of whom they they came from. No wonder that the President of the Royal Society exclaimed in 1833 that "such a model of the accomplished philosopher ... can rarely be found beyond the regions of fiction."[87] This was the man who would enthusiastically support Henry Talbot in the invention of photography.

Herschel had already been of some use to Talbot before the introduction of photography. Talbot's interest in science had continued after his ill-fated youthful chemical experiments,

10. William Henry Fox Talbot. *Carclew, the home of Sir Charles Lemon*. Salt print, salt fixed, from a calotype negative. Sir Charles, Lady Elisabeth's brother-in-law, is at the left. Henry Talbot lived in the context of an extended family, influential politically and socially, accomplished in the sciences and the arts, and capable of providing him with important support and connections. 17.0 × 21.1 cm. The National Museum of Photography Film and Television.

and in 1822 he was elected a member of Count Rumford's experimental Royal Institution of Great Britain. By the time he met Herschel in 1824, Talbot had published several papers in the *Annales de Mathématiques*, a respected journal edited in Nîmes. His first scientific paper to branch into other areas (and also the first based on experiment rather than abstract reasoning) was an 1826 one on colored flames. This was communicated by Herschel and published in Sir David Brewster's influential *Edinburgh Journal of Science*.[88] Talbot relied on Herschel for other introductions in the world of science. After confirming to Herschel that he had arranged for a shipment from Fraunhofer in 1826, Talbot asked if Herschel could "give me a letter to any of the savans of Geneva" for use on his upcoming trip.[89] Herschel was happy to; after wishing Talbot a good journey, he added jovially that "if I could slip myself into your portmanteau I should be very glad." Herschel said that "I also found on my return to Town your paper on Col^d flames which I shall as you desire immediately forward to D^r. Brewster."[90]

Very much like Herschel's earlier period of angst after Cambridge, Henry Talbot began to slide into decline by 1830. The nature of the problem (and its later resolution) was less defined in Talbot than it had been for Herschel. When Talbot published his first book in 1830, instead of a scientific treatise or an analytical work, he gathered together a number

11. William Henry Fox Talbot. *Constance Talbot and her daughters, in front of a rustic shelter.* Salt print, salt fixed, from a calotype negative. 19 April 1842. 15.3 × 18.8 cm. The National Museum of Photography Film and Television.

of *Legendary Tales*.[91] Lady Elisabeth's disappointment in him was most vocal by the middle of that year. Talbot was undoubtedly affected, at least to some degree, by the general state of affairs in Britain. In 1830, the 'Swing Riots' swept through Wiltshire and other areas of the country. They were the inevitable outcome of the intolerable economic pressures that increasing industrialization was inflicting on agrarian workers. As a result of his compassionate and surprisingly expert management of Lacock, Talbot succeeded in avoiding any local violence. He soon found that in trying to alleviate the condition of the poor, he was out of step with the local

farmers. Reform was in the air. Henry Talbot expressed his opinion that representation should be equitable; he stood for Parliament in 1831 as a reformer, but was defeated on this first try. Perhaps his entry into politics was less anomalous than it might at first appear. Talbot's ancestors (and many of his current relatives) had been deeply involved in politics. His cousin Kit, Christopher Rice Mansel Talbot, had entered Parliament in 1830. Lady Elisabeth considered her son's talents wasted in the game of politics, but she would have encouraged him to at least do something, anything, to break out of his ill humor. The passage of the Reform Bill in 1832

increased his constituency, and Henry Talbot was finally elected as a Member from Chippenham. He was to serve only one term.

Talbot's short political career proved unsatisfying but perhaps also convinced him that a life in science was what he wanted. A sure sign that Talbot was getting a grip on his doldrums came with his March 1831 election as a Fellow of the Royal Society. Proposed by his relatives Charles Lemon and William Fox-Strangways, Talbot's election was supported by the testimony of Michael Faraday, Davies Gilbert, George Peacock, Thomas Phillipps, and William Whewell (Herschel would have been happy to sign for Talbot as well save for his continuing protest against the Society).[92] Perhaps even this short experience in politics was for the best; Talbot's point of view on the relationship between science and society had been expanded. In 1833, he wrote to the botanist William (later Sir William) Jackson Hooker that "the difficulty which you complain of, of getting any bookseller to publish a scientific work on Botany is not confined to that science." Talbot suggested that there was a societal benefit to be gleaned from support:

> Abroad, not only is paper & printing cheaper, but assistance is rendered by the Governments. In my opinion public libraries ought to be established in all our principal Towns at the national expense. A considerable sum should be voted annually for the encouragement of science, which should be in part expended in patronizing literary undertakings of merit. From 20 to 50 copies of such works should be purchased by government & distributed to these provincial libraries, which small at first, would soon become important.[93]

Another sign that Henry Talbot was emerging from melancholy was his December 1832 marriage to Constance Mundy, of Markeaton.[94] The youngest daughter of the MP for Derbyshire, she came from a family possessed of more than the usual artistic interests and was a reasonably accomplished amateur sketcher herself. Constance's cheerful countenance was an important foil to Talbot's occasionally brooding behavior. She was highly supportive of Henry's efforts and proved to be a good moderator for the well-motivated ambitions of Lady Elisabeth. However successful in this, Constance never became the intellectual partner to Henry that Maggie was to John Herschel. The evidence for this is distressingly clear. Since Henry spent much time away from home, his correspondence to and from Constance is voluminous. It is perhaps understandable that she carried on no discourse about her husband's highly-specialized researches. But it is extraordinary that Constance, as an amateur artist herself, never once made any serious assessment of any of Henry's photographs. Constance rarely commented on his subjects and virtually never made suggestions for possible photographs. When Constance was vacationing separately in Wales in 1835, at a time when Henry's interest in his new discovery was at its first peak, she wrote that "I wish you could have taken the outline of the castle & fine elms behind just as I saw them – but I think you told me you could not produce the desired effect by any light except that of the sun."[95] But even this breezy comment was an exception. Her very occasional references to photography after it became public in 1839 indicate that she made some attempts to sensitize paper and make some prints; however, they betray a very superficial understanding of how the process worked. Perhaps Constance Talbot's artistic training exerted some influence on her husband during his picture making, but one is disappointed in efforts to trace hints of such an influence in their correspondence. Constance's understanding of her husband's work, including his photography, was conversational, and her role was to be minimal. It would be an overstatement to call her a photographer.[96]

Completing his article on colored flames in 1826, Talbot had explained to Herschel that "as I am not acquainted with Dr Brewster perhaps you will have the kindness to transmit it."[97] The relationship between Talbot and Sir David Brewster obviously flourished, for, judging by the surviving correspondence, Brewster and Talbot were in regular contact at least by 1833 and were good friends by 1836.[98] They shared interests in light and perhaps some personality traits as well. Brewster, as influential as he was, struck many as an abrasive personality. He had many admirers but few friends. Talbot was reclusive by nature but the two men hit it off very well. A letter from Constance to Lady Elisabeth, written on the occasion of Sir David's visit to Lacock Abbey in August 1836, is particularly revealing of Talbot's character:

> You are perfectly right in supposing Sir D.B. to pass his time pleasantly here. He wants nothing beyond the pleasure of conversing with Henry discussing their respective discoveries & various subjects connected with science. I am quite amazed to find that scarcely a momentary pause occurs in their discourse. Henry seems to possess new life – & I feel certain that were he to mix more frequently with his own friends we should never see him droop in the way which now so continually annoys us. I am inclined to think that many of his ailments are nervous – for he certainly does not look ill. I hear from Sir David that he <u>distinguished</u> himself at the Meeting in a conversation on the Improvement of the Telescope.... When I see the effect produced in Henry by Sir D. B's society I feel most acutely how dull must our ordinary way of life be to a mind like his! – and yet he shuts himself up from choice.[99]

Henry Talbot would never achieve the same levels of fame that Herschel (unwillingly!) reached. His scholarly contributions were generally less influential; much of this stemmed from the fact that he rarely took on the more general questions of the organization and role of science that Herschel approached. Unlike Herschel's minutely detailed and lengthy treatises, Talbot's journal publications tended to be very short. Frequently they reflected scientific concerns common to the day and were just as often as suggestive as they were declarative.[100] Even so, Talbot made two fundamental contributions to science before photography was even announced.[101] These stemmed from a growing awareness in Talbot's time of the interrelationship between forms of energy and matter. Talbot made one very practical contribution that is still in use today. In July 1834, he read a paper to the Royal Society summarizing his experiments on light: "I have lately made this branch of optics a subject of inquiry, and I have found it so rich in beautiful results as entirely to surpass my expectations."[102] In this, Talbot revealed his discovery of the *polarizing microscope*; his method of placing one polarizer close to the eyepiece and another below the stage is still considered highly effective. It provides an increase in contrast between the subject and the background and is an important tool in the analysis of internal structure. Talbot applied it immediately to studying the structure of crystals.

Whereas the polarizing microscope was a discrete invention of Talbot's, his work in *spectral analysis* (the analyzing of the physical makeup of substances through optical means) was more in the nature of fundamental contributions to the beginnings of an important branch of science. As Talbot was to remember in later years:

About the year 1824 or 1825, Dr. Wollaston gave one of his evening parties, to which men of science and amateurs were invited, and it was the custom to exhibit scientific novelties, and to make them the subject of conversation.

On the evening in question I brought as my contribution to the meeting some very thin films of glass (such as are shown in glass-houses to visitors by a workman, who blows a portion of melted glass into a large balloon of extreme tenacity, and afterwards crushes the glass to shivers). Such a film of glass I brought to Dr. Wollaston and his friends, and after showing that in the well-lighted apartment it displayed a uniform appearance without any markings, I removed it into another room, in which I had prepared a spirit lamp, the wick of which had been impregnated with common salt. When viewed by this light, the film of glass appeared covered with broad nearly parallel bands, which were almost black, and might be rudely compared to the skin of a zebra.[103]

Talbot's optical 'zebra skin' in fact provided some of the earliest evidence of the presence of the lines of sodium. These bands had been discovered by Josef von Fraunhofer (the same man who was the cause of Herschel's and Talbot's first meeting). Henry Talbot's first non-mathematical journal article, his 1826 "Experiments on Coloured Flames," was a foundation stone for spectral analysis.[104] The following year, Herschel incorporated Talbot's findings into his treatise on light. Two types of objects can be analyzed this way. In *absorbent* subjects (where the effect of incident light is analyzed), important pioneering work was done by Sir David Brewster and others. In the treatment of *self-luminous* subjects (such as the sun), Talbot and Herschel were the pioneers. Many of their subsequent publications returned to this subject of study.

Henry Talbot, through his substantial family connections and through his own efforts, now exercised a certain amount of political influence. An excellent demonstration of this was his effective support for the establishment of a national botanic garden at Kew. Long known as 'the Royal Vegetable Patch,' Kew had declined by 1838 to a most precarious position and was threatened with closure. Talbot's longtime botanical friend, Sir William Jackson Hooker (recently knighted for his botanical contributions), led the fight to establish a national collection. Agreeing that "it would be a pity indeed if Kew Gardens were to be sacrificed to a pitiful & false economy," Talbot persuaded his influential relatives to take up the cause.[105] He met with the Chancellor of the Exchequer, determined that petitions to Parliament from learned societies would have great weight, and proposed to the Council of the Linnean Society that they present a petition to the House of Commons.[106] His idea was accepted unanimously. By May, Talbot could report to Hooker that the Chancellor of the Exchequer "spoke confidently to me last night that something satisfactory would be done about Kew Garden. . . ." Although he was leaving town and could be of no further assistance, "I trust that it is put into a right train, & will issue favourably."[107] This support was perhaps Talbot's greatest and most effective contribution to the politics of science. Kew was saved and revitalized that year; in 1841, Hooker became its new director.

When considering the dynamics of the beginnings of photography, to paint Talbot as being junior to Herschel, as is often done, is terribly misleading. No one was like Herschel and only a few even approached his status. However, Talbot was an established scientist in his own right by 1839. The line of thinking that Talbot's status affected the start of photography can be traced to 1908, when the indefatigable Sir James Murray was researching the word "photography" for the *Oxford English Dictionary*. Trying to explain why Herschel withdrew from publishing his first paper on photography, Murray came to feel that Herschel's action indicated that a

12. William Henry Fox Talbot. *Copy of a hieroglyphic tablet at Ibrîm*. Salt print from a calotype negative. Plate 1 of *The Talbotype Applied to Hieroglyphics* (London, August 1846). Talbot's photographs frequently reflected his varied intellectual interests. In this very rare publication, Talbot made use of the reproductive powers of photography to distribute an important new attempt at Egyptian philology by Samuel Birch. 18.7 × 22.6 cm. The National Museum of Photography Film and Television.

state of competition had developed with Talbot.[108] "My conclusion," he wrote to Herschel's son,

> was that Sir John Herschell[sic], after getting to know what Talbot had done, generously withdrew his own paper from the Royal Society (& probably destroyed it), in order not to depreciate Talbot's work. He was a <u>great man</u> with a <u>great reputation</u> already secured, and Talbot had his to make, & also to protect himself against the claims of Daguerre, and I feel assured that your father generously withdrew the account of his own contemporary discoveries in Talbot's interest.[109]

Other than the fact that Herschel was indeed a 'great man,' nothing could be further from the truth. Unfortunately, Murray's speculation has been injected strongly into photo-historical literature, to the point where the concept of the supposed antagonism between Talbot and Herschel has become widely repeated.[110] John Herschel, a man of universally generous character possessed only of the ambition to learn, would have found such an attitude abhorrent, and never would have been so condescending as to treat Talbot as a junior for whom he had to clear a path. Herschel and Talbot were both senior scientists at the peak of their careers by the start of 1839.

A highly personal picture of Henry Talbot was presented by his granddaughter, Miss Matilda Talbot, in radio interviews in the 1940s and 1950s:

> The whole family of us came to Lacock when I was six years old in the summer [of 1877], and in September of that same year, he died. The memory I have of him is very clear; an old gentleman with a kind face and a kind voice, wearing a long coat of soft black cloth, rather crumpled. We did not feel in the very least afraid of him, and he let us look at things through his microscope . . . which has left an indelible impression on me to this day. We had always heard of him spoken of in the family as somebody marvelously clever, and also very kind. With strangers I imagine he may have been somewhat difficult, but in his home circle he was delightful. . . . I think we children thought of him as something almost supernatural. My mother so often told us how much he knew about the stars . . . then she constantly spoke of his interest in plants and flowers – how many rare and beautiful things he had got from distant places, and made them grow at Lacock. Once she showed us some hieroglyphics and said "Your grandfather knew what all those funny little pictures mean."[111]

Henry Talbot was indeed "marvelously clever." By the year 1839 – the year photography became public – Henry Talbot had already published four books, twenty-seven scientific papers, had given the prestigious Bakerian Lecture to the Royal Society (on crystals, in 1836), and had received their Royal Medal for his work in mathematics in 1838. It was a recently crowned and most impressive record, to which Henry Talbot would add considerably as he went through life. He revealed the art of photography from a position of some strength – a position, however, to be undermined from the start by his own procrastination, and by the efforts of an eminently worthy competitor.

II The Beauty of the First Idea:
A Selective Pre-History of Photography

THE PUBLIC RECEIVED its first glimpse of the art of photography at the start of 1839. In the context of the lively artistic ferment of Paris, Louis Jacques Mandé Daguerre's trapping of the ephemeral images formed by a lens sparked an immediate and enthusiastic response.[1] Henry Talbot was finally provoked into disclosing his photographic process, which he had kept secret for five years. While Talbot's was unquestionably an independent discovery, based on significantly different and ultimately more useful principles, he would never recover fully from this second-place ranking.[2] Talbot was forced to take solace in the conviction that whatever was to follow "cannot, I think, admit of a comparison with the value of the first and original idea" – an idea that was decidedly his own.[3] Just two months after this initial public announcement, in March of 1839, Sir John Herschel presented his first paper on photography to Britain's elite scientific body, the Royal Society.[4] In establishing the background to his own achievements, Herschel cited a handful of researchers whose work in chemistry and image-making he felt presaged the events of 1839. Herschel's severe distillation of the pre-history of photography was from an exceptionally well-informed point of view, reflecting the historical context that enveloped Herschel's and Talbot's initial thinking. Consequently, it is Herschel's framework that is expanded upon here to examine the question of what led up to the public introduction of photography.

In the popular mind, the concept of the camera and that of photography are often seen as synonymous. However, the essential pattern of the photographic camera, the *camera obscura*, literally a 'dark chamber,' had been a largely silent partner of artists for centuries before 1839.[5] In the camera obscura, an image was projected by a lens to a screen opposite in the darkened room. Later, this dark room was shrunken to the size of a portable box and the artist could trace what he saw projected on the ground glass. In order to realize photography, once an image had been modelled in such a camera, the next stage was to devise a means of retaining it in physical form. In the decades prior to 1839, the literature carried a wide variety of possible chemical approaches and any well-read person so motivated could have applied an existing procedure to the problem. Herschel rightly assumed knowledge of the camera itself as being so commonplace by the time of his paper that he could comfortably ignore the instrument completely.

So why did 1839 become the magic year?[6] The answer must lie largely outside the realm of technology. The very idea of creating permanent images by the action of light was introduced into British literature in a work cited by Herschel, Mrs Fulhame's 1794 *View to a New Art of Dying and Painting*.[7] Elizabeth Fulhame has long been an enigma in the history of

chemistry and remains one of the most mysterious and interesting people in the early history of photography.[8] It is likely that she was the wife of Dr Thomas Fulhame, an Irish-born resident of Edinburgh who had been a student of the famous chemist, Dr Joseph Black. Benjamin, Count Rumford, writing in the normally staid *Philosophical Transactions*, daringly referred to her as "the ingenious and lively Mrs. Fulhame."[9] In her introduction to *View to a New Art*, she recalled that around 1780 she started exploring means of producing patterns on cloth by the deposition of gold and other metals, including through the action of light. The social climate for a woman researcher in the eighteenth century was bound to have a discouraging effect. Elizabeth Fulhame remarked acidly that

> censure is perhaps inevitable; for some are so ignorant that they grow sullen and silent, and are chilled with horror at the sight of anything, that bears the semblance of learning in whatever shape it may appear: and should the spectre appear in the shape of a woman, the pangs which they suffer are truly dismal.

She mentioned her process to Dr Fulhame and some friends, who at the time deemed it so highly improbable that she abandoned her efforts. But, in October 1793, she met Joseph Priestley in London, who "viewed the performance in a very different light." His enthusiasm rekindled her interest and so bolstered her confidence that by the following year she published her work. Mrs. Fulhame explored the reduction of metals by light and the consequent formation of images. Significantly for photography, she suggested making maps with rivers formed of silver by the action of light – they could then be readily seen. In London shortly after the publication of her book, Elizabeth Fulhame's husband was trying to promote a process for producing white lead, an important pigment then commonly made in Scotland. Dr Fulhame tried to sell this to the Board of Trade, but was completely unsuccessful in finding any support.[10] Mrs Fulhame lamented the fact that there was no British encouragement for science and for individual initiative like this:

> The British empire should not forget, that she owes her power and greatness to commerce ... and should not ... compel her bees to swarm for protection to foreign climes, but rather permit them to roam in their native soil, and allow them, in the winter of their life, to sip a little of the honey of their own industry.

This lack of support by the British nation would not turn around until a change of consciousness (and, more pointedly, a recognition of commercial realities) spawned the Great Exhibition in 1851. Dr Fulhame's perception of his plight was

AN

ESSAY

ON

COMBUSTION,

WITH A VIEW TO A

NEW ART

OF

DYING AND PAINTING.

WHEREIN

THE PHLOGISTIC AND ANTIPHLOGISTIC HYPOTHESES
ARE PROVED ERRONEOUS.

BY MRS. FULHAME.

LONDON:

PRINTED FOR THE AUTHOR,
BY J. COOPER, BOW STREET, COVENT GARDEN,
And Sold by J. JOHNSON, No. 72, St. Paul's Church Yard;
G. G. and J. ROBINSON, Paternoster Row; and
T. CADELL, Jun. and W. DAVIES, Strand.

1794.

[ENTERED AT STATIONERS HALL.]

13. Elizabeth Fulhame. Title page to *An Essay on Combustion 1794.* This was one of the first reference sources that Herschel thought of when photography was announced. The George Peabody Library of the Johns Hopkins University.

exactly that which Henry Talbot would face over photography in 1839. A lukewarm British response to his efforts would stand in stark contrast to the concerted and highly nationalistic French promotion given their own inventor.

The last known letter from Thomas Fulhame was written from Paris in July 1802, while he was courting the French but obviously still hoping for support from the British government.[11] The period was a very tumultuous one for the British in France and this might suggest why Mrs Fulhame has slipped into obscurity. In May 1803, Napoleon's infamous

arrêté led to the imprisonment of thousands of Britons, in many cases for more than a decade. Nothing further is known of Elizabeth Fulhame. Perhaps, like her husband, she was already in the 'winter of her life' by the time her book was published. However, her brilliant idea lived on in her book, which was cited repeatedly in the early nineteenth century.[12] Not all of these citations were buried in obscure scientific references. In 1811, *Ackermann's Repository* suggested that her "metallic reductions upon cloths, silks, satins, and muslins ... may be readily repeated by our fair readers."[13] Are pre-1839 'photographic' artifacts preserved, unidentified, in museum textile collections today?

By 1839, it is unlikely that Mrs Fulhame's work was remembered by the majority of the members of the Royal Society until Herschel called attention to it. In contrast, the name of another proto-photographer that he cited, Thomas Wedgwood, was almost certainly more familiar. In 1802, Wedgwood's friend, the young chemist Humphry (later Sir Humphry) Davy, then lecturing on chemistry at the Royal Institution, published a brief account of Wedgwood's quest to employ the camera obscura to take what we would now call photographic images. Lengthy exposure times defeated Wedgwood's efforts in the camera but he was able to make shadowgrams of leaves and other objects in a manner similar to that which was to be done later. Some were produced on white paper, others on white leather, but they remained susceptible to the action of light and could be viewed only by candlelight.[14]

Thomas Wedgwood should not be passed over too lightly; if one were to ever fully comprehend his situation, there might be an answer to the riddle of photography. The son of the famous potter, Josiah Wedgwood, he is usually portrayed as a sickly youth whose early death occurred before his process had any impact. While his weak constitution tragically shortened his life, Thomas Wedgwood as an intellectual exerted great influence on his peers.[15] His scientific prowess had been demonstrated at a very early age. In describing a proposed family portrait, Dr Erasmus Darwin said that "little Tom is to be jumping up, clapping his hands at the sight of some chemical experiments."[16] The senior Wedgwood's connection with the Lunar Society, an eclectic grouping of philosophical figures, justifies further examination of the son's influential contacts in science.[17] Joseph Priestley encouraged Thomas Wedgwood in 1792 that "there is nothing more within the field of random speculation, and less within that of experiment, than the subject of light and heat ... this I hope is a business reserved for you. It is ground unoccupied."[18]

Just as photography was to have a dual identity, shared between science and art, there was another side to Wedgwood, a poetic side, of equal importance to his scientific

attainments. This was most appealing to Humphry Davy.[19] Thomas Campbell described Wedgwood as "a strange and wonderful being. Full of goodness, benevolence, with a mind stored with ideas ... [he was] a man of wonderful talents, a tact of taste, acute beyond description – with even good-nature and mild manners...."[20] Samuel Taylor Coleridge, perhaps Wedgwood's closest friend, praised him as

"he who, beyond all other men known to me, added a fine and ever-wakeful sense of beauty to the most patient accuracy in experimental Philosophy ... he who united all the play and spring of fancy with the subtlest discrimination and an inexorable judgement...."[21]

William Wordsworth exclaimed that Thomas Wedgwood's "calm and dignified manner, united to his tall person and beautiful face, produced in me an impression of sublimity beyond what I have experienced from the appearance of any other human being."[22] Some of that sublimity undoubtedly stemmed from the powerful drugs in which he indulged. Chronically ill and unable to work in the pottery, Wedgwood was plunging into declining health by the time Davy persuaded him to publish his concept for photography.[23]

At the time his process was disclosed by Davy in 1802, Wedgwood was travelling extensively in an attempt to restore his health. A continental trip, originally planned with Coleridge, put Wedgwood instead in the company of the English watercolourist, geologist and chemist, Thomas Richard Underwood. Sketching along the way and sharing a mutual interest in chemistry, would not Wedgwood's approach to image making by light have been one topic? If so, did Underwood explore Wedgwood's process on his own? Although Underwood was soon to be caught up in Napoleon's *arrêté*, his connections with the French savants gave him an unusual degree of freedom. He spent most of his remaining years in France, and died there in 1836, before knowledge of photography became public.[24]

Though Thomas Wedgwood himself died in 1805, his idea did not die with him, and his process was republished in scientific journals and books many times and in various languages prior to 1839.[25] It could be argued that few artists (parlour or professional) would have had contact with such journals. But, as a group, they could not have all overlooked *Ackermann's Repository* in 1816. As it had with Mrs Fulhame's cloth, the popular journal promoted duplicating Wedgwood's pictures as a form of polite entertainment. In addition to copying simple drawings and making profiles, *Ackermann's* suggested the use of partly transparent objects such as insect's wings.[26] There is some indication that Wedgwood shared his process with other scientists. James Watt, replying in 1799 to a letter from Josiah Wedgwood (Thomas' older

14. William Henry Fox Talbot. *Leaf with serrated edge*. Photogenic drawing negative. Ca. 1839. Had Thomas Wedgwood been able to "fix" (make permanent) his early experiments, they would have retained a visual character very much like this example produced later by Henry Talbot. 7.8 × 10.1 cm. The National Museum of Photography Film and Television.

brother), said that "I thank you for your directions for the silver pictures, on which, when at home, I shall try some experiments."[27] Nothing is known about any attempts that Watt might have made. Sir Anthony Carlisle, the aging but respected surgeon, on seeing the initial display of photographs in 1839, was the first of many to raise Wedgwood's name, claiming that he himself

> about forty years ago, made several experiments with my lamented friend, Mr. Thomas Wedgewood [sic], to obtain and fix the shadows of objects by exposing the figures painted on glass, to fall upon a flat surface of shamoy leather wetted with nitrate of silver, and fixed in case made for a stuffed bird, we obtained a temporary image or copy of the figure, which, however, was soon obscured by the effects of light.[28]

We know of no pictures by Wedgwood extant today, but they would have been very similar to Talbot's earliest work and might easily be confused with the experimental productions of others. Some survived for a long time.[29] But they remained vulnerable to all but candlelight, for Wedgwood had failed to identify a fixer that would make them truly permanent. Davy was forced to conclude with the lament that "nothing but a method of preventing the unshaded parts of the delineation from being coloured by exposure to the day is wanting, to render the process as useful as it is elegant."[30] It is surprising that Davy, rapidly emerging

as a brilliant chemist, was unable to propose a solution. He weakly suggested that "some experiments on this subject have been imagined, and an account of them may possibly appear in a future number of the Journals."[31] It is likely that once his friend died, with Davy's responsibilities in other areas increasing, he simply did not renew the search for a fixer. It is also possible that he saw little value in Wedgwood's quest beyond its scientific cast. Lord Brougham had to admit that Humphry Davy, whom he otherwise admired, "was fond of poetry, and an ardent admirer of beauty in natural scenery. But of beauty in the arts he was nearly insensible. They used to say in Paris that on seeing the Louvre, he exclaimed that one of its statues was 'a beautiful stalactite'."[32]

It was John Herschel who was to discover the fixer that Wedgwood and Davy lacked. Chance launched him on a series of experiments on hyposulphurous acids.[33] These formed a family of compounds related to the modern photographic hypo, the fixer familiar to working photographers today. In 1819, two decades before the public announcement of photography, Herschel's results were published in a series of articles in the *Edinburgh Philosophical Journal*.[34] Herschel did not 'invent' hypo and never claimed to.[35] However, he was the first to explore its properties, especially those which would later prove useful to photography. Although the breadth of his reading should have encompassed some account of Wedgwood's problem, Herschel either did not remember it, or perhaps his imagination was not stimulated by it. By 1819, anyone else eager to advance on Wedgwood's start would have found a ready solution to the problem of permanency in Herschel's widely-known writings.

The key to solving Wedgwood's difficulty lay in the very nature of the photographic image. Wedgwood had exploited the light sensitivity of various salts of silver, notably silver chloride, but this approach was nothing new. Chemists had long been aware of these properties; on a popular level, they were commonly employed for amusement in compounding secret inks. Wedgwood, however, thought to harness these properties to record the different intensities of light that made up the image in the camera obscura. Lacking a sensitive enough coating, he instead turned to shadowgrams of objects such as leaves. Physically and conceptually this was the same as capturing a camera image (but instead of the quantity of light being restricted through a camera lens, the full force of the sunshine was available on the paper). However, even thorough washing did not remove the balance of the light sensitive salts, nor did a coating of varnish inhibit their reactions, and the print would darken inexorably on further exposure to light. It appears from their comments that Wedgwood and Davy had formed only a very rudimentary understanding of the actual physical and chemical structure

of the photographic image. They assumed that since the sensitive salts could not be washed out, that these had entered "into union with the animal or vegetable substance, so as to form with it an insoluble compound. And, supposing that this happens, it is not improbable, but that substances may be found capable of destroying this compound, either by simple or complicated affinities."[37] As Talbot was later to write for his book *The Pencil of Nature* (in a passage deleted before publication), "they grasped at the existence of such a path, but they did not succeed in finding it."[38] The problem was, in some respects, more simple than Wedgwood and Davy had thought. In making their images, light broke down the largely invisible silver compounds that had been spread on the paper. Where the light acted, these compounds were reduced to a fine deposit of metallic silver, its apparent color being established by the size of the grain clusters so formed. The silver compounds in the areas unaffected by light remained in their original state. Most of them (particularly those formed in complex reactions with the organic material) were not soluble in water and thus could not be removed by any amount of washing. The image itself was composed of pure silver, surrounded by a background of light sensitive silver compounds. What was necessary to render this image permanent was the application of something that would act differentially on the silver and the silver salts, neutralizing or removing the now-unnecessary compounds, while not affecting the metallic silver that comprised the image. Hypo proved to be such an elixir.

As much as the thought might offend modern sensibilities, the tongue was an important analytical tool in the early days of chemistry. Herschel was led to investigate the hypo salts after being surprised at the bitter taste of a solution that had been put away for a few days:

> I may venture to hope, that the following experiments, imperfect as they are, being made in the absence of most of the *conveniences* for chemical research, may possess some novelty as well as interest. Even to have verified a known fact, by independent observation, is something, as it gives an air of reality, and body to science: but such is the nature of chemistry, that it is next to impossible to pursue an independent train of investigation, without encountering some novelty worthy of being recorded.[39]

The bottle turned out to contain a solution of hyposulphites. Perhaps the most influential "novelty" stemming from this enquiry was the aspect that was later to make hypo effective as a photographic fixer: "One of the most singular characters of the hyposulphites, is the property their solutions possess of dissolving muriate of silver [silver chloride], and retaining it in considerable quantity in permanent solution."[40] It would have been difficult for an interested reader to have missed this

point, for Herschel repeated that "muriate of silver, newly precipitated, dissolves in this salt, when in a somewhat concentrated solution, in large quantity, and almost as readily as sugar in water."[41] This quality, combined with the fact that the hyposulphites remained soluble in water, ultimately resolved Wedgwood's unanswered problem. Hypo would dissolve the remaining silver compounds "as readily as sugar in water" whilst leaving the silver image untouched. They could, in turn, be freely washed out, carrying away the unstable matter, and isolating – thereby preserving – a permanent image. In a sense, it was like soap acting on grease, effectively making it soluble in water.

The extent to which Herschel demonstrated these properties of hypo to his colleagues is unknown, but an intriguing hint is contained in his personal diary for 1819. Herschel set off for Paris with Charles Babbage, and, on 18 January, went to the "Institut at 3 . . . introduced to Poisson & Laplace by Biot. Present at Institut: Laplace, Biot, Arago, Poisson, Legendre, Vauquelin (Pres^r), Cuvier, Berzelius, Gay Lussac, Thenard, Laroux, Fourier." Several of these men were the cornerstones of modern chemistry. Of particular interest are François Arago, who would become Daguerre's champion, and his rival Jean-Baptiste Biot, the French scientist who would emerge as Talbot's primary ally in that country. Partially obscuring this list of names in Herschel's diary is a brownish-black chemical stain, labelled "Hyposulphite of Silver."[42] To whom had he exhibited this compound (in an obviously spontaneous manner on a diary page), and for what reason?

There is absolutely no evidence that Herschel encountered Wedgwood's work prior to 1839. Even if he had, it is likely that his long-standing and comfortable mastery of a special drawing instrument would have undermined any interest in chemical imaging in the camera obscura. It seems likely that during the same 1816 visit to Sir William Watson's that decided his future in astronomy, Herschel also took up Wollaston's camera lucida. Apparently anticipating a dull stay, he had told Babbage in advance that he planned "to take my book or at least my pen, ink & paper with me and write all the time."[43] But writing could not have taken up all his time, for Herschel's earliest known camera lucida drawing dates from this visit.[44] Watson was an accomplished draughtsman himself. Was it from him, or was it from Wollaston two years earlier, that John Herschel got his tutelage in camera lucida drawing? Whatever the source, Wollaston's instrument meshed perfectly into Herschel's approach to nature. His draughtsman's skills had been highly developed since youth. He already understood the intricacies of light and shade, form and line, substance and space, that facilitated two-dimensional representation. Wollaston's prism did not distort nature. Perhaps most important of all, it encouraged the

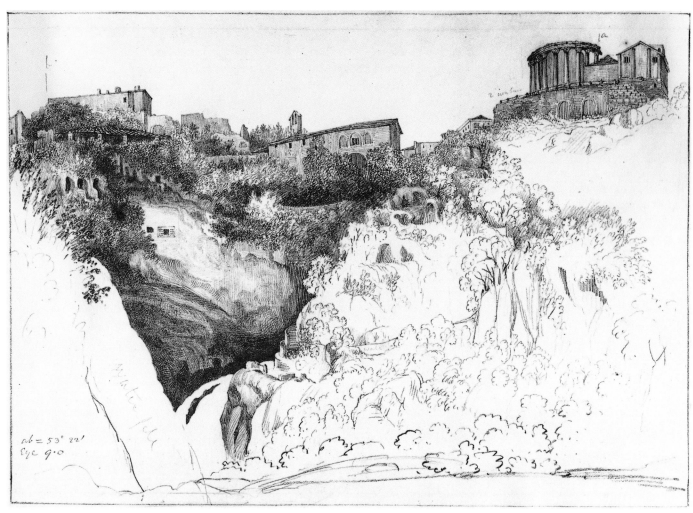

15. John Herschel. *Tivoli, principal fall and the Temple of Vesta.* Camera lucida drawing in pencil. August 1824. Herschel's analytical eye and facility with drawing stood him in good stead when recording his travels. This talent was in marked contrast to Henry Talbot's lack of draughtsman's skills. 21.7 × 31.0 cm. Courtesy of Ezra Mack.

tightly analytical observation that Herschel wished to do. John Herschel was to produce more camera lucida drawings – of higher quality and interest – than any other known individual.

As a drawing instrument, the camera lucida was little more than a small prism perched at the top of an adjustable brass stem. It was a brilliantly simple device (so simple, in fact, that its invention was inspired by a crack in Wollaston's shaving mirror).[46] The artist would mount the camera on his drawing board, looking down on the prism while adjusting the angle until nature's scene was reflected to his eye. By shifting the position of the eye very slightly to the edge of the prism, the drawing paper below would come into view. When the alignment was just right, part of the pupil would gather the reflected scene and part would see the paper.[47] Because of the proximity of the prism, these two images would fuse into one.

The world of the camera lucida is illusionistic. Nature's vista only <u>appeared</u> to be presented on the paper, allowing the artist to trace the outlines and forms. There is a lucidity, a lightness, about the image the camera lucida presents. The scene is at once vividly bright and ethereal, yet very real, and begs close examination. The lines, while delicate and accomplished in short segments, are formed with obvious confidence and authority. There is a truthfulness about the result, a fidelity to nature, that escapes the often mechanical impressions drawn with the aid of other optical instruments.

Wollaston's lens designs would be used by the first photographers and he had many links with the artistic community, yet his own artistic skills were undeveloped. This was a personal frustration and a professional failing as well. As Henry Talbot would find many years later, the ability to sketch nature's phenomena was an essential part of

the scientist's tool kit. A colleague recalled that around the year 1800, Wollaston gave up the practice of medicine and

a few months after we went together, with another friend, to the Lakes, the mountains, mines, and scenery of which furnished abundant food for thought. Geology, as a study, was at that time in its infancy, but with the forms, fashions, and contents of the hills he seemed already well acquainted. We could only take the outline of the districts, for neither of us could draw well, and we lamented our not being able to do so. Calling on him a few months afterward in town, I found him with a minute truncated and half-silvered prism fastened with sealing wax to a piece of wire. 'Look,' said he, 'here is the very thing we wanted at the Lakes;' and very soon came forth that elegant and very useful little instrument, the camera lucida.[48]

The camera lucida, in contrast to the murky room of the camera obscura, is a 'room of light.'[49] Wollaston's idea was fresh; like his laboratory on a tea tray, his camera lucida elegantly represented nature in a world in miniature. Compared to the camera obscura, the camera lucida was smaller and lighter, had no optical distortion, and took in a wider field of view. Wollaston's solid quadrilateral glass prism was a good choice; reflected twice, the image was kept in correct orientation. Mirror and lens surfaces are only partly efficient; the internal surfaces of a prism are virtually perfect reflectors, losing none of the light. Unlike the inescapable distorting effect of the curved surfaces of a lens, the flat surfaces of a prism kept the image inviolate. Objects at any distance were equally in focus. The effect of wide-angle or telephoto lenses could be achieved by simply changing the extension of the tube.[50]

The influence of the camera lucida is very little recognized today and is perhaps best known through the writings of Herschel's friend, Captain Basil Hall, a man whom Sir Walter Scott described as "that curious fellow, who takes charge of everyone's business without neglecting his own,"[51] and who Herschel himself respected as being "distinguished for the extent and variety of his attainments."[52] A Fellow of the Royal Society, Hall came from a noteworthy Scottish family. His father, Sir James Hall, was a prime supporter of James Hutton's theories of the formation of the earth, theories that were to influence deeply John Herschel in his travels. Marrying only after a distinguished naval career, Hall became an author and professional traveller. In his travels, he found camera lucida drawings invaluable in that "as far as they go they are correct, & this is a great point – for though what is given be very limited – there is nothing erroneous & this circumstance I observe always gives more or less an appearance of truth to the very slightest jotting with the instrument."[53] His enthusiasm with it stemmed from

the accuracy which belongs to all its delineations, and which is quite consistent with the most perfect freedom of execution in the hands of those who possess taste or capacity to represent nature with spirit. Its chief advantage, however, lies in the power it confers on a person like myself, who knows little of drawing, who cannot, by any degree of effort, represent a complicated object correctly without this instrument, and to whom, though the rules of linear perspective are more or less familiar, the labour of applying them in a sketch is to the last degree irksome and discouraging. The use of the camera in such hands is a real source of pleasure, and its results may often be useful.[54]

Captain Basil Hall's introduction to his book about camera lucida drawing in North America was the most passionate defense of the instrument:

with his Sketch Book in one pocket, the Camera Lucida in the other ... the amateur may rove where he pleases, possessed of a magical secret for recording the features of Nature with ease and fidelity, however complex they may be, while he is happily exempted from the triple misery of Perspective, Proportion, and Form, – all responsibility respecting these being thus taken off his hands. In short, if Dr Wollaston, by this invention, [has] not actually discovered a Royal Road to Drawing, he has at least succeeded in Macadamising the way already known.[55]

It is from Basil Hall that we learn that Herschel came to favor a new form of camera lucida designed by the Italian optician, Giovan Battista Amici.[56] In his own experience with Wollaston's instrument, Amici observed that the draughts-man was forced to view the image through one medium (the glass prism) and the paper through a different one (air). The eye had to fuse these two disparate images by critical placement right on the edge of the prism. In 1819, Amici announced several versions of a new design that circum-vented this problem.[57] The prism was cemented to a plate of glass fabricated with perfectly parallel surfaces.[58] The eye, comfortably aligned over a broad slit, looked through this glass to see both the paper and the reflected image of nature.[59]

Later in the century, Eliza Savage confronted the novelist Samuel Butler with the poetic question:

Lucidity, lucidity
We seek it with avidity.
Has a camera lucida anything to do with lucidity?[60]

The answer for many artists would have been an emphatic NO![61] Frustration with the camera lucida was a widespread reaction amongst artists – a remark by John Ruskin illustrates the remoteness of the device: "I more and more

wonder that ever anybody had any affection for *me*. I thought they might as well have got fond of a camera-lucida."[62] Butler himself purchased a camera lucida in Paris and on his next journey "brought back many more sketches than usual because he drew with the camera lucida, but it distorted the perspective and had to be given up.'[63]

Unlike the bulkier camera obscura, whose curved lens surfaces inevitably distorted nature, the flat prism of the camera lucida transmitted it without change. But this was not always what the artist expected. Strict adherence to proportion and perspective was all-important to Herschel; he would have recoiled in horror at the thought that man's truth could somehow exceed nature's. Contemporary reactions to the images of the camera lucida are important indicators of what photography itself was to face. Once photography was invented, Talbot would be forced to comment to Herschel that it was "a pity that artists should object to the convergence of vertical parallel lines since it is founded in nature and only violates the conventional rules of Art" (this is the pyramid effect that tall buildings assume when we point a camera up to take in their top).[64] Seeing his nephew's early productions from a camera, William Fox-Strangways complained to Henry that "I wish you could continue to mend Nature's perspective – we draw objects standing up & she draws them lying down which requires a correction of the eye or mind in looking at the drawing."[65] Talbot's friend and supporter, Sir David Brewster, would observe that "the photograph will differ considerably from any sketch which the artist may have himself made, owing to certain optical illusions to which his eye is subject. The hills and other vertical lines in the distance will be lower in the photograph than in his sketch." Long before photography, however, the same objection was raised to the camera lucida's literal translation of truth. Brewster recalled that

> Sir Francis Chantrey, the celebrated sculptor, shewed me, many years ago, a Sketch-Book, containing numerous drawings which he had made with the camera lucida, while travelling from London to Edinburgh by the Lakes. He pointed out to me the flatness, or rather lowness, of hills, which to his own eye appeared much higher, but which, notwithstanding, gave to him the idea of a greater elevation. In order to put this opinion to the test of experiment, I had drawings made by a skilful artist of the three Eildon hills opposite my residence on the Tweed, and was surprised to obtain, by comparing them with their true perspective outlines, a striking confirmation of the observation made by Sir Francis Chantrey.[66]

This phenomenon – the reality rather than the appearance of nature – confronted others who enlisted the aid of the camera lucida. *The Athenaeum* explained that

there is another consideration, connected with the principles of aerial perspective, which should direct the artist in the use of this, or any other mechanical contrivance. It frequently happens, that in attempting to draw an extended view with the Camera Lucida, we are surprised at the smallness of the distant objects; neither can we, by any care in the colouring, give them the importance they assume in nature. Now this shows that the instrument was misapplied, and that we should have done much better without it. Yet the representation is perspectively correct; there is, perhaps, no object in the foreground preposterously large;– then how can anything be wrong? The fault results from the limited means of art, compared with nature. . . . Had the distant parts been drawn larger with respect to the whole picture, it would have been more faithful to the effect of nature, and not have exhibited so strikingly the defects of an imperfect art.[67]

In spite of its trickiness, Sir David Brewster declared that by 1831 the camera lucida "had come into very general use for drawing landscapes, delineating objects of natural history, and copying and reducing drawings."[68] Perhaps this came from his Scottish perceptions, for an inexplicably high proportion of those who publicly confessed to its use were, like Hall, Scottish.[69] Yet, known collections of camera lucida drawings like Herschel's and Basil Hall's are very rare, partially because we do not recognize them, and partially because some artists actively concealed their use of the tool.

Even while the camera lucida was quietly serving the artistic community, the camera obscura was being turned towards photography. With the possible exception of Daguerre himself (whose actual process remained a secret at the time of Herschel's Royal Society paper in early 1839), the most significant contributor Herschel cited was Joseph Nicéphore Niépce, another Frenchman.[70] Niépce's hastily-arranged trip to Britain in 1827 was made out of concern for his brother Claude, who had been attempting to find a market for their internal combustion engine, but who was very ill and increasingly irrational in the letters he wrote home. Nicéphore also took advantage of this trip to try to find a patron for his process of *héliographie* – a means of producing images on sheets of pewter through the action of light. Niépce dissolved bitumen in a solvent, flowed this onto a metal plate, and once dry, exposed the plate to light. In a camera, after an exposure of some hours, the light would harden the bitumen. By flowing on a solvent, Niépce could remove the unhardened portions, resulting in an image created in the pattern of the light. It is not entirely clear what Niépce was trying to accomplish. His images could be viewed directly or used as a basis for a printing plate. Was his end goal more related to

printing or to what we came to know as photography? At least during his sojourn in England, Niépce cast héliographie in the context of the production of a printing plate. Either way, his process should have attracted attention. The age was one of growing scientific interest, the industrial revolution was going into its second great phase where utilitarian processes such as this would be more and more appreciated, and there was a well organized scientific society ready to receive new ideas. Niépce seemingly did all the right things – and yet failed.

Most likely in order to be near his brother, resident in Hammersmith, Niépce stayed at Kew, then a lively Thames village remote from London. When Niépce arrived at Kew he first approached William Townsend Aiton, Director of the Botanic Gardens. Aiton, a close friend of King George III, had maintained useful royal connections, and owned significant collections of paintings and drawings. Aiton took Niépce's idea to the king and it seems likely that Niépce's plates were exhibited at the Royal Court (although evidence to confirm such an exhibit has yet to be found). Niépce turned to Franz Bauer, the famous Austrian-born illustrator at Kew, as a translator. Bauer was the finest botanical illustrator of his day and was known for preserving exact scientific detail in highly artistic productions. Bauer became close friends with Niépce and was to be his greatest champion. And it was through Bauer, as a Fellow of the Royal Society, that Niépce began to meet other members of that body.

Two manuscripts in Niépce's hand, both dated 8 December 1827, have been generally accepted as an attempt on his part to make a formal presentation to the Royal Society.[71] Supposedly, these were rejected by the Society because Niépce would not share the secret of how he produced his plates. This is not entirely correct, although elements of it may be. One would expect the Royal Society to take a great deal of interest in his paper. Sir Humphry Davy (who had presented Wedgwood's researches in 1802) was its president. The brilliant and eccentric Dr Thomas Young was the Foreign Secretary; in 1802, Young was co-editor with Davy of the *Journals of the Royal Institution*. It seems likely that he was inspired by Wedgwood's article, for in 1803, Young employed light sensitive silver chloride to reproduce rings in the solar microscope (but with no desire to make them permanent).[72] William Hyde Wollaston, a vice president, devised both the camera lucida that was to inspire Talbot to invent photography and the camera obscura lenses that most photographers would come to use. In 1804, Wollaston's experiments on the light sensitivity of various compounds, notably gum guaiacum, were published.[73] John Herschel himself was Secretary, and should have been keenly interested in Niépce's process.

Yet Niépce's efforts failed so thoroughly that by 1839 he

was a virtual unknown. Why did photography not take root in 1827? The fault was hardly with the French inventor. The Royal Society, embroiled in the throes of a serious political crisis, was effectively paralysed by in-fighting. The venerable Sir Humphry was critically ill and barely functioning as president; Herschel sarcastically recorded in his diary that when he had "dined at Sir H Davy's . . . more good things were eaten than said."[74] Bitter arguments over Davy's successor came down to the possibility that either a social appointee or a scientist would become president (in the end, the king's brother won). There was a lot of politicking within the Society and the press carried persistent allegations over squandered money.[75] The Papers Committee, who would have been charged with appraising Niépce's December 1827 paper, did not even meet between summer 1827 and spring 1828; there is no way that they could have formally considered the paper at the time it was written.[76] It is unlikely that Wollaston would have actually rejected the paper (as he was posthumously accused of doing). Extremely ill and acutely aware of his impending death, Wollaston was frantically trying to get his own voluminous collection of papers in order.[77] Rather than opposing Niépce, it is more likely that Wollaston simply did not have time to consider Niépce's work in detail (and may well have not seen it at all).

The manuscripts' dating on 8 December, a Saturday, possibly provides a clue. The Royal Society did not meet on Saturdays but in a retrospective account of another of their vice-presidents, an early historian of Kew recalled "the best days of Sir Evrard Home, who . . . used to meet here, almost every Saturday, at Mr. Bauer's, many of the eminent men of the day, for purposes connected with Botany and other branches of Natural Philosophy, and a friendly and social intercourse."[78] It seems most likely that Niépce's paper was presented at Kew to Sir Evrard Home's local group (which would have included Fellows). The anecdote about Niépce's paper being presented to the Society most likely evolved from this meeting, the story getting its start in 1840 with Home's son, who said that "Mr. Niépce wished the King to see his work, which he did as well as Dr Wollaston, but the Royal Society could not enter into the merits of the thing as there was a secret in the case which Mr. N. would not divulge."[79] What the younger Home was probably recalling was that the Royal Society could not be in the position of endorsing to the king a process that remained a secret to them. They still had mechanisms for reading and publishing the paper, even with the secret. After all, the same group was to accept the reading of Talbot's first paper on photography in 1839 before he was prepared to disclose his manipulatory secrets. In any case, they could not as a group endorse anything; the preface to each issue of the *Philosophical Transactions* emphasized that "it is an established rule of the Society, to which they will always

16. Anonymous. *Talbot family member? sketching with a camera lucida.* This pencil drawing appears in a scrapbook compiled in 1826 by Emma Thomasina Talbot, Henry's cousin. Henry Talbot had many visual influences right around him; family members and family friends had artistic accomplishments that seemed to have eluded him before photography. Emma later married John Dillwyn Llewelyn and they, their daughter Thereza, and her husband, Nevil Story-Maskelyne, all became active in photography. 10.7 × 8.6 cm. Private Collection, Britain.

adhere, never to give their opinion, as a Body, upon any subject, either of Nature or Art, that comes before them."[80]

Prior to his departure from Britain in 1828, Niépce approached a wide range of people and institutions, including the Society of Arts, where he tried to reach Doctor Joseph Constantine Carpue. Carpue was so interested in natural representation that he once obtained a corpse and nailed it to a cross in order to judge the accuracy of a Michelangelo.[81] Had Niépce succeeded in his approach to the Society of Arts through Carpue, the record of it should have passed on to the then Photographic Society (and hence to the present Royal Photographic Society Archives). Niépce's major failing seems to have been exceptionally unlucky timing. Sir Humphry Davy finally resigned as president; both he and Dr Wollaston were to die shortly after Niépce's trip to Britain. There are

few personal records of the life of Dr Young; whatever he knew about Niépce is unknown and he died before the question of photography's history came up. Sir Evrard Home, who died in 1832, owned one of Niépce's plates and was probably the host to Niépce's presentation; as such, he could have been expected to have possessed the best records. Unfortunately, soon after his death, it emerged that he had plagiarized virtually all his scientific writings from the notes of his father-in-law, John Hunter. To put an end to the controversy, Home's son burnt all of his collections and papers, again before photography became of public interest.

Henry Talbot appears not to have been in London during the time that Niépce was making the rounds; also, he was not yet a Fellow of the Royal Society and may not have heard anything anyway.[82] But what of John Herschel? As Secretary of the Royal Society, he should have heard of Niépce's work and should have been fascinated by it. However, by 1827 there were unmistakable signs that Herschel, a true scientist, was growing increasingly impatient with the political machinations within the Royal society. By the time Niépce arrived, Herschel had already tendered his resignation as Secretary and was doing all he could to avoid contact with the Society or anyone else in London. Herschel's departure from the urban community was hastened by the overwhelming personal difficulties suffered by his longtime friend, Charles Babbage. First, one of Babbage's children died, and then his dear wife Georgiana began to sicken. As soon as Georgiana passed away, Herschel hustled Babbage off to Ireland for the month of September, taking camera lucida drawings of scientific activities and of objects of interest along the way.[83] Herschel returned to Slough after a month in Ireland and officially resigned as Secretary of the Royal Society. Had Herschel been in London that winter, it is almost certain that he would have taken an active interest in Niépce's work. Herschel was completing his monumental treatise on light in December 1827; that he brushed so closely with photography is indicated in his casual statement that "it has long been a matter of everyday observation, that solar light exercises a peculiar influence in altering the colours of bodies exposed to it . . . especially those of silver [which are] speedily blackened and reduced when freely exposed to direct sunshine. . . ."[84] But Herschel's withdrawal from scientific organizations was complete. Telling Babbage in no uncertain terms that he was sick of the life of a "savant by profession," Herschel explained that he had "given up my residence in Town and shall in future reside only in Slough. . . ."[85]

Prior to his own death in 1833, Niépce had taken on as partner, Louis Jacques Mandé Daguerre. Likewise attempting to capture the images of the camera obscura, Daguerre was very dependent on Niépce's success, if for no other reason

17. Joseph Nicéphore Niépce. *Heliographic copy of a print.* 1827. "From a print of about 2½ feet long." Preserved by Franz Bauer, this primitive photograph, actually a photomechanical printing plate, was brought to England in 1827. Niépce's work, however, remained largely unknown until 1839. This pewter plate was copied from a lithograph of a stage set for "Elodie," by Louis Jacques Mandé Daguerre, the inventor later to be Talbot's rival. 13.5 × 16.5 cm. The Royal Photographic Society.

than to confirm that his quest was not insane (a possibility that quite concerned Mrs Daguerre).[86] The mere fact that Niépce could exhibit successful plates at once proved the validity of Daguerre's quest and must have been an important encouragement in keeping him going.

It happened to be in the year of Niépce's death, 1833, that Henry Talbot first conceived of photography. In spite of the voluminous documentation on many aspects of Talbot's life and work, there are virtually no manuscript sources known that bear on this critical juncture. Perhaps there are no documents for which to search. Just ten years later, in the introduction to his seminal work, *The Pencil of Nature*, Talbot signalled that he had no definite record to refer to, and was stretching his memory: "such were, as nearly as I can now remember, the reflections which led me to the invention of this theory, and which first impelled me to explore a path so deeply hidden among nature's secrets." Talbot invited – indeed, encouraged – the possibility that the foundation of his invention was more complex than even he understood, admitting freely that "whether it had ever occurred to me before amid floating philosophic visions, I know not, though I rather think it must have done so, because on this occasion it struck me so forcibly." Even Humphry Davy, introducing his chemical lectures at the time of Wedgwood's publication, pointed out that "the future is composed merely of images of the past. . . ."[87]

What were Talbot's "floating philosophic visions?" It seems likely that at least one was provided by his friend, John Herschel. In 1831, Herschel demonstrated the ability of platinum salts to form a simple image under the influence of light. Further, in publishing this experiment a year later, Herschel not only cited Talbot as a witness, but also pointed out the property of hyposulphites of dissolving the unreduced salts of silver, an attribute which was the critical basis of a suitable photographic fixer. The circumstances of Herschel's discoveries about the light sensitivity of platinum salts were typical of his approach; echoing Newton, Herschel once confessed that he was content to "loiter on the shores of the ocean of sciences and pick up such shells and pebbles as take my fancy for the pleasure of arranging them and seeing them look pretty."[88] In March 1831, he recorded that "a metal labelled 'platina mixture' was found among my Father's old speculum specimens . . . by trial I found it contained a good deal of Platina. . . ."[89] Herschel's "first love" of light, as well as his pet chemicals, the hyposulphites, were among his standard analytical tools. It was natural for him to bring them both to bear on the curious mixture.

Charles Babbage happened to host a breakfast gathering at just the time Herschel was engaged in these experiments. Prompted by the impending visit of the prominent Scottish scientist, Sir David Brewster, this meeting gave Babbage the excuse to gather together a circle of friends and to show off the latest progress on his calculating machine. John Herschel was delighted at the prospect of sharing new discoveries with old friends; in his acceptance note to Babbage, he added that "3 days ago I fell on a most striking instance of the effect of violet light in producing a chemical compound of a singular nature – a <u>platinate of lime</u> which I mention to you that you may remind me to tell B. of it."[90] Herschel's "platinate of lime" (calcium chloroplatinate) was a compound quite similar to that which was later used in commercial platinum printing. Herschel's notebook entries and sketches clearly show that he was letting light make simple patterns in the test-tube solutions by masking areas with opaque paper.[91]

On Sunday, 26 June 1831, the group met and Herschel recorded in his diary that he "Breakfasted at Babbage's – Brewster – Talbot – Drinkwater – Robt Brown."[92] This informal gathering of friends might have been forgotten had it had not been for a French researcher's publication a year later of an experiment remarkably similar to what Herschel had demonstrated at Babbage's.[93] Herschel, in Hamburg, quickly dispatched a letter to Dr Charles Daubeny, chairman of the chemical section of the BAAS, who read it at the meeting in Oxford in 1832. Herschel's sudden need to establish his separate priority of invention presaged what Talbot would later face in Daguerre's announcement. Herschel's letter was summarized in Brewster's *Philosophical Magazine* under the

18. John Herschel. *Research notes.* In March and April of 1831, Herschel conducted a series of experiments on the action of light on platinum salts. In addition to using flower juices as color filters, he used light to make rudimentary patterns on the surface of a solution. These experiments were demonstrated to Henry Talbot at the time. The Science Museum Library, London.

title of "On the Action of Light in Determining the Precipitation of Muriate of Platinum by Lime-water:"

> when a solution of platinum in nitro-muriatic acid ... is mixed with lime-water, in the dark, no precipitation to any considerable extent takes place.... But if the mixture ... is exposed to sunshine, it instantly becomes milky, and a copious formation of a white precipitate ... takes place ... the same takes place more slowly in cloudy sunlight.[94]

Herschel's father had earlier investigated the varying properties of different parts of the spectrum. In several communications to the Royal Society in 1800 and 1801, William Herschel had expounded on the properties of the infra-red rays.[95] They behaved very similarly to light but they could not be seen. Their heat could be detected, however, and now his son found that they could effect other physical changes as well.

> This remarkable action is confined to the violet end of the spectrum. I have exposed tubes of the mixed liquids immersed in the sulphuric tincture of red rose-leaves, to strong sunshine for whole days, and [it is] ... altogether insensible to red light; but the moment it is taken out of the red liquor and held in free sunshine, the usual precipitation takes place as copiously as if it had been all the time kept in total darkness. Even yellow liquids suffice to defend it.[96]

Herschel had been interested for some time in the coloring matter extracted from flowers. In 1842, he would publish numerous photographic processes based on their light sensitivity; here, however, the dyes merely served as convenient color filters. He found the light-caused precipitate a "remarkable one" and was able to modify it in several ways. In exploring this solution, Herschel reminded his readers of a property that could have solved the earlier lament of Wedgwood and Davy for the lack of a fixer: "the precipitate ... a true platinate of silver, is easily distinguished from muriate of silver ... by its insolubility in the liquid hyposulphites."[97] Finally, since this letter was primarily designed by Herschel to defend his claims to priority, he called into testimony a number of scientific figures.

> The above facts were observed by me nearly two years ago, and have been shown by me to a great many individuals at various times in the interval; among whom I may mention ... Sir D. Brewster, Mr. Babbage, Mr. Talbot, and others, in London, last summer.... I mention these circumstances merely as ascertaining my early and independent observation of a fact which, at the time of its discovery, I considered to be sui generis, and which I cannot regard as of slight importance either in a photological or chemical point of view.[98]

This and other chemical efforts faded from Herschel's immediate interest as he began planning an extended astronomical expedition to the Cape of Good Hope. Talbot wrote to Herschel on 4 March 1833, that he had heard the rumor that Herschel was departing for the Cape, and added,

> I saw a very pretty experiment last Friday at the Royal Institution by which it is demonstrated that the electric spark is never continuous, however close the bodies are between which the sparks pass; but that on the contrary galvanic electricity gives a continuous discharge. This has brought to my mind a train of experiments which I formerly executed, attended with interesting results, one of which astonished me much when I first beheld it. It is a method of rendering the image of a body which is in the most rapid motion entirely fixed, so that you can see what happens to it under such circumstances, with as much ease as if it were at rest.[99]

Talbot went on to confess that "I don't know why I have suffered these experiments to slumber in my portfolio for seven years; but I am now thinking of presenting them in the form of a short paper to the Royal Society." It was this procrastination, this failure to publicly record what he had discovered, that would prove so devastating to Talbot when he was superceded in the announcement of the art of photography. In Herschel's reply of 7 March 1833, he

confirmed his Cape plans and hoped that they could keep in regular communication: "In my banishment (for though self-inflicted it will still be to a certain extent an exile) I shall feel much gratified by hearing from time to time of any of your proceedings. . . ." Herschel was particularly encouraging about Talbot's experiments in physical optics, observing that he was "aware you are in possession of a number of curious & interesting things in optical science and taking on every branch of that subject views of no ordinary kind. . . ." Herschel said that he had often wondered that Talbot

> should not have embodied them in some more impressive & permanent form than you have hitherto thought it worth while to do. I am very glad therefore that you entertain the idea of communicating some of them to the R.S. in the form of a paper, and I hope when you have fairly begun doing so you will not leave off till you have added to our knowledge by a large stock of new facts and to our philosophy by a copious disclosure of principles.[100]

Talbot replied on 9 March, offering that he would "be most happy to send you, during your residence at the Cape, not only whatever little contributions I may have the good fortune to make to the cause of science, but any other publications on the these subjects which you may wish to have. . . ." He added that

> I almost envy you your intended residence in South Africa, which possesses I am told serene skies & a wholesome climate. It is moreover a most favoured country with respect to its vegetable productions, and botany is a science to which I am particularly attracted. . . . I almost think of troubling you with a request that through your means I may be enabled to employ some gardener or labouring man of intelligence in collecting seeds and roots in different parts of the Colony which I may afterward hope to see flourishing in my greenhouse in Wiltshire.[101]

Herschel replied on 25 March that "I shall be very happy to be useful to you in the way you mention at the Cape provided you will give me full instructions what to do being myself entirely without judgment in all matters relating to the vegetable world." This was hardly true, but Herschel also responded warmly to Talbot's offer to send packages of scientific papers. Herschel's offhand comment that "I do not know whether you are chemically disposed – if so the process for the purification of uranium annexed may interest you," led to Talbot's oft-quoted reply in a letter of 27 March that "I am not much of a chemist, but sometimes amuse myself with experiments."[102] The pace of preparation for Herschel's trip was picking up. On 30 May, he wrote Talbot a brief and suggestive note about optics, apologizing that "I write in a hurry as I am now unfortunately compelled to do everything

– my days & hours being numbered and more pressing on me than I can accomplish."[103]

Talbot left for the continent on 21 June and was still out of the country when Herschel departed for South Africa in November. As the fates would have it, this was the very period in which Talbot made the imaginative leap to conceiving the art of photography. Only a matter of weeks separated the last communication between the two friends and the birth of this idea, an idea that they almost certainly would have shared with excitement. Later, Henry Talbot himself had difficulty reconstructing exactly how his invention of photography was born. Perhaps some of this confusion can be traced to great changes in his personal life. On 20 December 1832, after a long period of floundering, Talbot married Constance Mundy. Ten days before this he had been elected to the House of Commons. In this era of the Reform Bill, Parliamentary matters were so pressing that it wasn't until the following summer that the couple was able to escape on what amounted to a delayed honeymoon. It was during this trip that the idea of photography came about:

> One of the first days of the month of October 1833, I was amusing myself on the lovely shores of the Lake of Como in Italy, taking sketches with Wollaston's Camera Lucida, or rather I should say, attempting to take them: but with the smallest possible amount of success. For when the eye was removed from the prism – in which all looked beautiful – I found that the faithless pencil had only left traces on the paper melancholy to behold.[104]

This was certainly not his first exposure to the camera lucida. He had owned one since at least 1822, but this time Henry's embarrassment at his failure was perhaps intensified by the group situation in which he found himself.[105] As was typical of their times and station, the various members of the extended Talbot family ranged across the continent, going their separate ways at times, then periodically reassembling. It was in the context of a lively family gathering that the art of photography was conceived. Caroline and her husband, Lord Valletort, joined the Talbots. Her letter of 8 October suggests the social climate under which Henry operated:

> L^d V. joined me yesterday = while he went to the Villa Serbelloni, with which he was enchanted, we sketched at Bellagio & visited afterwards the Villa Sommariva – this morning wandered about a delightful mountain above the house, covered with Chestnuts, vines, figs & olives. Alas! we are just off, the moment the steamboat arrives from Domaso – but one cannot <u>always</u> stay here. <u>They</u> go tomorrow to Lugano for letters, via Milan – tomorrow we go <u>there</u> from Como.[106]

Talbot kept a tiny travel diary in which he recorded in

19. William Henry Fox Talbot. *Villa Melzi*. Camera lucida drawing in pencil. 5 October 1833. Compared with the drawings made by his wife and sister, Henry Talbot found that the "faithless pencil had only left traces on the paper melancholy to behold." It is possible that in the course of making this particular drawing, the inspiration to harness nature as his drawing mistress – to invent photography – came to him. 14.2 × 21.9 cm. The Science Museum, London.

skeletal form his day to day movements.[107] It also contained a scattering of brief observations on local customs and scientific matters but no explicit account of his thinking. September and early October were spent travelling about the towns of Lake Como, an area Talbot had visited before with Captain Feilding and his mother.[108] Like many a British traveller before and since, much of his travel was centered around the picturesque lakeside resort village of Bellagio, and it was in this area that Talbot found himself in the first days of October. After again meeting up with Henry and Constance, Caroline wrote to her mother that "the latter part of the time they were here, I entirely gave up to drawing...."[109] A handful (perhaps nearly the full output?) of Henry Talbot's camera lucida drawings survive.[110] Most of these carry little or no inscription but some can be related to locations in his diary. A few, such as the one labelled *Villa Melzi, 5ᵗʰ Octʳ 1833*, seem to emerge as having been more important to Talbot. If one considers the assessment of the struggling artist, it could indeed be regarded as "melancholy to behold." Was this the frustrating drawing that inspired the invention of photography? Everything fits. The subject was attractive and stimulating. Caroline had arrived that morning from Como, undoubtedly with sketchbook in hand: "we spent that day entirely at the Villa Melzi & Serbelloni."[111] Constance created a virtually identical – but far more accomplished – view of the same scene as her husband, probably at the same time.[112] Unless his ego departed substantially from that of other men of the period, Talbot's melancholy must have been

intensified by his young wife's easy mastery of the camera lucida. Lady Elisabeth's skill in drawing would also have been in mind. However, the idea for photography must have been Henry's alone, and quite possibly one he kept to himself at the time. Only nine years later, visiting Giovan Amici, Caroline would write to ask Henry to "pray send him the account of the original discovery, as amongst us all we have contrived to forget it."[113]

A decade before his fateful 1833 trip, Talbot had attempted to use the camera obscura for drawing. He had approached the instrument with great enthusiasm, and his cousin Charlotte wrote to him that "I hope you will take a great many sketches in your camera obscura, particularly if you go to Corsica as I have never seen any views of that island though I believe it is very pretty."[114] However, recalling this period in his *Pencil of Nature*, Henry Talbot confessed that he found the camera obscura

> in practice somewhat difficult to manage, because the pressure of the hand and pencil upon the paper tends to shake and displace the instrument (insecurely fixed, in all probability, while taking a hasty sketch by a roadside, or out of an inn window); and if the instrument is once deranged, it is most difficult to get it back again, so as to point truly in its former direction.

Perhaps some of Talbot's difficulties stemmed from poor eyesight. His son later remembered that "my father was almost blind of one eye, so that he could not see a stereoscopic effect."[115] Even though Talbot was capable of precise hand manipulations in his research (amply demonstrated in his optical work), he had not mastered the graphic tricks and conventions that expedited sketching.[116] The more formidable problem, however, remained the lack of the analytical and reductive abilities so essential to draughtsmanship. Talbot had yet to train his mind to understand the essential components of what he was seeing and it was this lack of discipline that was at the base of his difficulty. About the camera lucida, he said that "there is another objection, namely, that it baffles the skill and patience of the amateur to trace all the minute details visible on the paper; so that, in fact, he carries away with him little beyond a mere souvenir of the scene...."[117] A writer in *The Athenaeum* was forthright in his assessment, addressing Henry Talbot's problem directly:

> such means are like the railing of a road; they may keep the active traveller on the right course, but they cannot make the lame walk. Let not any one imagine that he can learn to draw, merely by purchasing a Camera Lucida; he might as soon learn music, by merely buying a fiddle.[118]

Whatever Henry Talbot may have lacked in artistic training was at least partially offset by a fertile imagination.

He perceived (incorrectly) that his basic problem with drawing was the inability to record all the minute details presented to him. In fact, he was baffled by too many. Defeated with the camera lucida, which shared its intimate image only with his eye, Talbot turned to the camera obscura, which actually projected an image onto an external surface:

> and this led me to reflect on the inimitable beauty of the pictures of nature's painting which the glass lens of the Camera throws upon the paper in its focus – fairy pictures, creations of a moment, and destined as rapidly to fade away. It was during these thoughts that the idea occurred to me ... how charming it would be if it were possible to cause these natural images to imprint themselves durably, and remain fixed upon the paper![119]

Talbot immediately grasped the physical basis of what would become the art of photography:

> the picture, divested of the ideas which accompany it, and considered only in its ultimate nature, is but a succession or variety of stronger lights thrown upon one part of the paper, and of deeper shadows on another. Now Light, where it exists, can exert an action, and, in certain circumstances, does exert one sufficient to cause changes in material bodies. Suppose, then, such an action could be exerted on the paper; and suppose the paper could be visibly changed by it. In that case surely some effect must result having a general resemblance to the cause which produced it: so that the variegated scene of light and shade might leave its image or impression behind, stronger or weaker on different parts of the paper according to the strength or weakness of the light which had acted there.

There is nothing in Talbot's writings to suggest that he held any embryonic concepts of photography in 1831, either before or immediately after Herschel's demonstration at Babbage's of the image formed by light-sensitive platinum salts. However, two years later, when Talbot had his revelation on the shores of Lake Como, would he not have considered Herschel's experiment, performed not so long ago and in his presence, its memory reinforced in the last year by the use of Talbot's own name in print? Or wouldn't the experiment at least have formed part of a subconscious "floating philosophical vision?" But at the time of this thought, Talbot was

> a wanderer in classic Italy, and, of course, unable to commence an inquiry of so much difficulty: but, lest the thought should again escape me between that time and my return to England, I made a careful note of it in writing, and also of such experiments as I thought would be most likely to realize it, if it were possible. And since, according to chemical writers, the nitrate of silver is a substance peculiarly sensitive to the action of light, I resolved to make a trial of it, in the first instance, whenever occasion permitted on my return to England.

Thus was his memory in the introduction to *The Pencil of Nature*. Talbot's "careful note" has never been traced and quite possibly had not even survived the decade until Talbot wrote his *Pencil*. There is a tidiness to this tale of discovery that might raise suspicion. Undoubtedly there were elements of the story that Talbot himself did not retain and there may well have been influences on him that he never even recognized. Perhaps new evidence will emerge some day. However, nothing has been discovered to date that seriously undermines the public version given by Henry Talbot, and it seems reasonable to regard his account as essentially true.

Henry and Constance arrived back at Lacock on 11 January 1834, and he immediately plunged into scientific activity. Within three months, Talbot had published two articles on various optical topics. By the start of summer, he reported on his "Experiments on Light" to the Royal Society, including his invention of the polarizing microscope.[120] At some point in the spring, as winter was shaken off and the light grew stronger, Talbot began a series of experiments to try to harness nature as his drawing mistress. One of the few relevant documents for this period is a very miscellaneous notebook in which he jotted various ideas. The front pastedown, in Talbot's hand, is simply inscribed "1834 May."[121] Immediately above a note dated 4 May, Talbot referred to Dr Gustav Suckow's 1832 *Die chemischen Wirkungen des Lichtes*, an influential work that he possibly used as a springboard.[122] Perhaps his attendance at the chemical lectures at the Royal Institution that spring also gave him ideas. On 14 March, for example, he attended Richard Phillips' talk on "Chemical Affinities."[123] He also attempted to discuss some chemical issue with Michael Faraday (perhaps the beginnings of photography?), but Faraday was too busy at the time.[124]

Starting with the well-known light sensitive property of silver nitrate was the obvious approach, but Talbot was soon disappointed with how little sensitivity it actually possessed. Freshly prepared silver chloride fared no better.

> Instead of taking the chloride already formed, and spreading it upon paper, I then proceeded in the following way. The paper was first washed with a strong solution of salt, and when this was dry, it was washed again with nitrate of silver. Of course, chloride of silver was thus formed in the paper, but the result of this experiment was almost the same as before....

20. William Henry Fox Talbot. *Botanical specimen*. Photogenic drawing negative, fixed with salt. Ca. 1835. Because of the low sensitivity of the materials, Talbot's earliest photographs were shadowgrams. By placing a plant, a piece of lace, or other flat object on the sensitized paper, pressing it into contact with a sheet of glass, and placing it in the bright sun, a sufficient exposure could be accumulated over time. Talbot recognized that many of these simple negative photographs had extraordinary beauty in themselves. In this case, the juices of the plant, squeezed out by pressure under the glass, stain the area of the stem. 22.4 × 18.3 cm. The National Museum of Photography Film and Television.

21. William Henry Fox Talbot. *Latticed window taken with the camera obscura*. Photogenic drawing negative. August 1835. "When first made, the squares of glass about 200 in number could be counted, with help of a lens." Mounted on blackened paper. 3.6 × 2.8 cm. image on 6.9 × 14.9 cm. card. The National Museum of Photography Film and Television.

So far, Talbot had not even achieved the level of results reached by Wedgwood and Davy three decades before. It seems clear from the myriad personal notebooks and letters, that he started his researches unaware of their earlier work. It was only later that he realized that it was their inability to identify a fixer capable of making the pictures permanent that had held them back. Talbot subsequently confessed that if he had been informed that so distinguished a chemist as Davy had been defeated in the search for a fixing agent, he would probably have been discouraged from further attempts.

Unhampered by anything akin to Wedgwood's perilous physical state, and with more time to the problem than could Davy, Talbot continued in the spring of 1834 trying numerous variations in proportions and ingredients. Practice in botanical classification had keenly honed his powers of observation; it didn't take him long to detect an anomaly, seize on its essential properties, and turn it to advantage. Like Wedgwood, Talbot made his sensitive sheets by first brushing writing paper with common salt. He then brushed on a solution of silver nitrate, which reacted with the salt in the paper to form light sensitive silver chloride. The paper was relatively insensitive, but Talbot observed that the edges sometimes darkened more quickly. He isolated the cause of this effect to the fact that, when applying the salt, the edges often received a haphazard treatment. The salt was absolutely necessary to the process, but a lesser quantity produced a greater effect! He had increased the sensitivity to the point where images could be formed. But he didn't stop there. Talbot then reasoned that this being the case, a very strong solution of salt would have the opposite effect and render the paper almost totally insensitive. The same substance when weak sensitized the paper to light, and when strong preserved it from further action. He had invented a working photographic process. And it verged on magic.

Talbot's *photogenic drawing* paper, as he termed it, was a *print-out* paper – the image appeared under the influence of light without the need for subsequent development. The sheet of paper was first carefully selected: uniformity of texture, the absence of contaminants, and minimal interference from the watermark were the main criteria. The paper was first soaked in a weak solution of common salt, dried, and then either brushed with or floated on a solution of silver nitrate.[125] Light sensitive silver chloride was formed and embedded in the surface fibers of the paper (no emulsion was involved). Each sheet of sensitized paper had to be made by hand and many were rejected for stains, uneven coating, or paper defects. It was best if used the day it was made. Talbot's first photographs were photograms: direct contact images made under an object such as a leaf or a bit of lace. The sensitized sheet of paper was placed under an object in a printing frame and put out in the sun. The length of exposure required depended on the quality of the sunlight, the opacity and color of the object, and the precise chemistry involved; printing times on the order of fifteen minutes would have been typical. This very substantial exposure was required because the reduction of the silver was entirely dependant on the direct energy of the sun's rays. The print would partially bleach in the fixing bath so the matter of exposure called for

some judgment. After what was considered to be a suitable exposure the print was fixed, washed and dried. Talbot (and later, others) experimented with many variations of this basic formula. The addition of chemicals such as ammonia or nitric acid, the fiber content and sizing of the paper, the type of fixing agent employed, and even the intensity of the light itself, all affected the color of the final image. A range of warm browns was normal. The image was now what we would recognize as a negative – the lights and darks were reversed – since it was the action of the light that deposited the colored silver.[126]

The second phase of Talbot's initial research was conducted during a stay in Geneva from 30 August until 4 October 1834.[127] The best record of this is contained in a largely unpublished addendum to one of his first papers on photography.[128] Writing to the Royal Society in March 1839, Talbot explained that his first memoir on photogenic drawing "was written in the course of a few days & therefore necessarily less perfect than I could have wished:"

One of the things which I forgot to mention in it, is my method of imitating etchings on copperplate, and which, though not a real art of photogenic engraving (if I may assume such a process to exist) yet might easily be mistaken for it, if not explained. This was among the first applications which I made of my principle, nearly 5 years ago, & is performed in the following manner.

Take a sheet of glass & smear it over with a solution of resin in turpentine. When half dry hold it over the smoke of a candle: the smoke will be absorbed by the resin, & altho' the glass will be darkened as usual there will be a sort of glaze over the smoke, which will prevent it from rubbing off. Of course if any opaque varnish should be at hand it will be simpler to use that. On this blackened surface, when not quite dry, let any design whatever be made with a needle's point, the lines of which will of course be transparent. When this is placed over a sheet of prepared paper, a very perfect copy is obtained every line which the needle has traced being represented by a dark line upon the paper–

In the autumn of 1834, being then at Geneva, I tried several photogenic etchings in this way, which were executed for me by a friend, as I am not myself skilled at drawing;– Among other views, was one of the city of Geneva itself, being the view, if I rightly recollect, which we saw from our window–

Another application of the same principle, is to make copies of any writing. This is so very easy & each copy takes so short a time in making that I think it may prove very useful to persons who wish to circulate a few copies among their friends of anything which they have written,

more especially since, if they can draw they may intersperse their text with drawings which shall have almost as good an effect as some engravings– The chief expense will be from the silver used, the quantity of which is however small: but no press being wanted it cannot fail to be, on the whole, a very economical process.

In Geneva, in the shadow of Sir Humphry's grave, Henry Talbot had achieved the success that had eluded Wedgwood and Davy three decades before.[129] Even with his new process, Talbot was reliant on hand-drawn art.[130] Who was this anonymous colleague who drew Talbot's cliché verre negatives long before the first public announcement of photography? Absolutely no record of him or her has been traced. They were presumably not a family member (although both Caroline and Lady Elisabeth were with him in Geneva and either could have stepped in). When pressed to prove his claims of priority in 1839, why didn't Talbot call on the testimony of this person to bolster his claims of work done since 1834? It seems most likely that his helper must have been someone no longer alive in 1839 and someone who Talbot had reason to believe would not have left behind a written record. Could it have been his step-father, Charles Feilding, who died in 1837? An important theme that emerges from these Geneva experiments is Talbot's early and immediate recognition of the value of his invention for the reproduction of engravings and text. This application would initially take the form of silver-based photographs illustrating his Pencil of Nature. Later, when these proved insufficiently permanent, Talbot would blend the worlds of photography and conventional printing. Instead of replacing the printing press entirely, he would use photography to make the master image that would then be printed by conventional means.

Yet all of this remained private. The earliest known contemporary reference to Talbot's photographs is contained in a letter written to him by his sister-in-law, Laura Mundy, in December 1834, in which she thanked him "for sending me such beautiful shadows, the little drawing I think quite lovely, that & the verses particularly excite my admiration. I had no idea the art could be carried to such perfection." The fixing process was still far from certain, however, for she added that "I had grieved over the gradual disappearance of those you gave me in the summer & am delighted to have these to supply their place in my book."[131] Talbot's early photographic production peaked the following year. As he continued his account in The Pencil of Nature, Talbot remembered that

during the brilliant summer of 1835 in England I made new attempts to obtain pictures of buildings with the Camera

Obscura; and having devised a process which gave additional sensibility to the paper, viz. by giving it repeated alternate washes of salt and silver, and using it in a moist state, I succeeded in reducing the time necessary for obtaining an image with the Camera Obscura on a bright day to ten minutes. But these pictures, though very pretty, were very small, being quite miniatures.

Using tiny cameras allowed Talbot to reduce the exposure time to within practical bounds. But the pictures were so small that he creatively described them as being like the work of lilliputian artists. Set about the grounds of Lacock Abbey, patiently gathering in light over an extended period of time, these small wooden boxes must have been seen by some as a bit of eccentricity on the part of the master. In 1835, vacationing separately, Constance wrote to Henry to describe a lighting effect: "the colouring reminded me a good deal of some of your shadows. . . . Shall you take any of your mouse traps with you into Wales? It would be charming for you to bring home some views."[132]

It is apparent that thus far Talbot had advanced on Wedgwood's work to the extent of making the images stable. This, of course, was a crucial step, but Talbot's pictures were still photograms, mere shadows made by direct contact of the subject and the sensitive paper. Talbot saw possibilities beyond this, however, and recorded in his notebook the thought that "if an object, as a flower, be strongly illuminated, & its image formed by a camera obscura, perhaps a drawing might be effected of it, in which case not its outline merely would be obtained, but other details of it." Clearly, while Talbot had captured landscapes and buildings in his mousetraps, he had not yet succeeded with an in-camera picture of a small object; perhaps had not even attempted one yet. He had thought through the problem quite thoroughly however:

For this purpose concentrated solar rays might be thrown on it: but best employ only violet light because we want chemical rays and not heating rays lest the flower should be scorched by their intensity. My large concave mirror might be covered with plate glass washed over with blue gum or resin. Perhaps ammonia & copper might be made to unite with water and gum, so as to remain transparent when dry: if not, it might be used in a viscid state pressed between 2 plates of glass. At any rate the rays might be intercepted by a small blue glass nearer the focus.[133]

In this, as in so many things, Talbot displayed uncanny insight into the future of photography. A decade and more after he wrote this, portrait photographers would construct giant blue-liquid filters, or glaze their studios with blue glass, in order to lessen the discomfort of their sitters.

22. William Henry Fox Talbot. *Notebook M.* 28 February? 1835. Long before photography was announced to the public, Talbot conceived of the idea of using a negative to make positive prints. Since early camera pictures would involve extended exposure to sunlight, Talbot also surmised that a blue filter would block the heating rays, while allowing those critical to photography to pass. The Fox Talbot Museum, Lacock.

The tones were reversed, light for dark, since it was the action of light that reduced the silver. There is one major document that sheds a little further light on this initial period of invention. Talbot's notebook *M* is dated on the flyleaf "Lacock 4th December 1834;" this is presumably the starting date of the notebook and thus the contents likely refer to his thoughts in 1835, with possible later annotations.[134] Characteristically, the contents are quite diverse, ranging from various aspects of chemistry to magnetism. There are several references to silver and non-silver based photographic processes, many of them obviously speculative, that demonstrate a high degree of understanding of how photography worked. There is one paragraph of particular interest. The only dating that can be applied to this section of the notebook is sometime on or after 28 February 1835. This was four years before Herschel was to coin the word *photography* and it is clear from this passage that Talbot had not yet settled on a term for his own invention. "In the Photogenic or Sciagraphic process, if the paper is transparent, the first drawing may serve as an object, to produce a second drawing, in which the lights and

23. William Henry Fox Talbot. *Photomicrographs of plant sections*. Salt print made from two solar microscope negatives. Ca. 1839. The intensely sunlit image projected by the solar microscope made possible some of the earliest "camera" negatives. Microscope images were also extremely difficult to draw by hand. 18.9 × 22.9 cm. The National Museum of Photography Film and Television.

shadows would be reversed." Here Talbot grasped the idea of using a *negative* to make a *positive* (two terms also subsequently contributed by Herschel). Talbot chose his words very conservatively. *Photogenic drawing*, employing light, was obvious. *Sciagraphy*, the art of depicting objects through their shadows, reflects a sense of wonder about an extension of vision beyond the ordinary – a depiction that serves to replace a physical object. It seems likely that Talbot drew inspiration for this term from Gresham College's Henry Gellibrand, who in 1635 addressed "the Lover of Mathematics" with an introduction to a book on making sundials. His phrasing and perceptions presage Henry Talbot's own:

> Neither stands this *Art of Shadowes* in any *darke* or *inferiour* place; for by them are we led on to many *rare and sublime speculations.* . . . To these [shadows] are our best *Painters* indebted for the Life and Grace of their choisest *Pieces*. In a word, it is this *Art of Shadowes* which rectifieth our *Account of Time.* . . . What more invaluable than *Time?* We have nought to boast of but only its possession, and that more momentary than the fleeting Shadow it selfe. . . . [135]

Had Talbot possessed the showmanship of his later rival, Daguerre, he might well have seized on *sciagraphy* as his insignia, rather than the relatively colorless *photogenic drawing*.[136] However, the new art of photography, under whatever name was chosen, was but one of Talbot's diverse

interests and in subsequent years the subject appeared infrequently in family correspondence. There is no evidence that he told anyone outside his family about it (equally, there was no reluctance expressed at doing so). Lady Elisabeth and Lady Jane Davy had known each other for some time.[137] Judging by an 1823 letter, Lady Davy and Henry Talbot had developed a warm social friendship.[138] Perhaps a near-miss occurred when the widow visited Lacock Abbey in 1837 for Talbot almost certainly had located Davy's account of Wedgwood's experiments by then – but he happened to be in London during Lady Davy's visit. Would he possibly have shared with her his photogenic drawings?[139] Talbot explained about the period after the glorious summer of 1835 that

> during the three following years not much was added to previous knowledge. Want of sufficient leisure for experiments was a great obstacle and hindrance, and I almost resolved to publish some account of the Art in the imperfect state in which it then was.
>
> However curious the results which I had met with, yet I felt convinced that much more important things must remain behind, and that the clue was still wanting to this labyrinth of facts. But as there seemed no immediate prospect of further success, I thought of drawing up a short account of what had been done, and presenting it to the Royal Society.[140]

How Talbot was to rue his inaction on recording this invention! A solitary and unexplained comment in Talbot's *May* 1834 notebook simply says "Patent Photogenic Drawing."[141] This suggestion or reminder or whatever was not acted on. In later years, not so much for profit as in an effort to preserve his identity as the inventor, Talbot would patent subsequent photographic processes. This would bring him little fame, even less income, and no end of grief. The brilliant summer of 1835 was to prove to be his most productive period prior to 1839. Only one research notebook is known for the period of 1836–8; the only mention of photography within it is a peripheral one in 1838.[142] Therefore, in the absence of more specific information, surviving Talbot photographs thought to pre-date the public announcement can be attributed most creditably to the year 1835.

If communication between Talbot in England and Herschel at the Cape of Good Hope had been less uncertain, photography would have been a natural idea for the two men to share. However, separated by months of travel, with no uniform postal system, it is understandable that each got caught up in his own world. A brief note from Herschel to Talbot in 1836 is known and in his diary for January 1837, Herschel recorded that he had "packed up . . . bulbs for Fox Talbot and dispatched . . . to England."[143] Herschel's camera lucida was kept busy right from his arrival at the Cape.[144] It

24. William Henry Fox Talbot. *Botanical specimen*. Photogenic drawing negative. 6 February 1836. Dated by Talbot on recto. 15.0 × 14.0 cm. The National Museum of Photography Film and Television.

was here that Maggie and John Herschel undertook their most stunning co-operative venture with the camera lucida. In his diary for 30 August 1835, Herschel noted "a splendid day. All the beautiful flowers coming out in such glory that M[aggie] & I in a pure rapture seized on them and neglecting all other duties & occupations set to work I outlining & she colouring them." This continued a practice Herschel himself had started before his camera lucida work, at least as early as 1809. More than 100 of Herschel's exquisitely drawn camera lucida flowers, sensitively colored by Maggie, survive. They are co-signed by the two collaborators.[145] In 1837, while at the Cape, Herschel continued the experiments he had demonstrated to Talbot in 1831. On 9 January he "prepared Platinate of Lime in a state for Actinometric Expt," and on the 15th, Herschel conducted "the Actinom[r] Exp[t] with Platinate of Lime. NB. Definition of the sun astonishingly fine."[146] If Herschel had sent a letter to Talbot along with the bulbs, this renewal of work with platinum would have been a topic fresh in his mind and one that logically he would have shared with Talbot. It would have made sense for Talbot to reply with hints of his invention of photogenic drawing. What would have been the result if he had? This speculation must have crossed Herschel's mind as well. In early 1839, attempting the new art in the gloom of an English winter under occasional sunshine, he was to complain to Talbot that "if the subject had been started while I was in Africa there would have been no end of the results."[147]

Herschel's next known letter to Talbot is from some months later, in July 1837, recalling that

> some little time before my departure from England, I remember you expressing a wish to procure specimens of

Cape Plants, Bulb, Seeds &c – and from something which occurred, I was led to suppose that I might hear from you respecting the engaging of a person on the spot to collect for you. As that however has not been the case, of course, I have taken no step of the kind. . . .

Perhaps more significantly, in this letter Herschel reiterated his basic respect for Talbot's work:

> I am very glad to perceive by the notices which reach me from time to time of what is going on in the Scientific world in England that you continue to cultivate (and that too with real and brilliant success) those pursuits, both theoretical and experimental in which, before I quitted England, you had already done so much to distinguish yourself. I trust you will feel yourself now too deeply pledged in this career to abandon it and that we may look upon these things as the earnest of still greater & more important discoveries both in mathematics and photology.[148]

But the opportune time for a casual mention of a new discovery had slipped by. This letter (which might have reached England near the end of 1837) must have gone unanswered. When Herschel returned to England in 1838, Talbot immediately reopened their correspondence. Herschel soon dropped by Talbot's London residence to talk of familiar things: astronomy and particularly botany. Talbot's interest in his new art of photogenic drawing had grown dormant, however. It is manifest from correspondence and personal records that the subject was never raised between the two men before Daguerre made his announcement. It was a lost opportunity that Talbot was to feel keenly.

The Dawn of Photography:
Herschel & Talbot
in the Spring of 1839

"WHAT MAN MAY hereafter do, now that Dame Nature has become his drawing mistress, it is impossible to predict" exclaimed Michael Faraday at the first sight of Talbot's images.[1] The new art of photography was introduced to the public in an atmosphere of inescapable tension. Henry Talbot's complacency was shattered at the start of 1839 by the news that he was not alone in taming the pencil of nature. In Paris, Louis Jacques Mandé Daguerre announced his seemingly magical means of capturing the images of a camera obscura. It is likely that Talbot first learned of Daguerre's achievement from the 12 January *Literary Gazette*.[2] No manipulatory details were reported save for the hint that the images had been secured on plates of copper. Views of trees, the Boulevards of Paris, a dead spider seen in the solar microscope – in short, anything motionless could be depicted with the utmost fidelity. That the details of this foreign invention were shrouded in mystery made it all the worse for the English inventor, for he faced the terror of the unknown. No wonder that Talbot felt that he had been "placed in a very unusual dilemma (scarcely to be paralleled in the annals of science): for I was threatened with the loss of all my labour, in case M. Daguerre's process proved to be identical with mine, and in case he published it at Paris before I had time to do so in London."[3]

The manipulatory details of the Daguerreotype would not be disclosed until the autumn of 1839. It would emerge that Daguerre placed a highly polished silvered copper plate in a box filled with the fumes of iodine. The tarnish formed was actually a light-sensitive silver iodide. Exposed in a camera for fifteen minutes or so, an invisible image was formed on the silver surface. At this stage, the image, although imperceptible, was far from inert. By subjecting the exposed plate to the fumes of mercury, a discernible image was formed when tiny globules of mercury adhered in the areas struck by light; a wash in common salt preserved it. Daguerre's silver plate was a unique image that appeared positive only when held at a certain angle. But it was terrifically detailed and seductive in its effect. The daguerreotype was a most improbable process and one whose basis Talbot could not possibly have guessed. Its explanation would be revealed only after Daguerre was awarded a lifetime pension from the French government. At the start of 1839, not knowing what he was facing, Talbot could only publicly lament that he could not

> help thinking that a very singular chance (or mischance) has happened to myself, viz. that after having devoted much labour and attention to the perfecting of this invention, and having now brought it, as I think, to a point in which it deserves the notice of the scientific world, – that exactly at the moment when I was engaged in drawing

25. William Henry Fox Talbot. *Lace*. Photogenic drawing negative. Ca. 1839. 22.0 × 19.0 cm. The National Museum of Photography Film and Television.

26. William Henry Fox Talbot. *Examples from Talbot's first exhibition of photography?* Photogenic drawing negatives, fixed with salt. Ca. 1835. When Talbot was surprised by Daguerre's public announcement in January 1839, he rushed to display his own productions. In the weak winter light, all he could show was those produced some years earlier. This copy of a print, and the image of the stained glass window in the great hall of Lacock Abbey (from the inside), were typical of what he displayed at the Royal Institution on 25 January. Several images of this sort, including his famous August 1835 oriel window, are mounted on a distinctive blackened paper, and are likely to be the first photographs the British public ever saw. Print, 6.9 × 7.0 cm.; window, 6.5 × 5.5 cm. The National Museum of Photography Film and Television.

up an account of it, to be presented to the Royal Society, the same invention should be announced in France.[4]

Lady Elisabeth made clear her fury:

I shall be very glad if M. Daguerre's invention is proved to be very different from yours. But as you have known it five years à quoi bon concealing it till you could by possibility have a competitor? If you would have made it known one year ago, it could never have been disputed, or doubted....[5]

As no one in Britain had yet seen what Daguerre could produce, Henry Talbot hastened to establish the independent priority of his photogenic drawing. The depths of an English winter were hardly conducive to Talbot's actually demonstrating his process on demand. As was often the case, he was then resident in London, removed from his laboratory at Lacock Abbey. Fortunately, Talbot's private portfolio was plump with experimental prints made in 1835, many of which had retained their original vigour. He must have started immediately contacting his scientific friends. One of the first persons that Talbot approached was Sir William Jackson

Hooker, the Regius Professor of Botany at Glasgow (and later director of Kew Gardens). On 23 January, Talbot sent him a photogenic drawing of lace to show to some of the manufacturers in the Scottish mercantile city.[6] Hooker later reported back that "your specimen of Photogenic drawing ... has interested the Glasgow people very much, especially the Muslin Manufacturers – & also excited great attention at a Scientific Meeting...."[7]

The earliest opportunity for a public showing to a scientific audience was on 25 January, when Michael Faraday addressed the more than 300 people who had assembled at the Royal Institution for the popular Friday evening lecture. After announcing the parallel discoveries of Daguerre and Talbot, Faraday invited the audience to inspect the customary library exhibits. There, displayed amongst diverse curious objects such as papier maché ornaments, specimens of 'artificial fuel,' and a collection of sixteenth-century engravings, were shown examples of Henry Talbot's black magic. Later in life, Vernon Heath remembered that on that occasion Faraday had observed that "no human hand has hitherto traced such lines as these drawings display; and what man may hereafter do, now that Dame Nature has become his

drawing mistress, it is impossible to predict."[8] Talbot selected examples of his photogenic drawing process meant to demonstrate

the wide range of its applicability. Among them were pictures of flowers and leaves; a pattern of lace; figures taken from painted glass; a view of Venice copied from an engraving; some images formed by the Solar Microscope, viz. a slice of wood very highly magnified, exhibiting the pores of two kinds, one set much smaller than the other, and more numerous. Another Microscopic sketch, exhibiting the reticulations on the wing of an insect. Finally: various pictures, representing the architecture of my house in the country; all these made with the Camera Obscura in the summer of 1835.[9]

The meeting and exhibition were noted in the weekly journals and one would think that private notes might survive indicative of an audience's reaction; however, none are known. The *Literary Gazette* summarized a few of the pictures that Talbot exhibited:

His copying of engravings (there is a sweet one of Venice), by first getting them with the lights and shades reversed, but then copying from the reversed impression, as before, is singularly ingenious. Figures painted on glass are exquisitely rendered; and an oriel window of many feet square is reduced to a picture of two inches, in which every line is preserved with a minuteness inconceivable until seen by the microscope.[10]

The only other published contemporaneous account so far traced, the confused and disparaging comments of Sir Anthony Carlisle, must surely have vexed Talbot:

At an evening meeting holden at the Royal Institution on Friday last, several specimens of shaded impressions were exhibited, produced by the new French Camera. The outlines, as well as the interior forms of the objects, were faintly pictured, and hence the application of this method of impressing accurate designs may become disregarded after public curiosity subsides.[11]

For Talbot, however, what he had shared with the audience at the Royal Institution was "a little bit of magic realised: – of natural magic."[12]

Writing from London earlier on the day of his Royal Institution exhibit, Talbot had opened the round of correspondence with Sir John Herschel on this exciting new field. The wording of his letter underscores the fact that the two men had not had any prior discussion of photography.

Having a paper to be read next week before the Royal

Society, respecting a new Art of Design which I discovered about five years ago, viz. the possibility of fixing upon paper the image formed by a Camera Obscura, or rather, I should say, causing it to fix itself, I should be most happy to show to you specimens of this curious process. If you could not make it convenient to call here, Slough has now become so accessible by the railway that I would take a drive there any day if you would appoint an hour.[13]

Herschel had already been alerted to Daguerre's work by a 22 January note to Maggie from their friend, Francis Beaufort.[14] Freshly back from the sylvan tranquility of the Cape of Good Hope (and only recently the diffident recipient of a baronetcy), Herschel increasingly resented the ease with which visitors could come to his home via the new railway. But Henry Talbot and his new invention would certainly have been welcome had not Herschel's poor state of health precluded any such immediate visit. He lamented in his diary on 8 January that he had been "villainously nailed by this vile sciatica." An old complaint, thankfully abated while he was in the warmth of South Africa, Herschel's rheumatism was to interfere with his work for the rest of his life. On 11 January he "plaistered my ailing limbs all over at Robart's recommendation with 'Poor Man's Plaister' a composition like Cobler's wax spread thin on paper – from hip to ankle & across the loins which makes one feel like an armadillo."[15] Miserable beneath his comical bandages, Herschel was forced to apologize to Talbot on the 27th that

I am sorry that it is impracticable for me to come up to Town to see your curious process for fixing the image formed by a Camera Obscura – the interest of wh at this moment is particularly great after what has recently been announced in Paris – but I am tied here by many engagements to say nothing of a rheumatic affliction which confines me a large portion of each day to my bed and forces me to avoid all exposure to cold which is not indispensable.

Talbot, frantically preparing his paper and exhibit for the Royal Society meeting, had to defer the visit, but replied sympathetically on the 28th that "I regret to learn that you are so much indisposed. This is our English Climate! after four years of an African sun it must prove a sad contrast indeed. I will come down . . . on Friday next. . . ." In a P.S. he asked Herschel's advice on an appropriate lens:

Do you think you could furnish me with the proper curves for a Camera Obscura object glass, of two feet focus, not achromatic (since the violet rays only are active) but to combine if possible the greatest diameter of object glass, with a tolerably flat field of view. The Camera Obscura

pictures which I will shew you are Lilliputian ones & require a lens to look at them. When first made they were extremely delicate but are now 3 years & a half old and I intend, as soon as the sun acquires power in the Spring, to make a fresh lot of them, more worthy of being looked at.

Talbot was to be bitterly disappointed in this. The sun failed to acquire its anticipated power and the weather further soured in the spring of 1839 – the summer was to prove disastrous. The very next day, 29 January, Talbot wrote again that "the 2 London principal Scientific newspapers, "the Athenaeum" & "the Literary Gazette" have both taken up with zeal (much more than I could have expected) the subject of my discovery of Photogenic Drawing." The editor of *The Athenaeum* offered to print the full text of Talbot's upcoming Royal Society paper "because, he observes, no time ought to be lost, the Parisian invention having got the start of 3 weeks." Although the well-meaning editor was correct, his offer presented a dilemma for Talbot. It would take a resolution of the Council to avoid this prejudicing later publication in the Society's *Transactions*. The Council would not meet before the next Saturday's publication date, so Talbot decided to poll the members individually to see how they might cast their formal vote; he hoped that Herschel would support him in this exception "under the peculiar circumstances."

Herschel replied on 30 January to both of Talbot's letters. Feeling that "rapidity of commn of inventions to the Public is of more importance than points of form and the interest of this particular invention ... is such that it ought to be preserved in some record more durable than the pages of a weekly journal." Herschel reiterated that the usual policy of the Royal Society was to discourage prior publication, but he added, "of course however it is competent to ye Council in a special case to waive these objections – I shall not be the one to object." Herschel's draft of this letter survives and reveals that in the version sent to Talbot, he tempered his initial encouragement to circumvent the rules.[16] In his draft, Herschel wondered if Talbot must "of necessity give to these Journals a verbatim copy – is there no matter of detail advantageous in the manipulations, no prospective improvements or hints for future wider applications which may advantageously be for a time withheld?"

There would soon be much more to talk about. On 29 January, just three days before Talbot's visit, Herschel began the methodical recording of his photographic experiments in his chemical notebook at Slough.[17] His chronicle of discovery, part of a long-standing regular series of explorations in various fields, was quite detailed and has never been fully examined. Often experimental photographs were attached and annotated on the notebook pages.[18] Experiment No. 1012

was the first to address the new problem of photography:

> Expts tried within the last few days since hearing of Daguerre's <u>secret</u> & that Fox Talbot has also got something of same kind. Chlor-silver paper prepared by washing 1st with Nitr Silver then with Mur. Potash. Covered $^1/_2$ a piece & exposed to light. Blued but not rapidly. In fact it is not at all susceptible enough for Daguerre's process.

However, this was just one approach of several that came immediately to mind.

> Carb-silver paper prepared by washing 1st with nitrate then drying then washing with Carb. Soda ... paper washed with this & dried. Nitr Silver paper washed & dried all exposed in the leaves of a book $^1/_3$ in $^2/_3$ out. Order of susceptibility 1. Carbonate, 2. Nitrate, 3. Acetate, 4. and worst of all, Muriate.

In analyzing Daguerre's process and in his "attempt to imitate" it, Herschel understood that he needed a "very susceptible paper," a "very perfect camera," and most importantly, a means of preserving the image. To the latter, he thought immediately of applying his hyposulphite of soda, "to arrest the action of light, by washing away all the chloride of silver or other silvery salt." It succeeded perfectly, on a sheet of sensitized paper that had been exposed under a pattern.

The next day, 30 January, Herschel was ready to put his plan into action. He drew on his vast experience in optics and chemistry and injected a bit of history as well. The framework of the forty-foot telescope made famous by his father was still standing; appropriately, it was the subject of the son's first attempts.

> Formed image of telescope with the aplanatic lens of Dolland's make on my construction and placed in focus paper with Carb. Silver. An image was formed in <u>white</u> on a sepia-cold ground after about 2 hours exposure which bore washing with the hypos. soda & was then no longer alterable by light. Thus Daguerre's probl is so far solved – for granting a perfect picture, the picture of this may be taken.

Within a day of starting on a totally new field, with no advance information, Herschel had created an in-camera image, made it permanent with hypo, and had grasped the essentials of the negative/positive process! That same day he copied prints and copperplate engraved letters, and the next day attempted his first "re-reversal" (a positive print from the negative): "it succeeded, but not well but there can be no doubt about it when all the minutiae are learned."

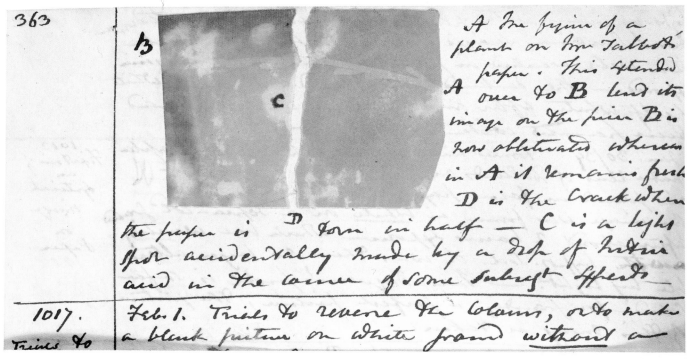

27. Sir John Herschel. *Research notebook*. On 1 February 1839, Henry Talbot visited Herschel at Slough in order to discuss his invention. Herschel took the un-fixed photogenic drawing that Talbot brought, tore it in half, and fixed one half in hypo. Herschel preserved in his notebook the first photograph the two men shared. Image, 5.5 × 8.0 cm. The Science Museum Library, London.

Interestingly, between the draft and the final versions of his 30 January letter, Herschel drew back from disclosing to Talbot the specific details of this initial work on photography. The draft gives detailed working procedures for what he had done to that point, significantly mentioning his use of hypo as a fixer, and in a postscript to the draft, he confirmed that

> on trial the hyposulphite appears to answer perfectly the end for which I have above proposed. It discharges completely all the ~~muriate of~~ silver from the paper except that which has been reduced by the light. Moisture renders the chloride infinitely more susceptible of light than when dry. N.B. What a beautiful mode of making the sun represent its own spots n times a day or of mapping the moon.

However, in the final version sent to Talbot, Herschel was more circumspect. After all, he had seen neither Talbot's nor Daguerre's productions, and rightfully felt that he should be somewhat guarded in what he disclosed until he knew more about the situation.

> I have myself been thinking since I got your note about this enigma. Here is one fact that forms the groundwork of my view of the process supposing chloride of silver to be the material used. That the Image in a Camera Obscura may impress itself on a paper imbued with that substance in its pores & rendered more susceptible than usual by moisture and gentle warmth (and perhaps also by the presence of hydrogen gas) I have satisfied myself by experiment. Thus we have a picture in which darkness represents light & vice versa. Now this picture will darken every time it is exposed to light till it is become entirely black and thus our picture is destroyed. But if the whole of the unreduced Chloride be washed out of the paper which may be done instantaneously and to the last atom by a process I have discovered – leaving the reduced silver still on the paper in the form of a fine Brown or Sepia tint – our picture becomes permanent. The representation of light by light and dark by dark remains difficult but I think not insuperable, even with this material. But Arago's process seems to require some more susceptible body than Mur. Silver & some coloured one which light whitens . . . I hope to see you on Friday.

Herschel, in common with most early experimenters, logically sought a direct positive image and was yet to be convinced of the advantages of the (as yet unnamed)

negative/positive system. In answer to Talbot's question about camera obscura lenses, Herschel referred him to a paper he had read to the Royal Society in 1821.[19]

In the meantime, Talbot was moving quickly to publicly record his priority of invention. His "Some Account of the Art of Photogenic Drawing," presented to the Royal Society on 31 January, was a non-technical paper designed to stimulate interest in the range of applications to which his invention might be applied – it revealed none of his manipulatory details.[20] The Royal Society received the manuscript on 28 January and thus Talbot had been given only a few days since learning of Daguerre to collect his thoughts. His tone was almost conversational and his excitement was palpable as he confessed to being "astonished at the variety of effects which I have found produced by a very limited number of different processes when combined in various ways; and also at the length of time which sometimes elapses before the full effect of these manifests itself with any certainty." When he spoke of the "art of fixing a shadow," Talbot revealed that the phenomenon

> appears to me to partake of the character of the *marvelous*, almost as much as any fact which physical investigation has yet brought to our knowledge. The most transitory of things, a shadow, the emblem of all that is fleeting and momentary, may be fettered by the spells of our '*natural magic*,' and may be fixed forever in the position which it seemed only destined for a single instant to occupy.

> Such is the fact, that we may receive on paper the fleeting shadow, arrest it there, and in the space of a single minute fix it there so firmly as to be no more capable of change, even if thrown back into the sunbeam from which it derived its origin.

Henry Talbot found no embarrassment in marvelling at magic – neither he nor Herschel ever lost their sense of joy at what the medium could produce. Equally, Talbot was a man of science and he paid homage to the precepts of inductive reasoning that his colleague had expressed so well. Talbot immediately acknowledged that the property of silver nitrate darkening in sunshine had been noted widely in the literature but maintained that he had started unaware of the earlier efforts of Wedgwood and Davy. They had failed to find a way to make their pictures permanent, and "no doubt, when so distinguished an experimenter as Sir Humphry Davy announced 'that all experiments had proved unsuccessful,' such a statement was calculated materially to discourage further inquiry." When Talbot started his researches in the spring of 1834, he had expected his prints would be transient and would darken over time. Talbot later reflected that Davy's comments "would perhaps have induced me to consider the attempt as hopeless, if I had not (fortunately)

28. William Henry Fox Talbot. *Some Account of the Art of Photogenic Drawing*. Read before the Royal Society, 31 January 1839. This was the first separate publication ever on the subject of photography. Quarto. Harold White Collection, Hans P. Kraus, Jr.

before I read it, already discovered a method of overcoming this difficulty, and of *fixing* the image in such a manner that it is no more liable to injury or destruction."[21] Although he kept his chemical secrets to himself, Talbot quite openly hinted about the eminently logical path that had led him to a 'preserving agent.'

> The nitrate of silver, which has become black by the action of light, is no longer the same chemical substance as it was before. Consequently, if a picture produced by solar light is subjected afterwards to any chemical process, the white and dark parts will be differently acted on. . . .

Talbot, of course, had early on found such a chemical in simple table salt. Even though his prints were already some years old, he was "able to show the Society specimens which have been exposed for an hour to the full summer sun, and from which exposure the image has suffered nothing, but retains its perfect whiteness." Most of these images were

photograms – direct contact prints from natural objects. This approach left a white image on variously colored grounds; as Talbot noted, not unlike the pleasing effect of Wedgwood-ware. In describing the copying of engravings, Talbot admitted that the reversal of tones was unexpected, but he gamely offered that this might prove of advantage to artists in the analysis of light and shade. The cure for conventional applications was very simple. "If the picture so obtained is first *preserved* as to bear sunshine, it may be afterwards itself employed as an object to be copied; and by means of this second process the lights and shadows are brought back to their original disposition."

Even at this stage, with materials of very low sensitivity, Talbot foresaw a wide range of applications for the new art. While full-tone portraits were still beyond reach, he suggested that photogenic drawing could replace the ever popular hand-drawn silhouettes. Paintings on glass, especially magic lantern slides, could be copied. One of Talbot's great interests was microscopy, where "the objects which the microscope unfolds to our view, curious and wonderful as they are, are often singularly complicated." However, this complexity posed no challenge for the "inimitable pencil" of nature:

> It is so natural to associate the idea of *labour* with great complexity and elaborate detail of execution, that one is more struck at seeing the thousand florets of an *Agrostis* depicted ... than one is by the picture of the large and simple leaf of an oak ... but in truth the difficulty is in both cases the same.

By refining the sensitivity of his paper, he was able to make good exposures at low power in the solar microscope in the space of a quarter of an hour. However, it was the capture of the camera obscura's "vivid picture of external nature" that Talbot found to be "perhaps the most curious application of this art," and the one "which has appeared the most surprising to those who have examined my collection of pictures formed by solar light." His success with solar microscope pictures led Talbot to believe that this goal was more than a "scientific dream." By using a tiny camera obscura, Talbot was able to obtain "very perfect but extremely small pictures; such as without great stretch of imagination might be supposed to be the work of some Lilliputian artist. They require indeed examination with a lens to discover all their minutiae."

"Some Account" was a report of work in progress, offering "to lovers of science and nature" a brief outline of the possibilities of the new art. Certainly the major reason that Talbot rushed this article into publication was to establish his priority independent of Daguerre's. *The Athenaeum* called special attention to their customary report of the Royal Society meeting, publishing a synopsis of Talbot's paper on 2 February, while noting the "obvious difference ... between the process of M. Daguerre and Mr. Talbot," in that "the former employs metal plates, whereas the latter uses prepared paper. There can be no question as to the superior advantages of the latter; for it would be most inconvenient, if not wholly impracticable, for the traveller to carry about with him several hundred metal plates."[22] But Talbot withheld permission to publish the full text, confident that he could reach a compromise with the Council of the Royal Society.

On the very day that Talbot's paper was being read in London, 31 January, the French physicist Jean-Baptiste Biot was replying to a letter from Talbot. They had known each other professionally for some years through a mutual interest in optics and light. Biot would soon become Talbot's most ardent (and virtually sole!) supporter in France. But on this day, he was transmitting what was certain to be bad news for Talbot:

> I would not wish to hazard a preconceived opinion in such a delicate matter but I must, in the interests of truth, inform you in case you are not aware of it, that M. Daguerre, as his friends know, has been constantly occupied with this research for more than fourteen years and I can attest that he spoke to me about it several years ago.[23]

Biot's letter, of course, would have taken several days to reach Talbot, so the first meeting with Herschel was not clouded by this information. Friday, 1 February, the day after Talbot read his paper, was the earliest chance he and Herschel had to see each other's results. Nearly half a century later, Maggie Herschel would vividly recall to their son that

> I remember very well the visit ... to Slough of Mr. Fox Talbot, who came to shew to Herschel his beautiful little pictures of ferns and Laces taken by his new process – when something was said about the difficulty of <u>fixing</u> the pictures. Herschel said 'let me have this one for a few minutes,' and after a short time he returned to give the picture to Mr. Talbot saying 'I think that you will find that fixed' – this was the beginning of the hyposulphate of soda plan of fixing.[24]

No account of the meeting from Talbot's point of view has been traced; Herschel recorded in his notebook that day that

> Mr Talbot came to Slough. Shewed him an engraving (a lithographed subject) just transferred in Carb. Silver & washed with hypos. sod. Also a picture of ye telescope just freshly formed – explained to him all my processes. He also shewed me his specimens of results but did not explain his process of what he calls "fixing." By way of trial of ye

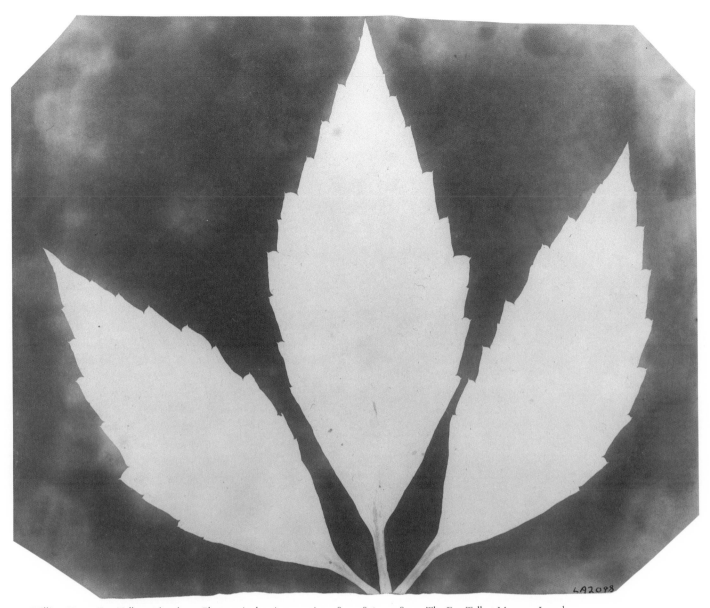

LA2098

29. William Henry Fox Talbot. *Three leaves*. Photogenic drawing negative. 1839. 18.6 × 22.8 cm. The Fox Talbot Museum, Lacock.

power of my process of "washing out" he gave me one of his unfixed specimens. In 2 minutes I brought him half of it washed the other not & on exposing both the washed half was unchanged the other speedily obliterated & at length grew quite dark.[25]

This first collaborative example from Herschel and Talbot still survives in Herschel's notebook, weakly but stubbornly preserving the image of a stem of a plant, successful now for more than a century and a half! Herschel continued his experiments that same day as soon as Talbot left. His first effort was to form a direct positive "without a double transfer." The first trials were not very successful. Frustrating the historical record, during the first ten days of February Herschel merely recorded that "a great many expts of various kinds" were undertaken.

This initial meeting led to a flurry of open correspondence between the two scientists with them freely sharing their hopes and breakthroughs. In Talbot's letter to Herschel on 2 February, the day after their session at Slough, he enclosed "a transparent drawing which I imagine may prove a good subject, if you like to copy it with the carbonate of silver, & then transfer it again, so as to have its original lights & shades." Talbot was already feeling that he was being forced into a nationalistic race, one that would grow ever more intense as the situation developed. In his letter, he told Herschel that "I hope that you will continue the very interesting experiments which you showed me yesterday as I am anxious that something should be effected worthy of the scientific reputation of the country."

On 6 February, while staying in London, Talbot started a research notebook.[26] During this month, he contemplated a variety of possible bases for photography, but the number of references to copper plates makes it obvious that Daguerre was playing heavily on his mind. Interspersed with this were records of practical application. On 10 February, he thought to put "holes in the back of Cam. Obscura, in order to see if the paper is in focus" and also thought to try to "make copies of Persian MSS." On 27 February, perhaps recalling his friend Sir David Brewster, he wondered if he might make a picture of the image of the kaleidoscope. After Herschel informally showed some of his first results to the Royal Society on 7 February, Talbot wrote on the 8th that:

As I understand that you exhibited some photogenic drawings at the R.S. last night, allow me to ask if it is your intention to publish at present any account of your method of "washing out?" My motive for asking is, that in that case I could take the opportunity of making known my method of "fixing," either separately, or in a joint communication with yourself to the R.S. if you should be willing to adopt that suggestion. At present, however, I merely wish to be informed whether you are intending to describe your process, or to wait a little.

Thus, Talbot was amenable to sharing at least portions of his work with Herschel, even to the point of a joint publication. This was still before he had publicly disclosed any of the working details of his photogenic drawing process. In a P.S. to this letter, Talbot returned to the issue of making the prints permanent. "Concerning 'washing out', vide Sir H. Davy in the 1st vol. of journal of R. Institution. He could not effect it – perhaps nothing else will answer than your ingenious recipe."[27] Why, since Talbot already had a working process that he knew was different from Herschel's, would he say that Herschel's was the only one? The answer must lie in the careful distinction that both men maintained between Talbot's term fixing and Herschel's of washing out. To 'fix' something is to place it in a stable or unalterable state and to 'wash it out' is to remove it. Talbot's use of common salt and potassium iodide as fixers did, in fact, convert the remaining light sensitive silver salts into relatively insensitive forms of silver chloride or silver iodide, neither of which was readily soluble in water. Herschel's washing out involved a property of hypo, through a complex two-stage reaction, of putting the silver salts into a water soluble form that could literally be washed out. Herschel often let the products of the reaction merely leach out into the water-based solution of hypo, without subsequent wash in pure water, which damaged the permanence of many of his early examples. At this stage, both men considered Talbot's process to be more simple and desirable, even though Herschel had only Talbot's word on the properties of his magic 'fixer.' This etymological distinction is all the more ironic when we consider that Herschel's hypo became commonly known as 'fixer,' even though his original label of it as a 'washing out' agent more accurately describes its true function.

Herschel replied to Talbot on 10 February, saying that he had exhibited some of his work at the Royal Society.

I left one or 2 Photographic specimens (very poor ones) with Mr. Roberton [the secretary] not as a formal exhibition to the R.S., but merely with a view to keep up attention on the subject by affording matter of conversation to those who might chance to see them in his hands or on the table in the Library in the Evening.

This is the earliest example of Herschel's use of the term photographic instead of Talbot's hopelessly cumbersome photogenic.[28] Continuing in his 10 February letter, Herschel felt that

as Daguerre has obtained his price for his secret of course it will soon be published – and I am told that his performances are so exquisite as to be almost miraculous.

So far therefore from having now the smallest objection to your mentioning either publicly or privately my application of the Hyposulphite to washing out the superfluous Silver, I rather wish it to be known. . . .

In his draft of this letter (written on the 9th), Herschel confessed that "all Idea of secrecy being taken off by the cat being let out of the Frenchman's bag, I have myself mentioned this to several persons."[29] In the version sent, he continued that he had

myself now mentioned it <u>conversationally</u> to more than one inquisitive person though I have no idea of writing myself on the subject unless something should turn up of a more striking character than anything I have yet hit upon. This <u>may</u> happen, for I find the imitation of engravings (Wh as I see by your paper in the Athenaeum, makes one of your applications) is capable of great delicacy & beauty and admits of a Re-transfer which, by careful attention to all the manipulations & especially to hitting exactly the right moments for withdrawing the pictures from the light, may I have not the smallest hesitation in saying, be carried to a great pitch of delicacy.

In the draft version, Herschel stated firmly that as a class of salts, the hyposulphites were "unknown to Davy or of course he could not have missed the application in question which is too obvious to need being made a point of." The version sent was softened to:

That Davy should have missed the "washing out" process is no wonder as he was not acquainted with the Hyposulphites – and although ammonia is a solvent of fresh Chloride of Silver it is but a poor one & would, I doubt not, have little effect on paper impregnated with <u>it</u>. The nitrate would be precipd by it as oxide.

Herschel had attended the Royal Society Council meeting the previous Thursday when Talbot's paper was discussed and had learned for the first time that Talbot had not yet disclosed his processes, especially that of 'fixing.' He explained to Talbot that "in consequence of this and of either some part having been withdrawn or of its being understood that you considered it incomplete and intended its completion with an account of the processes – it was proposed to 'postpone it' till it could appear in complete form." Herschel found this compromise objectionable and instead suggested that the paper be published in full in the Society's *Weekly Notice*. This would insure the "speediest circulation of its contents in the scientific world," without prejudicing later publication in the *Transactions*, and Talbot could secure as many offprints as he wished.

But Talbot, who had already delayed publication in *The*

Athenaeum for a week, had re-scheduled the paper for publication on Saturday the 9th, assuming that the Council would have acceded by then to his request. Even before Herschel wrote back to Talbot, the die had been cast. Talbot had written to Peter Mark Roget, the secretary of the Royal Society, on 5 February, to say that he was delaying separate publication just to see if it should carry the label "taken from the Transactions." He had received a discouraging reply, and angrily wrote back to Roget that

I have the honor to state to the Council of the Royal Society, that my motive for withholding for the present, some parts of my process of Photogenic Drawing, is, that <u>otherwise</u> I have reason to think I should be completely anticipated in those other, & perhaps more perfect, results, which I hope to work out during the ensuing summer. Now, this is a sacrifice which, as it appears to me, I ought not to be called upon to make. With this explanation I am content to leave the matter in the hands of the Council who no doubt, are the best judges of what is most for the interests of the society, and of science itself.[30]

The dilemma was excruciating for Talbot. Once before, he had become unwittingly entangled with the publication policies of the Royal Society and had not escaped embarrassment.[31] If he disclosed the manipulatory details of his process before Daguerre did, his rival might well incorporate Talbot's findings into his own announcement. At least certain members of the Council of the Royal Society would not be willing to bend the rules on publication for him. Talbot lamented to Roget that

I had a long letter from Sir D. Brewster this morning and what do you think he recommends me most particularly to do? Keep it a secret, for the present; until circumstances permit me to bring it to more perfection. Yet such is the difference of opinion in this world, that what is thus strongly recommended by some persons, is as strongly objected to by others.[32]

So confident had Talbot been that he had already instructed the Society's printer to set the text for a quarto page (for the *Transactions*). But, in spite of Herschel's liberal spirit and support, the Council decided firmly during their meeting on 7 February to restrict Talbot's publication to the less prestigious *Proceedings*. Henry Talbot had held off long enough. His text was first published in full in *The Athenaeum* on 9 February, a reasonable action which still thoroughly upset the Council.[33] Almost immediately, Talbot made use of the type originally set in anticipation of the *Transactions*, converting his article into the first separate publication on photography.[34]

The draft of Herschel's letter, written on the 9th,

30. Sir John Herschel. *Framework of William Herschel's telescope, seen through the window at Slough*. Silver-based negative on paper. 10 February 1839. This is the oldest known Herschel photograph and it is appropriate that he should have turned to the dominant visual icon of scientific progress, his father's giant telescope. It would turn out that this was based on a process essentially the same as Talbot's then secret *photogenic drawing*. Herschel had already come to object to this restrictive name and labelled himself as a "photographer;" he would introduce the term into the English language a month after this. 8.1 × 8.5 cm. The National Museum of Photography Film and Television.

31. Sir John Herschel. *Copy of an engraving*. Photogenic drawing negative. 27 February 1839. Herschel recorded that he made this on China paper and fixed it with hypo sulphite of soda. This example was sent by Herschel to Talbot. The reproduction of prints and engravings seen by both men as one of the most important potentials of photography and was a frequent topic in their correspondence. 7.7 × 11.4 cm. image on 8.3 × 12.1 cm. paper. The National Museum of Photography Film and Television.

complained of weather so dull that all results were imperfect. By the time the final copy was written the next day, the skies had cleared.

> The weather from the time you were at Slough has been till today so gloomy that little could be done. Today being bright I have made some much better Reverses of Copperplate and also a tolerable Re-reverse. One of the former I enclose. It is not the best by far but it is varnished for retransfer.

The P.S. contained the first hint of Herschel's 'exalting glass,' a greenish-tinted glass that paradoxically seemed to increase the rapidity of action of sunlight that passed through it to the sensitive paper! Spectral graphs became a common feature of his research notebooks after this as Herschel tried to unravel this conundrum. Dozens of different glasses were checked for their action. The effects of heat and moisture were soon ruled out, but certain glasses consistently enhanced the photographic action, especially in stronger light.

Talbot's reply of 11 February is crucial to understanding his attitude towards Herschel's work. The first rays of sunshine poking through the English skies since the start of Herschel's efforts had enabled him to make rapid progress, even to the point of discovering a seemingly magical glass that would shorten exposure times. Talbot could have taken this as a threat to his own reputation as the inventor. But instead, he shrewdly (and honestly) decided to maintain a clear distinction as to what constituted each person's unique contributions to the new art. After pointing out that the re-transfer process had been mentioned in his Royal Society paper and congratulating Herschel on the exalting glass, Talbot speculated on the probable nature of his chief rival's invention:

> Although Daguerre is said to succeed so admirably with the Camera, it does not follow that he can copy an engraving, a flower, or anything else that requires close contact. I say this, on the supposition that he uses a metal plate covered with a liquid from which light precipitates something previously held in solution.

The birth of photography coincided with the golden age of reproductive engravings in Britain.[35] A growing middle class, fed by the wealth and changes of the industrial revolution, became the new patron of the arts. While factory managers and merchants could rarely afford original oils, they created a huge market for reproductions of works of art. Talbot's

32. Sir John Herschel. *Research notebook*. 11 February 1839. Right from the beginning, Herschel was intrigued by the effects of different colors of light on different photographically-sensitive substances. The Science Museum Library, London.

extended family was a part of this market. Their correspondence reveals an active interest in print collecting (and swapping), and many examples survive in the family's albums. Although Talbot alternately warmed and cooled to the idea of reproducing prints, he could not help but have been affected by the obvious enthusiasm for prints around him. This explains why Henry Talbot frequently perceived the real strength of his process not so much as a means of creating new images, as one of multiplying existing ones.

There is not the smallest doubt that the finest engravings can be imitated, & I wished that we might have the honour of first exhibiting them. I can work with very thick engravings on a summer's day. . . . I am so confident about the success of copying engravings judging by those which I have already made, that I should like very much to prepare a collection of them, to be shown at the Scientific Meeting at Birmingham or sooner. I wish to know if you do not

think that the publication of the washing out, fixing, &c. &c. would prevent this, by putting it in the power of anyone either at home or abroad, to exhibit such a collection before we may be ready to do so![36]

By using "we," Talbot clearly expressed his hope that Herschel would be a partner to these efforts. If Herschel were amenable to the idea, Talbot wanted to keep the secrets between them for the time being.

This was my idea when I supposed that it might be best not to disclose at present the washing out process, the retransfer, &c. until brought to a state more worthy of publication, inasmuch as the Parisians would hardly be able to discover it immediately if it is no part of Daguerre's process, & I wished to show them that we could do something here which they could not imitate as yet. Do you think me right in this respect?

And indeed, Herschel most emphatically thought Talbot to be correct. In his unusually detailed letter the next day, 12 February (the meaning of which has been interpreted in some writings as indicating friction between the two men),[37] Herschel embraced Talbot's idea of working co-operatively but maintaining the separate identity of their discoveries: "I shall mention no further the process of washing out with the Hyposulphite if you disapprove of it & shall wait with patience for the revelation of your mode of fixing which must be a very chemical bijou." Clearly giving Talbot credit for also copying engravings, he excitedly spoke of the future potential where

> to do it beautifully is an art to be learned, & many and curious minutiae will have to be discovered and reduced into practice before either of us can arrive at that perfection which I am confident the thing is capable of. And it is very probable that in studying these processes each may hit on something useful in different lines and in comparing notes a process may arise better than either would have divined separately.

After giving detailed explanations of his discoveries to date about the exalting glass, Herschel declared to Talbot that he was already (and not surprisingly) leaning towards the scientific and analytical applications of photo-chemistry.

> You will easily see what a world of interesting experiments these points are likely to broach, on the laws of chemical absorption of media solid, liquid & gaseous, coloured & colourless. I only regret that my present position cut off almost from the use of my apparatus & Chemical agents will sadly impede me in their prosecution. However, some are very obvious & very easy – & these must be tried first.

In concluding the letter, Herschel responded to Talbot's speculations on the nature of Daguerre's process, returning to his 1831 experiments with platinum:

> Something like your notion of a liquid floating a metal plate had occurred to me – viz, that certain metals being covered with paper moistened with a soln of Platina mixed with lime water, might precipitate the latter, or rather might receive onto black metal the white precipitate which light produces in that solution.

Producing a direct positive by putting a light-toned negative on a dark ground was the later concept of the ambrotype and the tintype. More immediately, it was the visual basis of the daguerreotype, which depended on the reflection of a dark area in the silver. Without seeing Daguerre's productions Herschel had happened to hit on the way that they acted on the human eye (although he was far from the mark on the chemical basis). By the end of the year, Herschel himself

would be producing direct positives on glass with the character of ambrotypes.[38] This particular experiment, however, using the platinum solution of 1831, proved unsuccessful as Herschel "found that mere daylight is not strong enough to determine the formation of that precipitate." As in many of these letters, the postscript contains the most significant information. Herschel added a note on 13 February:

> My letter yesterday or rather yester-night was written after Posthour, & I now open it to enclose a PS, stating one or 2 results of today which has been sunshiny. 1st. I have discovered your secret of fixing, or if it is not yours it is equivalent. The ferrocyanate of Silver is not affected by light, therefore the further action of light on nitrated paper is prevented by a wash of Ferrocyanate of Potash . . . I do not ask you to tell me what your mode of fixing is but I think now I may venture to ask is it different from this?

Talbot's fixer – table salt – was in fact different, although it worked on much the same principle, but this underscores Herschel's respect for Talbot's stabilization rather than washing-out. Talbot replied on 14 February that

> I must congratulate you on your very original and beautiful discovery of the exalting power possessed by certain glasses, which appears to be placed beyond doubt by the specimens which you enclose . . . your ingenious method of fixing with the ferrocyanate, is different from mine; but whether better or not, I cannot say, time alone can test it properly. The ferrocte of silver is still present in the dark parts of the paper, mixed with silver or oxide of silver; will it not slowly act upon the latter & whiten it? I mean in the space of a twelvemonth for I have ascertained that these slow Chemical actions go on for a year or two, and produce great changes in the long run. Therefore, unless there exist reasons demonstrative of the Contrary, I should not think the ferrocyanated pictures safe from change, without a year's experience of them. I know some things will completely whiten the paper blackened with silver in a month (tho' kept quite dry) which have no apparent effect on it, in a day.

He concluded with a regret about circumstances similar to Herschel's:

> Having left all my apparatus & chemicals in the country, I have not attempted anything lately beyond one or two little experiments. I am prevented leaving town at present by domestic circumstances, but in a month or two, I hope to be able to produce some much finer specimens than I have hitherto shown; none of which were made with the intention of being exhibited, but entirely as trials & experiments.

On the day Talbot wrote him, 14 February, Herschel recorded in his diary that he had

pursued without intermission the Photographic transfer of engravings. Prepared and set going a lot sent me by P. Stewt [his brother-in-law, a printer, Peter Stewart] – But it being a decided cloudy gloomy day (except just towards evening) made little progress. Figures have a strange effect – fair women are transferred into negresses &c &c. The fixing by Prussiate Pot. works well in practice – but it enfeebles the work more than the hyposul. Pot. The enigma of the 'exalting glass' grows more obscure. Today it hardly had any sensible effect.

On the 15th, Herschel worked on photography until he had to go to the Royal Society committee meetings in the afternoon and on the 16th, a "tolerably sunny day," his "re-transfers much improved. Landscapes &c. Mezzotints especially good. . . . Got from town 2 very thick Plates of glass to bear a hard squeeze & urge home the engravings to be copied &c." A few weeks later, also troubled by difficulties in keeping intimate contact between the original and sensitive paper in the printing frame, Talbot thought to try an "air cushion, or bladder with a little air in it to keep the plants &c, tight against the glass, or India rubber in sheets."[39]

Continuing his correspondence with Herschel on 19 February, Talbot reported that he had been trying to use the ferrocyanate of potash to preserve the prints but that it failed in all his attempts. Perhaps, he thought, it was because "what I have obtained from the Chemists is not exactly of the same quality as yours . . . I presume I have not yet used the proper method with this liquid." Variations in the purity and strength of chemicals were frequently at the root of perplexing situations for the early photographers. It was not a new problem, nor one unique to photography.[40] Photographic chemicals were often made up in the kitchen by the photographer himself. Those purchased from a chemist adhered to no standard. Even discounting cheating and dishonest practices, few chemists employed the same approaches as others, and often were not consistent themselves from week to week.[41] Similar capriciousness was found in the manufacture of papers, which presented even greater problems. Most significantly, this letter marks a turning point in Talbot's strategy towards disclosing his process. He had still not published the manipulative details but must have been troubled by the growing number of speculative articles and independently-discovered processes that were blossoming almost daily in the journals. Someone else might easily stumble across his exact working method, or one so similar that his claims to priority would be mooted. In the meantime, also, Talbot had received the letter that Biot wrote him on 13 February:

No one here doubts for a moment the independence of your research . . . far from regretting that M. Daguerre's exhibition decided you to publish your results now, which you might have preferred to conserve with the object of further improvement, we are naturally pleased from a scientific point of view since we shall probably have this subject treated from different points of view and by different means.

Noting that Daguerre's hands were tied by the contractual situation in which he had placed himself, Biot encouraged Talbot by saying

it is still, Sir, in your power to be first by allowing all scientists to know of your invention, independently of all rivalry . . . for my part, I cannot urge you enough to publish and I take the liberty of expressing to you my regret in not finding your method explicitly given in the copy of your memorandum which was sent to us from the Athenaeum.[42]

The French scientists had been kept informed of Talbot's claims by Biot. In his reports to the French Academy, Biot could supplement what had been published in England with information gleaned from Talbot's letters.[43] There was certainly no longer any reason (if there ever had been) for Talbot to withhold information from his old friend Herschel. Talbot continued his letter of 19 February to Herschel (before any of the details of photogenic drawing were published) that

I will now inform you of the 2 methods of fixing which I discovered & which I have very often employed with success; requesting you not to mention them just at present. The first is the hydriodate of potash [potassium iodide]. This requires some nicety of management, because if too strong, it injures the ground; if properly managed it answers beautifully. The piece of lace I showed you at Slough was preserved by this means, & has lasted five years – often exposed to the sun. But my usual plan, is to immerse the design into a strong solution of common salt, and not to wash it out. Exposed to sunshine this often acquires a light lilac tint; but if it is an object to secure perfect whiteness this may be attained by proper management.

Herschel received this letter on the 20th and immediately put Talbot's fixing processes to trial. Of Talbot's common salt, Herschel recorded in his notebook that "it is very odd that the latter acts but little on the darkened parts rendering them only slightly redder. As to the Hydr. [potassium bromide] it turns yellow." On that same day, 20 February, Talbot wrote that "I am very much obliged to you for a sight

33. Sir John Herschel. *Leaf with superimposed character*. Silver-based negative on paper. 26 February 1839. Signed and dated by Herschel on verso, where he indicated that the negative was fixed with hyposulphite of soda. 13.2 × 6.6 cm. The Museum of the History of Science, Oxford.

of your photogenic drawings, some of which possess great beauty, and give promise of still more." After finally citing success with fixing with the ferrocyanate, Talbot expressed a remarkably casual view towards his first public disclosure of the long-awaited working details of his process.

If there is a meeting of the R. Socy tomorrow, I intend to request Mr Christie to read a note, briefly mentioning the nature of my processes; which will then be free to all the world to adopt, or to find out better ones for themselves. The weather both yesterday and today was of the most Anti-Photogenic description, in London.

It is unfortunate that there is so little documentation

available for this critical juncture when Talbot relented and decided to publish. Talbot's "Account of the Processes Employed in Photogenic Drawing," a concise letter to the Secretary of the Royal Society, was read at the meeting of 21 February.[44] Four days later, Biot revealed the details to the French Academy.[45] Talbot's publication temporarily eclipsed Daguerre, who had only communicated the existence of his main process on silver without disclosing details. Now that the matter was in the open, Talbot moved forward to publicize the English efforts as much as possible. On 27 February, he wrote to Herschel.

Will you allow me to communicate to M. Biot, who will of course mention it to the Académie des Sciences, your two beautiful methods of fixing or washing out, by the hyposulphite & the ferrocyanate? With respect to the former, I should also wish to add a reference to the work in which you first described the hyposulphuric acid, which I do not exactly know where to find.

Talbot displayed unusual cunning in this move, for Herschel's name was much better known in France than his own. The association with Sir John Herschel, "a mere hint from whom is of authority,"[46] could only add luster to any impression made by Talbot. The reference to Herschel's publication of the properties of hypo twenty years earlier would imply a historical continuity badly needed in combating Daguerre's claims to priority. Herschel's reply of 28 February, far from expressing disappointment that Talbot's 'chemical bijou' was merely common table salt, instead applauded the very simplicity of that which Talbot had achieved.

I had been trying various modes of rendering nitrated paper more sensitive – till I read your most curious account of your processes, which opens quite a new view of the subject and is altogether one of the most singular things I ever saw. You must have hunted down the caprices of these combinations with great perseverance and patience. When I read it I gave up further trials, your processes being so very simple & complete – I had most hopes of the Gallate of Silver which is affected by light very differently from its other salts.

As it happened, Herschel's abandoning of his hopes for the gallate of silver would significantly delay the progress of photography on paper. The compound would prove to be the key for Talbot's calotype process, which in turn was the key to making photography on paper viable. Herschel would never regret that the credit for this invention remained centered on Talbot. His genuine respect for Talbot's methods made him an enthusiastic partner and he told his friend freely that

(1) 13 leaves

Note on the art of Photography or the application of the Chemical rays of light to the purposes of pictorial representation, by

Communicated Read 14 March 1839
March. 14
1839. by Sir J. F. W. Herschel Kt. KH. VPRS.

Attention having been recently much directed to the very remarkable applications of the Chemical rays of Solar light to the representation of natural objects or works of art by a species of painting or drawing (to which it appears to me that the term adopted in the title of this note may on the whole be most appropriately applied) — by Messrs. Diepse and Daguerre in France and by Mr. Talbot in this country any contribution however small to our stock of information in the present stage of the subject

34. Sir John Herschel. *Manuscript for "Note on the art of Photography or the application of the Chemical rays of light to the purpose of pictorial representation."* This was Herschel's first paper on photography. Read to the Royal Society 14 March 1839. St John's College Library, Cambridge.

you are quite welcome to make such mention as you may think proper to M. Biot of my processes for washing out by the Hyposulphite of Soda . . . and perhaps it may be as well to send him a few specimens (unless you see occasion to the contrary) for which purpose & for your own inspection I annex a few – with remarks.

The nine specimens he described in the letter were primarily designed to show a range of different fixing options. Finally, Herschel became more emphatic in his objection to Talbot's name for his process: "Your word <u>photogenic</u> recalls van Mon's exploded theories of thermogen & photogen. It also lends itself to no inflexions & is out of analogy with Litho & Chalcography."[47]

Extracts of Talbot's letter to Biot were read at the Academy of Sciences in Paris on 4 March.[48] In a letter to Talbot on 7 March, Biot related that he had included the information on Herschel's hypo, but that "our chemists had guessed that this must have been the process he used and that he must have been led to this method by his previous work, precisely as you explained in your letter." Biot added his challenge to Talbot's terminology (although his alternative would not have satisfied Herschel): "do you not think that the names 'heliogenie' or 'photogenie' attributed to this new art are not too restrictive and that some more general qualification should be given to it, such as, for example, 'actigenie?'" But, he added diplomatically, "it is for those who discovered it to find a name."[49]

Talbot's reply to Herschel of 1 March betrayed the fundamentally empirical nature of his studies. He had stumbled on common table salt as a fixer by astute observation of the consequences of uneven coating near the peripheries of his paper. While he knew that a strong solution of salt converted the paper into something relatively insensitive, he had no idea what was the theoretical basis of this attribute.

My method of fixing with <u>salt</u>, answers best when the dark parts of the picture are <u>very</u> dark, & uniformly so, as when I take the outline of a plant, a fern leaf, &c. &c. In that case the ground does not sensibly suffer. It is apt to injure the finer shades. There is a proportion which when hit off gives beautiful results, as one immersion of the picture fixes it, & quite white. But upon what chemical reasons does the process depend, or why should it be <u>at all</u> possible, to obtain fixation in this manner? Nothing that is said in Chemical works concerning Chloride of Silver has any bearing on the subject, nor do they even mention its <u>insensible</u> state. I have tried Daguerre's receipt, with muriatic ether [ethyl chloride]. It does not succeed well with me; I should be glad to know if you have tried it.[50]

Herschel wrote back on 2 March but unfortunately this letter appears to be lost.[51] In the meantime, public interest in photography was growing. The new President of the Royal Society, Lord Northampton, featured various examples of early photography at the scientific soirée he hosted on 9 March. Herschel wrote to Maggie that "Nepce's [sic] pictures are to be at Ld N's tonight. Niepce is or rather was a French man!"[52] This private communication emphasizes that Herschel had previously caught no hint of Niepce's visit to England in 1827/28.

By mid-March, Herschel felt that he had made enough progress to communicate some of his observations to his scientific colleagues. His "Note on the Art of Photography, or the Application of the Chemical Rays of Light to the Purposes of Pictorial Representation," was communicated on 14 March to the Royal Society.[53] In this paper, Herschel provided a brief overview of the invention of the art, citing the contributions of Niépce, Daguerre, Talbot, and others. When Captain Beaufort called Herschel's attention to the account of Daguerre's discovery ("then, as now, concealed") in the *Compte Rendu*, the scientist recorded that "as an enigma to be resolved, a variety of processes at once presented themselves. . . ." As a chemical researcher of considerable attainment, Herschel immediately thought of the light sensitivity of the salts of silver and of applying his own pet chemical, the hyposulphites, as a preserving agent: "The picture should be <u>wholly immersed</u>, during a few seconds, then dipped two or three times in pure spring water & dried between blotting papers. . . ." He also recalled the similar properties of gold compounds, first described by Count Rumford and based on the work of the intriguing Mrs Fulhame.[54] While Herschel made it clear that he had not conceived of photography himself before 1839, he immediately thought to apply his 1832 experiments on the light sensitivity of platinum.[55]

With his March 1839 paper, Herschel submitted nearly two dozen specimens of various approaches to photography. Only one camera picture was included; most of the examples were copies of printed art. "The application of Photographic processes to the art of Copying Engravings, lithographs, mezzotints, or original drawings of every description, is one susceptible of great development, and capable of producing very beautiful results."[56]

Herschel had experienced some difficulties with such replications at first but he had now reached a high level of confidence. "Many of these are copies from very elaborate and highly finished ornamental steel-plate engravings and when examined with a powerful magnifier, will be found to render every stroke and dot with a fidelity quite equal to that of a printed impression."

Lacking established terms for the reversal of tone (terms which he himself would later supply), Herschel referred to

the "first transfers" (the negative) and "second transfers" (the positive printed from it). And it was at this point that Herschel clearly signalled that his interest in photography was becoming centered on in its facility as an analytical tool – another way of understanding the physical world around him – rather than as a means of artistic expression. "It was in prosecution of the experiments by which the processes best adapted for executing these transfers were educed, that I was led to notice some remarkable facts connected with the action of the chemical rays on nitrated paper." Herschel started with paper impregnated with silver chloride, but found it so "capricious" that he "was on the point of abandoning the use of silver in the enquiry altogether and having recourse to Gold or Platina...." Had Herschel continued this swing towards the noble metals, it is likely that a much larger proportion of early photographic prints would have survived. However, in much the same way that Talbot had discovered the fixing properties of table salt, Herschel noticed an anomaly on the edge of a print where the coating was uneven. This led him to trying other argentine compounds: silver chloride was found to be the least responsive, with silver acetate, nitrate, and carbonate found to be increasingly susceptible. He was also attracted to those silver compounds of organic origin, both animal and vegetable, "of these latter several, (especially the Gallate and Urate) are still under trial and present remarkable peculiarities."

By far the most intriguing mystery these preliminary researches presented to Herschel was the enigmatic effect that various colored glasses had in filtering the sun's rays. His observations could only be suggestive at this point, but based on the experience of twenty or thirty different kinds of glass, Herschel detected that the relationship between the color of the light and the action on photochemical surfaces was more complex than had been thought: "A very interesting and inviting field of research is thus laid open, which nothing but the almost total want of convenience for enquiries of this nature in my present position has prevented my entering into." Herschel outlined his future plans to form a pure spectrum of light in a prism and then analyze the photographic effects of its components. This was a logical extension of his father's experiments on infra-red light some forty years before. John Herschel also submitted a specimen of a print exposed under a certain sheet of glass. Inexplicably, the area covered by the glass darkened more quickly than the area next to it. Herschel's experiments ruled out the effects of moisture, heat, or reflected light, and could only conclude that the glass blocked certain rays of light that diminished the photographic effect. The properties of this mysterious and powerful 'exalting glass' were to form one of the major threads of Herschel's research – research that actually led to practical results.

Herschel concluded his paper with a review of the various approaches to making the pictures permanent. He had found nothing preferable to the hyposulphites, although he recognized that success with this demanded an amply exposed print: "photographs executed where the sun though tolerably strong was dulled by the London smoke drifted hither by an East wind – though sharp and strong, were almost completely obliterated by this and other reagents!" Photographers throughout the nineteenth century were troubled by this effect. Although it is doubtful that many understood why, most soon learned that print-out prints made on a dull day, even if given longer exposure, did not retain their strength or color in the fixing. This ensued from the fact that intense light precipitated the silver quickly in relatively large silver clusters. Weaker light, prolonged to give the same total exposure, eventually yielded a similar total density, but with lower contrast. The lower contrast resulted from the self-masking effect of print out paper. As light struck the paper in the image areas, the silver visibly darkened, and thus inhibited subsequent light. Printed quickly under strong light, the clearest areas of the negative would let through a massive dose of light before the darkening effect caught up in the print; consequently, they became very dense in the print. In weaker light, these same areas would start to darken and would then inhibit further darkening. While strong light precipitated the silver in relatively large clusters of silver deposits, weaker light produced smaller clusters. These smaller clusters interfered with the reflection of light differently, resulting in a warmer tone to the eye. In either case, an unfortunate side effect was that hypo attacked the periphery of these clusters. Expressed as a percentage of the total area of silver, the boundary of a large cluster was less important than the boundary of a small one. Consequently, larger clusters (resulting from brighter light) bleached less.

Most other chemicals, including the hydriodate of potash to which Talbot had turned, Herschel found to be of limited utility. He held out hope of identifying an even more simple process, finding that "when the paper used is very thin, pure water by washing out the nitrate of silver, effectually fixes the photograph...." Herschel determined that the type of paper affected the color of these, generally giving a brick red image. However, by washing these with hydrosulphuret of ammonia, the image was converted to a more conventional black tone.[57]

Talbot was increasing his efforts to make scientists on the continent aware of his invention He could not be at the reading of Herschel's paper, but asked the next day, 15 March, if Herschel would "like to send some specimens of your engravings to Baron Humboldt & the Berlin philosophers; I received a letter from him today...." In Talbot's letter, fixing/washing out was still a central topic: "As you

35. William Henry Fox Talbot. *Erica mutabolis*. Photogenic drawing negative. March 1839. Signed, identified, and dated by Talbot on verso. 12.3 × 11.4 cm. The Museum of the History of Science, Oxford.

told me that you had not quite succeeded in <u>fixing</u> with common salt I enclose a fragment done in that way; and 2 others (yellow) done with <u>iodine</u>." The most significant news, however, dealt with a new direction in Talbot's work – the use of bromine.

> I have found the Bromide of silver very sensitive and intend saying something respecting it in a paper to the R.S. next week. I enclose a scrap, exhibiting 4 different states of the Bromide of which one is nearly <u>invisible</u> (exactly as with the Chloride & iodide). Consequently a stronger solution of Bromide Potash will <u>fix</u> a drawing made with Bromide Silver. At least I presume that this consequence may legitimately be inferred. I send a few specimens of this sensitive paper. If they have lost their virtue, another wash of nitrate of silver will probably restore it.

This technique of using one concentration of a chemical to sensitize a paper and a stronger one to destroy that sensitivity is exactly what Talbot had done in his original table-salt-based photogenic paper. While the bromides eventually proved not as effective as Talbot wished, they were to prove to be an important contribution. Herschel immediately grasped their value and wrote back the next day, 18 March,

thanking Talbot for the examples of the new sensitive paper: "It really deserves the name, and in fact so far surpasses my expectations from any trials that I had made that I cannot help congratulating you on your hitting on so valuable and curious a discovery." In reply to Talbot's request for a few specimens to send on to Baron Humboldt in Berlin, Herschel explained that he had "handed over all my best specimens of copies of Engravings to the R.S. and owing to want of Sun yesterday or today I have none worthy of sending to Baron Humboldt...." In the P.S. to the letter, Herschel relented and enclosed a number of examples demonstrating different approaches to making the pictures permanent.

> I have laid my hands on a few specimens not of the best but passable, which perhaps you may think worth sending to H[t]. The brown-looking one with the palm trees is not fixed – the others are. The Bas-relief is fixed with a sol[n] of Ferrocyanate of potash containing $^1/_{100}$ its weight of the salt and seems not disposed to fade.

Apparently in deference to Talbot (but in quotation marks), Herschel referred to "photogeny" in connection with a speculation on how Daguerre's process might work. Thinking that a recent paper in the *Annales de Chemie* contained a hint of Daguerre's methodology, he considered the use of a chlorine compound.[58] "The 'oily liquid' has also been called <u>chloric ether</u> [ethyl chloride] and as you mentioned 'Muriatic Ether' in a late letter as one of Daguerre's reagents this seems to strengthen the suspicion that we are to look in this direction for his process." While Herschel was to be proven wrong in this speculation, this passage strengthens the impression that he and Talbot, perhaps for nationalistic reasons, considered themselves pitted against Daguerre.[59]

On 21 March, Talbot communicated his use of bromine to the Royal Society in a "Note Respecting a New Kind of Sensitive Paper." This paper, using silver bromide, "is very sensitive to the light of the clouds, & even to the feeblest daylight. But it is insensitive to radiant heat & therefore suffers no change from the warmth of the fire before which it is dried." Again, only a synopsis would be published in the *Proceedings*, but Talbot's original manuscript has been preserved.[60] In it, he stated one of the problems inherent in the new field.

> From want of an acknowledged unit of measure it is difficult to define its <u>degree</u> of sensibility: but the following experiments made during the bad weather of last week will serve as an approximation. At 5 P.M. in very cloudy weather in London, this paper being placed in a Camera Obscura & directed towards a window; a picture of the window bars was obtained in six minutes. Shortly

after sunset, being then still darker, the paper exposed near a window changed its colour sensibly in 20 or 30 seconds.

Another critical section of this paper, not fully covered in the *Proceedings*, is of great historical interest, for it revealed details of Talbot's late 1834 work in Geneva. Talbot explained that

the memoir which I had the honour to present to the Society on the 31st of January, and which contained my first account of the art of Photogenic Drawing, was written in the course of a few days & therefore necessarily less perfect than I could have wished. In re-considering it, altho' I do not find that anything has been erroneously stated, I perceive that there are some omissions, arising from haste of composition.

Talbot, indeed, was to lament that the surprise of Daguerre's announcement obliged him

to use all possible expedition in drawing up a statement, and exhibiting specimens to the Royal Society. If I had known that M. Daguerre intended to keep his process so long a secret, I would not have written on the subject in so imperfect and hasty a manner. But I had no choice; at least I thought I had none, which comes nearly to the same thing. But I never supposed for a moment that this memoir would be mistaken for a regular treatise written by me on the Photogenic art, or as containing all the facts which I was acquainted with.[61]

Talbot explained in this addendum that

Another application of the same principle, is to make copies of any writing. This is so very easy & each copy takes so short a time in making that I think it may prove very useful to persons who wish to circulate a few copies among their friends of anything which they have written, more especially since, if they can draw they may intersperse their text with drawings which shall have almost as good an effect as some engravings— The chief expense will be from the silver used, the quantity of which is however small: but no <u>press</u> being wanted it cannot fail to be, on the whole, a very economical process.

In isolated phrases in Talbot's personal notebook, there was growing evidence of his interest in modes of public expression. On 3 March, he recorded various related thoughts: "Nature magnified by Herself, or, Nature's Marvels 'And look thro' Nature up to Nature's God'" and the more simple and eloquent phrase, "Words of Light." In a letter on 21 March, Talbot explained his idea to Herschel: "The enclosed scrap is to illustrate what I call 'Every man his own printer & publisher' – to enable poor authors to make

36. William Henry Fox Talbot. *Botanical specimen*. Photogenic drawing negative. 13 November 1838. Dated by Talbot on verso. After achieving success in 1835, Talbot seems not to have made very many photographs in 1836 and 1837. Near the end of 1838, shortly before Daguerre's public announcement, he produced a number of botanical photographs, apparently with the intention of revealing his photogenic drawing process to the public. 17.4 × 9.6 cm. The Royal Photographic Society.

37. William Henry Fox Talbot. *Photographic copy of type.* Negative. Ca. 1840–3. The possibilities of photographic reproduction of handwriting and type, and the implications that this would have for publishing, occurred almost immediately to Talbot. Virtually all printing today (including the present book) is produced using a process based directly on this concept. 6.1 × 9.8 cm. The Fox Talbot Museum, Lacock.

facsimiles of their works in their own handwriting. It is a poor specimen, the hyposulphite having failed somehow to do its duty." Although he could share only a rough example, it shows that Talbot had turned, at least temporarily, to Herschel's hypo, a decision that he was to reverse a few weeks later. Even at this early stage, the main line of Talbot's thinking was the possibility of publication employing photography. Sir William Hooker had responded so enthusiastically to the early examples he received that Henry Talbot was encouraged to propose what would have been the first publication to have been illustrated with photographs. Sending Hooker a photogenic drawing of a plant, done in Wales "with a November sun," Talbot asked "what do you think of undertaking a work in conjunction with me, on the plants of Britain, or any other plants, with photographic plates, 100 copies to be struck off, or whatever one may call it, taken off, the objects?" Talbot also enclosed one of his first examples of *cliché verre*:

> Pray accept also the enclosed Photographic imitation of Etching, an invention which I made in the autumn of 1834. The present specimen was however not made by myself, I cannot draw so well any body who can draw, may multiply their drawings in this manner, viz. by drawing them on varnished glass, & using photographic paper for the impressions.[62]

Sadly, Hooker did not respond directly to Talbot's suggestion of a joint publication. However, as a botanist, what he was

most pleased with was the imitation of an <u>etching</u>. Can that be made available for Botanical drawing? Plants should be represented on paper, either by <u>outline</u> or with the shadows of the flowers (which of course express shape) <u>distinctly</u> marked. Your beautiful Campanula hederacea was very pretty as to general effect: – but it did not express the swelling of the flower, nor the calyx, nor the veins of the leaves distinctly. When this can be accomplished as no doubt it will, it will surely become available for the publication of good figures of plants.[63]

As it was, silver photography would prove inadequately permanent to fill the publication role that Talbot envisioned for it. However, his later work in photographic engraving would still employ the sun, substituting printer's ink for the more ephemeral silver, and this would realize his vision.

By the time of his 21 March letter to Herschel, Talbot had read the description of Daguerre's paper process in the *Compte Rendu* of 18 and 25 February, and had determined that "the muriatic ether forms no part of Daguerre's <u>grand</u> process, but it is only a sensitive paper which he has set up <u>in opposition</u> to mine; not nearly so good I think." Talbot was entirely correct in this assessment. Daguerre had explored quite a number of different approaches during his years of experimenting. But Daguerre had not been trained in scientific methodology, and was incapable of building on his experiences. His conception of the range of possible approaches was undoubtedly limited. He must have imagined that Talbot's process, being on paper, could be no better than his own attempts on paper. The Daguerreotype – the image on a silver plate – was both his first and his last successful process.

By 27 March, Herschel could report to Talbot that "having had 2 days of occasional (very tantalizing) sunshine, I have tried some new things," wryly noting that "the want of Sunshine however is a terrible drawback on these exp^ts. If the subject had been started while I was in Africa there would have been no end of the results." Had photography been introduced sooner, the consistent sunshine, better health, and comparative lack of distractions that Herschel enjoyed at the Cape almost certainly would have guaranteed superior progress. Several ideas were covered in this letter.

> 1^st– by placing an etching on a <u>smoked</u> glass . . . behind an <u>aplanatic</u> lens . . . a copy of the etching <u>reduced</u> on any required scale is obtained thus imitating Gourad's celebrated process for taking off engravings in varied dimensions . . . the scale may be enlarged. The reducing process on trial succeeded perfectly, only a care is required to follow the Sun. By the use of highly sensitive paper this inconvenience would be much diminished – & by attaching the whole apparatus to an equatorial with clock-motion would be eliminated.

Enlarging remained a problem for much of the nineteenth century, with exposure times often extending to the better part of an hour. Herschel's idea of adapting the clockwork drive employed by astronomers to keep their telescopes fixed on a star would later be taken up by some enlarger makers (although it is doubtful that they realized who first thought of this approach). The second point in his letter was the hint that his "attempts to produce a sensitive paper at a single washing with one liquid promises [sic] to be not wholly unsuccessful."

Talbot might have been taken aback at what Herschel was pursuing. In his notebook on 26 March, Herschel, after "considering the instability of urea and its animal nature, and reasoning on the action of uric acid–I tried urea (in that state in which nature provides it freely)...." Using it as a wash over silver nitrate, he found that "the effect is most remarkable. It produces a paper infinitely more sensitive than the nitrate and which does not blacken over in the absence of light.[64]" Herschel had also deduced why Talbot was having so much trouble with the use of hypo:

Your sensitive paper is so fully impregnated with Silver that the Hyposol. Soda in the degree of dilution most convenient for use precipitates the Silver as Sulphuret (see my papers). This Evil may be avoided by substituting the H.S. of Ammonia for that of Soda or by adding ammonia to the H.S. of Soda.

Herschel's earlier published description of the 'sulphuret' was as silver hyposulphate, which would have been rapidly converted to silver sulphide. The last major point in this letter dealt with the "very striking" differences he was getting with his exalting glass between Talbot's paper and plain nitrated ones. Herschel concluded with a P.S. that "I protest against people taking out patents for any little step they may make in the application of this or any other new method in the arts." This protest was not against Talbot, whose position on his main discoveries Herschel strongly supported in patent controversies, but rather against attempts by others to take advantage of this.[65] Talbot's reply of 28 March was that

I am glad that you agree with me respecting the attempt of Mssrs. Willmore, Havell, &c. to take out a patent for a process which I have myself executed 5 years ago at Geneva. In the Literary Gazette of next Saturday, I shall insert a letter to the Editor on the subject. They have however, abandoned the patent.... P.S. I should like to communicate what you say respecting enlarging etchings to the Literary Gazette. Have you any objection? Else Havell will be taking out a patent for it.[66]

Talbot was cheered by very encouraging results with the new bromide paper.

I am very glad to know that the addition of ammonia will prevent the formation of the sulphuret of silver, which circumstance has occurred to me several times and spoiled my pictures. Accurate experiments on the new sensitive paper gave the other day, the time of discoloration in daylight (not sunshine) two seconds to three seconds. Biot finds it nearly instantaneous, & is making a great many exp[ts] on it. He says "Je ne crois pas qu'il soit possible de trouver une substance plus sensible." Do you think he means by this to express an opinion that it is equal in sensibility to Daguerre's substance?

Feeling that he was perhaps closing the gap with Daguerre, Talbot's mood regained its optimism.

Today I tried with my Bromine paper to copy my neighbour's house. Notwithstanding the unfavourable weather the result was very encouraging. In some places the individual bricks are given which compose his façade. I am therefore very desirous of ascertaining the proper mode of fixing a Bromide picture, without injuring its delicate shades; I wish you would make some experiments thereon.

Finally, in referring to Herschel's enlarging/reduction process, Talbot declared that

The art of expanding or diminishing an etching by the Camera Obscura is one which I have long contemplated, but to you belongs the merit of having first realized it. I did not speak of it in my memoir to the R.S. because I had laid down a rule for myself not to speak of what I had not tried.

In a follow-up letter the next day, 29 March, Talbot passed along some messages from Biot to Herschel, including an invitation to Talbot and Herschel to come to Paris to see Daguerre's works, an invitation made by Daguerre himself. Herschel was already, in fact, planning a trip to France and would have the opportunity to take Daguerre up on this invitation. He wanted to attend his brother-in-law's wedding and also to confer with François Arago about the magnetic observations to be done in conjunction with the upcoming Ross Antarctic Expedition. Talbot, inexplicably, would not go to France to see Daguerre, even though Talbot's interest in his rival's process was abundantly clear.

Herschel's reply of 31 March, is unfortunately missing and the next letter available to us is again one from Talbot, this one dated 10 April.[67] Talbot confessed that "I send the enclosed not as being a very well-chosen object, but as a specimen of fixation by Iodine." The tentative nature of these early photographic experiments was emphasized in the statement that this specimen "does not change at all by

38. Sir John Herschel. *Letter with photograph.* Silver-based negative printed directly on a letter to William Harvey at the Cape of Good Hope, dated 6 April 1839. In order to avoid the extra postage imposed on an enclosure, and possibly to prevent theft, Herschel simply made his example directly on the letter. Virtually all early photographs were produced on writing papers anyway. Herschel employed Talbot's table salt fixing, realizing that hypo would be unobtainable at the Cape. Harvey, an important botanist, unexpectedly had to quit the Cape early in 1839 due to failing health, so it is likely that the letter was returned to Britain unopened. Image area 7 × 19.5 cm. Wellcome Institute Library, London.

39. Sir John Herschel. *Lace with flowers*. Experimental lead-based negative on paper. 19 April 1839. Seeking a more sensitive paper, Herschel devised a lead and urea process that "so far surpasses in beauty & minute exactness of detail anything I have got before that it may date as an Epoch in the art of Photography." Producing a "fine rich velvety crimson" tone in a few seconds, this paper unfortunately proved to be unpredictable in its results. It is, however, typical of the hundreds of experiments Herschel made in attempting to understand the underlying mechanisms of photography. 8.5 × 9.9 cm. The Museum of the History of Science, Oxford.

daylight today, but in truth it is very cloudy weather which does not afford a sufficient test of the fixation." Talbot's troubles with patents were already starting to plague him and he couldn't resist mentioning the problem to Herschel: "I have sent an account of your diminished pictures to the Literary Gazette where you will find considerable vituperation of me by an artist of the name of Willmore." Ending on a more positive note, Talbot enthused that "yesterday I obtained some very interesting results, and I am in hopes they will lead to a new branch of the Art."

Some insight into Herschel's attitude towards photography during this period is revealed in a letter written by his wife to Aunt Caroline. The weather had warmed, and Maggie noted that Herschel

is in admirable health now, & enjoys this lovely spring weather excessively, for his favourite recreation is out of doors, planting his Cape Bulbs, & whenever he is not to be found in his study, we are sure to trace him to the bulb beds ... [he] confesses that if this weather were to last, England would be as pleasant as the Cape.

But new interests were mixing with old.

Herschel has also been busying himself about another favourite occupation because connected with Chemistry – viz the Photographic drawing which is now the scientific rage in this country. The process is not all perfected yet, and Herschel is daily making great improvements in it – in the meantime he sends you a copy of his new coat of arms, copied after the Photographic (or as some call it) Photogenic fashion.

After describing the process, Maggie continued that

I did not think my description would run out so long, but I see Herschel so happy & so busy, about it, & trying new chemical substances every day, that I scarcely think of anything else myself. His experiments will be interrupted for a few weeks after the 1st of May, as we are going to Nantes to see my youngest Brother receive the Bride who has been destined for him from almost her childhood.[68]

On 22 April, then preparing to go to France, Herschel wrote to Talbot to express

many thanks for your photograph fixed by Iodine. It is curious that I had tried alcoholic solutions of Iodine without success. Neither have I ever been able to fix on nitrated paper, with common salt in any proportion. Total or at least destructive obliteration has always been the consequence. Even the salt in our Spring water is deleterious, to an extraordinary degree of which more presently.

Photography was only one of Talbot's new activities. Herschel modestly demurred about the gift of Talbot's newly published book, *The Antiquity of the Book of Genesis*, that "I wish I were learned enough to thank you duly for your work...."[69] After a brief discussion of the book's implications, Herschel hastened "to return to our Photographs. Having had 2 or 3 good days of late I have made one or two good hits." The first of these was

a capital improvement in the mode of transferring, in which two, 3, or 4 printed/photogrd surfaces are made to conspire in their action on the light as it transverses them, before it gets to the paper. The exact superposition is accomplished by fiducial pin holes. To save the passage of light through more papers than necessary, I photograph both surfaces of each paper, taking care to operate a semi-inversion as to right and left, which is easy.

This printing method of using several registered negatives may seem futile in its complexity. However, obtaining adequate density in a negative for subsequent printing was still quite difficult for both Talbot and Herschel, and any

approach that would help this might justify the efforts. Talbot negatives survive that indicate that he experimented with this suggestion, in one case as late as 1845.[70] The second technical point in Herschel's 22 April letter came close to realizing a goal that he had pursued nearly from the start of photography. On 16 February, Herschel recorded in his notebook that instead of hypo he had

> tried pure water to wash out. Why should it not – the nitrate is a soluble salt. Is succeeds perfectly but the washing carries away with it a great deal of the reduced silver . . . pure water . . . by the way gives a red colour, not brown. . . .

After a few trials, Herschel concluded this was unreliable, but in his 22 April letter to Talbot he could again report

> a new and perfect process of fixing. I have already mentioned fixing by water. But on further trials it failed, without my being able to say why. But as soon as I found how very minute a proportion of Muriate of Soda spoils the Picture, I understood the whole affair, and on trying pure water (snow-water at least, having no means of distilling) the success was complete. The fixation is complete–the picture perfectly uninjured and unaltered in colour. To ensure success the picture must soak for 3 or 4 hours in 3 waters, draining and absorbing by blotting paper at each change of water. If the paper be very thick the last water may have a dash of hyposulphite in it, but it is better to avoid this.

This comment resulted from the triumph Herschel recorded in his notebook on 19 April. He had long been disillusioned with hypo which when

> much used at lengths gets loaded with Sulph^t of Silver and deposits it on the Photographs spoiling them completely. That it greatly enfeebles – and in many cases quite washes clean out the picture . . . finding also that the evaporation of spoiled Hyposulph. to dryness does not restore its power of fixing but rather makes it worse I resolved once more to try water.

Urban sprawl was having its effect; Herschel finally identified the changing water at Slough as being the source of the trouble:

> I observe here that my pump water is now at least 5 fold more loaded with muriates than it was 5 or 6 years ago – so much so that it is quite unusable when silvery solutions are concerned. And to this I now began to attribute the frequent failures I have hitherto experienced in attempts to fix by mere water. Accordingly I now tried snow-water (ie. pure). The success is complete.

The area around Slough and Windsor was coming under increasing developmental pressure, partially as the result of the popularity of the new queen, but mostly from the effects of the railroad. It is not surprising that Herschel's source of water was becoming contaminated. At first glance, the deleterious effects of these minerals may seem strange since Talbot used the same salt as a fixer. However, Talbot employed a very weak solution of salt to form a light-sensitive silver chloride. The key to Talbot's success was in then using a strong enough solution to put the silver chloride formed into a relatively insensitive state. The remaining silver chloride was not soluble in water, which explains why Davy and Wedgwood had been unsuccessful, even with soap. As soon as Herschel isolated this, he realized that pure water would fix Talbot's images by removing the soluble silver salts, but could not wash out the remaining insoluble ones. By using rainwater and thus avoiding the formation of any chlorides, Herschel was able to restrict his coatings to water soluble silver salts. The unexposed ones could be washed out quite effectively, making the pictures permanent. Assuming no contamination, this was an effective approach; some of Herschel's water-fixed images survive to this day, apparently no worse for the wear than many of their contemporaries that had been hypo-fixed.[71]

The major disclosure in Herschel's 22 April letter, though, was that of

> a new mode of preparing paper. It is highly sensitive though less so than your wonderful Bromide papers but the change of tint progresses more steadily passing from pink to rich crimson and finally to perfect blackness. I observe in your paper the first impression is very sudden after which it seems to relax in rapidity of change. In some respects this is inconvenient as a photograph unfixed cannot be exposed a moment without damage.

This was Herschel's 'plumbozoic' paper, no. 1038. In his diary on 19 April he celebrated a "very fine sunny day. Photography. Discovered a new process by means of the Pinkish Col^d precip of Lead &c and nitrate silver – as per hint obtained yesterday on rough trial," and the "preparation of a stock of fresh papers & various trials for tomorrow." In his research notebook, he recorded with delight that

> their effect is superbly beautiful. A fine rich velvety crimson. And used in combination with a duplicated transfer, the resulting copy so far surpasses in beauty & minute exactly of detail anything I have got before that it may date as an epoch in the art of Photography. Havell would have a patent on it in a week.

With what appeared to be such a major breakthrough,

Herschel returned to some secrecy with Talbot in his letter of the 22nd:

I annex a specimen of the paper so prepared but as I am still employed in "perfectionizing" it – in varying its tints – and in "approfounding" its chemical nature, I mean to keep it yet a while a secret. I will only say further of it that it is no chance discovery. I found it where I looked for it, and where I know I shall find something better worth looking for.

Experiments with the lead/urea approach continued through 25 April, on which day Herschel recorded in his notebook that

having very highly varnished some engravings on both sides until completely transparent, the effect on Plumbozoic paper (Exp. 1038) is most curious & beautiful. The richness of copies is really surprising & it is done with great rapidity. 10^m or $1/4$ hour in a good sun is enough to give the utmost effect.

Herschel added laconically, "there is however great difficulty in getting there." The very next day, 28 April, Herschel's notebook entry for experiment No. 1042 enthusiastically recorded that "today I discovered a paper so very sensitive that it equals or even surpasses Talbots & that without Bromurets, and with the decided advantage of growing regularly blacker & blacker by continued exposure, up to a pitchy blackness." Mulling over his recent experiments, Herschel thought to try a first coat of pure hydrate of lead, followed by a wash of silver nitrate. Although this did not equal the sensitivity of his plumbozoic paper, "still it was clear that something might depend on a certain state of division. . . ." The next step in Herschel's thinking demonstrates the supportive effect that Talbot and Herschel were having on each other. Indeed, lacking the stimulus of this sort of symbiosis undoubtedly contributed to Talbot's slow progress before 1839. Herschel thought that "this might be analogous to the state in which they are placed by Talbots 1^{st} process for increasing the sensibility of muriated paper (successive washes)." By applying Talbot's technique to compounds of lead, Herschel found that "the effect was most extraordinary. It produced a paper of such sensibility that merely passing it through a sunbeam, held between the finger & thumb, a clear outline of the finger &c was traced. It darkened under the eye before an open window in cloudy daylight. . . ." It was a marked advance that Herschel could not afford to ignore: "applied myself therefore – though sorely pressed for time (having to set off for Nantes tomorrow)." He put off his departure for a day. The process was quite simple:

I find the following recipe answers well. 1^{st} wash. acetate of lead 2^{d}– ammonia + weak sol^n of Mur. Soda 3. – nitrate of silver, drying between each. Being a tolerably sunny day, I find that in 60^{sec} a very fine transfer of an engraving (rendered transparent by varnishing both sides) is given. The colour is a rich lilac-purple passing as it deepens to the tint of fresh ink, & thence to intense black. Having by neglect left a transfer 5^m exposed on the frame, I found it spoiled, being completely weakened.

At this time, Herschel had no intimation that his processes based on lead would prove to be unstable and a failure. Continuing in his 22 April letter, Herschel sent Talbot "a few specimens (unfixed) of my progress in the Copying of Engravings – but as I am soon going to Paris (May 1) . . . I must beg the favor of you to return them to me soon . . . I have not time now to prepare fresh ones for the Frenchmen."

On 25 April, Herschel withdrew his "Note on the Art of Photography" from publication. However surprising this action may seem, it was not at all an unusual one for an author of a Royal Society paper to take.[72] Herschel withdrew his paper because he felt he was making such regular breakthroughs that the information contained in the paper was already obsolete.

The remaining letters sent before Herschel departed for Paris were both written on 27 April. Talbot related that he had "discontinued lately the use of hyposulphite as a fixer, in consequence of having spoiled some pictures with it, without being able exactly to ascertain why. But I think it arises from something in the paper, since others made at the same time were properly fixed." This has been interpreted by some historians as meaning that Talbot found hypo to be useless. However, he obviously saw these difficulties as temporary ones: "Probably a few experiments directly made for the purpose, would show the cause of failure, and the way to avoid it in the future." The main subject on Talbot's mind, though, was France. He accepted Herschel's offer to take along a package of examples. After relaying the message that Biot had been pleased with Herschel's prints that Talbot had sent on, he sought to prepare his friend for the upcoming trip.

When you are in Paris you will no doubt have an opportunity of seeing Daguerre's pictures. I shall be glad to hear from you, what you think of them. Whatever their merit, which no doubt is very great, I think that in one respect our English method must have the advantage. To obtain a second copy of the same view, Daguerre must return to the same locality & set up his instrument a second time; for he cannot copy from his metallic plate, being opaque.

In this, Talbot had limited his thinking. Precious

40. Sir John Herschel. *Three leaves*. Photogenic drawing negative. Labelled in pencil on verso, "512. Water fixed." 1839. In his research notebook on 19 April 1839, Herschel joyously recorded that "today also I succeeded in another <u>great</u> desideratum." If his hypo fixer was overused, it deposited sulphur compounds in the photographs, enfeebling some and spoiling others completely. Also, hypo was then expensive and difficult to obtain. Employing pure silver nitrate and avoiding the slightest contamination with chlorides, he was able to produce a light sensitive paper where the un-used silver nitrate remained fully soluble in water. By carefully controlling the conditions (more carefully than would have been practical in commercial practice), Herschel could make permanent photographs using just water as a 'fixer.' In this case, the purity came from employing melted snow. 9.7 × 12.2 cm. The National Museum of Photography Film and Television.

41. William Henry Fox Talbot. *Roofline*. Salt print from a photogenic drawing negative. May 1839? It is likely that Talbot's pencil note on verso, "fx 1.12," refers to his experiments on adding ammonia to the nitrate of silver. This increased sensitivity and improved the color. 21.3 × 17.4 cm. The Royal Photographic Society.

daguerreotypes remained unique objects; within a short time they themselves would become subjects for the camera. In fact, Talbot soon saw his own paper negatives as a way of copying daguerreotypes. He continued,

> but in our method, having first obtained one picture by means of the Camera, the rest are obtainable from this one, by the method of re-transferring, which, by a fortunate & beautiful circumstance rectifies both of the errors in the first picture at once; viz. the inversion of right for left; & that of light for shade. N.B. I have found that Camera pictures transfer very well, & the resulting effect is altogether Rembrandtish.

The apt comparison of photographic prints to the broad and moody tones of Rembrandt's work was one to be repeated frequently in contemporary reviews. However, this passage strongly implies that Talbot had not made positive prints from any of his camera negatives until a fairly late date, long after Herschel had succeeded with them. This is surprising, for Talbot had grasped the underlying concept of the negative/positive process at least as early as 1835.[73] Perhaps he had previously tried this only with photogram negatives and not with camera negatives.

Herschel's letter of the 27th is preserved in both draft and final form.[74] To Talbot, he wrote

> I sit down in great haste just to mention to you a step I have made this morning of a very decided character with respect to the discovery of a paper even more sensitive I think than the Bromine specimens you sent me, with the addition of this valuable property that the Bromine paper wants, viz. that the tint goes on deepening in arithmetical progn with the time, whereas yours comes to a still stand very soon. It is moreover prepared with materials of the most ordinary and abundant description, without Bromine, or any chemical rarities.

The draft of this letter (essentially the same as the one sent) had been written just after Herschel's first success with the new process. In the draft, however, he expressed a lament that he left out of the version sent: "I wish I were not hurried to Paris as I am convinced that one or 2 days more on this new scent would have led me to some most valuable conclusions." The new approach appeared to hold great promise.

> I annex a specimen of the paper and also of a photograph

done with it in 60 seconds exposure to the light of a cloudy sky with occasional glimpses of sun just enough to cast a shadow. To try its efficiency in the Camera obscura, I put up a specimen of the paper ~~in the early part of the day~~ while the sky was densely clouded, as it continued to be the whole time of exposure. In 45.m The picture was formed & more intense than any I have yet procured with the Camera in a whole day. – In 2.h The picture was strongly and decidedly coloured and quite as complete as could be desired – as to sharpness &c.

This serves as a reminder as to just how much difficulty Herschel, Talbot, and other experimenters were having making negatives in the camera. "Whole day" exposures were being employed. The sun, still weak in the spring, remained a variable, but "the day growing brighter lately I placed another paper in the Cama – In 10m the picture though faint was distinctly outlined and might serve as a traveller's sketch." The lack of specialized terminology and standards by which to describe results led to comparisons with known phenomena. "In less than 1s in a sun enough to cast a feeble shadow, the discoloration was decided & even strongly marked. In 20s in such a sun the tint is that of ordinary writing ink when smeared with a feather on paper." Herschel ended his letter expansively and with an unusual lapse of modesty.

> I think therefore we are safe in declaring that the process of photography is now placed within the reach of every body – is quicker than copperplate engraving (ie. than the more elaborate sorts) – is susceptible of quite as great delicacy as the most finished copper plate work – and is quite available for self registry of all sorts.

This was written on Saturday. On Monday, 29 April, Herschel recorded in his diary a day of "photography and bulb planting," taking advantage of long exposure times to slip in horticultural pleasures. The very next day, he was on his way to Paris. Less than three months had passed since Henry Talbot had made his trip to Slough on 1 February to share with his old friend Sir John Herschel the latest branch of interest in his scientific work. Herschel departed England full of confidence that his methodical experiments, guided by inductive reasoning, had just led to a fundamental solution far superior to Talbot's earliest efforts, and perhaps even to those of Daguerre. In this, he was to be proven wrong.

IV Storm Clouds & Rainbows;
 Summer 1839 – Spring 1840

"IT IS HARDLY saying too much to call them miraculous" – so reported Herschel to Talbot immediately on seeing his first daguerreotype. At the beginning of May 1839, within days of leaving his "photography and bulb planting" at Slough, Herschel arrived in France and met with Louis Daguerre. It was at once a thrilling but a sobering experience. The fantastic detail and tonal richness of the silver plates were as seductive to Herschel as they were to everyone who had seen them. Clearly, Daguerre had long since passed those boundaries Herschel assumed might limit the art of photography. While suggesting fabulous new possibilities, it is not surprising that these splendid pictures made him realize that the work he and Talbot had done so far was rude by comparison. On 9 May, he wrote to his friend that "though much pressed for time I cannot resist writing to you first to say that I have this moment left Daguerre's who was so obliging as to shew us all his Pictures on Silver saved from the fire which burned his house and also one on glass."[1]

Occurring just two months previously, the fiery destruction of the Diorama, Daguerre's life work and main source of income, had become one more element in the drama that was the birth of photography.[2] But Herschel was not to be diverted from his enthusiasm for the images that he saw:

It is hardly saying too much to call them miraculous. Certainly they surpass anything I could have conceived as within the bounds of reasonable expectation. The most elaborate engraving falls far short of the richness & delicacy of execution. Every gradation of light & shade is given with a softness & fidelity which sets all painting at an immeasurable distance. His times also are very short. In a bright day 3m suffices for the full effect up to the point where the lights become excessive. In dull or rainy days & in the interior of an apartment (for copying sculptures and pictures) from 5 to 10m are requisite.

The beautiful effect of ~~the~~ River Scenes in rain must be seen to be appreciated. Sculptures are rendered in their most minute details with a beauty quite inconcievable [sic]. In scenes of great detail, every letter in distant inscriptions – every chip in the corner of every stone in every building is reproduced & distinctly recognizable with a strong lens all the grainy stones in distant chaussées are faithfully rendered.

In his excitement about the quality of the images, Herschel almost forgot to comment on the nature of Daguerre's process; it was left to a footnote in his report to Talbot to add that "the pictures are on very thin sheets of plated copper, neither expensive nor very cumbersome. A traveller may easily carry in his trunk a sufficiency for all his purposes." Daguerre's actual process was to remain a tightly guarded secret for several months yet and there would have been no

42. Richard Beard. *Daguerreotype of William Henry Fox Talbot*. Ca. 1842. While Talbot clearly understood the importance of the portrait market, he was never able to make a commercial success of calotype portraiture. At the time this portrait was done, his rival's process had a much shorter exposure time and much greater detail. Taken with Wolcott's Reflecting Apparatus, a camera employing a large concave mirror instead of a lens, at the Royal Polytechnic Institution. 5.1 × 4.1 cm. visible image; 14.5 × 14.0 cm. frame. The Fox Talbot Museum, Lacock.

way for anyone, even someone like Herschel, to guess how they were made merely by examining one.

Herschel departed from Paris the day after seeing Daguerre's pictures to attend the wedding of his brother-in-law (and later photographer), John Stewart.[3] In spite of his brief exposure to the daguerreotype's charms, Herschel was fully confident that Talbot would be as excited as he. "In short if you have a few days at your disposition I cannot command you better than to come & see. Excuse this ebullition...."[4] The year 1839 was to prove to be a very rough one for Talbot. When the race for photography was announced, Henry Talbot started as second from the mark, burdened with a product initially inferior to that of his competitor. Throughout much of 1839, Talbot was fighting an enemy that he did not know, for the working details of Daguerre's process remained secret until August. Few of Talbot's countrymen were as supportive as Herschel and England herself offered Talbot no official help. The problem had little to do with Talbot. In large part, the situation

mirrored the differences in the patronage of science between France and England. France's scientific establishment was highly centralized and state-supported. England's tradition, bolstered by its class structure, was more that of the gentleman amateur.[5] The Royal Society of London, the premier organization, was by 1840 more settled than it had been at the time of Niépce's visit. But it remained in many ways a gentleman's club with no remit to promote national development. Only occasionally did it disburse funds or co-ordinate projects for the government. Its rules specifically prohibited the Royal Society from endorsing any work of nature or of art. The other significant scientific group, the British Association for the Advancement of Science, was less elitist and – at least by intent – more progressive. The BAAS had been established largely as a result of Charles Babbage's vitriolic denunciation of the state of affairs that led to the election of the Duke of Sussex, rather than a scientist, as President of the Royal Society. But it was some decades before the level of professionalism envisioned by its founders set in. The Society of Arts was established in 1753 to promote the application of science to manufacturing (a topic the Royal Society avoided). It would have been a logical champion for Talbot except for the fact that its tightly scheduled agenda did not encourage immediate attention to a whole new type of invention.

Even the weather was against Henry Talbot as 1839 shaped up to be a uniformly miserable year. By autumn, Herschel was jotting in his research notebook such comments as: "the sun is most baffling & disheartening – never was such a summer for want of sunshine," and "in such intervals as the dreadful state of the weather would allow – ie in half hours and quarter hours before breakfast & in gleams made a great n° of trials...."[6] In technical terms, the daguerreotype was very nearly at its zenith at the time of its birth. Talbot's photogenic drawing was still in its infancy. In 1839, at a time when the secrets of the daguerreotype were frozen in progress during negotiations for their sale, a brilliant sun would have allowed Talbot to narrow the gap – but he was denied even this opportunity. A lesser man than Talbot might well have given up.

The French were the first of Talbot's problems. Almost certainly with a bit of embellishment, Herschel's long-time friend, the French astronomer François Arago, publicly quoted him to the effect that the English efforts to date had been childish.[7] Margaret Herschel, reporting to Herschel's Aunt Caroline, couched her husband's reaction less severely, saying that "the Photographic drawings of the English experimentalists on Paper are not worthy yet of being compared with those of M. Daguerre, but I hope his secret will now be divulged, as I hear he has got a pension from gov't."[8] Daguerre had briefly, and unsuccessfully, attempted

43. William Henry Fox Talbot. *Building silhouetted through trees*. Salt print. Date unknown. 16.3 x 20.6 cm. The Fox Talbot Museum, Lacock.

to sell the daguerreotype by subscription during 1838. With the loss of the Diorama, exploiting the financial potential of his new invention became more critical. The pension that Daguerre sought (and was to gain before the end of the year) accorded him official recognition and supported him for the rest of his life. But Talbot was an intrusion on this effort. What sort of reception could Talbot have expected had he travelled to Paris at this time? Perhaps it was wise that he stayed away, for a very unevenly matched playing field was being laid out. Dominique François Jean Arago, a well-respected and highly accomplished scientist, battled fiercely to champion Daguerre. Whatever Arago's motives, personal or professional, his methods lacked the impartiality displayed in his scientific work. Even though England and France had put the Napoleonic wars behind them, the greater commercial battles of the industrial age were beginning to take shape. Some of Arago's motives undoubtedly were nationalistic. However, he even went so far as to limit mention of Daguerre's deceased partner, Joseph Nicéphore Niépce.[10] The efforts of another French inventor, Hippolyte Bayard, to establish an independent claim, were derailed by Arago until after Daguerre's position was secure.[11] His reasons for this must have been strategic. To persuade the government of the immense importance of the daguerreotype, Arago felt that he had to establish Daguerre in a unique position.

In fairness to Arago, the French scientist had a very delicate balancing act to perform and he must be applauded for securing – in the very first year of photography – a government pension for Daguerre in recognition of the importance of his invention. In order to achieve this Arago had to tantalize the public's interest and raise the demand for a disclosure of Daguerre's working methods. In the process of accomplishing all this, Arago seems to have lost the scientific objectivity that had characterized most of his previous career. Lady Elisabeth, telling her son that the landscape painter, Sir Augustus Callcott, considered his discovery "very important to Art," also reported that Sir Augustus was "very indignant that Arago with his usual nationality pretends entirely to overlook your Papers and gives the credit of the discovery to Daguerre. This makes Miss Fox very angry too, & ought to stir up English ire."[12] Henry Talbot was a careful scientist and above all a gentleman and was already being deeply stung by the promotional tactics in Paris. As 1839 unfolded, he was increasingly antagonized, and complained that

> there can be no doubt of the great injustice of M. Arago. He does not seem to recollect that candour would be as great an ornament to his character as scientific eminence, and that the want of it, when conspicuous & evident to the whole scientific world, must result in injury to his own reputation. Already his absurd nationality, in declaring

the French to be the inventors of the Steam Engine, has called forth de vives réclamations on this side of the Channel, and half the President's speech at Birmingham the other day was occupied in defending Cavendish against his unfair and unreasonable attacks.[13]

By 1844, Margaret Herschel pled to Aunt Caroline that "we can't tell what great stir in France of M. Arago's you allude to, for he is more addicted to politics than to Science...."[14] This situation was exacerbated by the personal struggles between François Arago and Jean-Baptiste Biot.[15] The two men had worked together closely at the start of Arago's career (Biot was twelve years his senior), but difficulties emerged in 1807 when Biot attempted to exclude Arago's name from a report they jointly authored. Other rivalries developed and by 1813 the situation was so severe that the two men publicly signed an agreement aimed at healing their dispute. The rift did not heal and only got worse. One must wonder if Biot's support for Talbot in 1839 was motivated in part by a desire to counter Arago's championing of Daguerre. Arago had become a proponent of popularizing the work of the Académie des Sciences, the most visible example of this being his pivotal role in the publication of the *Comptes Rendus*. Arago felt that immediacy of disclosure of new inventions was desirable; Biot countered that this haste would lower the quality of scientific publications. Talbot, of course, sided with Biot. But Talbot hesitated to publish his photogenic drawing process, wishing to perfect it, and was eclipsed by Daguerre.

Herschel returned to England from France by the end of May and was unwillingly dragged yet again into the limelight. On 12 June, along with the poet, William Wordsworth, he was honored with a Doctor of Laws by the University of Oxford. But scientific interests soon returned to the fore. The journey to France had clarified for John Herschel the nature of his interest in photography. In the first few months of 1839, the main thrust he shared with Talbot was in seeking new and better ways of making pictures. After the trip to Paris, the two men continued to work closely, routinely sharing information on their respective photographic efforts. However, their emphasis within the art began to diverge. Given their personal interests, it seems this division was inevitable. Talbot pursued the quest of enlisting nature's aid to produce artistic works; he grew from the experience and would cultivate his innate talent. But until the spring of 1840, he was to be tormented by frustrations and setbacks. Herschel had come to see photography in a very different way. He appreciated its image-making potential, but this had little personal appeal for him. Herschel would produce some fully successful photographs before 1839 ran its course. However, with few exceptions, when he felt a need for

pictorial representation, Herschel remained loyal to his pencil sketches with the camera lucida. Herschel revelled in the philosophical complexities of photography, taking delight in the variety of processes possible, but suffered no confusion between scientific endeavors and direct contributions to artistic production. Herschel's attitude towards the relationship between art and technique was underscored in his analogy concerning the hope that politics would some day become rational; to him, this was "about as reasonable as the notion of teaching Painting as an Art by giving instructions in the minute philosophy of Light and the chemical property of colours."[16]

In many ways, in distinct contrast to Talbot's plight, 1839 was a good year for Herschel. Questions of priority did not trouble Herschel as they did Talbot and he could simply enjoy the philosophical challenges of the new art. As he had made clear a decade before in his *Preliminary Discourse*:

A mind which has once imbibed a taste for scientific enquiry, and has learnt the habit of applying its principles readily to the cases which occur, has within itself an inexhaustible source of pure and exciting contemplations. ... Accustomed to trace the operation of general causes, and the exemplification of general laws, in circumstances where the uninformed and unenquiring eye perceives neither novelty nor beauty, he walks in the midst of wonders: every object which falls in his way elucidates some principle, affords some instruction, and impresses him with a sense of harmony and order. Nor is it a mere passive pleasure which is thus communicated. A thousand questions are continually arising in his mind, a thousand subjects of enquiry presenting themselves, which keep his faculties in constant exercise, and his thoughts perpetually on the wind....[17]

In contrast, Talbot, with little possibility of making pictures in the dismal weather and with the unquantified threat of Daguerre's process hanging over his head, made scant progress during the summer of 1839. In fact, some of his best examples remained the leftovers from "the brilliant summer of 1835."

In any case, much of Britain's scientific community was preoccupied in the preparations for the upcoming Antarctic voyage to be headed by James Ross. Along with many of his colleagues, Herschel had been actively involved in the scientific planning for this expedition. On 21 June, Talbot was placed on the Royal Society's Committee of Botany to help "consider the subjects desireable to be alluded to by the expedition under Captain Ross."[18] It presented a golden opportunity to demonstrate an application of the new art of photography, yet incredibly, Talbot did not take advantage of his new position. It was up to William Buckland, the

President of the Geological Society, to suggest it. On 3 July, he wrote to Talbot that "my interview with you yesterday has led to the important result of Capt Ross taking out several Cameras to make Photogenic drawings of scenery &c which he may visit. No one had suggested this till I came to the Committee."[19] Buckland then directed the naturalist for the expedition, Robert MacCormick, to call on Talbot at his London residence. MacCormick recalled having

about an hour's conversation with him respecting his new process, of which he presented me with a specimen, and an invitation to spend a day or two with him at his country house, where he promised to give me a practical lesson on the whole process. He also showed me a representation of his house, which occupied him for four hours in finishing.[20]

Time was running out. On 1 August, Herschel took a bold step. Knowing that Daguerre's disclosure was imminent, Herschel made a direct appeal to the French inventor to share his "beautiful process:"

permit me to apply to you in the name of the Council of the Royal Society for the purpose of procuring, if possible, an apparatus with the proper Camera Obscura and 100 plates properly prepared to receive impressions, and with instructions for its use and for executing the singular and extraordinary process by which you have been able to effect such wonders. If the request appears to you extraordinary, the circumstances of the case will explain it. Captain Ross (the discoverer of the Northern Magnetic Pole) is about to proceed on a voyage of Discovery and circumnavigation of the Antarctic Pole, in command of two ships, the Terror and Erebus, admirably equipped and every way furnished with instruments of Science and Art. Now the Council of the Royal Society are earnestly desirous that the Expedition should sail provided with the invaluable resources furnished by the Daguerreotype process – first depicting the scenes they may visit – and as it will be yet 3 weeks before the sailing of the ships, and it has been stated that within that time your process will probably be divulged – they consider that the importance of the occasion justifies this direct application to you. I shall hope for your early reply, and that it will be such as to enable me to announce to the Council that the apparatus and instructions will be forwarded in time (ie to arrive before the 20th August, inst.)

Anticipating that Daguerre might yet be sorting out his marketing schemes, Herschel proposed that "should you wish that the instructions should yet remain for some time secret you may send them sealed and may rely on their not being opened till the ships shall have passed the Cape of Good Hope."[21] In spite of Herschel's having invoked François

44. Christian Albrecht Jensen. *Sir John Herschel*. 1843. Oil Portrait. Margaret Herschel found this to be a very accurate depiction of the famous scientist at the height of his career, before subsequent events would break his health and age him prematurely. 68 × 52 cm. The Royal Society, London.

Arago's name as a reference, Daguerre apparently did not wish to risk early disclosure of his secret, and no daguerreotype apparatus or instructions were made available. Perhaps this was to avoid upsetting an essential part of Daguerre's marketing strategy, one that was tied into a family business. The bill authorizing Daguerre's pension had been passed and signed into law by the beginning of August, but the disclosure of the working details was delayed.[22]

On 22 August, Talbot wrote to Ross that "hearing that you had some intention of making drawings in the Southern Regions with the Camera Obscura I would have offered any assistance in my power to you but that I knew you could not possibly spare the time that would be requisite."[23] The expedition had already sailed when the working details of Daguerre's process were finally disclosed in Paris on 19 August to a wildly enthusiastic crowd. The hope was retained that an outfit sent out on a faster supply ship could still catch up with Ross. However, by 27 August, Francis Beaufort, the Hydrographer of the Navy, wrote to Herschel,

enclosing "a note from Pentland respecting Daguerre's instrument – and giving me a message for you. The Daguerreotype is evidently unfit for Ross at least in its present state."[24] An additional, equally pessimistic opinion came two weeks later when a Fellow of the Royal Society reported back to Herschel that he had "delivered your kind introductory letter to Arago & was at the Institute the day he read the account of Daguerre's process. It is a very difficult & certainly a very different process to your own or Talbots & I think as to its being reduced to general practice not likely to be followed up."[25]

The hope of the infant photography aiding the Ross expedition was beginning to fade. By mid-October, John Lubbock's optimism was about all that was left:

> I am very anxious to know whether you have succeeded in getting a Daguerreotype for Capt[n] Ross. It seems to me very desireable that one if not two should if possible be sent after him if he sailed without one. I have got one over myself, some of the things broke, the object glass of the Camera just got loose but fortunately was not broken. I think therefore that it' should be examined and repeated here & such things as are liable to miscarry be sent in duplicate. Have you made any experiments with it? It seems to me that Daguerre has completely solved the Photogenic problem for whatever is distinct in the camera I succeed in getting distinct on the plate. I have not any doubt I could get a Daguerreotype over from Paris in ten days through our correspondents there, if it were thought desireable I should be very glad to be of any use by writing to them. . . . It is a great pity that all cameras are not made on the model of Daguerre's which would allow of trying Photogenic paper or any other substance sensitive to light.[26]

Lubbock assisted Talbot in obtaining a supply of the special daguerreotype plates.[27] William Horner Fox-Strangways had already arranged for the Foreign Office to bring in a daguerreotype camera for his nephew; Henry Talbot was one of the first in Britain to receive the Giroux model.[28]

After seeing Daguerre's marvels and returning from France in May, Herschel "tried in June & July an infinity of exp[ts] on Photographing & fixing."[29] First, however, on 4 June, Herschel recorded in his notebook that

> I must here note before continuing my account of yesterday's & today's exp[s] that on April 28 immediately on the discovery of my sensitive paper I placed it in the camera obscura and obtained results every way satisfactory, having succeeded in procuring several views of the 40 foot reflector (one of w[h] I left in Paris with Arago and one with Biot) . . . During my journey in France I found that

Window at Lacock c.1838

45. William Henry Fox Talbot. *Window at Lacock Abbey*. Photogenic drawing negative. Summer 1839? This teary-eyed view of a window, with its fantastic form, likely betrays an attempt to expose the paper while wet when it would be most sensitive. The "W" on recto identifies this as Talbot's *Waterloo* paper, a term he first recorded in his notebook in July 1839. 11.4 × 11.3 cm. The Royal Photographic Society.

the sensitive paper of 1042 <u>will not keep</u>. It grows very brown in the dark by keeping . . . I find it to be incapable of resisting spontaneous decomposition. . . .

In redoubling his efforts at photographic research, Herschel was to make some very practical contributions to the art, although this was certainly far from his intention. More importantly, during the years of 1839 and 1840, when science, law, and human nature seemed uniformly arrayed against Henry Talbot, Herschel emerged as one of his most loyal and effective supporters and advisors. On 24 June, Herschel started a letter of encouragement to his friend:

When I wrote to you from Paris I was just warm from the impression of Daguerre's beautiful pictures. After reflexion I feel no way disposed to abate in my admiration. However that has not prevented my wishing that the processes which have <u>paper</u> for their field of display should be perfected, as I do not see how else the multiplication of

copies can take place, a branch of the photographic art which Daguerre's processes do not by his own account admit of. The day or 2 before I left England I believe I wrote to you stating that I had got a new sensitive paper. The basis of this is <u>Lead</u>. I mean that the ground wash of a salt of lead is applied before the muriatic salt. Acetate of lead is what I have used and the result is a very remarkable degree of sensitiveness combined with a sharpness & richness of effect I have not before met with. In sensitiveness I think it equals your bromuretted paper – at least that specimen you sent me.

Herschel was interrupted in writing this letter and met with Talbot before it was actually posted. In the meantime, on 2 July, Talbot wrote from London (the now-familiar terms negative and positive had yet to be applied):

In the little packet of photogenic drawings which I send today by the Railway, there is a retransfer of a fern leaf;

these are easily made but in the estimation of most people are less pretty than the first or white images.

I send also the copy of a transparency a view of ruins by moonlight, re-transferred in the same way, which is necessary with this class of objects, otherwise they have no effect. If you recollect you tried one of these transparent views last March, at which period of the year the weather was not good enough for a copy to be obtained from it.

I shall certainly make trial of your muriate of lead. . . .

On 6 July, Herschel returned to the letter that he had suspended two weeks earlier, thanking Talbot for the "very pretty specimens" and readily conceding the practical superiority of Talbot's processes:

I find that my leaden paper is subject to great inconvenience of turning not only yellow but dark brown (when rendered very sensitive) by keeping even a few days. And as I have now got the right process & proportions for your salted paper, whose sensibility is after all quite sufficient for every purpose, I prefer the latter the trouble of preparation being the same in both, viz: 3 washes.[30]

Continuing his letter, Herschel enclosed "a specimen of a retransfer from an engraving, fixed. The original has a somewhat misty air especially in the distant column. The Lady's face & neck are strongly shaded by her veil. The photograph as you will perceive has very much the air of a copperplate engraving."

Although Talbot's research notebook reveals no hint of it, when he met with Herschel in early July they apparently discussed an experiment, perhaps one that Talbot himself had suggested. It was one that was to define the trunk line of Herschel's subsequent research. Continuing on 6 July, Sir John reported that:

I attempted the experiment of the glass cylinder to detect the fixed lines if any in the Chemical Spectrum. The Expt however is too refined for my present possibilities in the way of extempore apparatus & I commend it to your more efficient nursing as one sure to produce some capital result only I begin to doubt whether the cylinder be so good a mode as others for illuminating the angular breadth of the luminous line.

Failing, and bungling this, I tried the naked spectrum, and here to my surprise & delight I found that there are facts in abundance to reward research.

And, indeed, abundantly rewarding facts there were. Using his simple apparatus, Herschel had confirmed the sensitivity of photographic materials to ultraviolet light. Employing a 'beautiful' heavy flint prism given him by Fraunhofer,

Herschel found that "the Chemical action extends enormously beyond all visible violet light. The end of visible violet as seen through a cobalt glass, about bisects the Chemical Spectrum."

Additionally he observed that the maximum photographic effect occurred in the area of blue/green light, and the minimum in the pure red. But to Herschel, "the most remarkable part of the affair" was the effect of red light: "though its action is feeble . . . [it] differs from all the rest by communicating a red-brown colour to the sensitive paper – and this tint is the more decided the more completely the yellow & green rays are excluded. . . ." The quest for color was a natural one and common to many of the early photographic experimenters. Anomalous effects that produced various tints were taken as indications of a possible path to color photography:

Here then we have your curious remark of the photographic impressions from red coloured pictures & parts of pictures being themselves analogously coloured – traced up to the action of certain definite rays in the spectrum. Should the same continue good I propose to try the effect of finer rays, collected in larger quantities in focus of lenses especially further towards the red end so as to make quantity compensate for feebleness of action, when it may be fairly surmised that much more decided hues of red colour will be produced – and who knows but that the black tint produced by the blue-green may possibly be insulated by analysing the incident light not by the prism, but by coloured media, and prism combined.

No perfect color filters were available. But, by using a prism to break up the spectrum and color filters to further refine the bands of light, Herschel hoped to identify and control the cause of the colors:

by using the prism first to separate all but the pure prismatic tint of given refrangibility & then re-analysing this by media I conceive it possible to obtain rays totally exempt from any colour but the elementary one wanted. You will at once see what a fine train of expts this opens.

The mixed colors of sunlight were not the only possible source: "coloured flames ought to be tried & the Electric lights of metals which Wheatstone has shown to be definite & characteristic."

The day after writing this, 7 July, Herschel reported to Talbot that "in an hour or 2 of good sun this morning" he "formed a very concentrated & intense spectrum of small dimensions by throwing a spectrum on a large lens and receiving the focus on sensitive paper." Herschel included a graph illustrating that the effects of different colors of light on

sensitive paper were not necessarily the same as what the eye perceived. Most importantly, however, Herschel felt that

> the tint produced on the sensitive paper is <u>actually a coloured picture</u> of the spectrum. But this is to be understood in a very moderate & humbly imitative manner. It is as if the tints were <u>coloured in darkness</u>, <u>not in light</u>. As we speak of a red-black – a brown black, a green black, a blue black &c. . . . My present interpretation of these facts is that Red light (I do not mean red <u>refrangibility</u>) destroys to a certain feeble extent the red, blue, and yellow reflected by the paper – but <u>less</u> of red.

Similarly, Herschel found that blue and yellow rays also seemed to destroy less of their own color. He enclosed a specimen, warning that "it is <u>not</u> fixed." Persuading the spectrum to take its own picture was a tremendously exciting concept to Herschel; he recorded in his research notebook that during the month of July he "prepared many spectra on sensitive paper – and gave specimens to Wheatstone – Daniell – Beaufort – Baily – and others – at meetings of the RS Council & Committee."

On 19 July, Talbot acknowledged receipt of the image of the spectrum, which "tho' unfixed, <u>still retained the colours</u> with sufficient distinctness . . . are these definite compounds, according to the atomic theory, or are they mixtures? . . . it is hard to believe that these are differently coloured oxides of silver . . . fixing destroys these faint colours as I have found." Talbot also suggested that "the transfer from an engraving which you sent, is very good: try some Rembrandt etching, perhaps it would come out as bold as the original." He had been working with little success himself, having found "various obstacles to making good transfers of Camera pictures; so that the final result hardly reaches one tenth of the perfection which the picture has when first taken out of the instrument."

Largely because of these disappointments in making the prints, Talbot remained less than fully convinced of the advantages of the negative/positive system that he had created. That Daguerre's competition was continuing to control his own behavior was obvious. In his private notebook, Talbot used the term *Waterloo* to designate a class of sub-stratum papers. He never used the term in public (perhaps to avoid inflaming the French) and crossed out his other suggestion: named after the Duke of *Wellington*. The term Waterloo began appearing (without explanation) in Talbot's notes during July 1839. On 15 July, he defined "Common Waterloo Paper" as "common photogenic paper" washed with a solution of potassium bromide.[31] After this, Talbot used Waterloo as a generic term to describe a variety of papers prepared with a chemical base; he then applied other chemistry, such as the ammonio-nitrate of silver, to further

sensitize these Waterloo papers. He even made a *Double-Waterloo* by applying successive washes.

Continuing in his 19 July letter to Herschel, Talbot lamented his recent lack of success, "but the weather being now singularly gloomy, is partly the cause of it." While nature had been uncooperative, yet another form of cloud was taking shape over Talbot's head. "I am afraid our Birmingham meeting will be greatly discouraged by these events, if indeed it takes place at all. A Chartist irruption into section A would put fly to all the Sciences." This was the annual conference of the BAAS, to be held in August. It was the first year that photography could be presented to this, the largest regular assembly of British scientists. In spite of the miserly sun, Talbot worked throughout 1839 assembling examples of the full range of his art. Perhaps he could yet wrest the lead from his French rival; was it a merely coincidence that Talbot's first exhibit was a photographic copy of the Great Seal of England? On 26 August, in glass cases at the *Exhibition of Models, Specimens of Manufacture, and Works of Art*, Talbot displayed nearly a hundred captioned examples marshalled under four divisions of the art.[32] His classes were direct copies of engravings and botanical subjects, "reversed images" (positive prints from negatives), views taken with the camera obscura, and images made with the solar microscope. The lot was accompanied by a printed checklist.[33] Never again was Talbot to display so many of his photographs at one time. But bad luck was to follow him even here. Social unrest ruled the region. Violence promulgated by the working-class advocates of the 'People's Charter' chased the scientists away in droves.

During the meeting of the Mathematical and Physics section, Henry Talbot, "rose to offer a few remarks on M. Daguerre's photogenic process."[34] Even the official synopsis in the Association's *Report* reveals Talbot at a low point.[35] Talbot remembered that the manipulatory details of Daguerre's process, "reaching us during the meeting of the British Association, gave rise to an animated discussion in *Section A*, and I took the opportunity to lay before the Section the facts which I had myself ascertained in *metallic photography*. . . ."[36] Only recently acquainted with the working details of his rival's process, Talbot tried desperately to incorporate its essential elements into parts of his own previous work. Perhaps his most extraordinary statement had to do with the exploitation of the latent image. This was the almost magical key to the sensitivity of the daguerreotype and was really the cornerstone of the process. When Daguerre removed his plate from the camera after a relatively short exposure, nothing was visible. Development over mercury fumes brought out the image – the weak initial exposure was chemically built into a useful image. Talbot attempted to trivialize this breakthrough by observing that

> it had been repeatedly stated in the *Comptes rendus* of the

46. William Henry Fox Talbot. *Venus*. Photogenic drawing? negative. Ca. 1840. 4.2 × 4.3 cm. The National Museum of Photography Film and Television.

47. William Henry Fox Talbot. *Lace, 100 times magnified in surface*. Photogenic drawing negative. 1839. From Herschel's own collection. 13.5 × 17.3 cm. The National Museum of Photography Film and Television.

French Institute, that M. Daguerre's substance was greatly superior in sensitiveness to the English photogenic paper. It now, however, appeared that this was to be understood in a peculiar sense, inasmuch as the first or direct effect of the French method was very little apparent, and was increased by a subsequent process. This circumstance rendered it difficult to institute a direct experimental comparison between them. If it could be accomplished, he doubted whether M. Daguerre's process would be found much more sensitive than his.[37]

Talbot rarely stretched the language so far. His charge may have been true, as far as it went, but it was a very narrow and unfair interpretation of the relative merits of the two processes. The end result of Daguerre's total process was to provide a fully exposed image in a fraction of the time required by Talbot's print-out paper, and that is how it must be judged. At this stage, regardless of Daguerre's promotional tactics, Talbot had been technically eclipsed quite fairly. Interest in photography was running high after Daguerre's disclosure. Following Talbot's talk, such "an animated discussion ensued" that the reporter complained that "the questions and replies succeeded each other with such rapidity, that we could scarcely catch their import."[38]

Having had the opportunity at Birmingham to consider Daguerre's lead and now more fully apprised of the basis of his rival's process, Talbot was in a better position to emphasize the virtues of his own. He wrote to Herschel on 8 September that

> I believe you have not seen any of my photographic attempts with the Solar Microscope. I therefore enclose 4 specimens of magnified lace. I have great hopes of this branch of the Art proving very useful, as for instance in copying the forms of minute crystallization which are so complicated as almost to defy the pencil. . . . I expect to be able to compete with M. Daguerre in drawing with the Solar Microscope, when a few obvious improvements have been adopted. By the way did he show you anything remarkable of this kind[39]

Mentioning that he had discussed Daguerre's process at the British Association meeting, Talbot casually asked Herschel if he had "tried M. Daguerre's plan yet, and with what success? I have not yet had leisure to make the attempt." Herschel responded quickly on 10 September:

> I have just rec[d] your very pretty specimens of Magnified Lace which are highly interesting in point of their object & principle & very fine in point of execution. Daguerre neither shewed me or alluded to anything of the kind as having been done by him, though of course the "Daguerro-type" [sic] is applicable to that purpose.[40]

Although Herschel told Talbot in his 10 September letter that "I have not tried Daguerre's process," this situation was about to change. Just three weeks later, Herschel helped his friend, the headmaster of neighboring Eton, Dr Edward Craven Hawtrey, to make a pioneering daguerreotype – one of the very first accomplished in Britain. In Herschel's diary for 1 October, he noted sparsely: "Hawtrey Daguerreotype," and on the 4th, made a fuller entry: "walked over to Eton called on D[r] Hawtrey & saw his 1st trial of the Daguerreotype, a Laocoon."[41] Within three months, Herschel was to move away from the area of Eton and Hawtrey appears to have flirted with the art only briefly. None of Hawtrey's or Herschel's daguerreotypes are known to have survived.[42] In any case, Herschel had found a substitute that served his needs well. Continuing in his 10 September letter, he told Talbot that

> I yesterday succeeded in producing a photograph on glass having very much the character of his results – being Dark on a bright ground as is natural, not reversed as to right & left, and having much the appearance of being done on polished Silver. The process is delicate & very liable to accident in the manipulations, as it consists in depositing on the glass a perfectly uniform film of muriate of silver. . . . To do this without injuring the film requires great precaution. When placed glass foremost in the focus of a Camera this takes the image with much greater sharpness than paper. It fixes with a wash of hypo sulphite . . . the reduced silver forms a brilliant metallic film on the glass which adheres firmly & will bear considerable friction. The glass being then smoked or black varnished the effect is as described.

In his research notebook for 9 September, Herschel had recorded the details of this "New Daguerreotype on Glass" process.[43] It took forty-eight hours to precipitate the silver film on the glass plate and careful drying afterwards:

> Having dried it I found that it was very little affected by light but by washing with nit. silver, weak & drying it became highly sensible. In this state I took a Camera picture of the telescope on it. Hyposul soda then poured cautiously down it washes away the Mur Silver and leaves a beautiful delicate film of Silver representing the picture. If then the other side of the glass be well smoked & black varnished – the effect much resembles Daguerreotype being Dark on White as in Nature & also right & left as in nature & as if on polished silver.

Even though Herschel was pleased to have replicated the appearance of Daguerre's process, he saw additional benefits from an image based on glass. Continuing in his 10 September letter to Talbot, Herschel pointed out that

if the varnish be omitted there seems no reason why impressions should not be taken from it ad infinitum provided the film can be got thick enough. And for this I propose to connect the Silvered Surface with the pole of a Galvanic pile under solution of silver so as to cause more metal to be precipitated on it & thereby thicken it. Probably also the silver film may defend the glass from the corrosion of fluoric acid gas – in which case an actual etching on glass would be the result.

This method of making negatives on glass, a tedious but fully functional process, was used by Herschel for some of the most historically significant and romantic of the early photographs. The telescope that formed his subject was the vestigial remains of his father's massive and renowned forty-foot reflector. This giant machine was the very symbol of British science in the late eighteenth century and remained a considerable tourist attraction (often, much to the son's chagrin!). It was a meaningful and convenient subject for John Herschel's first work in photography. But the wooden framework, long exposed to the elements, was decayed and becoming dangerous, and was pulled down between 5 and 7 December.[44] Significantly, the image of this retiring symbol of the old science was perpetuated by the child of the new, photography.[45] Scores of paper negatives and prints of the telescope exist that undeniably must date from the first year of photography.[46] But the best examples are the several glass negatives John Herschel made of his father's telescope during October. These negatives were so successful that a series of commemorative prints was made from them in 1890 – another could still be done today![47] Perhaps because of the delicate manipulation required in this early glass process, only a few photographers mastered it. The photographic experimentalist Robert Hunt and the scientific writer John Thomas Towson were known to have been successful with the process.[48]

When Herschel first showed one of these photographs on glass to Talbot, he modestly suggested that it was "but a step, although quite a recent one, of improvement in the photographic process. . . ." Talbot is reported, "after looking at it carefully for a short time" to have exclaimed that "it is the step of a giant!"[49] He had thought of using a similar process back in March, but had never actually tried it. In his research notebook, Talbot proposed to "wash glass with varnish, let chloride silver subside on it thro' a tall jar (mixing weak nitrate & weak salt) if this stratum is even, & adheres, make picture on it, remove the whites with hyposulphite & photograph."[50] Talbot was still keeping a close eye on his competition. On 15 November, he informed Herschel that

The French government have sent a person lately from

48. Antoine Claudet. *Daguerreotype of Nicolaas Henneman*. Ca. 1843. Henneman, originally Talbot's valet but soon his partner in photography, took an immediate interest in the new art. He kept up with the progress of Talbot's rival at least as much as the inventor did. Taken at the Adelaide Gallery on the Strand in London. 6.5 × 5.3 cm visible. The Fox Talbot Museum, Lacock.

Brest to the Coast of Africa well supplied with Daguerotype [sic], to bring home views of the African scenery. This will be very interesting to behold! Have you made any pictures by Daguerre's method? I have not yet done so, but have procured his apparatus complete from Paris. M[r] Lubbock has been very successful in his attempts.

One specimen of the art which I purchased from M[r] Cooper of the Polytechnic Institution presents two circumstances of which I should be glad to know the explanation. (1) The outlines are in the opinion of everybody, sharper than in nature, in the case of buildings seen projected against the sky. (2) There is an appearance of irradiation, or a luminous edge, as if the moon were behind the buildings. I would also observe that the relative illumination of the objects differs from nature, objects really twice as luminous, appearing four times so. The sky, which is always the most luminous part of my photographic pictures on paper, is not so in the Daguerotype. It is much less luminous than the image of a sheet of white paper stuck against a wall; altho' the brightness of the latter is the mere reflected brightness of the sky.[51]

Herschel replied on 4 December that

Your remarks on the Daguerreotype are quite in accordance in one respect with how I mean the excessive sharpness & moon-lighting or frost-edged effect of chimneys &c against the sky. I cannot account for it. Your other remark as to the relative brightness of objects is very

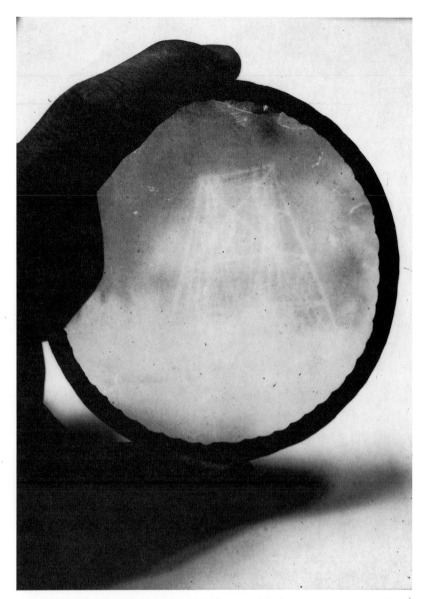

49. Sir John Herschel. *The framework of William Herschel's forty-foot telescope, shortly before dismantling.* Silver chloride negative on glass. 9 September? 1839. Herschel employed glass as a chemically-neutral base superior to paper for experimentation. Through a laborious process of precipitating freshly-formed silver chloride, a light sensitive surface could be made to adhere tenaciously to the glass. Exposed through the glass in a camera, a detailed image was recorded. Herschel privately called this a "new Daguerreotype on glass;" by smoking the back of the sheet, the effect of a positive picture was formed in much the same way that later ambrotypes would be produced. Negatives on glass would not be common until more than a decade after this example. Yet, as tedious as the process was, it was still practical, and this negative remains printable to this day. 10.0 cm. diameter. The National Museum of Photography Film and Television.

singular and cannot but depend on some interesting relations not yet made out. It has not struck me.

At this very time, a new twist was injected into the drama of photography. An English patent was applied for, under the title of a *New or Improved Method of Obtaining the Spontaneous Reproduction of All the Images Received in the Focus of the Camera Obscura*. Extraordinarily, it was Daguerre himself who was behind this act, his identity shielded by the English patent agent, Miles Berry.[52] The invention that was supposed to be free to the world was to be restricted in only one country – England. Daguerre must have undertaken this with the explicit knowledge and tacit approval of François Arago and this duplicity cannot be satisfactorily explained away. Although the patent was eventually overturned, daguerreotypy found itself in the courtroom before the end of 1839.[53] In the meantime, the anonymous filing had a chilling effect on Talbot. He had no way of knowing, indeed, could hardly have been expected to guess, that it was his arch-rival Daguerre who was behind the patent. On 12 September, thanking Herschel "for the description of your new method of making a picture on glass," he hastened to warn his friend:

> Do not publish it at present, for the following reason. Some one has lately taken out a patent for improvements in photogenic drawing . . . having conversed with a lawyer on the subject I find there is nothing to prevent him from monopolizing the Daguerreotype (in England) if he is so disposed. Now, until he enrolls his specification, which he may delay 5 months longer, he is at liberty to claim as his own any improvement that you or I or any one else may publish, <u>and prevent us from employing it without his permission</u>. Those things only are safe, which were published previously to the date of the patent.

Based on this, Talbot gave Herschel advice that was to play a critical role in the timing of subsequent events: "such is the state of the law at present, and there is no help for it, that I know of, it behooves us therefore to describe no new process, applicable to the art, before next year."[54]

Herschel did not reply until 4 December, by which time Daguerre had been revealed as the instigator of the patent. He inquired of Talbot:

> as to publication I would gladly know whether you consider those remarks to apply now that it is known that Daguerre himself is the patentor of his own process – as in that case, I would yet keep quiet what slight facts have accrued to me respecting photographic processes. . . . My intention was if you think the objections on the score of the patent resolved – to draw up a short paper for reading to the R. Society.

Herschel had accumulated enormous amounts of astronomical data during his sojourn at the Cape. These observations were an extension of his father's life work and the son felt quite keenly a filial responsibility to complete their publication. This was why, in summarizing his photographic researches, he told Talbot that

> I am rather desirous now, to throw them off and thus get rid of the subject – not because I am tired of it, but because its future pursuit would tread upon my astronomical work to which it must be now a matter of duty with me to devote my entire attention to the exclusion of all other even more attractive subjects.

Concerned for the fate of his colleague's research, Talbot replied to Herschel on 7 December, promising to

> write to Town & enquire whether Daguerre has yet <u>enrolled</u> the specification of his patent. Six months are allowed, but that time must be nearly expired. The last I heard of it was, that he had by his agent applied to the Lord Chancellor for an injunction to restrain the Adelaide Gallery from showing the process; but although this application was <u>ex parte</u>, the Chancellor refused to do so. I do not know whether this portends that the patent will not be sustained.

Talbot added that "in a subject in which common sense enters in so very small a proportion as it does in our Patent Laws, it would be unsafe for anyone but a Lawyer to hazard an opinion." Talbot's heartfelt advice was basically sound and Herschel reluctantly delayed the publication. But there had been other important news in Herschel's 10 September letter. He was continuing to pursue the possibility of color photography.

> The Sun has been so dreadfully niggard of his beams that I have been unable duly to follow up the very curious train of enquiry about the peculiar efforts of the spectrum-rays. The white spot corresponds strictly to the extreme red. And the whitening power is transmitted through Cobalt blue glass. But the most curious thing is the effect on paper already deeply tinted by a pure violet ray. On such paper the extreme rays develope a red of a surprising richness & intensity of which I enclose you a specimen. I should observe that the prism used for the enclosed is a <u>water</u> prism.[55]

On 6 September, Herschel wrote in his research notebook that on

> finding a prism and large crown glass very troublesome I fitted up an apparatus by which a Prism of Water large enough to afford a copious supply of light was made to throw its beam on Cauche's Achromatic object glass 3in

[*Handwritten notebook page by William Henry Fox Talbot — largely illegible cursive script.*]

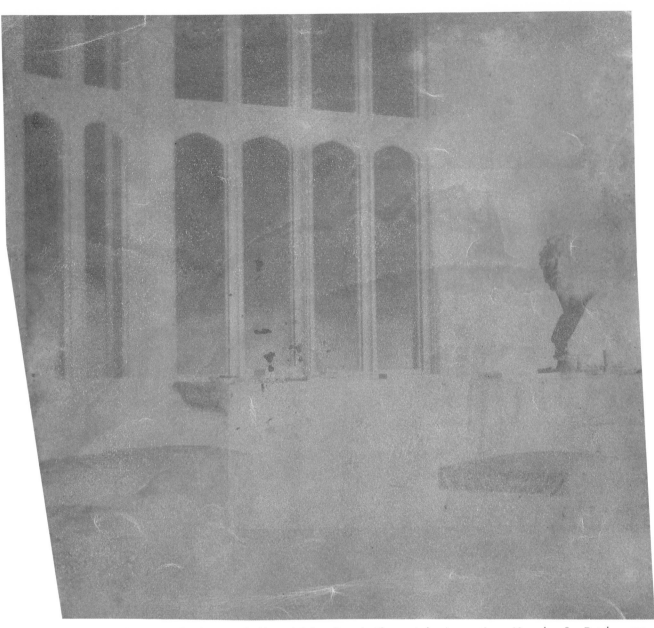

51. William Henry Fox Talbot. *The Oriel window at Lacock Abbey, with the bust of Patroclus.* Photogenic drawing negative. 23 November 1839. Dated on verso in Talbot's hand. 16.1 × 17.3 cm. The National Museum of Photography Film and Television.

apart 26in focus. A superb concentrated spectrum was obtained and by a little management could be kept steady on a fiducial dot made on the paper exposed. Ray chosen as fiducial = the insulable yellow-green wh penetrates a thin cobalt blue glass. In this way of operating beautiful results are obtained.[56]

By 1 October, Herschel had refined his technique, and recorded in his notebook that he had

adapted an old Quadrant Pillar (belonging to Birds Quadt) for a Polar axis & contrived a clock motion with the old Markey clock so as to fix the Spectrum by a Clock Motion. It is very simple – almost no contrivance and works very well every part being adjustable. There immediately took place an immense improvement in all the spectra being sharper finer & attended with much less trouble to watch & keep them right.[57]

The theoretical underpinning of photography was so complex that Herschel had also noted with some delight in his 4 December letter to Talbot that "there is no end to the Caprices of this subject." In this letter, he also revealed that he had "been trying a few combinations with a view to facilitating the Camera-photoging with paper which is certainly susceptible of great development." A major problem was that "sensitive papers will not <u>keep</u> . . . and to prepare them when travelling is very difficult & trouble-some." Herschel's solution to this problem was to prepare a lead-based paper which was "ready for the travellers use and may be exposed to air & light ad liberum." For use in the field, it required only a quick wash of silver nitrate and could then be exposed " <u>wet</u> in the Camera having duly adjusted the focus by trial on unprepared paper so treated." Realizing that further chemical manipulations in the field were difficult, Herschel suggested keeping the exposed paper (wet or dry) in the dark returning home, "<u>after</u> which fix with Hyposulphite of Soda – the only liquid I find never to fail." Herschel also could not resist mentioning another process

which I think may be of great service to travellers under conceivable circumstances – viz. that in place of <u>fixing</u> the photograph on the spot it may be by a certain application A totally obliterated instantly – and after remaining as white paper in his portfolio, or exposed to air and sun ad liberum for an indefinite time – the image may be recalled in an instant and fixed by brushing over with another liquid B. I have some idea that two images may be made to coexist on the same paper both invisible and either of which may be thus recalled at pleasure without the other, but I have not yet satisfied myself of its practicality.

In an age when secret writing was both utilitarian and a

52. William Henry Fox Talbot. *Lacock Abbey.* Salt print from a photogenic drawing negative. Spring 1840. Note on recto in Talbot's hand, "D or 4th copy." Frustrated with the weak images he was able to produce with short exposures, on 28 February 1840, Talbot recorded in his notebook that "given a faint photograph A . . . , if B is copied from A, C from B, D from C, &c. may we not arrive at length at a much stronger copy than the original?" 18.7 × 22.9 cm. The Royal Photographic Society.

common parlour amusement, such a process could be quite appealing.

Talbot replied on 7 December. While recognizing that he might be losing his closest supporter in photography to a longer-established calling of astronomy, he knew Herschel well enough to know that the siren song of the new art could not be stilled:

I do not learn from your letter whether you have yourself experimented on the Daguerreotype – I've procured all the apparatus from Paris, but not yet had leisure to attempt a single picture. . . . I am sorry that your great Astronomical work should oblige you to withdraw your attention entirely from Photography, & trust however that you will occasionally revert to the latter as an amusement, especially as the experiments require only occasional superintendence, & during the greater part of the time, execute themselves.

Talbot was still having difficulty with Herschel's fixer: "I am rather surprised that you find the Hyposulphite never to fail. I find that unless it is strong it does not fix the <u>lights</u> quite <u>white</u>, but they have a dirty or gloomy appearance; and if it <u>is</u> strong, it is apt to destroy the more delicate shadows." Finally, in this 7 December letter, Talbot pointed out that he had employed a camera process similar to Herschel's "for

some months past, often with great success." In connection with this, Talbot made clear that

> I rather deprecate a too hasty disclosure of this method, as I am convinced we are only on the threshold of what may be done. Although the perfection of the French method of Photography cannot be surpassed in some respects; yet in others the English is decidedly superior. For instance in the capability of multiplication of copies, & therefore of publishing a work with photographic plates.

Talbot was already laying the groundwork for his photographic masterpiece, *The Pencil of Nature*, a book that would not be published for another five years. But Talbot's optimism had taken a beating during the dismal summer of 1839. Licking his wounds from the disappointment at Birmingham, Talbot's outlook was revealed in an October letter to Sir John Lubbock, the Secretary of the Royal Society. While he continued to toy with nature's pencil, Talbot was becoming so discouraged that he limited his ambitions to the extent that "if I can attain to the level of common amateur sketching I shall be satisfied." Still, Talbot retained some hope, explaining that "I have never yet tried the paper with a <u>really</u> good camera, because such are rarely to be met with in London. Consequently, it is to be hoped that the merit of the paper processes are not yet fully developed."[58]

But they were developing – Talbot was, in fact, beginning to make more progress than that for which he gave himself credit. Even if his conscious expectations for photography were limited to 'amateur sketches,' the art itself was beginning to teach him some lessons. In spite of the gloomy light and his own gloomy mood, Talbot was moving with a bit more surety in creating pictures. In this letter to Herschel of 7 December, he enclosed

> a little sketch of the interior of one of the rooms in this house, with a bust of Patroclus on a table. There is not light enough for <u>interiors</u> at this season of the year, however I intend to try a few more. I find that a <u>bookcase</u> makes a very curious & characteristic picture: the different bindings of the books come out, & produce considerable illusion even with imperfect execution.

Today, inundated with thousands of photographic images, it is difficult to keep in mind just how extraordinary these early pictures were to those who first saw them. Four decades after 1839, the vivid impression created by perhaps this very picture of a bookcase still haunted one writer:

> there used to be visible in the corner of an optician's shop window in Regent street a pale and dingy vignette ... it was on a thin yellowish paper, and its hue was a monochrome of an uncertain bistre; but whether the thing itself was a mezzotint engraving, or a lithograph, or an Indian ink drawing, none but the initiated – and the flaneurs were not yet initiated – could tell. It represented only a few shelves full of variously bound books; but the marvel about it was that every particular volume, from bulky folios to ragged backed paper pamphlets, was delineated with an accuracy of draughtsmanship and a microscopic fidelity in texture and detail ... No modern pre-Rafaellites ever produced such exquisite "finish" as was visible in the contents of those miniature shelves; and, abating the depressing sepia tint pervading the whole, the books looked alive – as much as objects of still life could look indeed ... the sallow little vignette in the optician's window was one of the earliest known specimens of that which was subsequently called the Talbotype....[59]

Progress continued throughout the winter. On 28 February 1840, Talbot wrote to Herschel, enclosing "Patroclus & Venus, done yesterday in fine weather ... these are from plaster casts, I have no marble bust here to copy from." In spite of his lowly plaster origins, the highly reflective and ever-patient Patroclus was one of Talbot's favorite sitters.[60] He used other statuary from time to time; in her diary a few weeks after this, Lady Elisabeth complained that "Henry broke the bust of Clytie, which I have had for 43 years!"[61]

But now Herschel had little time to contemplate his friend's advances. Thankfully escaping the infant mortality and cholera so common to the time, the Herschel tribe had grown considerably over the years to the point where the family home at Slough was too small. Another pressure to move came from the advent of improved communication. Having grown happily accustomed to seclusion in South Africa, Herschel found it increasingly difficult to get on with his work in England. His reaction to the Penny Post was indicative of his attitude. Soon, Herschel would confide in a friend about the

> constant and <u>irritating</u> service of <u>the daily post</u> in the form of an innumerable quantity of small demands on time & pen which when satisfied (after eating away hours which might be far better spent) leave me sick & wearied & in no condition to write to any one I care for. I find others complain of this new form of annoyance which the "Penny Post" that ultra-civilized invention inflicts and which seems monthly on the increase....[62]

There was no way that Herschel could live in Britain and escape the postman. However, he could abandon the district made newly popular by the young Queen Victoria. Slough, in the vicinity of Windsor, had been a good choice of location at the time when his father had moved there. William Herschel was dependent on the patronage and notice of the king;

equally, George III's visitors could be shown an interesting example of British advances. This royal connection was not important to John Herschel. Also, with technology defying the old bounds of geography, Slough and London had been drawn inexorably together. When Talbot travelled there to give Herschel the first showing of the new art at the beginning of 1839, he noted with satisfaction in his diary that trip out to Slough took 38 minutes, the trip back just 36, and that he was home in 52 minutes[63] Herschel's contemplative moat had been breached by the Great Western Railway. Explaining their move to his Aunt Caroline, he wrote in horror that "since the good old times the neighbourhood is so changed that it seems as if we were already in another country. A railroad runs close to the village and brings down hundreds of idle people and all day the road in front of the house is kept in a riot and dust with the railroad omnibuses."[64]

After searching for much of 1839, the Herschels settled on a large house and grounds near Hawkhurst, in Kent, which they re-named *Collingwood*.[65] Their new home was to prove ideal. By March 1840, Margaret reported to Aunt Caroline that "in our new house Herschel will have his study, his laboratory, and Litter rooms all under the same roof with his family, he will have his conservatory for petting his bulbs, he will be removed from the bustle of London...."[66] However, this was not without disruption. Two months later she was forced to admit that "the House too is very comfortable, although of course Herschel finds it rather difficult to adapt a fashionable gentleman's premises into a Philosopher's workshop, but by degrees I dare say all will be well managed."[67]

Given the disorder consequent to moving his household and the failing winter light, it is not surprising that Herschel made no entries in his research notebook between 28 October 1839, and 3 January 1840. Forced to remain alone at Slough in order to wind up local affairs, Herschel allowed himself the diversion of a few experiments on photography. But the winter heating season was upon him. In his research notebook for 6 March 1840, Herschel recorded that his experiments were being interfered with: "dreadful smoke haze can hardly see trees in Upton Lane." Two days later, visiting Slough, Margaret reported to Aunt Caroline

Our weather is now splendid, as we have only to complain of the London Fogs brought by the east wind which dull the effect of a glorious sun & blue sky, & interfere with Herschel's experiments on the Solar Spectrum which are intensely interesting, and by which he hopes to prove soon that his Father's assertion of the existence of heat beyond the coloured rays is quite true.[68]

This air pollution had a marked effect on Herschel's photographic work. In 1840, in his next Royal Society paper on photography, Herschel took pains to explain that

In an atmosphere so loaded with coal smoke as that in the neighbourhood of London, peculiarities of absorptive action may have place which rarely or never occur elsewhere. The tint of coal smoke is yellow (as may be seen in perfection in a London November fog), and more than one instance of the intense power and capricious singularities of very pale yellow media in their action on the chemical rays will come hereafter under our notice. In the locality from which this paper is dated, a light easterly wind brings with it abundant smoky haze from London, to which rural prejudices assign the name of "blight" and attribute to an insect origin. On such occasions, when the sky has been otherwise cloudless, (comprising nearly half the poor allowance of sunshine of the last summer,) I have been continually at once annoyed and surprised, by the slowness of photographic action, and by the fugitive nature of its results under the process of fixing.[69]

Adhering to Talbot's advice, Herschel had temporarily delayed the publication of his Royal Society paper. But his need to get on with his astronomical observations was too pressing. On 27 February, he wrote to Talbot to inform him that

I waited till the 14th was come and gone before I sent in my Photographic paper to the RS as soon as it is printed I shall send you a copy unless you would like to see the sheets as they are revised in wh case I will cause reviews to be sent you and will gladly alter any expression you may disapprove.[70]

What was the significance of Herschel waiting until after 14 February to submit his paper to the Royal Society? This date marked the expiry of the six month waiting period for the enrollment of Daguerre's patent. Herschel had taken Talbot's advice to heart and wished to avoid any possible confusion of his processes with Daguerre's. It was now too late to influence the publication, but Talbot replied from Lacock on 28 February that he had "written to Town for a copy of the specification of Daguerre's patent, as enrolled, but have received no answer as yet, have you seen it? and do you know whether he attempts to patent anything beyond his own invention?" A spirit of hope continued in this letter: "this morning in very cloudy weather I found that my sensitive paper, well dried at the fire, was pretty strongly affected by the radiation of the clouds in three seconds. Do not you think this is equal to the sensibility of Daguerre's iodized plates?" In addition to making technical advances, Talbot was growing in his mastery of imagery and the quality of his photographs was improving steadily. He was soon to be

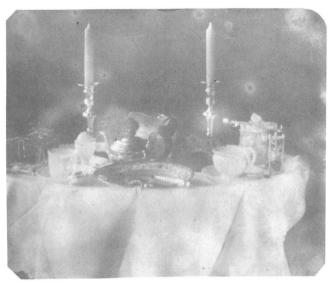

53. William Henry Fox Talbot. *Tabletop.* Salt print from a photogenic drawing negative. 2 March 1840. Signed and dated on verso. 17.7 × 21.7 cm. The Fox Talbot Museum, Lacock.

54. William Henry Fox Talbot. *The clocktower in the courtyard of Lacock Abbey.* Photogenic drawing negative. 5 April 1840. Dated by Talbot on verso. 14.3 × 18.7 cm. The Fox Talbot Museum, Lacock.

providing a real challenge to Daguerre on visual grounds. Herschel perhaps noticed this sooner than Talbot himself. He wrote Talbot on 3 March, giving

> many thanks for your <u>beautiful</u> specimen. I took the liberty (not I hope one you will disapprove) to give them to an Italian friend on his way to Florence via Paris with a request (on my part) that he would shew them to Biot & Arago, who are probably hardly aware of what may be done by paper.

The report that Herschel had been delaying was finally read to the Royal Society on 20 February. It was a densely-packed comprehensive summary of his work to date. But he led with the caution that

> lest the title of this communication should induce an expectation of its containing any regular and systematic series of researches developing definite laws, or pointing to any distinct theory of photographic action, it may be as well to commence it by stating its pretensions to be of a much lower kind, its object being simply to place on record a number of insulated facts and observations respecting the relations of both white light and of the differently refrangible rays to various chemical agents, which have offered themselves to my notice in the course of photographic experiments originating in the announce- ment of M. Daguerre's discovery.[71]

While Herschel earnestly felt that "the facts themselves, in the present state of our knowledge, will, I believe, be found by no means devoid of interest," his real intent in publishing them was the belief that they "may lead, in the hands of others more favourably situated for such researches, and, I may add, in a better climate than ours, to inquiries of the utmost interest."[72]

The previous March, thinking himself on the verge of a breakthrough, Herschel had withdrawn from publication his first paper on photography. Continuing in the present paper, he generously pointed out that in the meantime, his initial processes had been

> far surpassed by the curious and powerful processes of Mr. Talbot, not then divulged, as well as by those which I have myself since fallen upon.... Of course it will be understood that I have no intention here of interfering with Mr. Talbot's just and long-antecedent claims in this or in any other points; but having bestowed much attention both then and since on these processes, so as to produce results far from unsatisfactory, it will be necessary to say a few words in justification of the time and pains I have devoted to this branch of the inquiry.

While Herschel's initial camera had been little more than a "burning-glass," he understood the practical need for a photographic camera "in which the three qualities of a flat field, a sharp focus at great inclinations of the visual ray, and a perfect achromaticity, are indispensable." But the eventual perfection of camera pictures could be assumed. Since the details of Daguerre's process were by then known, Herschel stressed the virtues of his and Talbot's approach on paper.

A much more important line of inquiry, as far as

applications are concerned, appeared to be the exact reproduction of indefinitely multiplied fac-similes of an original photograph once obtained, by which alone the *publication of originals* could be accomplished. And this seemed the more deserving of attention, as it was understood that M. Daguerre's pictures admitted of no such reproduction, thus giving a decided superiority to the use of paper, or other similar material, provided it could by any means be wrought up to equal perfection of effect.

A year before, in response to Talbot's awkward term, 'photogenic drawing', Herschel had given the art its root name of 'photography'. Borrowing from the field of electricity, he now established another foundation stone in the terminology:

> To avoid much circumlocution, it may be allowed me to employ the terms positive and negative, to express respectively, pictures in which the lights and shades are as in nature, or as in the original model, and in which they are the opposite, i.e. light representing shade, and shade light. The terms direct and reversed will also be use to express pictures in which objects appear (as regards right and left) as they do in nature, or in the original, and the contrary.

He felt that "since it is a fact that the negative reversed photographic impression of an engraving, however highly finished ... is quite equal in precision and finish to the original engraving," once the manipulatory details had been worked out for camera negatives, "the problem of photographic *publication* is solved...."

Herschel recounted other scientific points from his earlier paper, including "that the intensity of chemical action of different rays in the solar spectrum appears to be in great measure disconnected with their colorific impressions on the eye...." His pursuit had turned towards the production of colors, leading to "many details equally novel and unexpected, in the experiments about to be related, in which the prismatic analysis of the rays has been resorted to." Herschel had applied himself so much to photography during 1839 that he was in a position to offer both practical advice and theoretical observations. On the important issue of fixing photographs, Herschel unequivocally stated that he found "the surest and best fixing material to be a liquid hyposulphite, and of these I prefer that of soda." He cautioned that the use of hypo had to be done with care:

> the photograph must be first well washed by soaking it in water, to free it from all superabundant nitrate of silver, which is very apt to produce a sulphuret on its first contact with the hyposulphite. If the paper be prepared with the simple nitrate, the water must be distilled, since the smallest quantity of any muriatic salt present attacks the

55. William Henry Fox Talbot. *Country house*. Salt print from a photogenic drawing negative. 15 April 1840. 16.7 × 20.7 cm. The Fox Talbot Museum, Lacock.

picture impressed on such paper with singular energy, and speedily obliterates it, unless very dark.

This explained why hypo mercilessly bleached some of the early papers. Traces of salt, introduced by the well water, converted part of the image into a form soluble by the fixer. After applying the hypo, it was critical to wash both sides of the print

> with repeated and copious affusions of water, aided by a soft sponge, with a *dabbing* motion, often turning the picture, until the liquid comes of without the slightest *sweetness*. The photograph is then fixed, and may be dried and put by; but to make it quite secure it is best to repeat the process, and if the paper be thick, even a third time.

Had more photographers followed the care indicated in this advice, it is likely that our pictorial legacy from the first decades of photography would have been much greater! Herschel also pointed out that

> it makes a great difference, in respect of the injury done to a photographic picture by the fixing process, whether that picture have [sic] been impressed by the long-continued action of a feeble light, or by the quick and vivid one of a bright sun. Even supposing the pictures originally of equal intensity, the half-tints are much less powerfully corroded or washed out in fixing, in the latter case than in the former.

As previously indicated, in print-out papers, where the silver was reduced from its salts solely by the energy of light,

the rapidity of printing affected the size of the silver clusters. Slower printing led to a finer grain (and somewhat warmer image tone) that was more susceptible to attack by the fixer. In fact, inadequate light levels produced weak prints, no matter how long the exposure was continued. This was a subtle and little understood effect for some time and probably influenced far more productions than has been recognized. As long as a casual amateur could pick his days, sunshine could be waited for and strong prints would result. However, anyone trying to produce quantities of prints (as Talbot would soon attempt for publication) faced the necessity of printing regardless of the weather. This effect also stacked the deck against photographers working in urban areas. The wealthy amateur on his country estate, safely removed from skies laden with coal smoke, was likely to be able to expose his prints in stronger light, and likely to obtain better and more consistent results than the urban professional.

Herschel also advised on the process of making copies from negatives and prints. For larger pictures (11 × 10"), he recommended glass at least one-third of an inch thick:[73]

> the contact should be as close as can be produced by any pressure short of what will break the glass, as the smallest interval is injurious by allowing dispersed light to spread. Even that arising from the interposition of a thin film of mica is hurtful to the sharpness of the impression.

There were other tricks. Thin paper was best for making negatives; the transparency of thicker paper could be improved by oiling or waxing (but thorough washing became more difficult with thicker layers of fibers). Without exception, all paper was uneven in thickness and thin spots were more dramatic in thinner paper, letting through more light and giving a blotchy effect. Herschel first thought to impose another sheet of paper over the negative during the exposure of the print; acting as a diffuser, it limited this effect. He then extended this technique to solving another problem. It was difficult to get sufficient density in the negatives to make a strong print, and it then occurred to him to employ two identical negatives face to back, "being first delicately adjusted under a magnifier, by fiducial points made with a fine needle in each, are in that position to be cemented together at the edges, or rather at four points, one in the middle of each side." While this approach would not be practical in the long run, it had the important effect of facilitating the production of some very good prints. These proved what could be attained, and established a visual goal for which to aim. Herschel admitted that

> it would be tedious and serve little purpose, were I to recite individually the numberless combinations I have tried with a view to the increase of sensitiveness and

facility of preparation of this useful material; especially as, after all my trials, I am obliged to admit (which I most readily do) that the specimens recently placed in my hands by Mr. Talbot far surpass in respect of sensitiveness any that I have yet produced of a manageable kind, and that for all ordinary purposes I have ended in adopting his process of preparation, as far as I understand it.

Herschel did outline a few particulars, a minor one of which was to prove significant in retrospect. Employing organic compounds, but "failing of any marked success in this line, (with the somewhat problematic exception of the gallic acid and its compounds)," he unknowingly touched on the very chemical – gallic acid – that within the year, in Talbot's hands, was to be the key to successful photography. But for the present, Herschel merely laid out the wide range of possibly applicable chemicals, including alkaline urates "from the *Boa Constrictor*. My specimen had been long kept, at least fifteen years."

In finally publishing his negative/positive on glass process, Herschel made less of a point of its image-making potential and instead stressed that

> this mode of coating glass with films of precipitated argentine or other compounds, affords, it may be observed, the *only* effectual means of studying their habitudes on exposure to light, free from the powerful and ever-varying influence of the *size* in paper, and other materials used in its manufacture, and estimating their degree of sensibility and other particulars of their deportment under the influence of reagents.

A major portion of Herschel's paper was devoted to the mostly anomalous results using colored light from different parts of the spectrum. Red light, as he had pointed out in his earlier paper, seemed to destroy photographic activity. But, of the results so far from his spectrum apparatus, "it would be mere waste of time to recount the almost numberless experiments on particular preparations of paper made with this apparatus, especially as they lead to no general laws." The effect of the spectrum on vegetable colors was only briefly summarized in this paper, but would become an important component of his next one. In describing his *actinograph*, Herschel admitted that

> as I do not mean this paper for a regular treatise, as on the contrary it pretends only to be mere collection of insulated facts, observations, and processes, I may be pardoned for inserting in this place an application which very early suggested itself . . . viz. that of a self-registering meteorological photometer or *actinograph*.

On 4 March and 12 March Herschel appended some

miscellaneous notes, gathered in fitful batches in his final days at Slough. Finding a way to impress what he called the *thermic* rays on the paper, Herschel said that

> if any doubt should remain in the minds of photologists as to the correctness of my father's results, which placed the maximum heat beyond the last visible red, the ocular evidence of their effects thus afforded must at once set the question at rest. But the extent to which the thermic rays thus traced, overlap the luminous and even the chemical or oxidizing rays, is, I must confess, to myself quite unexpected.

In conclusion, Herschel again took notice of the poor air quality, suggesting that since the atmosphere acted as a photographic filter, the light at high altitudes might vary in both the nature and force of its photographic action. Following Herschel's suggestion fifteen years later, Charles Piazzi Smyth would prove this on the peak of Teneriffe.[74]

As soon as he had finished this article, Herschel sent a note to his longtime friend, William Whewell, saying that "I have just handed in a long rambling scrambling paper about photographical matters to the R.S. and of this subject for the present I have made a clean breast."[75] At this point in 1840, a lovely spring was just then emerging in England. For Herschel, it was a time when other interests would press in on his photography. But Henry Talbot was about to become an artist. Sunshine was the currency of early photography. As the gray skies of 1839 gave way to a splendidly bright 1840, by 19 April, Herschel could only lament to Talbot that "of all this superb weather I have been able to make not a slightest use! Every thing I have in the way of apparatus is packed and on its way to Hawkhurst where henceforward please to address me should you have occasion to write or reply to this." That the complications of the move to Kent had caught up with Herschel is reflected in the fact that he made absolutely no entries in his research notebook between 17 March and 7 August 1840. It was the worst possible time for him to be removed from photography. In his reply of 30 April, Talbot could not help but gloat that "the present weather is the finest and most settled, since the birth of Photography." The miserable year of 1839 was about to be atoned for, restoring to Talbot both his optimism and his vision:

> Whenever there comes a very bright day, it is as if nature supplied an infinite designing power, of which it is only possible to use an infinitesimal part. It is really wonderful to consider that the whole solar flood of light, should be endowed with so many complicated properties, which in a vast majority of instances must remain latent, since most of the rays pass away into space, without meeting with any object.

Talbot tried to cheer his frustrated friend as well. "This is splendid weather for you on arriving at your new residence. Hawkhurst <u>sounds</u> like a very pleasant rural retirement abounding in hawks and forest glades. I have interrupted this letter several times to listen to a nightingale who is perched on a bust just outside my window." Having taken advantage of the sun, Talbot also enclosed "some photographs, all done with the Camera. If they get crushed in the Post Office bags, they may easily be smoothed either by ironing, or by being left some hours in a press."[76]

Henry Talbot's vision was being cultivated and was evolving rapidly. Undoubtedly he had listened to advice from many quarters. Some of this would have come from the artists within his own family; some from outside artists and other interested parties. But nothing was more important than the tutelage of his own photographs. Talbot was beginning to see photographically. In a 3 May reply to Talbot, Herschel was a tough critic but an enthusiastic one:

> your extremely beautiful camera pictures which you have sent me in such abundance. I think in another year or two <u>your art</u> will beat Daguerre's. In many respects its already equals it – but it seems to me as if the camera were not always well in focus. I presume these are retransfers and I cannot enough admire their evenness of ground.

Herschel's own frustration was clear, regretting that he had "nothing to send you in return. All this superb sun for one day of which I would almost have given my little finger last summer, passes without the possibility of my availing myself of a single beam of it...." Even though he had several interesting experiments in mind, it was "<u>just too late</u> as now every atom of my apparatus is packed & on its way hither. This <u>is</u> tantalizing!" Knowing that Talbot had by now acquired a set of Daguerre's apparatus, Herschel suggested in this letter an experiment that Talbot might like to try. But his new abode was a constant (and joyous) distraction:

> I think in respect of nightingales we can challenge the world here. So far as woody glades & green pastures go this place answers your Etymological idea of it but in place of Hawks we have only crows – in immense abundance and where they come from I cannot tell as I see no nests. A meteorol[l] neighbour tells me that not a drop of rain has fallen here since the Queen's wedding day.

As important as the good weather was the fact that he had begun to learn some of the 'tricks' of securing fine photographs in a way that had always eluded him in sketching. In May 1840, Talbot mounted his third major exhibition of photographs. His latest photogenic drawings were to be shown in London at the Graphic Society; in a preview, the *Literary Gazette* looked at Talbot's pictures

56. William Henry Fox Talbot. *Cherub and urn*. Salt print from a photogenic drawing negative. 29 April 1840. 16.8 × 21.8 cm. The Fox Talbot Museum, Lacock.

57. William Henry Fox Talbot. *Garden implements in front of a hedge*. Salt print from a photogenic drawing? negative. Ca. 1840. 17.7 × 21.3 cm. The National Museum of Photography Film and Television.

during his spring residence in the country; and certainly they are not only beautiful in themselves, but highly interesting in regard to art. The representation of objects is perfect. Various views of Lacock Abbey, the seat of Mr. Talbot; of Bowood; of trees; of old walls and buildings, with implements of husbandry; of carriages; of tables covered with breakfast things; of busts and statues; and, in short, of every matter from a botanical specimen to a fine landscape, from an ancient record to an ancient abbey, are given with a fidelity that is altogether wonderful.... Among the curious effects to be observed is the distribution of lights and shades. The former, in particular, are bold and striking, and may furnish lessons to the ablest of our artists. The crystal bottles on the breakfast-table are also well worthy of attention; their transparency is marked with singular truth; but, indeed, there is nothing in these pictures which is not at once accurate and picturesque.[77]

Many of these specific photographs can be identified within Talbot's own collection.[78] They show the confidence of a maturing artist. It is difficult to separate, on either technical or aesthetic grounds, the best of the photographs that Talbot was able to produce in the spring of 1840 from those 'masterpieces' usually associated with a later period. Curiously, Talbot does not seem to have announced the Graphic Society exhibition to Herschel, although in a 15 June letter, he drew attention to his competition. By then he had obtained Herschel's Royal Society paper:

I have read your memoir with great interest, and will send you some remarks as soon as I find a leisure moment. I enclose a few photographs. There are 100 Daguerre pictures on view at the Polytechnic. Some of the localities are interesting (Rome & Naples) some are very well executed, but others are not,

adding, in a postscript, that the photographs would "require ironing smooth after their journey." They must have arrived in good condition, for Herschel immediately replied on 19 June that he was

very much obliged indeed by your very very beautiful Photographs. It is quite delightful to see the art form under your hands in this way. Had you suddenly a twelvemonth ago been shewn them, how you would have jumped & clapped hands (ie if you ever do such a thing).

That which pleased me most is I think (for it is difficult to chuse) the garden scene with trees & trellis. It is so very unlike any drawing – and then, the difficulty of doing foliage at all. Then the corner of a sunny wall with garden tools. How admirably the brooms shews – & the shine of the spade. As a drawing the old back-front of Lacock Abbey with the pile of wood strikes me as very finished.

In spite of his praise of the pictorial quality of Talbot's new work, Herschel felt compelled to point out an old demon, observing that the last specimens Talbot sent "have changed by keeping. One in particular but which seems to me the best – the reflexion of your Abbey in the river has been altered partially...." Enclosing a diagram to explain his comments, Herschel identified areas where the "pristine tints" were retained, and areas where outlines of other prints could be detected. And Herschel could not hide his delight at his restored sense of privacy. In a postscript, he added that "as your London address is unknown to me I address this to Lacock to be forwarded. This may savor to you of a man dropping out of the current of the world's knowledge but I hope it will be excused."

It wasn't until August that Herschel was able to re-start his photographic researches. He could no longer ignore the opportunity, since, as he told his aunt, "we have had and are still having a most magnificent summer – such a one as I do not remember ever before in England."[79] Significantly, the first entry in his research notebook betrayed his horticultural interests: "Aug. 7. 1840. Hawkhurst. Spectrum thrown on Paper deeply tinged with juice of Petals of dark Purple Dahlia." On 30 August, he sent Talbot

a specimen which (the sun being too superb to resist the temptation of trying once more for colours) I produced this morning. It holds out I think a very fair promise of solving the problem of coloured Photographs being a faint & rainbow like, but yet unequivocal representation colour for colour of the whole luminous part of the spectrum....

This rainbow spectrum had flaws, "but that I have not a doubt of completely obviating so that its pretensions shall be literally though perhaps at present not brilliantly vindicated." Confident that improvements would be made now that the first step had been taken, Herschel also enclosed "a Pink Lady – a positive impression from an Engraving taken on paper stained with the juice of red flowers. The effect is pretty especially if held in certain lights."

Talbot's reply, on 1 September, closed the exchange between the two men during this phase of photography. Their frustrations and triumphs had been varied. Talbot sent along more photographs – camera views "of vignette size, suitable to tourists who cannot conveniently take about with them a larger apparatus," and positive prints of leaves. By this time, Talbot was corresponding directly with the experimentalist and historian Robert Hunt, who was repeating Herschel's experiments on the spectrum.[80] Talbot was a skeptic:

I should be much surprised if it were found possible to represent the prismatic tints rigorously, because I see no

58. William Henry Fox Talbot. *Sunlit objects on a window ledge*. Salt print from a photogenic drawing negative. 30 May 1840. Dated in the negative. 16.9 × 20.9 cm. image on 18.1 × 22.7 cm. paper. The National Museum of Photography Film and Television.

connexion between the colour of the ray dependent upon the length of the undulation & the colour of the photograph, dependent upon it is very difficult to say what ... I am afraid vegetable substances will not be practically available to any great extent.

Surprisingly, Talbot claimed that he had

not been able this summer to give more than a desultory and divided attention to the subject. I had & still have the intention of making a little photographic tour, in search of

objects more picturesque than my own immediate neighbourhood supplies. A great desideratum is more sensitive paper, in order that the tourist may make many sketches in one day with one instrument. Or, what would come to the same, an improved object glass allowing of large aperture.

Herschel had observed that Talbot had made great strides aesthetically and technically, but Talbot complained that "I cannot say I have much improvement to boast of, of late, but

59. William Henry Fox Talbot. *Basket under a tree*. Salt print from a photogenic drawing negative. 3 May 1840. By the spring of 1840, Henry Talbot had begun to learn from the art that he had conceived. Although the technical problems were then formidable, especially with long exposure times, he already at this time began to approach much of the subject matter and many of the themes more closely associated with his later calotypes. Examples dated before September 1840 (ie, definitely <u>not</u> calotypes), prove that Talbot's artistry stemmed from a growth in perception and visual sensitivity, rather than having been enabled by a technical breakthrough. In fact, sheer technical limitations aside, it is impossible to create a meaningful aesthetic or conceptual division between the last of his photogenic drawing negatives and the beginnings of the calotype. 17.0 × 20.7 cm. image on 18.7 × 22.8 cm. paper. The Fox Talbot Museum, Lacock.

the art remains in status quo since April or May." That status quo was shortly to be overturned. Within the month, Henry Talbot would dramatically surpass his goal of "attaining to the level of amateur sketching." Soon, the quality and range of Talbot's photographs would begin to surprise and delight even their author. Photography as an art form was about to be established – magic was to set the way.

V Photography Becomes an Art

FOR HENRY TALBOT, September 1840 was arguably the single most important month in his entire relationship with photography. Within the span of little more than a fortnight, Talbot reached a goal he had sought from the beginnings of the art, only to realize this goal's limitations. Almost immediately, indeed miraculously, Talbot's research showed him the path to the future of the art. Surprisingly, this was revealed on a trail that he had travelled for some time. At the end of 1839, when Talbot plaintively confessed that "if I can attain to the level of common amateur sketching I shall be satisfied," he still had in view the target set at the start of his photographic researches.[1] On the shores of Lake Como in 1833, it was the frustration at not being able to accomplish a common amateur sketch that had inspired Talbot to contemplate how to tame nature's pencil. For much of 1839, Henry Talbot chased his competitor, attempting to equal Daguerre's virtuosity and marketing finesse, while succeeding only in frustrating himself in the process. The adversarial nature of their relationship was obvious. It took the brilliant sun of 1840 to demonstrate to Talbot that he could make pleasing and useful images. Throughout 1840, his photogenic drawing technique was refined. Better cameras (one of them Daguerre's!), increased facility with the hand manipulations, and some fine tuning of his chemistry all contributed to higher quality negatives. But what really influenced the course of events was Talbot's growing mastery of two-dimensional rendition. Guided by the comments of his family and friends, Talbot studied his own photographs and these very images taught him how to see.

In the controlled conditions of the inventor's studio, the daguerreotype and photogenic drawing each had merits. For portraiture, however, the greater sensitivity of the daguerreotype process provided such a crucial edge that by the end of 1839, Talbot had ceded this application to his rival.[2] Photographs taken under field conditions were another matter. Talbot hoped that Daguerre's metal plates would prove inconvenient to carry. However, since the materials for both processes were hand-made and volatile, most of the steps had to be undertaken in the field anyway. So much in the way of chemistry and apparatus was necessary for either process, that any difference between the actual plates or paper had little influence on the heft of the entire outfit.

In seeking a marketing differentiation from Daguerre, Talbot and Herschel seized on the fact that the paper processes produced negatives from which multiple prints could be made. These permitted the publication of plates and the replication of engravings, even though the printing of the positives remained a difficult and problematic step. Looking at his first photographs, Herschel said that "to operate a second transfer, or, by a double inversion to reproduce the original effect, is a matter of infinitely greater difficulty...."[3]

But then, the overtures of the direct positive were also initially troubling to Talbot. On 12 September 1839, he had written to Herschel that

> the whitening power of sunshine on iodized paper . . . is a most inconvenient property, for in consequence of it, it is difficult so to fix a photograph with sod. potass. as to resist prolonged exposure to light. If framed & glazed, one week's exposure to daylight is injurious. . . . I have kept some photographs 4 or 5 months in a portfolio w^ch still retained a ground of the deepest black, yet one day's exposure to light destroyed the blackness & reduced it to brown.

At the time, he felt that "the whitening power is not energetic enough to be employed directly to obtain the lights & shades in their proper place, in working the Camera Obscura."

After the personally disastrous year of 1839, Talbot could only return to the base from which he had started, namely, a 'sketch' – a solitary direct positive on paper, to rival the daguerreotype. He was not alone in this quest. Hippolyte Bayard and Jean Louis Lassaigne in France, Dr Andrew Fyfe in Scotland, Robert Hunt, and Sir John Herschel himself were amongst those who sought direct positive processes. However, a year after Talbot's disparaging lament on the whitening power of sunlight, on 17 September 1840, he turned the property to good use, with the discovery of a process he designated as the *leucotype, or positive photogenic drawing*. Starting with a sensitized Waterloo paper, Talbot would

> darken it suddenly by holding it while wet in the sunshine, then dry at the fire & wash with iodide potass. Use it wet. I find that 2' suffices at 5 PM to obtain a picture of lace, grass &c. A picture of the hall window made in the camera, some hairs casually on the paper caused it to whiten behind them & some distance around them. . . . These leucotypes washed in hot water were found well fixed.[4]

Here was a process, reasonably sensitive, that could be fixed simply with hot water. And, best of all, it produced a direct positive, just like Daguerre's process, without the necessity of going through an additional printing stage. Why are examples of leucotypes, indeed, even mention of them, so rare? They probably would have been more common, had not Talbot been drawn almost immediately to an even more intriguing procedure.

Just days later, on 20 September, Talbot was verging towards a breakthrough that would prove to be so simple and so dramatic that he would actually fear for its loss. At some point (lest his notebook should fall into the wrong hands), Talbot took the security precaution of physically cutting out all occurrences of a critical word. He had found that by washing over double-Waterloo paper with a mixture of silver nitrate and his secret chemical, that he could create a paper that was "very sensitive, & turns very black." Continuing on 21 September, Talbot noted that " ☐ increases the sensibility of W or Bromine paper, but much more than that of yellow or Iodine paper.—" Talbot used what he called an 'exciting liquid,' composed of

> 1 part by measure nit. silv. common strength
> 1 . . . acetic acid
> 1 . . . ☐ strong solution.

So far, this appeared to be only a variant of his earlier print-out processes. But there was something unique in its extreme sensitivity; on 22 September, Talbot observed that his new paper "when excited, gives a picture in 5' cloudy weather exhibiting even the tiles on the roof &c &c." The next day, 23 September, Talbot recorded a most extraordinary phenomenon:

> the same exciting liquid was diluted with an equal bulk of water, and some very remarkable effects were obtained. Half a minute suffices for the Camera. The paper when removed is often perfectly blank but when kept in the dark the picture begins to appear spontaneously, and keeps improving for several minutes, after which it should be washed & fixed. . . .

The "G," the cut-out mystery word, Talbot's secret weapon – was gallic acid. Here was photographic magic! It presented an intriguing possibility:

> the same exciting liquid restores or revives old pictures on W. paper which have worn out, or become too faint to give any more copies. Altho' they are apparently reduced to the state of yellow iodide silver of uniform tint, yet there is really a difference & a kind of latent picture which may be thus brought out.

The term *latent image* has become inextricably associated with Talbot – but in a modified meaning that is now so firmly entrenched that his original application of the word has been lost. His initial term was *latent picture*. Talbot was fascinated by the potential of reviving, Lazarus-like, his faded earlier negatives.[5] He had not yet perceived what was to emerge as a far more useful property, a property now associated with the term latent image. On 23 and 24 September, in a flurry of experiments, Talbot

> revived a picture made last May, representing objects placed on the floor of the gallery. The pattern of the carpet became visible. White objects assumed a deep red tint (when held against the light) but the carpet tho' strongly

60. William Henry Fox Talbot. *Ribbon*. Leucotype direct positive? 17 September 1840. Dated in Talbot's hand on recto. 8.5 × 7.2 cm. The National Museum of Photography Film and Television.

depicted, had no tendency to redness. This picture & others have been twice plunged in hot water and once in iod. pot. without destroying the (latent) representation, to say nothing of the lapse of time. A camera picture made yesterday in 2', & which was faint the spontaneous action having been stopped by fixing it with iodine, was washed with the exciting liquid & revived, or rather, the spontaneous action recommenced as if it had not been interrupted.

One of the marks of creativity is the ability to imagine the implications of unexpected phenomena. Talbot was homing in on the true import of his new discovery. By 24 September, he recorded tentatively that:

I find 8 seconds enough for a strong impression of the outline of a house, in cloudy weather. Also the lighter tiles on the roof are very plainly depicted. If the impression is not strong enough, I find it may be strengthened by immersion in iod. pot. & then more of the G. wash. In 3 minutes a singular picture was obtained, the sky deep fiery red especially by transmitted light, against which the roof almost white contrasted as if covered with snow.

Finally, on 26 September, Talbot comprehended that his breakthrough was not merely a tonic for failed negatives. He had discovered a near-magical means of amplifying the effect exerted by light in his camera. Instead of the "remarkably dark weather" defeating him as it had done so often, it now became a challenge that Talbot welcomed – and triumphed over:

3 and even 1 seconds exposure at the window produces complete darkening (by spont.) in the G. paper ... This sens^ve paper takes a feeble impression, but which is speedily brought out by a second wash of G. Probably weaker G paper w^d do as well as washed. 10" at sunset in the darkest weather produces an invisible impression w^ch can be brought out.

This startling sensitivity sent Talbot's creativity racing. Although he had not yet named his new process, he immediately thought of trying to photograph "Objects. Sun behind a cloud. Moon. View by moonlight. Fire. lighted candle. Vase, at first screened from sunshine. Magnified D.type details. White clouds. Diffraction bands. Spectrum darkroom with chemical rays introduced. Cobra. Agapanthus."

Talbot finally appreciated the real destination of his train of experiments. A weak exposure in the camera, insufficient to make a useable image, could be brought out and strengthened by an additional wash of gallic acid and silver nitrate. This is the sense in which we understand the latent image today. The developing-out approach is the basis of virtually all current photographic materials. The latent image (as presently defined) had, of course, been the basis of Daguerre's process all along. The anecdotal story of Daguerre's first success generally has him filing away yet another failed attempt at capturing the image in a camera obscura. Returning to the cupboard some days later, Daguerre was astonished to find that a picture now occupied the formerly blank plate. By trial and error, he finally isolated the fact that a dish of mercury had spilled nearby, and that the fumes had developed the image that had been impressed, but previously unseen, on the plate. However apocryphal is this story (and several points of it admittedly do stretch belief), given Daguerre's chemical naiveté, it is likely that the discovery of the daguerreotype came about in somewhat this fashion. It was a totally unexpected effect for which to search and Talbot's research notes make it amply clear that he did not set out to find it.

Just where did Talbot get this idea of latency? Had it been in his subconscious all along? In March 1834, even while Talbot was formulating his first photographic researches, he attended a Royal Institution lecture by Richard Phillips on "Chemical Affinity." Although the discussion was not about the effects of light, "the lecturer concluded with explaining what was meant by the *nascent* state of bodies, which, he observed, was frequently requisite to ensure chemical action...."[6] This might have alerted Talbot to the fact that

61. William Henry Fox Talbot. *Roofline of Lacock Abbey*. Salt print from a calotype negative. 22? September 1840. Accomplished with but a five minute exposure in cloudy weather, this is one of Talbot's very first calotypes, taken even before he was certain of the full implications of what he had just discovered. 7.2 × 10.0 cm. image on 11.4 × 18.0 cm. paper. The Fox Talbot Museum, Lacock.

physical materials can be prepared for a change (a concept loosely related to latency). A case of detachment of cause and effect was recorded by Talbot in his notebook in 1835:

> Paper washed with Nit. silver . . . was held in the sunshine some time but darkened so little that the figure of a plant was hardly seen upon it. Hung up afterwards in ordinary daylight for an hour or two, the ground darkened, and not the figure, so that the latter became plainly visible!!! Hence it appears that the solar rays by darkening the silver somewhat, predispose it to darken it more, of its own accord, or in common daylight. Thus the effect is produced long after the cause has ceased to operate.[7]

Did Talbot seize on this idea? Sadly, it appears not. A few months later in 1835, in a published article on "The Nature of Light," he employed a similar experiment as an example:

> A sheet of paper was moistened with a solution of nitrate of silver, a substance which, it is well known, is capable of being blackened by the influence of solar light. Half of the paper was covered, and half exposed to sunshine; but owing to its being a dull day in the winter season, no effect was produced. After several minutes the paper was removed, and being examined, showed hardly any perceptible difference between the part that had been covered and that which had been exposed to the sun. It was then removed to another room, where the sun does not shine in the winter season, and accidentally exposed to the daylight. Some hours afterwards I was surprised to find that the paper had become partially darkened, and that the dark part was that which had been previously but ineffectually exposed to the sunshine, while the other part still retained much of its original whiteness. This anomalous fact, of which I could find no explanation at the time, appears to me now to be closely connected with what I have advanced as a probable cause of phosphorescence.[8]

Moreover, in 1839, in his British Association report on Daguerre's process, Henry Talbot betrayed no understanding of the significance of the latent image to the daguerreotype.[9] It wasn't until 30 March 1840, that he again asked the related question in his research notebook, "can sensitive paper be excited without being darkened? . . . In such case, an image thrown on it in ye usual way wᵈ perhaps be more readily impressed?" But this really referred to an increased receptiveness rather than a subsequent amplification. In any case, it was merely a speculation, based on the possibility of using a gas or colored light. But did he have this in mind when he shared his poetic thoughts with Herschel in a letter on 30 April 1840? "It is really wonderful to consider that the whole solar flood of light, should be endowed with so many complicated properties, which in a vast majority of instances

must remain latent. . . ." In the end, the most obvious explanation is also the most convincing. Watching the extraordinary effect of reviving faded negatives in September 1840, Talbot finally grasped the technical heart of Daguerre's success. Previously, Talbot had relied on the sun to provide all the energy to reduce the silver; a significant amount of energy was required, and within the camera, this energy could only be obtained by the accumulation of light through an extended exposure. By taking a faintly exposed plate out of the camera and amplifying through chemistry the invisible change that light had wrought, Daguerre had been able to build up a completed image.[10] Now, Talbot could do so as well. Observation of a chance phenomenon had radically shifted Talbot's point of view. As Herschel declared in his *Preliminary Discourse*,

> the character of a true philosopher is to hope all things not impossible, and to believe all things not unreasonable. He who has seen obscurities which appeared impenetrable in physical and mathematical science suddenly dispelled, and the most barren and unpromising fields of enquiry converted, as if by inspiration, into rich and inexhaustible springs of knowledge and power on a simple change of our point of view, or by merely bringing to bear on them some principle which it never occurred before to try, will surely be the very last to acquiesce in any dispiriting prospects of either the present or future destinies of mankind. . . .[11]

The critical component of the magical developer, gallic acid itself, was nothing new to British researchers.[12] In fact, Humphry Davy had published a means of making it in the same journal in which he revealed Wedgwood's experiments.[13] In February 1839, as soon as he received Talbot's just-published manipulatory details for photogenic drawing, Herschel wrote him that "when I read it I gave up further trials, your processes being so simple & complete – I had most hopes of the Gallate of Silver which is affected by light very differently from its other salts."[14] Two years later, Herschel acknowledged this in a letter to his friend, Sir John Lubbock (characteristically, without a trace of bitterness or envy):

> The action of the Gallic acid and its conjunction with Nitrate of Silver is indicated in my paper as a 'problematic exception' . . . the fact is that in my experiments the action was capricious and anomalous, the trial papers being laid by to dry were sometimes found spontaneously darkened sometimes not. It is evident now that this arose from their having been prepared without any precaution to exclude common daylight. . . . The point of the Gallates was reserved for further inquiry and lost sight of.[15]

In Herschel's 1840 Royal Society paper, he had noted the "somewhat problematic exception of the gallic acid and its

62. William Henry Fox Talbot. *Experimental portrait. Of a Talbot daughter?* Calotype negative. Ca. 1841. Talbot noted on verso that the exposure was just thirty seconds in the shade of the evening. 6.1 × 5.5 cm. The National Museum of Photography Film and Television.

63. William Henry Fox Talbot. *The stable court, Lacock Abbey.* Calotype negative. Ca. 1840–1. The anomalous colours sometimes produced by variations of chemistry and light often made Talbot's negatives themselves objects of beauty and wonder. 8.5 × 9.5 cm. image on 9.3 × 11.4 cm. paper. The National Museum of Photography Film and Television.

64. William Henry Fox Talbot. *Horatia's harp, in the library at Lacock Abbey*. Salt print from a calotype negative. 6 October 1840. Dated in the negative. 12.7 × 13.0 cm. The National Museum of Photography Film and Television.

65. William Henry Fox Talbot. *Portrait of Constance Talbot*. Salt print from a calotype negative. 10 October 1840. 9.3 × 7.5 cm. image on 10.4 × 8.6 cm. paper. The Royal Photographic Society.

compounds," but had not pursued it.[16] Talbot had also touched on gallic acid in the course of his research. Clearly, he had been stimulated by Herschel's suggestion. In a 28 March 1839 letter to Lubbock, Talbot said

> I recommend to you to try the sensibility of paper washed first with nitrate of silver, & then with gallic acid, the latter to be pure. I have not tried it yet, but it is has [sic] been mentioned to me both by Herschel & another experimenter, so that I think it must be among the best recipes yet found out.[17]

Talbot himself tried gallic acid soon thereafter. He observed in his research notebook entry for 13 April 1839 that "bromine paper, is greatly increased in sensibility by washing it with saturated solutn of Gallic acid; And it becomes quite black, which is an advantage. Washed with water & then with bromide potash, & washed out, it seemed tolerably fixed."[18] Gallic acid is mentioned dozens of times in various contexts in Talbot's notes, but obviously it was not until September 1840 that he realized its significant properties.

Due mostly to the pressure of his move, Herschel's correspondence with Talbot became irregular during the latter part of 1840 and no letters between them are known to exist for the period between 1 September 1840 and 16 March

1841. The two men must have met informally during this period, however, at least at gatherings of the Royal Society. Certainly, Herschel had not forgotten his friend, nor in any way had his respect for Talbot's accomplishments diminished. He seemed to be well aware of the advances that Talbot was making, although clearly Talbot reserved the technical details of what he would eventually call his calotype process.

In the meantime, the Royal Society considered awarding its prestigious Rumford Medal to either Daguerre, Herschel, or Talbot for their contributions to photography (in the end, it was awarded to Biot for his work on light).[19] However, the Society decided to confer their Royal Medal on Herschel. On 13 December, a very proud wife wrote to Herschel's Aunt Caroline that

> The Royal Society Anniversary has just passed, & the Royal Gold Medal was for a third time awarded to him — this year for his Paper on the Photographic action of the Solar Spectrum, though his modesty was wishing to pass it on to Mr. Fox Talbot who has been experimentalising very neatly, & successfully, on different kinds of Photographic Paper....[20]

66. William Henry Fox Talbot. *The footman.* 14 October 1840. Waxed calotype negative. Dated in Talbot's hand in pencil on verso. Taken with a three minute exposure. Redeveloped by Harold White, who noted that this negative, having originally been fixed in potassium iodide, "had bleached, but was revived as recommended by Talbot." 16.3 × 21.0 cm. Harold White Collection, Hans P. Kraus, Jr.

67. William Henry Fox Talbot. *Lacock Abbey*. Salt print from a calotype negative. 24 December 1840. Dated in the negative. Henry Talbot seemed completely insensitive to the effects of the periphery of his photographs. This trimming is more irregular than most, but it was not unusual for him to slash off a corner or to roughly trim a print or negative with a pair of shears. 17.2 × 21.4 cm. image on 18.6 × 22.9 cm. paper. The National Museum of Photography Film and Television.

68. William Henry Fox Talbot. *Lattice iron bridge*. Salt print from a calotype negative. 21 February 1841. Talbot recorded on the negative that, in spite of the weak winter light, this took a ten minute exposure. 16.1 × 21.6 cm. image on 17.8 × 22.6 cm. paper. The National Museum of Photography Film and Television.

bring home rude unintelligible sketches! They may now fill their portfolios with accurate views, without much expenditure of time or trouble; and even the accomplished artist will call in sometimes this auxiliary aid, when pressed for time in sketching a building or a landscape, or when wearied with the multiplicity of its minute details.

Reclaiming an area previously abandoned to the daguerreotype, Talbot predicted that "one of the most important applications of the new process, and most likely to prove generally interesting is, undoubtedly, the taking of portraits."[24]

The word 'calotype' was first published as the head of this article; indeed, the term might have been only days old at this point. The first (and only!) use of the term in Talbot's research notebooks was an unadorned mention on 30 January 1840.[25] In conferring the name calotype, Talbot wanted to stress that since "several photographic processes being now known, which are materially different from each other, I consider it to be absolutely necessary to distinguish them by different names, in the same way that we distinguish different styles of painting or engraving." In spite of his efforts to choose a name, Lady Elisabeth promoted the alternative *Talbotype*. Henry himself obviously preferred his original word and employed the honorific term only when pressured by commercial expediency. By the time of his announcement, Talbot the scientist had finally gained sufficient confidence as an artist to

> remember it was said by many persons, at the time when photogenic drawing was first spoken of, that it was likely to prove injurious to art, as substituting mere mechanical labour in lieu of talent and experience. Now, so far from this being the case, I find that in this, as in most other things, there is ample room for the exercise of skill and judgement. It would hardly be believed how different an effect is produced by a longer or shorter exposure to the light, and, also, by mere variations in the fixing process, by means of which almost any tint, cold or warm, may be thrown over the picture, and the effect of bright or gloomy weather may be imitated at pleasure. All this falls within the artist's province to combine and to regulate; and if, in the course of these manipulations, he, *nolens volens*, becomes a chemist and an optician, I feel confident that such an alliance of science with art will prove conducive to the improvement of both.

What a dramatic elevation from his position of little more than a year ago, then only seeking a simple sketch! Talbot revealed additional details in a subsequent letter, published two weeks later.[26]

One day, last September, I had been trying pieces of

Margaret Herschel's comments strongly imply that Talbot had already showed Herschel examples of the calotype. Henry Talbot was moving to set his new process in place; prints sent in January 1841 to Sir David Brewster elicited a warm response:

> I return you many thanks for the very beautiful Photogenic drawings you have been so good as to send me. The larger drawing of Lacock Abbey is particularly interesting to me as a specimen of the great power of the art, and as recalling the many happy hours I spent within its walls. You have surely not published the <u>precise</u> method of executing these drawings.[21]

On 8 February, Henry Talbot enrolled a patent for *Certain Improvements in Photography*.[22] He dispatched a letter to the *Literary Gazette*, explaining that "it is now two years since I first published a brief account of Photogenic Drawing. During this interval I have taken much pains, and made many experiments, with the hope of rendering the art more perfect and useful."[23] Stressing his negatives' outstanding sensitivity and the improved certainty of the fixing process, Talbot declared confidently that

> I think that the art has now reached a point which is likely to make it extensively useful. How many travellers are almost ignorant of drawing, and either attempt nothing, or

69. William Henry Fox Talbot. *Garden implements near a stone wall*. Salt print from a calotype negative. 23 February 1841. Dated in the negative. 14.9 × 21.3 cm. The National Museum of Photography Film and Television.

70. William Henry Fox Talbot. *Bust of Patroclus*. Salt print from a calotype negative. 4 April 1841. Dated in the negative. 5.3 × 3.1 cm. image on 7.3 × 4.2 cm. paper. The National Museum of Photography Film and Television.

sensitive paper, prepared in different ways, in the camera obscura, allowing them to remain there only a very short time, with a view to finding out which was the most sensitive. One of these papers was taken out and examined by candlelight. There was little or nothing to be seen upon it, and I left it lying on a table in a dark room. Returning some time after, I took up the paper, and was very much surprised to see upon it a distinct picture. I was certain there was nothing of the kind when I had looked at it before; and, therefore (magic apart), the only conclusion that could be drawn was, that the picture had unexpectedly *developed itself* by a spontaneous action.

Was this an echo of Daguerre's anecdote of discovery? Yet the account must be basically true, for why else would a methodical scientist like Talbot admit to such a providential advance? Even the setting was magical, as Talbot pointed out, for "the operator of course remains in a darkened room, lit by candles only." Anyone who has developed his own photographic pictures will recognize the sentiment in Talbot's declaration that "I know few things in the range of science more surprising than the gradual appearance of the picture on the blank sheet, especially the first time the experiment is witnessed." Finally, he reiterated the utility of the phenomenon that had first caught his attention: the ability of the developing fluid to revive old negatives, faded, but with details that

had been lying in an invisible state on the paper all the time, *not destroyed* (which is the most extraordinary thing) *by so much exposure to sunshine*. They were protected by the fixing liquid. But no one could have supposed beforehand . . . that it could have exerted so complete a protecting power.

Talbot hurried to embody his new process in a pamphlet, *Two Letters on Calotype Photogenic Drawing*, and dispatched copies to his colleagues. Dr George Butler, Talbot's former headmaster at Harrow, addressed

my dear friend and most admired magician . . . what a mass of wonders is contained in your reprint from the Literary Gazette! I am quite bewildered by the perusal. Latent pictures, really existing, <u>but invisible</u>! It is impossible to imagine, where this may end . . . how mad Daguerre will be when he hears of your <u>unrivalled</u> success![27]

Another recipient was Sir John Herschel, who wasted no time in congratulating Talbot on 16 March: "I really cannot express the surprise and delight with which I read your Circular rec^d this morning giving an account of the Kalotype (to which however I doubt not all the rest of the world will assign the name of Talbotype)." Herschel was not alone in thinking that Talbot's name, like Daguerre's, should be linked to the inventor's premier photographic process. He continued that

I always felt sure you would perfect your processes till they equalled or surpassed Daguerre's but this is really magical. Surely you deal with the naughty one. . . .
 I wish I had a sheet of it here at this moment where I am sitting in a warm summer house on the edge of what we call our <u>lake</u> with the brightest sunshine sparkling on the water and the reflexions of the oak trees in all the Bays and creeks touched out most delicately in the most heavenly sky and temperature it is possible to conceive. Never was surely such a succession of Blue Skies and Photographic weather since Britain was an Island as we have had since this time 12 months, and finely indeed you have availed yourself of it.

In a stroke, Herschel comprehended that many of the anomalous results observed by both him and Talbot might well have been the overtures of the calotype:

As almost all our chemical processes have been hitherto performed <u>in the light</u>, there is no doubt that the cases of <u>exceptionally rapid</u> photographic action have on that account hitherto escaped notice. There are many cases where precipitates are seen to acquire colour very rapidly . . . and it would be worth while to execute a series of experiments of mixtures precipitations &c in total darkness.

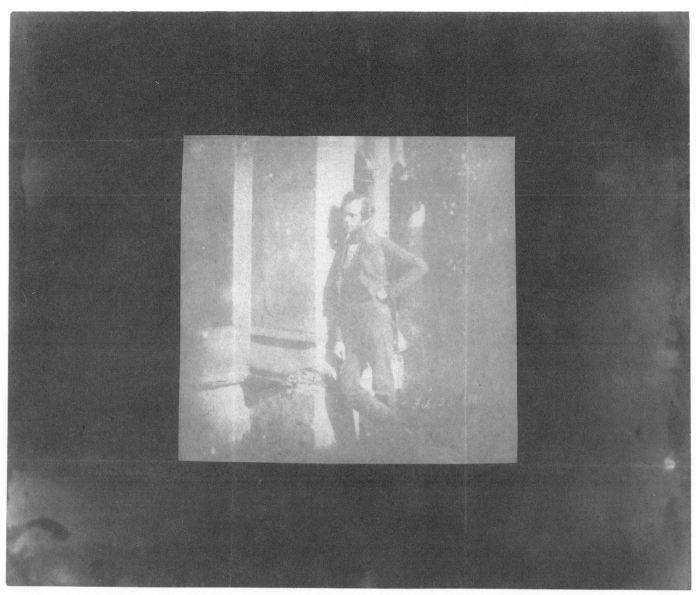

71. William Henry Fox Talbot. *Nicolaas Henneman in the cloisters at Lacock Abbey*. Salt print from a calotype negative. 23 February 1841. Labelled on verso, "done in 1 minute H.F. Talbot Photogr." One of Talbot's early portraits most admired by his contemporaries. This particular print belonged to Sir John Herschel. 10.5 × 11.3 cm. image on 18.5 × 22.7 cm. paper. The National Museum of Photography Film and Television.

But to mention such notions to you is like conveying coals to Newcastle. Only as bodies in the <u>nascent</u> state are sensible to influences which they resist when fully aggregated, and as it is barely possible that as your papers have been prepared expressly for keeping, you may have operated without regard to this condition, its mention may possibly strike some link of association that may lead you to yet further improvements of a process already most wonderful.

Whilst dispatching his pamphlets, Talbot must have realized that his correspondence with Herschel had lapsed more than six months previously. Eager to resume regular contact, he had already written on 17 March (before receiving Herschel's letter):

I remember that I said in my last letter to you, that Photography remained <u>in status quo</u>. It happened singularly enough that immediately afterwards I discovered the process to which I have given the name of Calotype.... I enclose a specimen which has been much liked by the artists in London, it is the portrait of a young man, done in <u>one minute</u>.

Still smarting from the lack of recognition that had been accorded to photogenic drawing, Talbot sought to secure his fame: "I have taken a patent for the Calotype, but nevertheless intend that the use of it shall be entirely free to the scientific world." Talbot added buoyantly that "there appears to me to be no end to the prospect of scientific research which Photography has opened up." On receiving Herschel's first letter, Talbot wrote again on 18 March:

I have no doubt that substances exist more sensitive to light than that which I now use; indeed it is reasonable to suppose that increased results might be obtained by merely varying the proportions of the chemical mixture, but these experiments take too much time, & must be left for future investigation....

Complications were again shaping up with the country's premier scientific body: "I expect in less than a month to be able to publish the process of the Calotype tho' I don't yet know whether it can be sent to the R. Society." Finding new ideas for pictures within himself, Talbot commented on

what a pleasant residence Collingwood appears to be; lakes and old oak trees are very much to my taste, and I am now looking out for a country house for the summer, because I find or fancy that the air of this neighborhood is not salubrious, at least for a long time together.... I must now really transport my apparatus to some locality where picturesque objects are to be met with, such as a Cathedral, or a seaport Town, for my own neighborhood is

not particularly suited to the Artist, and offers no great variety of subjects....

Talbot enclosed "a few more specimens," explaining in a postscript that "the portrait was done in the shade in 3 minutes. The footman opening the carriage door is also a good likeness, done in 3 minutes sunshine. The Elm tree in 1 minute, camera 15 inches focal length, diamr of object glass 1 inch."[28]

On 22 March, Herschel wrote Talbot to thank him for

your very interesting & numerous specimens of the new Process. Of the Portraits that done in the shade in 3m in some lights & at a proper distance has quite a real air. The Leaning figure is also very good. Both are much superior in effect to the Daguerreotype portraits. Of the Landscapes the view at Clifton – the snow scene and the projecting window piece at Lacock Abbey strike me most & are very superior to any you have before produced.

Herschel opined that Talbot was "quite right in patenting the Calotype, with the liberal interpretation you propose in exercising the patent right no one can complain." A decade later, Herschel would be a key witness on behalf of Talbot's patent for the calotype.[29] But Talbot's friend was to be proven sadly wrong when he added that "I must say I never heard of a more promising subject for a <u>lucrative</u> patent of which I heartily give you joy."

Denied in his own country the formal recognition France so willingly accorded Daguerre and quite understandably still wounded by the events of early 1839, Talbot saw few options for establishing his reputation. This patent, indeed the entire patenting process, was to be turned against him. Under the arcane English patent law (the same law that had so distorted Talbot's and Herschel's plans late in 1839), Talbot had up to six months after enrolling his specification in which to disclose the details of his new process. Had he waited to the end of this time, the announcement would have fallen in August, a period when there was virtually no scientific activity in England. But even more serious and threatening pressures were mounting in France. When Talbot informed Jean-Baptiste Biot of his advances, Biot was already aware that Daguerre was claiming discovery of a new means of obtaining extremely short exposures. In January 1841, invoking the specter of a repeat of Daguerre's triumphal announcement in January 1839, Biot warned Talbot that

if he publishes before you, the discovery belongs to him <u>scientifically</u> ... there would remain for you the knowledge that you had also discovered it ... but in the eyes of the public you could only hope to have the title of second inventor, since you published later.... This is why I beg you, in your own interest as well as that of science, not to

forego, by your desire to perfect the details, the legitimate honour that must be given to you for such an important improvement on your first processes.[30]

Almost immediately, Biot warned of an additional threat. Hippolyte Bayard, the independent inventor of a direct positive process on paper, revealed some of his manipulatory details on 8 February 1841. Biot wrote to Talbot the next day, saying that Bayard's "pertinacity and determination has led him to make a large number of prints on sensitive paper by means of a camera obscura. Our artists have expressed great satisfaction with these prints."[31] The perceptive Biot was also quick to spot an essential difference between Talbot's and Bayard's approach. After a close examination of a portrait sent by Talbot, Biot wrote on 16 March that

> I think I discovered on your print an indication that might well uncover some detail of your operations. It is the date, 23 February 1841, that I find is in the normal manner of writing. As it certainly was not traced in reversed letters, this suggests that there are two operations; the first giving the print with the whites in the place of the blacks and the second restoring them to their true place by transmission.[32]

What was Talbot to do? Although Biot was obviously trying to be helpful, the pressure from the French threatened Talbot's orderly perfection and disclosure of the calotype process. Daguerre's new technique would later prove to be of no significance, but Talbot had no way of knowing this at the time. Talbot's bad luck was again closing in. Even before he received Biot's letter, he could see that his account of the calotype was running into complications that might prevent its publication in the Royal Society's prestigious *Transactions*. This, of course, had been the fate of his earlier papers on photogenic drawing. On 17 March, Talbot wrote to Herschel that

> I was going to send a paper to the Royal Society, explaining the process, but having been told that there are doubts whether the paper would be printed in the Transactions (on account of the patent) I have written to Christie to request him to let me know from authority whether such is the case. If so, I shall not send the paper at all, but communicate it to some other scientific body, probably the French Institute.

Samuel Hunter Christie put some of Talbot's concerns at ease within the week. After polling the other members of the Council, he assured Talbot that

> I cannot see that these processes being subsequently described in the specification of a patent can in any way preclude the publication of the paper in the Transactions. I

72. William Henry Fox Talbot. *The rape of the Sabines, printed into a lace border*. Salt print from a calotype negative. Ca. 1842. Talbot had a small copy of the famous sculpture at Florence and used it repeatedly in his photographs. He (or his family) also experimented with a number of photographic frames and borders; did he realize the irony of the juxtaposition in this case? 17.5 × 11.2 cm. The National Museum of Photography Film and Television.

73. William Henry Fox Talbot. *Two women, possibly Talbot's sisters Caroline and Horatia, in the cloisters at Lacock Abbey.* Ca. 1842. Salt print from a calotype negative. 8.6 × 9.0 cm. The National Museum of Photography Film and Television.

74. William Henry Fox Talbot. *Figurines on three shelves, in the courtyard of Lacock Abbey.* Ca. 1841. Salt print from a calotype negative. 15.0 × 14.6 cm. The National Museum of Photography Film and Television.

know of no rule by which it would be thus precluded . . . It is of course for you to consider how far the reading of the paper and its publication in the Transactions may affect your patent. For my own part . . . it would give me much satisfaction . . . to see it adorning our Transactions.[33]

Even while Talbot was struggling with the conflicting demands of publication, the 1841 scientific season was drawing to a close. Left with few alternatives by June, Talbot found himself forced into action. First, to the Royal Society, then to the French Academy, he submitted the working details of his calotype process. This timing was to prove fatal. Biot confirmed that

in conformity with your wishes, I communicated to the Academy last Monday [June 7th] your long-awaited process for the making of sensitive paper, which you call Calotype. The Academy listened to the communication with great interest and you will be able to see it in the proceedings which were published yesterday.[34]

Charles Wheatstone had conveyed some prints from Talbot and Biot reported that the Academy "especially admired the striking character of the figure of your servant opening the door of your carriage . . . how many physical peculiarities remain to be discovered or to be explained in this process!"[35]

Talbot's paper was read to the Royal Society on 10 June.[36] Two days later, on 12 June, he sent Herschel the *Literary Gazette* containing his account of the Calotype.[37] It was time to let his colleague know the method by which the splendid photographs he had been sending had been made:

I enclose a sheet of the paper covered with iodide of silver. This is to be washed with a solution A + B.
A. is a solution of 100 grains crystd Nitrate Silver in 2 ounces distd water, to which is added $\frac{1}{3}$ ounce of <u>strong</u> acetic acid but not so strong as aromatic vinegar.
B. is a saturated solution of gallic acid (which I enclose a sample of) in cold distilled water.
A and B are <u>to be mixed</u> in small quantities at a time and in equal volumes.
By moistening the paper with the liquid, & exposing it for a second to daylight; it will be easily seen that the impression continues to come out spontaneously after the cessation of the exciting cause.

Amateurs who tried to follow Talbot's initial procedures, as outlined in the *Literary Gazette* and elsewhere, were more often than not frustrated by incomplete understanding of the details of the process. But then, Talbot considered his actual working techniques distinct from the scientific underpinnings of the process. In practice, Talbot steadily refined his own procedures and his successful negatives were made

75. William Henry Fox Talbot. *Beech trees, Lacock Abbey*. Salt print from a calotype negative. Ca. 1841–2. In March 1841, George Butler, Talbot's childhood tutor, suggested that "what I should like to see, w^d be a set of photogenic Calotype drawings of Forest Trees, the Oak, Elm, Beech &c. taken, of course, on a <u>perfectly calm</u> day, when there should not be one breath of wind to disturb and smear-over the outlines of the foliage. This would be the greatest stride towards effective drawing & painting that has been made for a Century. One Artist has one touch for foliage, another has another . . . but your photogenic drawing would be a portrait; it would exhibit the <u>touch</u> of the great artist, Nature . . ." 15.8 × 19.3 cm. The National Museum of Photography Film and Television.

76. William Henry Fox Talbot. *Patroclus, in the courtyard of Lacock Abbey.* Ca. 1841. Salt print from a calotype negative. 18.0 × 21.7 cm. image on 18.6 × 23.0 cm. paper. The National Museum of Photography Film and Television.

77. William Henry Fox Talbot. *The milliner's window*. Salt print from a calotype negative. Ca. 1842. The fanciful title was applied by Lady Elisabeth; in fact, this was her own collection of bonnets, taken in the courtyard of Lacock Abbey. 14.3 × 19.5 cm. The National Museum of Photography Film and Television.

employing carefully honed techniques. Once protected by the patent, Talbot rightly assumed that these improvements were proprietary information, to be shared only with those he licensed. This left a void in the literature for amateurs who wished to practice without the benefit of Talbot's personal tutelage and others stepped in to meet this need.[38] Thus, in spite of the patent, Talbot's name slowly became estranged from the ordinary working practices of calotypists. This was one factor in the cavalier attitude many photographers had developed towards Talbot's patent by the early 1850s – virtually no one worked from the sparse instructions that Talbot himself had disseminated.

On 24 June 1841, with an unusual alacrity suggesting the existence of a predetermined outcome, the Royal Society's *Committee of Papers* rendered a final decision that the calotype

should be published merely in the *Proceedings*.[39] Talbot was furious. On 29 June, he demanded that the Society delete all but the title of his paper from publication. The secretary, Peter Mark Roget (with whom he had locked horns over photogenic drawing), attempted to comply with his request, but found that it was too late, that the paper was already set in type. Talbot wrote angrily on 30 June, suggesting that "the sheet can easily be <u>cancelled</u>. I will be responsible for the expense should the Council think it ought not to fall upon the Society. No other method occurs to me by which this unfortunate affair can be so easily set right again."[40] In the end, the brief account in the *Proceedings* was published as planned.[41] Talbot complained to Herschel on 1 July:

On the 10th June I read my paper to the R. Soc^y describing

the Calotype process.... On my return to Town from a little rustication, I found that the Council had rejected the paper from the Transactions. On enquiring the cause, I was told that they understood the paper to have been printed elsewhere previously to its being read to the Society. A very erroneous supposition; and it is greatly to be lamented that in a body like the Royal Society such a system of secrecy , or mystery, should prevail, as not to give the author of a Paper any intimation whatever of such an objection being made, nor ask him for any explanation.

Although he held out the possibility of further communications to the scientific body, "the result is, that any future papers of mine on the same subject will appear in the Transactions, as members without a head – acephalous – hardly intelligible, or rather, I shall do better to abstain from writing any." Bitterly, he added that "I am sorry that the body whose office it is to encourage science in England, encourages it in this way – but such is the case."[42]

Herschel felt very keenly the pain under which his friend was suffering. He wrote at length to Talbot on 5 July, trying his best to console him, and outlining what he felt the Council might have done. Herschel encouraged Talbot to

afford them an opportunity of gracing their transactions by a record of this discovery without violating former precedents.... That this was not done I think it must be regretted. It is very important, on every account, for public utility as well as for good feeling's sake that the really scientific men of this country should understand each other and work together in a spirit of mutual accommodation and good will.[43]

Talbot, in resignation, replied to Herschel on 25 July, that he did not

intend to take any steps with regard to my last paper read to the R.S. I think I have great cause to complain of the Council ... but in general I do not think of answering an objection until it is made, & I never could have imagined that they would decide without enquiry & without any communication with the author, that the Rules of the Society had been broken, and without being sure of the fact. I believe the fact to be quite the other way. The communication was sent in first to the Royal Society. Does the Rule require the author should keep the subject a secret till his paper is read to the Society?

Although he had to be diplomatic about the country's premier scientific body, Herschel agreed most emphatically with Talbot's position. The Society recessed (as usual) for the summer, but as soon as they started up in the autumn, Herschel wrote at length to the Secretary, his friend, Sir John Lubbock, asking for a reconsideration of Talbot's case:

Shortly after the recess I received a letter from Mr. Talbot in which referring to his paper about the Calotype process (the rejection of which by the Council from the Transactions seems to have given him much chagrin) he states as a matter of fact ... that "the communication was sent in first to the Royal Society," and argues thereon I think not unreasonably that having given such preference to that body he could no longer be bound under pain of exclusion from their Transactions, to keep his process a secret until it might suit their convenience to promulgate it by public reading of his paper.

Herschel's main point was that

if, as it would appear, the ground of its rejection by the Council was the publication of his process by the French Academy prior to the reading of his paper by the Royal Society containing that process, it may be clearly brought into view that this ground was not of the Author's creating but originated in the different degrees of promptitude displayed by the two bodies in placing before the public the information communicated in them.[44]

In France, François Arago, who had long since realized that the pace of science was picking up, sought to disseminate scientific information more quickly. But the British establishment had yet to change, and Lubbock curtly replied to Herschel that he had "placed your Lr before the Committee of Papers, but the circumstances were quite before them when the decision was come to in respect of Mr Talbot's paper. I much regret that he should see it in a different light."[45] And that was the end of the matter. Cruelly trapped between the conflicting demands of timely publication and institutional precedent, none of Talbot's major papers on photography were published in the Royal Society's *Transactions*. Banished to the less prestigious *Proceedings*, Talbot turned to private publication, just as he had in 1839, issuing his Royal Society text in a pamphlet, *The Process of Calotype Photogenic Drawing*.[46]

The summer of 1839 – the first public year for photogenic drawing – had been a miserable one and the poor state of the weather had inhibited Talbot's start, delaying the bulk of his photographic production until 1840. Now, in the summer of 1841, Talbot was attempting to make a fresh start with the calotype. The previous winter and early spring had been most promising and Henry Talbot's first attempts with the calotype thrived as a result. In April 1841, Margaret Herschel told Aunt Caroline: "I must first mention the weather, for it is so lovely, that it would be a positive ingratitude to pass it over ... by day the cheerful sun light [is] so warm and bright that Herschel has already recommenced his photographic experiments from his south window in his little snug sanctum upstairs...."[47] In May, she elaborated that her husband

78. William Henry Fox Talbot. *Honeysuckle*. Salt print from a calotype negative. Early 1840s. 15.4 × 20.0 cm. image on 18.9 × 22.8 cm. paper. The National Museum of Photography Film and Television.

79. Sir John Herschel. *Photograph made with the juice of the petals of Mathiola Annua, double ten-weeks stock.* 1841–2. John Herschel had a life-long interest in botany and started employing the juices expressed from the petals of flowers in his chemical experiments long before photography. Depending on the method of extraction (usually done with alcohol), the dyes often had a different color than that of the petal from which they were taken. He even found solutions of these colors to be a convenient source of color filters for controlling light. In his experiments towards color photography, Herschel made hundreds of experiments on the bleaching effect of sunlight on flower juices. His goal was to find extracts that would produce a specific tint under a certain wavelength of light. He noted that an alcohol-based extraction of the petals of this common flower produced a "rich and florid rose-red" tint on his papers. It had a minimum of response to blue light, but was "considerably sensitive" to red and yellow rays and could "with patience yield extremely beautiful photographs." While it could not likely have formed a practical color process – exposure times varied from an hour or two to several days – this approach produced some remarkably vivid and stable color photographs. Had Herschel been able to pursue these experiments under a grant given him by the Royal Society, it is almost certain that he could have produced an experimentally successful color photograph by 1843. His method would have been very similar to that employed in color prints today. A primary color of light would affect a certain color layer, bleaching a particular color of floral dye. By superimposing different colored layers with sensitivities to different primary colors, a full color picture could be built up. This particular example was exhibited at the Royal Society on 16 June 1842. 9.1 × 13.2 cm. The Humanities Research Center, The University of Texas at Austin.

is really very well now and in excellent Spirits ... and by the bye, to continue his experiments in Photography. This art is advancing to astonishing perfection in England now – Mr. Fox Talbot having discovered a process by which he can even take portraits in 3 minutes on paper, which promises to be of much greater utility & convenience than the Metallic Plates used by Daguerre, although nothing can yet exceed the beauty and distinctness of these last. ... I enclose some of Mr. Fox Talbot's pictures taken with the Camera Obscura, although I think they have become rather blotty since Herschel received them.[48]

Herschel's keen interest in botany flourished in the expanded gardens and uninhibited sunlight at his new residence in Kent. As has been noted, he had brought back a quantity of living specimens from his sojourn in South Africa, adding to the diversity of the flora. The botanical interests were neatly dovetailed into photography and on 14 May, Herschel revealed to Talbot that he had been making "a vast Nº of trials ... on vegetable juices." These largely resulted from testing the effects of different parts of the spectrum on specific plant juices. Although the action of the light was slow, at least one of the papers prepared with flower juices "on the contrary is very sensible – the spectrum annexed was impressed in 55 minutes."

Talbot, even while preoccupied with his impending plans

to reveal the calotype process, replied in wonder on 19 May that "the specimens of the effects of light on vegetable juices are very curious; it will be long ere Science will be able to account for all these anomalies." His acceptance of the concept of the negative was still far from total:

I have recently succeeded in combining with my Calotype process, the method of forming positive photographs which has been studied by yourself and Lassaigne, Fyfe, & Hunt.

The success is very encouraging. The positive pictures are formed in the Camera in about five minutes; they are generally invisible at first, but may be brought out by my process; it is easy in the same way to make positive copies of engravings, by superposition & pressure – Such copies are much sharper than the positive copies obtained in the way hitherto practiced, viz. by a double process.

Talbot had been working closely and intensively with his assistant, Nicolaas Henneman, rapidly assembling a photographic portfolio. Once the working details of the calotype were revealed in June, Talbot wrote to Herschel on 25 July.

I don't know whether you have tried my Calotype process, if so I hope you may have met with success. We find that portraits may in general be taken in about a minute in ordinary daylight, but we are attempting further improvement. Daguerre has rather mismanaged the communication to the Academy of his last discovery.... However, whatever it is, if the process is instantaneous as reported, it is very wonderful.

Herschel had to reply that he was "quite ashamed to say that I have not yet repeated the Calotype expt but I have been preparing a parcel of reports for the B. Association...." The move was still disruptive and was one factor

which has prevented my doing anything towards getting my chemical preparations into action or doing any thing that requires the use of any reagents except such as happen to be ready at hand in a few loose bottles turned up out of a sort of chaos in which state all my chemical concerns have been ever since I left Slough having never had time to unpack & establish them.

However, his garden, just one of nature's various laboratories, had come to the rescue:

All I have done in the Photographic way has been with vegetable substances needing no preparations & no additions other than the contents of those same loose bottles which happened to be at hand or extempore makeshifts of the rudest kind. However in this desultory way I blundered not long since on a curious enough

80. Sir John Herschel. *Sheet of experimental photographs of the spectrum.* 1841–2. By exposing various substances to a rainbow of light, Herschel was able to determine which ones had sensitivities to certain colors of light. The top three examples show various exposures on a silver-based direct positive paper invented by Robert Hunt. The bottom one employed an iron compound. At the time these were exhibited to the Royal Society on 16 June 1842, this latter one displayed the production of blue color by blue light, and violet color by violet light. 22.1 × 11.5 cm. The Royal Society, London.

imitation in vegetable photography, of your Calotype....
The picture being first impressed, and visible (in which
point it is not like the Calotype) was then totally
discharged – leaving white paper. This being exposed to
light by very slow degrees recovered its former intensity.
About 24 hours diffused light suffices (as for sun we have
had none of late).[49]

Despite a promising start to 1841, the summer soon turned
bleak, stymieing both Herschel and Talbot in their progress.
For Talbot especially, the situation was most tortuous. This
was the first summer in which his calotype could have been
employed, but the weather only repeated the struggle Talbot
had had with photogenic drawing in the poor summer of
1839. Herschel, in examining various substances, was less
concerned with practical results than with research data, but
still found that with exposures sometimes extending into
months, there was much confusion between the action of
light and the deterioration of the chemicals. As he looked
back at the summer of 1841 the following year, Herschel
explained that

> I next placed a strip, partly covered, in a south-east
> window, where it remained from June 19 to August 19,
> receiving the few and scanty sunbeams which that interval
> of the deplorable summer of 1841 afforded.... A mezzo-
> tinto picture was now pressed on a glazed frame over
> another portion of the same paper, and abandoned on the
> upper shelf of a green-house to whatever sun might occur
> from August 19 to October 19. The interval proved one of
> almost uninterrupted storm, rain, and darkness.[50]

Two months' exposure would hardly do! Perhaps it was
the weather, perhaps it was the press of other circumstances,
but whatever the reason, correspondence between Talbot
and Herschel lapsed once again during the winter of 1841.
The pause was momentary. Early photography was about to
enter its final and most spectacular phase. With the advent of
spring and more promising weather, Talbot re-opened their
communications on 18 April 1842. Talbot's photography had
so far concentrated on the people and environs of Lacock
Abbey: "I enclose some specimens of portraits, groups of
figures, & other Calotypes. I am going into Germany shortly
and hope to make some views of interesting architecture
either at Heidelberg, Nuremberg or some other old city."
Herschel, also eager to resume their discussion, replied on 21
April, giving

> a great many thanks to you for the exquisite specimens of
> the Calotype which surpass anything I had heard of. The
> power of depicting scenes of conversation & acting
> between living persons is a wonderful stride. The tour you
> are projecting in search of architectural specimens will be

the most interesting thing imaginable. In a very few hours
you will get on record all the details of a cathedral which
would have cost a draftsman years of yore to execute with
infinitely less fidelity.

The reproduction of color was still his main interest:

> I have not done much lately in photogy having been at
> work at my astronomical reductions and the flower season
> not being come on – but within these two fine days I have
> made some considerable steps towards colour and have got
> at some very singular facts.... I have succeeded in getting
> (at last) a very respectable green but unluckily it does not
> lie precisely in the green region of the spectrum.... I
> perceive however that a perfect coloured spectrum though
> difficult no doubt is far from hopeless and I think I clearly
> see my way to the production of at least a passable one
> which if the present fine weather lasts another week I
> expect to hunt down, and in that case I shall probably be
> able to send you in return for your beautiful things some
> coloured impressions of coloured pictures.

Talbot departed on his journey and wrote to Herschel
from Munich on 2 June. Meeting with Dr Steinheil, Talbot
was chagrined to find that they had been thinking along
similar lines on a means of producing telescope specula.
Acutely reminded of his troubles in photography, Talbot
lamented that "Science is now cultivated by so many, that it
is impossible that cases of simultaneous invention should not
frequently arise."[51] Travelling on the continent, Talbot
missed the reading of another of Herschel's Royal Society
papers, one that Sir John "intended as a continuation or
supplement" to his 1840 paper. Titled "On the Action of the
Rays of the Solar Spectrum on Vegetable Colours, and on
some new Photographic Processes," this paper proved that
Herschel's shift in interest to photo-chemical researches was
complete. He soon told Mary Somerville that "I now prefer to
call it Actino-chemistry – giving the scientific rather than the
artistical turn to the word...."[52]

In this paper, Herschel felt obliged to let the members of
the Society know why his progress in this field might have
appeared so sporadic. He explained that the

> extreme deficiency of sunshine during the summer and
> autumn of the year 1839 prevented me from prosecuting
> efficiently up to the date of that communication. The
> ensuing year 1840 was quite as remarkable for an excess of
> sunshine as its predecessor for the reverse. Unfortunately
> the derangements consequent on a change of residence
> prevented my availing myself of that most favourable
> conjuncture, and it was not till the autumn of that year
> that the inquiry could be resumed.

Herschel had a bit more free time at his disposal during the summer of 1841, but because of the weather could make little use of it in photography. However, as the summer of 1842 came around, a repeat of 1840 seemed to have commenced. Herschel had employed dyes derived from flowers since his earliest chemical researches. Once dissolved in alcohol and spread on paper, frequently the colors had changed (red poppies, for example, gave a blue tint).[53] They now became a major part of his photographic repertoire: "the materials operated on in these experiments have been for the most part the juices of the flowers or leaves of plants, expressed, either simply, or with the addition or alcohol, or under the influence of other chemical reagents." Whereas the silver salts darkened under exposure to light, the vegetable dyes usually bleached. Light produced light, thereby giving a direct positive. Herschel also noted a general tendency for a specific color of light to destroy its complementary color; red light bleached blue tints. These flower processes were very slow in their action, but they still pleased Herschel. After adding alkalies to one solution, "to my surprise, it manifested rather a high degree of photographic sensibility, and gave very pretty pictures with a day or two of exposure to sunshine." Herschel, while not seeking processes to be susceptible to practical application, realized that these might become the basis of color photography. The tints were often vivid; even more surprisingly, many of them have retained their colors to this day.[54] Herschel viewed the hundreds of experiments he had performed as important only in their collective testimony:

I shall conclude this part of my subject by remarking on the great number and variety of substances which, now that attention is drawn to the subject, appear to be photographically impressible. It is no longer an insulated and anomalous affection of certain salts of silver and gold, but one which, doubtless, in a greater or lesser degree pervades all nature, and connects itself intimately with the mechanism by which chemical combination and decomposition is operated ... to all cases in which chemical elements may be supposed combined with a certain degree of laxity, and so to speak, in a state of tottering equilibrium.

Herschel's paper was dated 13 June 1842. The Royal Society's season was about to close, and he included mention of two other processes, not based on flowers. In one of these, "the effect proved exceedingly striking, issuing in a process no wise inferior in the almost magical beauty of its results to the calotype process of Mr. Talbot, which in some respects it nearly resembles...." Although he was not seeking practical processes, Herschel knew that others would be interested in the manipulatory details, thinking the process might gain

general use (it never did). He named it the "*Chrysotype*, in order to recall by similarity of structure and termination the *Calotype* process of Mr. Talbot, to which in its general effect it affords so close a parallel."[55] As Herschel explained, in this elegant process,

paper is to be washed with a moderately concentrated solution of ammonio-citrate of iron, and dried. The strength of the solution should be such as to dry into a good yellow colour, not at all brown. In this state it is ready to receive a photographic image, which may be impressed on it either from nature in the camera-obscura, or from an engraving on a frame in sunshine. The image so impressed, however, is very faint, and sometimes hardly perceptible. The moment it is removed from the frame or camera, it must be washed over with a neutral solution of gold of such strength as to have the colour of sherry wine. Instantly the picture appears, not indeed at once of its full intensity, but darkening with great rapidity up to a certain point ... at this point nothing can surpass the sharpness and perfection of detail of the resulting photograph. To arrest this process and to fix the picture (so far as the further action of *light* is concerned), it is to be thrown into water very slightly acidulated with sulphuric acid and well soaked, dried, washed with hydrobromate of potash, rinsed, and dried again.[56]

Herschel explained that he had recently taken up this path "in the examination of that interesting salt, the ferrosesqui-cyanuret of potassium, described by Mr. Smee ... which he has shown how to manufacture in abundance and purity by voltaic action on the common, or yellow ferrocyanuret."[57]

The invention of these iron-based processes resulted from Herschel's correspondence with the promising young chemist, Alfred Smee.[58] In April 1842, at Herschel's request, Smee was happy to supply some new chemicals, and the next month he was thanking Herschel for the "beautiful and interesting photograph which I presume was executed with the red salt in conjunction with a persalt of iron as that compound deposits prussian blue under the combined action of air and light. I trust that by variety of manipulation you will be enabled to adapt it to the camera."[59] Herschel replied that Smee's mention of the "highly coloured salts ... has furnished me with an infinity of beautiful photographic processes."[60] Without knowing for what they were required, Smee continued to supply Herschel with other electrolytically produced compounds. Smee was completely surprised at the outcome, saying that he "had not the slightest idea that they could be used for Photographic purposes and did not even know the purpose for which you were likely to want such coloured salts."[61]

Smee's iron salts also led Herschel towards what would

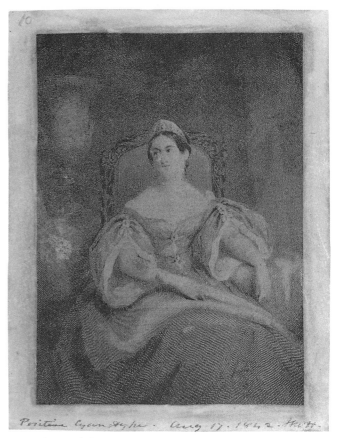

81. Sir John Herschel. *Specimen of chrysotype, or aurophotography*. Gold-based negative on paper. 1842. Herschel found the effect created by the substitution of gold for silver "exceedingly striking, issuing in a process no wise inferior in the almost magical beauty of its effect to the calotype process of Mr. Talbot, which in some respects it nearly resembles . . . nothing can surpass the sharpness and perfection of detail of the resulting photograph." Perhaps because of the distinctive purple colour, perhaps because they were less sensitive to light than were silver prints, chrysotypes never became popular. They proved much more permanent, however, and had Herschel's process been more employed we would have had a much greater surviving legacy from the first years of photography. 12.1 × 9.5 cm. The Royal Society, London.

82. Sir John Herschel. *Copy of an engraving*. Positive cyanotype. 17 August 1842. 10.4 × 7.8 cm. image on 11.9 × 9.4 cm. paper. The National Museum of Photography Film and Television.

prove to be one of his most significant practical contributions to the art. As yet, though, it did not have a name. He continued in his 1842 Royal Society essay that

> paper simply washed with a solution of this salt is highly sensitive to the action of light. Prussian blue is deposited . . . after half an hour or an hour's exposure to sunshine, a very beautiful negative photograph is the result, to fix which all that is necessary is to soak it in water, in which a little sulphate of soda is dissolved, to ensure the fixity of the Prussian blue deposited. . . . After washing, the ground colour disappears, and the photograph becomes bright blue on a white ground.

Herschel thought of many variations on this approach: "if in lieu of the perchloride of iron, we substitute a solution of that curious salt the *ammonio-citrate of iron*, the photographic effects are among the most various and remarkable that have yet offered themselves to our notice in this novel and fertile field of inquiry."

Since his paper would not be considered for publication until autumn, Herschel took advantage of the delay to add a

Laminaria saccharina.

83. Anna Atkins. *Laminaria saccharina.* Cyanotype. Published in October 1843 in Part 1 of *Photographs of British Algae; Cyanotype Impressions.* Atkins was the first to apply photography to scientific book illustrations, issuing *British Algae* in parts over a ten-year span. Herschel's cyanotype paper, in addition to being economical and easily worked, produced a rich blue background most appropriate for these "flowers of the sea." This example is from Herschel's personal copy. 29.2 × 25.2 cm. Spencer Collection, The New York Public Library, Astor, Lenox and Tilden Foundations.

postscript on 29 August, incorporating the results of his work during the intervening summer. After having successfully substituted silver for gold in the chrysotype process, Herschel felt it important to reiterate that hypo "alone, I believe, can be fully depended on for fixing argentine photographs." In a loss to the future historical record, Herschel added that

> I might here describe many other curious and interesting photographic results to which, under the genial influence of such a summer as, possibly, has never before been witnessed in England, have been conducted. But in so doing I should surpass the reasonable bounds of a Postscript illustrative of my text.

However, there was one major concept that he wished to clarify. In another contribution to the terminology of photography, Herschel conferred a name on his Prussian blue photographs:

> *Cyanotype.* – If a nomenclature of this kind be admitted (and it has some recommendations), the whole class of processes in which cyanogen in its combinations with iron performs a leading part, and in which the resulting pictures are blue, may be designated by this epithet. The varieties of cyanotype processes seem to be innumerable. . . .

The particular cyanotype process that Herschel felt had "pre-eminent beauty" happened to be a direct positive one. But it is important to bear in mind that he intended this term to be a family name, representative of various approaches to making a photograph, the common denominator amongst them being that they all produced images in the iron pigment known as Prussian blue. Commercial exploitation of photography was far from Herschel's intent. It is therefore ironic that the cyanotype eventually proved to be the most commercially viable of all the paper processes of the 1840s.[62] In various forms it survived well through the twentieth century, somewhat as a clearly photographic medium, but more significantly as the basis of the architect's blueprint.

Closer to the event, however, Herschel's timely discovery of the cyanotype facilitated one of the most extraordinary productions of early photography.[63] And happily, in linking together diverse pursuits, it led to the production of the first book to be published with photographic illustrations. The thought of doing such a thing had occurred to Talbot, of course, almost immediately; in one of his first letters to Herschel about photography, in March of 1839, he sent a print, along with the thought that "the enclosed scrap will illustrate what I call 'every man his own printer and publisher.'" The substitution of photography for the printing press would "enable poor authors to make facsimiles of their works in their own handwriting."[64] It was not Talbot, nor a poor author, nor in fact an 'every man' who first realized this ambition, but rather a woman of unusual foresight and determination. Anna Atkins, the only daughter of the scientist John George Children, had been a friend of the Herschel family since youth. While little is known of her artistic training, by 1823 she could very competently illustrate her father's translation of Lamarck's *Genera of Shells*.[65] Atkins also produced some lithographs (a popular if challenging pastime) and thus was cognizant of the needs of both scientific illustration and printing.

Atkins' father had chaired the Royal Society session when Talbot first disclosed the details of photogenic drawing on 21 February, 1839. Enjoying direct contact with both Talbot and Herschel, Children and his daughter followed the rapidly unfolding drama of photography as it happened. On 14 September 1841, Children wrote to Talbot that

> on my return from town, I found the calotypes safe on my table. . . . When we return to Kent, my daughter and I shall set to work in good ernest till we completely succeed in practicing your invaluable process. I am also extremely obliged to you for introducing me to Mr. Collen – from whom I have received much valuable information. I have sat to him for my Calotype this morning. I have also ordered a camera for Mrs. Atkins from Ross.[66]

Father and daughter attempted calotypy right away. Like most neophytes, they found Talbot's directions did not cover the many complexities adequately. Children soon lamented in a poem, *On Failing to Take the Calograph Portrait of a Beautiful Young Lady*:

> Why fail to paint so fair a face?
> Why shines the Sun so dim?
> He fears to dwell upon such grace!
> Such beauty <u>dazzles</u> him![67]

Although none of Anna Atkins' camera work is known to have survived, there is tangible and eloquent evidence that she soon conquered photography in another, more personally significant, way. In 1835, Children wrote to the botanist, William (later Sir William) Hooker, saying that "my daughter, Mrs. Atkins, has a great fondness for Botany, and is making an Herbarium."[68] In 1839, the year of photography, Anna Atkins became a member of the Botanical Society of London, one of the first scientific organizations to admit women.[69] Although her father was the Vice-President, it was Anna who remained most active in the organization.[70] Both Talbot and Herschel were passionate about botany and it is natural that they exploited plants as a convenient and interesting early subject. Botanists, perhaps more than other scientists, were quick to seize on the possibilities that photography offered. It is almost certain that Children and

his daughter attended the meeting of the Botanical Society on 1 March 1839, when John Thomas Cooper, Jr. showed the members "numerous figures of Mosses and Ferns produced by the Photogenic process of Mr. Talbot."[71]

It is not known precisely what motivated her, but sometime during the summer of 1843 Anna Atkins undertook the task of becoming the first photographic book publisher. By October 1843, she began issuing the parts of *British Algae: Cyanotype Impressions*.[72] Each part contained a number of plates that were contact prints from specimens of algae – sun prints of nature's diversity. The text pages were either in Atkins' hand or in title letters composed of strands of seaweed. Both plates and text were reproduced in Herschel's cyanotype process. As she explained in her preface:

> The difficulty of making accurate drawings of objects as minute as many of the Algae and Confervae, has induced me to avail myself of Sir John Herschel's beautiful process of Cyanotype, to obtain impressions of the plants themselves, which I have much pleasure in offering to my botanical friends.

With dedications written in October 1843, Anna Atkins sent copies of the first part to Herschel and to the Royal Society. When finished ten years later, the final work comprised 389 pages of captioned plates and 14 pages of titles and text. Every sheet was an original cyanotype photograph. Certainly more than a dozen copies were produced, and distributed to botanical friends, including Henry Talbot.

This decade-long undertaking not only involved Anna Atkins, but also her servants and friends as well.[73] Certain aspects of Atkins' position in society facilitated the production. In an era when botany was about the only science in which women were encouraged (and then only barely), the connections of Anna's scientific father cannot be overlooked. Her house at Sevenoaks was blessed with a very good well and furnished ample room for production in the kitchen and outbuildings. The supply of sunlight would have been as generous as nature would dole out, not suffering degradation from the air pollution that so troubled Herschel in the vicinity of London. It is quite possible that Atkins' father made the quantities of electrolytically produced salts that she needed for her photograms.[74] Still, thousands of sheets of cyanotype paper had to be prepared by hand. Hundreds of various and delicate specimens of algae had to be made ready, washed, arranged, and dried. Each sheet took its turn in the sun, was washed, dried, and flattened. Then the plates had to be collated and sewn together. The cyanotype was a particularly fortuitous choice. Had Atkins attempted to make her prints using Talbot's silver process, the task would have been overwhelming. Its chemicals were more expensive and more difficult to handle. The fixing process was much

more involved (and much more uncertain). And Talbot's position on the use of his patent had yet to be tested. Cyanotypes were cheap, easily processed, and were amongst the most permanent of all photographic processes. The most severe drawback of the cyanotype was that the inescapable color was a deep, rich blue. Its application to portraits of people was thereby limited, but what could have been more appropriate as a background to the 'flowers of the sea?'

In 1842, when he was taking great strides with the cyanotype and other processes, Herschel remained hopeful that he would be able to continue to prosecute his experiments in photography. On 1 June, he wrote to the Royal Society requesting financial support, explaining that

> having been for some time engaged in the prosecution of the subject of the chemical action of the several rays of the solar spectrum, and the distribution of heat in and beyond the limits of the visible spectrum, I have found those enquiries most materially forwarded by the use of a peculiar apparatus rudely constructed by myself for the purpose of fixing the solar spectrum. . . .

Many of his results had already been published in the *Philosophical Transactions*, but

> others of a highly novel & interesting character awaiting further development) – have led me to the conclusion that this is one of the subjects most likely to prove fertile and productive of new relations illustrating the nature of light and heat, and deserving to be prosecuted with every aid which can tend to give accuracy and definiteness to the results.

In order to advance further, Herschel required "a degree of fixity of the spectrum during many successive hours, and general convenience and manageability, together with adaptation to precise measurement of the phenomena . . . [which could] only be attained by the optician's aid." Herschel had designed an instrument, too expensive for his own purse, that he hoped the Royal Society would underwrite, explaining that "it is not possible for me to state without conference with an Optician, the probable expence of such an instrument &c. Speaking vaguely I should consider that it could not well be under 50 or 60£." As further evidence of what he hoped to accomplish, Herschel included

> for the inspection of the Committee specimens of spectra photographically impressed on certain preparations of paper, which may serve to shew the extremely definite nature of some of those chemical relations of the differently refrangible rays which constitute the objects of the enquiries alluded to, and the complexity of the action which it is designed to analyse.[75]

84. Sir John Herschel. *A proposed actinoscope*. Pencil drawing. 1842. Herschel's experiments on effects of the spectra on different substances required very long exposures to sunlight. In October 1839, he first used a clock mechanism to track movement of the sun, fixing the spectrum thrown by the prism for extended periods of time on the same place on the paper. This is one of several approaches he explored in 1842 in an attempt to advance his researches. The Humanities Research Center, The University of Texas at Austin.

Herschel's myriad experiments were beginning to impose an intellectual structure on the photochemical basis of photography. Maggie reported to Aunt Caroline that Herschel's "photographic papers to the Royal Society seem to have excited great interest."[76] The Society was only too happy to fund such promising research from their senior scientist. Appropriately, the money came from the Wollaston fund (established by Herschel's old mentor). Unfortunately, construction of the instrument proved to be outside the ordinary practice of the famous Dollond optical firm. So much time was wasted in re-design that Herschel eventually had to give up the whole idea; he returned the £100 grant in 1843.[77]

A major part of Herschel's difficulty was the press of time. He felt an absolute obligation to complete his father's astronomical career by publishing his own extension of this work into the summer hemisphere. In describing some photographic experiments to Aunt Caroline in May 1841,

Margaret reassured her that she had not given up "spurring him on with his Cape calculations, for so much of his valuable time was spent in making these observations, that I am determined not to be happy until the work is completed & out of his hands. Am not I a very cruel wife! ..."[78] John Herschel himself was torn between conflicting demands – he lamented to Maggie:

> Don't be enraged against my poor photography. You cannot grasp by what links this department of science holds me captive – I see it sliding out of my hands while I have been dallying with the stars. Light was my first love! In an evil hour I quitted her for those brute & heavy bodies which tumbling along thro' ether, startle her from her deep recesses and drive her trembling and sensitive into our view.[79]

What other contributions could Herschel have made if

more time had been available? On 22 March 1843, Talbot wrote to inform Herschel that "M^r Hunt is engaged in writing the History of Photography which Mess^rs Longman are going to publish. He has laid it down as a rule, I understand, to verify all the facts himself; but that must be impossible."[80] In his history, Hunt attributed a significant measure of photography's progress to date to Herschel, but that contribution was already being forced into remission. Even as Anna Atkins was about to publish *British Algae*, Henry Talbot, the inventor of photography, remained less than fully convinced that the negative/positive approach was the best. Talbot continued in his 22 March letter to Herschel that

> I have succeeded in giving absolute fixation to the pictures obtained by the single or direct positive process which was a desideratum. It now remains to obtain greater sensitiveness in the positive papers. They are at least 10 times slower than the negative ones; but that is not all, the process is more delicate & as you have several more variable quantities to deal with, it is more difficult to discover how the <u>maximum</u> effect is to be obtained. M. Bayard at Paris whose efforts are directly solely to this point, does not seem to have succeeded. I think I shall shortly visit France & see how they are getting on there in matters of science.

Herschel replied on 25 March, calling his gold-based chrysotype

> a pretty pendant to your Kalotype. Since that I have got several very beautiful photographic effects from Mercury, Iron, and Lead, as also by the use of the cyanic compounds, some of which I enclose for your inspection. I must request their return as they form part of a series, which I keep under my eye to watch their slow changes which are very curious and in some case lead to total or almost total obliteration in others with a most remarkable increase of clearness & distinctness. . . . They are varieties of a process for which I propose to use the name of Celanotype . . . from the blackness and engraving like effect of some of them.

Herschel's main interest remained in understanding the effect of light on material substances. One process he found "remarkable when negative for its exceeding intensity & distinctness. Now, lines & streaks before impressioned have come out. I am still working at this process which has led me such a dance as I never before was led by anything in the way of an Exp^t." But in all his recent processes, there was a common thread: "in none of these specimens does either silver or gold occur – and our Materia Photographica is extending daily." Inviting Talbot to call in at the Royal Society to see examples of his latest productions, Herschel also added the encouraging note that he was "very glad to hear you are at work on the improvement of your positive Calotype which after all for travellers anxious to <u>realize</u> their productions, is the more valuable."

It was Talbot's turn to comment on the appropriateness of Herschel's terminology. In a letter of 29 March, he said that

> with respect to the name "Celanotype" it appears to me not sufficiently <u>descriptive</u>; for the positive Calotype process affords copies of engravings equally sharp and black, & which might be mistaken for real engravings. But as your new process involves a very remarkable peculiarity, viz. the change from <u>negative</u> to <u>positive</u> of the <u>same</u> photograph, I should wish the name given to it to be one allusive to that fact, and if you are not yet decided upon your nomenclature I would suggest that the above peculiarity might be concisely and clearly expressed by the name of Amphitype.

The term *amphitype* was to have several uses in photography; it became most commonly known starting in the 1850s as an alternative term for collodion direct positives (ambrotypes). Herschel readily conceded its preference in his reply to Talbot of 31 March when he sent along some new examples.

> N^o 844 is remarkable for having no silver in it – the colouring ingredients being Iron Mercury and Lead. It is connected with a series of singularly complicated and capricious processes in which Mercury in its various stages of oxidation plays the leading part (& of which the "Amphitype" is one and not the least puzzling & capricious). It has led me such a dance as I never before was led by any physical enquiry and I have not yet succeeded in reducing it to a definite and <u>certainly successful</u> process giving clear and producible results, in consequence of which I have not yet published my account of it. Meanwhile I thank you for your name "Amphitype" which suits it in more ways than you had in view when you suggested it & which I shall certainly adopt for it – in preference to Celanotype or Allotype.

Talbot wrote back on 5 April. He still felt that "the positive Calotype is a very pleasing method. It is less sensitive than the negative, perhaps 10 times, but in this class of phenomena correct numerical comparisons are impossible. To make a positive image of a piece of lace, or object of that kind, 1 second of sunshine is ample." But Talbot's view of the value of negatives was soon to be reinforced. He informed Herschel that "in a week or 10 days I am going to Paris, & shall take that opportunity to instruct some French artists in the Calotype of which I believe they have no notion, altho' published 2 years ago."

85. William Henry Fox Talbot. *The Nelson Column in Trafalgar Square, when building*. Salt print from a calotype negative. Winter 1843–4. The bronze statue of Nelson was placed in position in November of 1843; the scaffolding was erected for this purpose. 17.0 × 21.1 cm. The National Museum of Photography Film and Television.

86. William Henry Fox Talbot. *Cathedral at Orleans.* Salt print from a calotype negative. June 1843. The brush marks were typical of the hand-coated papers Talbot employed at Lacock; many of the prints produced later at Reading were prepared by floating the paper on the chemicals and these have uniform borders. 16.3 × 20.1 cm. image on 18.9 × 23.1 cm. paper. The National Museum of Photography Film and Television.

87. William Henry Fox Talbot. *The Suspension Bridge at Rouen*. Salt print from a calotype negative. May 1843. 14.8 × 20.3 cm. The National Museum of Photography Film and Television.

Henry Talbot was correct about the French; outside of scientific circles, very few people had even heard of his calotype process. But the situation was really no different for him in England. By 1843, the daguerreotype was beginning to make some inroads into portraiture (largely as a novelty at the time), but the calotype was unsuccessful even at this.[81] However, Talbot had by now mastered his own art and furthermore, he knew that he had. Finally in 1842, after tormenting him in so many ways, the Royal Society awarded Talbot the prestigious Rumford Medal "for his discoveries and Improvements in Photography."

Talbot's own photographs proved that his art was ready for application. He now needed to convince others that they could apply it as well. His efforts formed the capstone of his photographic career, the beautiful publication he called *The Pencil of Nature*.[82] Henry Talbot's *Pencil* provided a compelling demonstration of the vision of this remarkable man. No other single book is so vital to understanding the emergence of the art of photography and it is undoubtedly the most important book from the art's first decade. *The Pencil of Nature* is a prime source of historical information and a repository for some of Talbot's finest photographs. Issued in six parts from 1844 to 1846, at its heart were twenty-four plates that embodied Talbot's conviction of the potential of photography for book illustration. As has been seen, in March of 1839, Talbot approached the botanist, William Jackson Hooker, with the suggestion that they might collaborate on a photographically illustrated volume of British plants. At the end of 1839, in correspondence with Herschel, Talbot stressed that "although the perfection of the French method of Photography cannot be surpassed in some respects; yet in others the English is decidedly superior. For instance in the capability of multiplication of copies, & therefore of publishing a work with photographic plates."[83]

With so many links, personal, botanical, and photographic, Talbot surely was fascinated by Atkins' start on the cyanotype *British Algae* (his later references to this publication make it clear that he viewed her work with favor, certainly not as competition).[84] Atkins' book was a scientific publication designed to meet a very practical need. Talbot himself required a means of promoting photography. Besides, it would have been churlish for him not to celebrate the success of the unpatented cyanotype in this specialized application; his friend Herschel had given out the details of the process freely for all to use. But the plans of others were more troublesome for Talbot. Another acquaintance of his, William (later Sir William) Snow Harris, applied at the beginning of 1843 for permission to use the calotype. In his reply, Talbot made clear his personal stake in the application of his patent:

However willing I might be to give to your & friends the

free use of the Calotype for purposes of science, I am not prepared to say that I could do the same in the instance to which your letter refers – the intention being (if I understand you) to prepare Calotype drawings for an extensive work, which are to be afterwards engraved & published. Now this was one of the chief objects contemplated, when I went to the expense of procuring a patent, viz. that it would be applied to the illustration of works requiring great fidelity & accuracy of drawing.

However, this understanding protectionism gave way to salesmanship. He asked

why your friend proposes to go to the great expense of having the drawings engraved, when the process itself is capable of furnishing an unlimited number of copies, all facsimiles of each other, and at an expense I should think far inferior to that of engraving. The Calotype process dispenses not only with the draughtsman but also with the engraver & the copperplate printer. It executes the whole itself. The pictures I believe to be quite permanent. A month's exposure to daylight at a window produces no effect on them, for they seem to have the same fixity as a printed page.[85]

It was clearly time for Talbot to take matters into his own hands and to demonstrate his ideas. He obviously discussed more than one approach with others, for Robert Hunt wrote him saying that "Mssrs. Longman have informed me that it is your intention to publish calotype views of the cathedrals &c and have asked me to refer to your production in the work I am engaged on 'Light considered as a Chemical Agent.'"[86] But Talbot's book was to take on a different form, apparently one recommended to him by his uncle, William Fox-Strangways around the time of the introduction of the calotype. On hearing of Henry's plans for the *Pencil*, he recalled that

your book of specimens is just what I suggested to you three years ago – you know perhaps the book that was published at the time of the introduction of lithography by Senefelder & Ackermann, called a complete Course of Lithography with specimens – something in that style – quarto – but less voluminous, & a greater variety of tint & colour, would do....[87]

It is apparent that Fox-Strangways influenced Talbot more than we have a record of. In this unusually detailed letter, he thanked Henry "for a most liberal supply of Calotypes, a name which I can not get people to adopt, it is hard work to stop them calling them Daguerreotypes & having once adopted the term Photographs, they will not unsettle their minds any farther." Referring to two pictures proposed for

88. William Henry Fox Talbot. *The soliloquy of the broom.* 13 February 1843. Salt print from a calotype negative. The negative (in The Royal Photographic Society) is dated in Talbot's hand in pencil on verso. The earliest iteration of this image is dated 21 January 1841. 16.1 × 18.8 cm. Hans P. Kraus, Jr.

89. William Henry Fox Talbot. *The open door.* Calotype negative. April 1844. Dated on verso in Talbot's hand. This is the actual negative used to print plate VI of *The Pencil of Nature.* 14.4 × 19.4 cm. The National Museum of Photography Film and Television.

the *Pencil*, he tried to encourage his nephew to exploit the visual treasures of his native country:

> Orleans & Chambord are particularly good, but I grudge the fine delicate effects of the statues on the Parisian houses. I wish it was all Gothic tracery. The facsimiles are just the thing. Could you not make some of Magna Charta & publish it, with a vignette of Lacock, or at least of the Tower where it is kept?

No photograph of Lacock's Magna Charta has been traced, but Henry must have listened to this advice, for a picture of the tower was included in the *Pencil*, along with mention of the document. Fox-Strangways also prompted:

> Is the light in Kings College Chapel strong enough to allow of taking a Calotype of it? Turkish fountains & kiosks would make beautiful subjects for the art. Has Lepsius sent you any Calotype views from Egypt? Why do you not go on purpose some day & take Stonehenge . . . Among your garden scenes you ought to take the Nun's Cauldron & Ela & the rest of the groupe on their donkey.[88]

It is likely that the concept of the *Pencil of Nature* project was one that evolved for Henry Talbot over time. In his research notebook in September 1839, Talbot had written the title, "New Art. Nature's Pencil. N⁰· 1."[89] The roots of this

sonorous title are clear. William Jerdan, Talbot's tireless supporter and the editor of the *Literary Gazette*, must have been re-reading his *Decline and Fall of the Roman Empire* just as photography was announced. Gibbon had used the phrase with a totally different meaning, but Jerdan found it wonderfully applicable to the new art. In February 1839, he headed an article on the daguerreotype: "French Discovery – Pencil of Nature." Talbot could not have missed this; it was placed immediately adjacent to his signature on his 30 January letter about photogenic drawing.[90]

Henry Talbot explained his plans to his sister Caroline (his sketching companion on the shores of Lake Como when he first conceived of photography in 1833). In February 1844 he sent her "the prospectus of a Notion, to use an American phrase, that will interest you."[91] Henry elaborated to his other sister, Horatia, that

> I have announced . . . the forthcoming appearance of a work to be entitled the Pencil of Nature; – we mean to guarantee to the Public that the plates will be executed by persons who know nothing whatever of drawing; & they may have all confidence in what they find there, since no artist is to be allowed to have any hand in it.[92]

On 24 February 1844, William Longman sent Talbot "a proof of your Prospectus of the Pencil of Nature. We shall be obliged by your returning it with any corrections by return of post."[93] When Sir David Brewster received the prospectus, he wrote back excitedly that

> I have watched all the advertisements of the Pencil of

90. William Henry Fox Talbot. *The open door*. Salt print from a calotype negative. April 1844. This is a close variant of the published version; the slight displacement of the shadows betrays the brief passage of time between exposures. 14.4 × 19.5 cm. The National Museum of Photography Film and Television.

Nature with great interest and have ordered a copy for our University Library. It is a bold experiment – I do not mean as a speculation but as one which will entail personal labour & superintendence upon yourself, & I and many others look forward to its consummation as an event which, sanguine as I was I never could have anticipated.[94]

Even if he had so chosen, there is no way that Talbot could have undertaken a project of this magnitude on his own. Not a man of trade, he still had enormous responsibilities in connection with Lacock.[95] Besides, as a scientist, photography was only one of many interests maintained by Talbot. As he explained to William Jerdan, "the complexity of the Art requires a division of labour; one person should invent new processes while another puts in execution those already ascertained, but hitherto I have been the chief operator myself in the different branches of the invention."[96] The person Talbot chose as a helper, Nicolaas Henneman, had in fact been critical to Talbot's photography since the first public days in 1839. He has often been dismissed merely as Talbot's servant but the relationship was much more complex than that. Born Klaase Henneman in a small farming community in northern Holland, he was "nothing like the typical Dutchman, but a lively, volatile fellow who had lived much in Paris, & become more of a Frenchman."[97] During service to a diplomat's widow in Paris in the 1830s, Henneman took advantage of the opportunity to become cultured, outgoing, and fluent in several languages (English, unluckily, not being his strongest!). After acting as a courier to Lady Elisabeth, Henneman became Henry Talbot's valet around 1838. As Talbot's constant companion during the birth of photography, he gained special insight and seems to have taken an early independent interest in the art.[98] Henneman primarily filled the role of Talbot's research assistant and photographic partner (routine printing tasks were handled by another servant).[99] Henneman travelled with Talbot on photographic outings including the 1843 one to France. By 1843 he was working virtually as a partner and it appears that he may have quit Talbot's employ as a servant that year to become a contractor to him in photography. There is a record in one of Talbot's notebooks of a "last settlement" on Nicholl's account on 30 March 1843.[100]

At the beginning of 1844, with Talbot's support, Nicolaas Henneman established his own photographic business in Reading, a bustling market town midway between Lacock and London on the newly extended Great Western Railway.[101] The business that became known as the *Reading Establishment* was set up specifically for producing photographs and was the first such operation in the world.[102] Talbot recorded that he saw the premises for the first time on 14 February 1844, thereafter making frequent stops at the *Reading Establishment* when travelling to and from London.[103] Henneman's building at No. 8 Russell Terrace was ideally suited to its task. A dis-used schoolhouse, it had one large windowless room that faced onto a glass conservatory. One of Henneman's assistants, John Henderson, recalled that

for some time the movements of this lively foreigner were watched with some degree of suspicion, the chief reason being that he was known to be purchasing every possible variety of paper at the different stationers, and rather unusual quantities of chemicals at different shops, added to this he lived alone in a rather large house for a bachelor, and worked all day in a sort of conservatory or small glass house at the back of his residence, which he never left unlocked, so the old Housekeeper thought him a most mysterious person, his hands being stained all shades from brown to black he seldom appeared in public unless well gloved....

Henneman offered to show him how to "take views" and invited Henderson to his studio.

Of course I went and was rather astonished at the sight his studio presented, his Cat and Dog, himself, a large variety of Busts, Statuettes, and various articles in every variety of position appeared in various shades of brown on hundreds of sheets of paper; he had then done nothing away from home. In a few months we had become close friends....[104]

Henderson also remembered that Thomas Augustine Malone, later an important photochemist, joined with Henneman:

to our great delight my friend Harrison, myself, and the Chemists assistant, Tom Malone, were invited by him to spend an evening with him, when he showed us all the nature of his occupation and explained what he was engaged in endeavouring to accomplish ... After this there was no further mystery about it, we were all pretty frequent visitors to his Studio, used to constantly sit for our portraits, and help him in preparing his papers, arranging the Camera, a rather ponderous affair, and doing all we could to assist in the work.[105]

Reading was likely chosen as much for geographic convenience as for anything. However, it was an unusually sophisticated provincial town with a stimulating populace and much literary and scientific activity. The locus of intellectual pursuits was George Lovejoy's bookshop, located a short walk from where Henneman set up. Henneman was soon buying paper at Lovejoy's and later gave a lecture to the Reading Literary and Scientific Institution which met on its premises.[106] Henneman wasted no time and plunged right in on the task of making photographic prints. In spite of the fact

91. Circle of William Henry Fox Talbot. *Nicolaas Henneman taking a portrait.* Salt print from a calotype negative. Ca. 1844. 8.2 × 7.1 cm. The National Museum of Photography Film and Television.

92. William Henry Fox Talbot. Cover of the first fascicule of *The Pencil of Nature.* June 1844. Royal Quarto. Hans P. Kraus, Jr.

that every sheet of paper had to be sensitized by hand and exposed liberally to the elusive British sunlight, he had billed Talbot for 10,400 photographs by the end of his first eight months![107]

In February 1844, Constance wrote from Lacock to Lady Elisabeth that "Nicole is here – and has had a fine day instead of his usual dark weather – and <u>very</u> busy they have been all day – making experiments on the sensitiveness of different preparations, besides taking a few pictures. We are to carry on operations on a grand scale now …"[108] Once again, the weather controlled Henry Talbot's actions. In contrast to the disastrous summers of 1839 and 1841, however, in this instance it supported him. Commenting on Henneman's progress in May 1844, the *Reading Mercury* said that "the late brilliant sky and clear atmosphere have been most favourable for these processes."[109] Shortly thereafter, they revealed that

a very beautiful Work has been commenced…. The first number of it contains very exquisite impressions from different subjects originally reflected in a Camera Obscura: the letter-press is illuminated, and the whole is of a very costly description, several *thousand* impressions have been literally printed or painted by the sun's rays, in the last few months….[110]

There was no precedent for what Talbot wanted to achieve with *The Pencil of Nature.* He had been the author of books but

Talbot had no previous experience in book design or marketing. Although Longmans probably provided some advice, under the terms of his contract Talbot had to furnish completed books for distribution. Talbot chose his cover design brilliantly – the splendidly bold red and black pattern still captures attention. The chromolithographs are attributed to Owen Jones, the influential architect and ornamental designer, who likely not only designed the covers but produced the lithographs as well.[111] Henneman, of course, printed the photographic plates. The firm of J. & H. Cox (the printers of Talbot's earlier texts that had been barred from the *Philosophical Transactions*) printed the letterpress. Talbot selected the London binder, Alfred Tarrant, to do most of the remaining work; their invoice for the initial issue of the *Pencil* summarizes many aspects of its production:

150 Part 1 Pencil of Nature done up in wrappers with Caouchouc backs, leather up the backs, boards cut to size of Paper. Drawings, squared & Mtd. with lines. Touching up 150 each of 3 plates and numbering plates & parts. 5 plates each part & 5 mtg boards each part. £12.13.2[112]

93. Circle of William Henry Fox Talbot, possibly directed by Benjamen Cowderoy or the Rev. Calvert R. Jones. *The Reading Establishment*. Salt prints from two calotype negatives, ca. 1846. Each print approximately 20 × 28 cm. Gilman Paper Company Collection.

On 24 June, remarkably close to schedule, the first number of *The Pencil of Nature* was published with five plates. A reader whose eyes had been stimulated by the forceful cover design would have been further excited by the first plate: "Part of Queen's College, Oxford." Resulting from Talbot and Henneman's joint trips to Oxford in 1843, it was boldly and frankly photographic. Truncating the buildings and celebrating the play of light, this dramatic view of Queen's Lane presented the calotype at its best and made a splendid beginning for the *Pencil*. Talbot, who had sought the picturesque, wrote that

> this building presents on its surface the most evident marks of the injuries of time and weather, in the abraded state of the stone, which probably was of a bad quality originally. The view is taken from the other side of the High Street – looking North. The time is morning. In the distance is seen at the end of a narrow street the Church of St. Peter's in the East, said to be the most ancient church in Oxford. . . .

Henry's uncle, William Fox-Strangways, when he first saw photogenic drawings, had exclaimed that "I wish you could contrive to mend Nature's perspective – we draw objects standing up & she draws them lying down which requires a correction of the eye or mind in looking at the drawing."[113] In this case, Talbot took his advice, and placed his camera in a room above the Angel Inn, across the street.[114] In reviewing "Queen's College," the *Art-Union* found the representation

"the most perfect that can be conceived; the minutest detail is given with a softness that cannot be imitated by any artistic manipulation; there is nothing in it like what we call touch; the whole is melted in and blended into form by the mysterious agency of natural chemistry."[115]

Talbot took a large number of negatives during his 1843 trip with Henneman to France. He also retained hope (never to be fulfilled) that a patent on his process in France would be productive. Turning from England, Talbot's second plate was a "View of the Boulevards at Paris," also taken from an elevated vantage point. Undoubtedly in a direct challenge to Daguerre, Talbot emulated a popular early view by the Frenchman and strove to establish that the calotype now captured the detail that the daguerreotype once had as its exclusive domain. In his text, Talbot explained that

> this view was taken from one of the upper windows of the Hotel de Douvres. . . . The time is the afternoon. The sun is just quitting the range of buildings adorned with columns: its façade is already in the shade, but a single shutter standing open projects far enough forward to catch a gleam of sunshine. . . . They have just been watering the road, which has produced two broad bands of shade upon it. . . . A whole forest of chimneys borders the horizon: for, the instrument chronicles whatever it sees, and certainly would delineate a chimney-pot or a chimney-sweeper with the same impartiality as it would the Apollo of Belvedere. . . .[116]

94. William Henry Fox Talbot. *Part of Queens College, Oxford*. Salt print from a calotype negative. 4 September 1843. Plate I of *The Pencil of Nature*. 16.2 × 20.2 cm. image on 18.8 × 23.1 cm. paper. The National Museum of Photography Film and Television.

The *Literary Gazette* marvelled that the photograph "takes in vast masses of building, a distant horizon of chimneys, and also trees in the foreground; the effects of light and shade are remarkable, and well deserving the attention of the land-scape-painter. The angles of vision, too, merit his study, as determining perspective lines in a singular manner."[117] The *Art-Union* found that

> it is curious to observe the entire absence of human life in the picture; this will forcibly strike those who know how crowded is the Boulevard des Italiens in the afternoon, for that is the time of day. This, however, will be a matter of surprise only to persons unacquainted with the nature of photography; and it is only necessary to say in explana-tion, that no moving object can be represented.[118]

In Talbot's announcement of Part I of *The Pencil*, he commented on the figures frequently introduced into French engravings, assuring readers that "the plates of the present work will be executed with the greatest care, entirely by optical and chemical processes. It is not intended to have them altered in any way, and the scenes represented will contain nothing but the genuine touches of Nature's pencil."[119]

A major function that *The Pencil of Nature* was expected to fill was to demonstrate the variety of practical uses to which the calotype could be applied. In the related plates III, "Articles of China," and IV, "Articles of Glass," Talbot attempted to combine an explanation of photographic effect with suggestions of application. In writing about the china, he predicted that

> From the specimen here given it is sufficiently manifest, that the whole cabinet of a . . . collector . . . might be depicted on paper in little more time than it would take him to make a written inventory . . . and would a thief afterwards purloin the treasures – if the mute testimony of the picture were to be produced against him in court – it would certainly be evidence of a novel kind. . . .[120]

Talbot had slowly become aware that the public had little knowledge of the power of photography, explaining that "the articles represented on this plate are numerous: but, however numerous the objects – however complicated the arrange-ment – the Camera depicts them all at once. . . ." Talbot added a technical hint that the lens "should be diminished by placing a screen or diaphragm before it, having a small circular hole. . . . The resulting image is more sharp and correct. But it takes a longer time to impress itself upon the paper. . . ." In writing about the companion picture, Talbot pointed out that

> The photogenic images of glass articles impress the

sensitive paper with a very peculiar touch, which is quite different from that of the China in Plate III. . . . White china and glass do not succeed well when represented together, because the picture of the china, from its superior brightness, is completed before that of the glass is well begun. . . . Blue objects affect the sensitive paper almost as rapidly as white ones do. On the contrary, green rays act very feebly – an inconvenient circumstance, whenever green trees are to be represented. . . .

Seeing the china, the *Literary Gazette* was delighted, finding them "all exceedingly curious. A boy and a china basin with a bird upon it, on the right of the centre vase in the second row, are the most perfect fac-similes of the articles they copy that we ever saw, and yet either might be drawn on the space of a thumb-nail."[121]

In the final plate in the first part of *The Pencil of Nature*, Henry Talbot honored an old and reliable friend. In classical times, Patroclus had remained resolutely loyal to Achilles. At the dawn of photography, reincarnated in the form of a lowly plaster bust, Patroclus had served as one of Talbot's most frequent photographic subjects.[122] Through many dozens, if not hundreds, of trials, this patient and reflective figure gave the inventor the opportunity to study the effects of light on his sensitive paper. Talbot explained to his readers that

> Statues, busts, and other specimens of sculpture, are generally well represented by the Photographic Art. . . . These delineations are susceptible of an almost unlimited variety. . . . The directness or obliquity of the illumination causing of course an immense difference in the effect . . . and when to this is added the change of size which is produced . . . by bringing the Camera Obscura nearer to the statue or removing it further off, it becomes evident how very great a number of different effects may be obtained from a single specimen of sculpture. . . . A better effect is obtained by delineating them in cloudy weather than in sunshine. For, the sunshine causes such strong shadows as sometimes to confuse the subject. To prevent this, it is a good plan to hold a white cloth on one side of the statue at a little distance to reflect back the sun's rays and cause a faint illumination of the parts which would otherwise be lost in shadow.

The *Literary Gazette* found the

> bust of Patroclus, really sublime in style and effect. Photography is admirably adapted for sculpture; and a noble gallery of all that is great in that art might readily be produced in such splendid imitations as that now before us. Mr. Talbot's instructions as to the best means for taking these 'likenesses' are of high practical value.[123]

95. William Henry Fox Talbot. *An ancient door, Magdalen College*. Salt print from a calotype negative. 9 April 1843. 16.2 × 20.6 cm. The National Museum of Photography Film and Television.

96. William Henry Fox Talbot. *The ladder*. Salt print from a calotype negative. Prior to April 1845. Plate XIV from *The Pencil of Nature*. 17.1 × 18.3 cm. The National Museum of Photography Film and Television.

The *Spectator* felt that "the delicate gradations of light into shade produce an appearance of relief and rotundity which attests the superiority of the 'Pencil of Nature' to that of Art."[124]

What immediate effect did Talbot's issuing *The Pencil of Nature* have? Although the reviewer for *The Critic* confessed that he was "in doubt whether to treat this as a contribution to Science or to Art," clearly he had received Talbot's message:

The Pencil of Nature affords abundant evidence of the utility of the Calotype process–to the traveller, in fixing the scenes he visits; to the naturalist, in procuring a faithful representation of living and inanimate objects; and to the world at large in preserving the features of those dear to us. Nor should its value to the artist be unnoticed; since the limnings of The Pencil of Nature demonstrate the importance of a due knowledge and observance of the distribution of light and shade in delineating every object, and the compatibility of breadth of effect with minuteness of detail in a picture. The triumph of Titian and the Old Masters is complete indeed, when Nature herself produces pictures exemplifying the soundness of the principles on which they painted....[125]

The Morning Herald, exclaiming that "the nineteenth century can accomplish anything," felt that Talbot's

experiences gave a key to the whole photogenic process, which, by successive experiments, has been matured to the excellence we now find. In the "Pencil of Nature" ... these illustrations are not simple imitative transcripts, but *book pictures* executed by nature herself: and it is almost beyond belief that they emanate from mere chemical sources and exist in total independence of either pencil or burin.... When the sun is shining, and there are shadows sharply diffused, as well as broad contrasting lights, the landscape and still-life productions of the Talbotype are eminently picturesque and definite. Some specimens of street architecture and foliage are given in the "Pencil of Nature," and justify the favourable remarks and expectations which have been hazarded.[126]

In sending the first number of the *Pencil*, Talbot had explained to William Jerdan, the editor of the *Literary Gazette*, that

I have met with difficulties innumerable in this first attempt at Photographic Publication, & therefor I hope all imperfections will be candidly allowed for, and excused. I have every reason to hope the work will improve greatly as it proceeds, & that British Talents will come forward and assist the enterprise.[127]

97. William Henry Fox Talbot. *The tomb of Sir Walter Scott in Dryburgh Abbey*. Salt print from a calotype negative. Late 1844. Plate 13 of *Sun Pictures in Scotland*. "Taken at the close of an autumnal evening." 16.9 × 17.9 cm. The National Museum of Photography Film and Television.

98. William Henry Fox Talbot. *Loch Katrine*. Salt print from a calotype negative. 1844–5. Plate 17 of *Sun Pictures in Scotland*. 8.3 × 10.7 cm. The National Museum of Photography Film and Television.

99. William Henry Fox Talbot. *Sir Walter Scott's Monument, Edinburgh, as it appeared when nearly finished*. Salt print from a calotype negative. October 1844. Plate 2 of *Sun Pictures in Scotland*. 19.7 × 15.8 cm. The National Museum of Photography Film and Television.

100. William Henry Fox Talbot. *The Hungerford Suspension Bridge*. Salt print from a calotype negative. 1845. This graceful pedestrian bridge across the Thames, designed by Isambard Kingdom Brunel, had just been opened when Talbot took his photograph. By 1860 it was taken down to make way for the railway bridge at Charing Cross. The chains, however, were incorporated into the Clifton Suspension Bridge as a memorial to Brunel. 16.8 × 21.3 cm. image on 18.7 × 23.0 cm. paper. The National Museum of Photography Film and Television.

101. William Henry Fox Talbot. *The haystack*. Salt print, varnished, from a calotype negative. April 1844. Same as plate X of *The Pencil of Nature*. Varnish was employed at the Reading Establishment as an experimental preservative – the results were rarely as satisfactory as in this case. 16 × 21 cm. Thomas Walther Collection.

Those British talents proved to be very slow in coming to Talbot's aid. Only a few of his countrymen took an interest in his photography during the 1840s. As his uncle observed,

> Henry is not fitted for a Publisher. . . . I am sorry the Pencil of Nature is to have fewer pictures but in no case will Henry be a gainer of money I am sure. Fame however he has & will ensure . . . but this (a few excepted) is a money making Country & consequently not inhabited by lovers of the fine arts.[128]

In his published review of *The Pencil of Nature*, Jerdan, Talbot's advocate from the start of photography, expressed his genuine respect for the inventor:

> the acuteness and sagacity displayed in these trials, and the philosophical conclusions drawn alike from attainment, peculiar phenomena, changes, and failures, reflect great credit on Mr. Talbot's perseverance and clairvoyance. Nitrates, chlorides, iodides, &c, all contributed to fill up the measure of his information. . . . We have only to add another tribute of our applause to that gentleman for the skill with which he has overcome the difficulties of a first attempt at photographic publication . . . and the art in general [will] be manifestly benefited by his own performance and by stimulating others to adopt a similar course of investigation and exertion.[129]

But perhaps the reviewer for *The Athenaeum* summed up Talbot's efforts most fairly:

> The experiment of photographically-illustrated books is now before the world; and all who see Mr. Talbot's production will be convinced that the promise of the art is great, and its utility and excellence, in many respects, of a high order . . . In the twelve plates which have now been published in the 'Pencil of Nature,' we see illustrated the beauties and the defects of photography. . . .[130]

In an earlier review, *The Athenaeum* felt that Talbot's *Pencil* was "a wonderful illustration of modern necromancy."[131] Now, they added that "photography has already enabled us to hand down to future ages a picture of the sunshine of yesterday."[132] Both Talbot and Herschel must have liked that assessment. In spite of years of struggling to understand the scientific basis of photography, they remained romantics and had not lost their sense of wonder at the new art. "Light was my first love," declared John Herschel. "I have captured a shadow," rejoined Henry Talbot.

102. William Henry Fox Talbot. *Books in disarray*. Salt print from a calotype negative. Early 1840s. Photography's ability to capture the variation in bindings fascinated early viewers and pictures of books on shelves were a repeated theme in Talbot's work. Like his later and more famous "Scene in a Library" plate in *The Pencil of Nature*, these bookshelves, in fact, were set up in the courtyard of Lacock Abbey to take advantage of the sunlight. 14.1 × 17.9 cm. The National Museum of Photography Film and Television.

Postscript

CERTAINLY FOR JOHN Herschel, perhaps to a lesser extent for Henry Talbot, the strains of photography were performed within the cacophony of a complex life. Against the background of conflicting demands, petty politics, and poor weather, neither man achieved with the art what he might have done in a vacuum. Either man could fall short of goals that we might wish on him. Yet even though both Herschel and Talbot were extraordinary products of an extraordinary time, perhaps the complexities that they perceived in their lives differed very little from those we see in our own. Our heroes were human and in their accomplishments become all the more heroic for that. We can speak with some confidence on the two men because of the minutely detailed record left by them and those around them. When he was only eight years old, the young Henry Talbot charged his stepfather to "Tell Mamma & everybody I write to to keep my letters & not burn them."[1] For the most part, this seems to have been done. Some crucial elements are presently missing from the archival records of both Talbot and Herschel but these stand out from their exceptional nature. Rarely is there the sense of self-editing expressed in Sir John's 1841 sonnet, "On burning a parcel of old MS:"

Wrecks of forgotten thought, or disapproved
 Farewell! And in your smouldering flames
 Read me a parting lesson. As the friend
Familiar once, but since less fondly loved
(Dire spite of Earthly chance!) & wide removed
 (With earthquake of the heart!) has ceased to blend
 Warmth with my warmth, and sympathies extend
Where mine are linked & locked! Yet not all in vain
 Do I receive your warning. On I hie
 All unrepressed, though cautious, nor complain
 Of faint essays in tottering infancy
Enough, if cleansed at last from earthly stain.
 My homeward march be firm, and pure
 my Evening Sky.[2]

Herschel could never have been Talbot's Arago. Questions of impartiality aside, in spite of considerable talents and a great respect for his friend, John Herschel was no more disposed towards the rough and tumble tactics of public promotion than was Talbot. But Herschel's active presence served Talbot in substantial ways. The mere fact that Sir John took such an active interest in the art legitimized the newcomer to both the scientific and the popular community. Rather than a threat, Herschel's brilliant and steady advances were a stimulant to Talbot. Also, Henry Talbot took such a terrible beating in the first two years of photography that often he must have felt that Herschel was his only friend competent and true. In bolstering Henry Talbot, Sir John Herschel served to keep alive the spirit of photography on paper.

103. Sir John Herschel. *Experimental cyanotype.* Ca. 1842. 10 × 9 cm. The Museum of the History of Science, Oxford.

Hidden in the mass of experiments that Herschel conducted were some very practical contributions. His hypo fixer remains to this day the best way to 'wash out' (not fix!) silver photographs. Had photographers more carefully followed his instructions on contamination, washing, chemical balance, and the effects of organic substances, we would have a richer legacy from the early days of photography. Herschel's cyanotype, mastered so beautifully by Anna Atkins, remained uncommon as a photographic process until its simplicity was appreciated by the second great amateur movement starting around 1890. In the form of the blueprint, however, the cyanotype was an essential tool of architecture and industry until very recent times. The cyanotype was the best known member of Herschel's family of iron-based processes; others, like the chrysotype, enjoyed very limited application in the practice of photography. But their practical effect was great. The most exquisite expressions of photographic printing in the nineteenth century were the various platinum processes; they were permanent and they were beautiful. At their core was an iron process evolved from what Herschel had identified. In spite of these practical contributions, the myriad individual photographic experiments that Herschel conducted were rarely significant in themselves. He didn't expect them to be. As he did so

successfully in other areas, John Herschel applied his inductive approach to the new art of photography. The thousands of facts and anomalies that he gathered were the building blocks of the fields of photochemistry and photological research. These led to the formulation of more general axioms, platforms from which further facts could be hunted down. Within Herschel's lifetime much was accomplished in this way – often by others, as he would have wished.

In a much less obvious way than his chemical and optical discoveries, Herschel's concern with nomenclature was an important organizational foundation as well. We must not forget that John Herschel gave the new art its very name – photography. His terms for the negative and positive are still in daily use. There were others, especially the one in 1860, when Herschel mused on the possibility of "taking a photograph, as it were, by a *snap-shot* – of securing a picture in a tenth of a second of time...."[3] It was not only in his creation of words, but even more so in his employment of them, that Herschel was tremendously important. Talbot wrote well and was often delightful in his predictive capabilities. But Herschel's peculiar gift of expressing complex concepts simply and lovingly within a broad framework of science and life caused him to be called

the Homer of science because he was its highest poet. It is the poet's function to move the soul – rousing the emotions, animating the affections, and inspiring the imagination; and all this Herschel did on almost every page of his writings ... he has drawn beautiful pictures of nature's doings – so beautiful that they have disposed two generations to find their recreation and joy in science.[4]

In 1861, whilst nearing the age of seventy and collating a lifetime of work, John Herschel started a *General list of all my drawings and sketches.*[5] The vast majority of his personal selections for his portfolio had been accomplished with the camera lucida. If light was John Herschel's first love, Wollaston's 'chamber of light' was his most exquisite means of expressing that love. The camera lucida became an integral part of his vision for more than fifty years. Ready facility with the camera lucida modulated John Herschel's reaction to the announcement of photography in 1839. The question as to why he didn't invent photography decades sooner, as he surely could have done, must be answered with reference to his satisfaction with the camera lucida. Its portability suited his working methods and its accuracy met his visual needs. More importantly, the very nature of building a sketch with the device suited Herschel philosophically as well. The camera lucida gave him the opportunity to study the various details of the scene that he was recording – nothing was calculated to bring him greater inner peace. Indeed, the camera lucida simultaneously encouraged and compelled

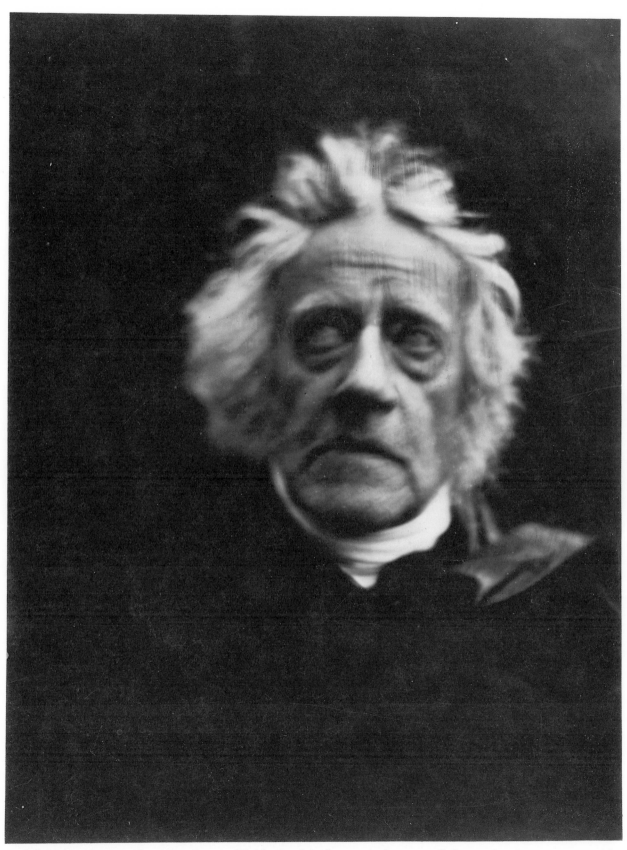

104. Julia Margaret Cameron. *The astronomer*. Portrait of Sir John Herschel. Albumen print from a wet collodion negative. 1867. 30.2 × 23.2 cm. The Royal Photographic Society.

105. William Henry Fox Talbot. *Winter trees*. Ca. 1840–2. Salt print from a calotype negative. 16.5 × 19.2 cm. image on 19.7 × 24.9 cm. paper. The National Museum of Photography Film and Television.

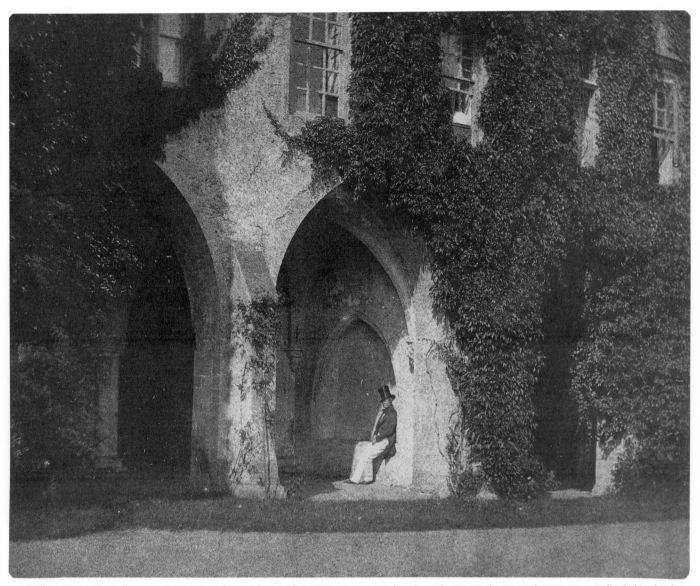

106. William Henry Fox Talbot. *The ancient vestry*. Salt print from a calotype negative. September 1845? The sitter is the Rev. Calvert R. Jones, Talbot's friend and one of the most accomplished of the early photographers. 16.5 × 20.6 cm. The National Museum of Photography Film and Television.

Herschel to meet his Baconian duty to report on what he saw. Camera lucida drawing was analytical rather than exploitative; the fleeting action of taking a photograph would have robbed him of this opportunity. John Herschel never wavered in his appreciation of the expressive potential of photography; he was simply not interested in taking photographs himself. Talbot gloated that his new art "can make the powers of nature work for you, and no wonder that your work is well and quickly done."[6] In his *Pencil of Nature*, Talbot expressed his thrill on finding that the time of the day had been unknowingly recorded on a clock tower in one of his photographs. Herschel would have been disappointed in himself not to have noticed the clock in the first place. It would have been a part of his camera lucida drawing.

Herschel's sketching partner and brother-in-law, John Stewart, became an important photographer and one whose work Herschel greatly admired. Sir John encouraged the wonderfully eccentric documentary photography of Charles Piazzi Smyth.[7] And Julia Margaret Cameron, whose pre-Raphaellite photographs might seem anything but scientific, gave full tribute to Sir John:

> Your eye can best detect & your imagination conceive all that is to be done & is still left undone. For you were my first Teacher & to you I owe all the first experiences & insights which were given to me when you sent me in India a score of years ago . . . the first specimens of Talbotype, of photographs coloured by the juices of plants &c &c.[8]

Cameron's portraits of Herschel, taken when he was nearing the end of his life, define the image of the grand old man of science. So powerful are they that it is difficult to remember that Herschel was much younger and in much better health when he was most active in photography.[9] Just as for Talbot, there was no conflict between science and art for John Herschel. As he wrote on the eve of the birth of photography,

> The gulph is bridged which parts the world of thought
> Science is poetry. Her lyre is strung
> With double chords, & from its depths are wrought
> Strains which in either sphere by eager ears are caught.[10]

In the five years between the announcement of photography in 1839 and the publication of Talbot's *Pencil of Nature* in 1844, Herschel published more than fifty scientifically connected articles, processed the bulk of his Cape observations, moved house, served on various commissions – and had four more daughters with Maggie! His schedule was to get worse. By 1848, he wrote to Talbot that

> I have much on my hands which has no connex[n] with Science and am moreover kept hard at work on Scientific matters not of my own chusing and so prevented from working at subjects of my own choice among w[h] the Chief would be physical optics – but alas! Optical experiments shall I never I fear be able to make more![11]

In November 1850, Sir John Herschel was appointed Master of the Mint. With a desperate need for scientific reform, England again required someone of the caliber of Sir Isaac Newton. Herschel took on the responsibility only after considerable persuasion and appeal to his patriotism. It meant leaving his beloved family, living in a London whose smoke-laden air was literally deadly to his fragile lungs, and thrusting himself into the turmoil of human affairs. Herschel's participation in the Great Exhibition of 1851 was forced to be minimal. As much a personal toll as he endured, Herschel's contributions to the Mint reform were meaningful. He had mustered the strength of character but his body could not keep up. In 1853, he tendered his resignation, but it was refused. Wartime preparations and well-meaning friends persuaded him to stay in office longer than he could endure. In his diary in August, Herschel confessed that "I desire here to record my deliberate opinion that any man having anything to do with the Public Service under the Treasury who can do anything else is a fool. Though it is writing my own condemnation."[12] His vision began failing and he started to take laudanum. By September Herschel recorded that he "again waked at 2. Took Camphor – but no relief. And Oh! the horrors of these morning early vigils. All the desolation of this horrible position seems to roll upon one like a sea. Toss. Toss. Toss." Maggie and the children and the peace at Collingwood were all that were left to him. Getting up at five one morning to travel there, he had to walk four miles in the rain; "However all effaced on arrival & a happy family & Gods blessing. Another period at home. . . . A day <u>at home</u> – a day of utter oblivion of the dark dismal pool of despair from which I emerge to light & life." In November 1853, Sir John Herschel called in on a soirée, but "simply looked in & slid back home. The meeting with Men of Science is now accompanied to me with feelings too painful to bear more than absolute good breeding requires."

It was not until two years later that Sir John was allowed to resign and even then it was only through the skillful (and concealed) intervention of Lady Herschel. Her husband's health had been broken in service to his country. He had lost half an inch in physical height and much more in spirit. Thus, during the time of the Great Exhibition and the radical changes in photography that took place in the 1850s, Sir John Herschel had been forcefully removed. It was a bad time for Talbot as well. With motives no more sinister than protecting his name and the livelihood of his loyal helper, Nicolaas Henneman, Henry Talbot became embroiled in bitter patent controversies in the early 1850s. Photography

107. William Henry Fox Talbot. *Rouen*. Salt print from a calotype negative. 16 May 1843. 15.2 × 18.5 cm. The National Museum of Photography Film and Television.

had become so valuable in the marketplace that there was little room, and even less sentiment, for the art's inventor.

Along the way, Henry Talbot and Louis Daguerre had unwittingly traded places. Each eventually met his rival's goal. Daguerre was the public communicator and it would be fair to assume that his pursuit of the daguerreotype was initially motivated by a desire to bring ever more realistic images to his audiences. Ironically, what he created was the most intimate of all photographic representations, a precious and shiny little plate encased under glass. Henry Talbot, on the other hand, started with the goal of making an amateur

sketch for his own use. He eventually achieved something far greater – one of most powerful mass communication mediums ever devised. Talbot is often given credit for discovering the latent image. To so honor him is patently unfair to Daguerre and this accolade must be dismissed. What Talbot contributed is far more complex – and far less technical. The daguerreotype evolved most rapidly as an instrument of commerce. Many daguerreotypes have a seductive beauty and prove without doubt that a handful of daguerreotypists were artists. But to Talbot alone belongs the romance of photography. Talbot was a visionary half-

108. William Henry Fox Talbot. *Experimental photoglyphic engraving of an angel.* Ca. 1860. Liquid aquatint. 10.1 × 7.2 cm. plate on 14.4 × 11.2 cm. paper. The National Museum of Photography Film and Television.

blind before photography. The scientist of Lacock regarded his new child with a sense of wonder and awe – magic was everywhere in his writings about the art. Talbot's timing was awful. Initially, he was bested by Daguerre, he ran afoul of the Royal Society's intricate publication rules, few sympathized with his plight, and the skies literally clouded over. It was the magic of photography that sometimes only he could see that kept him going. For Henry Talbot, this magic did not lie in the domain of mirrors and alchemy. Tracing his progress through his photographs one can feel the pains and struggles and triumphs of the growth of an artist. His biggest breakthrough was in fact a very gradual one. Even before Talbot discovered the calotype, his child was teaching him how to see. By the time he assembled the album for exhibition at the Graphic Society in the spring of 1840, Talbot had triumphed over the deficiency that had motivated him to invent photography in the first place. Neither aesthetic nor technical points meaningfully separate the last of Talbot's photogenic drawings in the spring of 1840 and the first of his calotypes that autumn. The calotype was a necessary technical breakthrough – necessary not for Talbot's personal development – but necessary for the growth of the art in the commercial marketplace. Its reduced exposure times broadened the base of potential subject matter and treatment. And it gave Henry Talbot a confidence impossible for him to maintain during the year 1839.

The approach of making multiple prints from a single negative was Talbot's. For a time, like others, he saw the

negative as a burden, but on it book production depended. Talbot's *Pencil of Nature* was started in 1844 at the peak of his optimism. Originally projected as a series of ten to twelve folios, it was eventually to be overwhelmed by insurmountable production and marketing problems. This in no way invalidates Talbot's vision – the *Pencil* remains a beautiful book today – but only proves that his plan was overly ambitious for the uncertain state of the art. The plates in *The Pencil of Nature* started fading almost immediately. The dreadful water supply at Reading was an immediate cause.[13] Many of the others would have to wait for the advent of sophisticated research tools (such as electron microscopes) to be identified. Our knowledge of the true mechanisms underlying the photographic image has only come about in recent times. There is no way that Talbot and his colleagues could have understood the intricacies. But Talbot clearly understood their implications. By the time of the Great Exhibition in 1851, Henry Talbot had come to accept that photographs based on silver, no matter how carefully they were done, were cursed with original sin.[14] And thus it remains. We can do better now with advanced knowledge, highly refined materials, and careful storage, but silver photographs remain ever vulnerable; but no amount of refinement in processing can totally protect the silver from the ravages of time and storage. Photographic survivors from Herschel's and Talbot's era are magical. They are fragile but compelling voices from the earliest days of photography.

Right in the middle of his growing technical problems, Henry Talbot suffered a tremendous personal loss. In March 1846, his mother, the redoubtable Lady Elisabeth Feilding, died. Her ambitious love and unflagging support for her son had been the main source of strength he needed to bring his brilliant ideas before the public. The evidence of years of correspondence attests to the fact that Henry Talbot had the highest regard for his mother's intelligence and her judgement. Whatever wounds her sharp tongue might have inflicted were always well intended and generally were deserved.

Further troubles were to beset Talbot and he could well have been a defeated man. But in that lies a further story. Starting in 1833 in a quest for a sketch, by the time of the *Pencil of Nature*, Henry Talbot had proven his mastery of an art. He then cashed in only part of his original dream on a new one. Talbot ceased to take original photographs but redoubled his efforts in the service of photography. He clearly saw that the future of photography was inextricably intertwined with that of the printing press. Talbot spent more than two decades in intensive research on translating photographs into permanent printers' ink. His fertile mind conceived of the photographic halftone that is only now being displaced in reproductive processes. His photographic engraving and later photoglyphic engraving processes were the forerunners of the modern photogravure process. Talbot was proven correct in his vision; the vast majority of photographs that affect us today are reproduced in ink, not in silver. He never stopped trying to live up to the well-founded expectations that Lady Elisabeth had instilled in him. In 1877, Henry Talbot died whilst writing a book chapter explaining the implications of photoglyphic engraving.[15] It is a story yet to be completed.

Notes

1 Draft of letter, Herschel to James Grahame, from Munich, 18 September 1824. HS8:319, RSL.

2 Letter, Herschel to his mother, from Munich, 20 September 1824. Lo517, HRHRC. In fact, Herschel had missed Fraunhofer at his workshop and first met him at a dinner at Captain Feilding's house on 18 September. Having arrived just the day before, his introduction to Talbot must have been on the 17th or the 18th. Additional note of this meeting is in Louis Otto Moritz von Rohr, *Joseph Fraunhofers Leben, Leistungen und Wirksamkeit* (Leipzig: Akademische Verlagsgesellschaft M.B.H., 1929), pp. 2, 38–9. One of Fraunhofer's uniquely fine prisms was to play a critical role in Herschel's early research on color photography. Talbot was the one who obtained this prism (and other optical goods) for Herschel, through the offices of the Bavarian ambassador and undoubtedly with the help of his uncle, William Horner Fox-Strangways. Letter, Herschel to Talbot, 24 January 1826. LA26–2, FTM. See also Herschel's memoranda of a letter to Fraunhofer, 27 January 1825. HS19.5, RSL. While he disagreed with Fraunhofer's assessment of telescope styles, Herschel remembered "his liberal and friendly reception during a visit to Munich, which I shall ever recollect with pleasure, and in which I had ample opportunity to admire both the resources of his genius and the simplicity of his manners. . . ." Herschel, *Observations on Mr. Fraunhofer's Memoire on the Inferiority of Reflecting Telescopes When Compared With Refractors* (Slough: privately published, 15 August 1825), p. 6.

3 Herschel's diary entries imply fairly regular contact. His first mention of Talbot was in connection with Royal Society business: on 16 October 1822, he recorded that he "returned . . . Airy's paper & Talbot's letter." On 20 November 1824, Herschel "Dined at home. After tea, Talbot." On 14 April 1825, "Dined at RS Club. Gay Lussac there – Talbot dined with me." On 6 January 1826, "Evg. Geological Socy with Dr Fitton, Mr Talbot & Sir C. Lemon." On 7 January 1826, Herschel met with several scientific people, including "Dr. Wollaston, Mr. Talbot." On 23 February 1826: "A besetting day. Fitton, Whitfield, Harvey, Talbot, Babbage, Murchison all called 1 after another & from 10 till 4 had not 1 moment alone also Capt. Haley." *Diaries*, W0004–0008, HRHRC.

4 Priestley, *Experiments and Observations, Relating to Various Branches of Natural Philosophy; with a Continuation of the Observations on Air* (Birmingham: printed by Pearson and Rollason, 1786), v. 3, pp. xix–xx.

5 Obituary, *Proceedings of the Royal Society of London*, v. 20, 1872, p. xvii.

6 Obituary, *The Athenaeum*, n. 2273, 20 May 1871, p. 624.

7 At the bicentenary of Herschel's birth, the only biography (termed, too modestly, by its author as merely a 'sketch'), is Günther Buttmann's *The Shadow of the Telescope; a biography of John Herschel*, translated by B.E.J. Pagel, introduction by David S. Evans (New York: Charles Scribner's Sons, 1970). There are entries in many of the standard biographical compendiums, including the *Dictionary of National Biography* and the *Dictionary of Scientific Biography*. Sir John Herschel was widely missed by his peers and a myriad of obituaries and testimonials was published in the period immediately after his death; the variety of interests stressed by different groups that published them illuminates various aspects of Herschel's diverse character. One example of many is N.S. Dodge, "Memoir of Sir John Frederick William Herschel," *Annual Report of The Board of Regents of the Smithsonian Institution . . . for the Year* 1871 (Washington: Government Printing Office, 1873), pp. 109–35. Herschel compiled a list of all his writings to date (including those published under pseudonyms), as "A Complete Catalogue of the Writings of Sir John Herschel," *The Mathematical Monthly*, v. 3, 1861, pp. 220–7. An overview of Herschel's life up to about 1830 is found in Schaaf's, *Tracings of Light: Sir John Herschel & the Camera Lucida* (San Francisco: The Friends of Photography, 1989). Herschel's stint in South Africa is covered in *Herschel at the Cape: Diaries and Correspondence of Sir John Herschel, 1834–1838*, edited by David S. Evans, Terence J. Deeming, Betty Hall Evans, Stephen Goldfarb (Austin: The University of Texas Press, 1969). Another important source on this period is Brian & Nancy Warner, *Maclear & Herschel, Letters & Diaries at the Cape of Good Hope 1834–1838* (Cape Town: A.A. Balkema, 1984). His very unhappy period as Master of the Mint in the early 1850s is outlined in Sir John Craig's *The Mint: a History of the London Mint from A.D. 287 to 1948*

(Cambridge: Cambridge University Press, 1953). Significant journal articles and introductory essays have explored aspects of Herschel's thought; examples include Walter F. Cannon, "John Herschel and the Idea of Science," *Journal of the History of Ideas*, v. 22 n. 3, April–June 1961, pp. 215–39. David B. Wilson, "Concepts of Physical Nature; John Herschel to Karl Pearson," *Nature and Victorian Imagination*, edited by U.C. Knoepflmacher and G.B. Tennyson (Berkeley: University of California Press, 1977), pp. 201–215. Sydney Ross, "John Herschel on Faraday and on Science," *Notes and Records of the Royal Society of London*, v. 33 n. 1, August 1978, pp. 77–82. Michael F. Partridge contributed an introductory biographical essay to the new edition of Herschel's *Preliminary Discourse* (New York: Johnson Reprint Corporation, 1966). Particularly thought-provoking is Silvan S. Schweber's introduction to *Aspects of the Life and Thought of Sir John Frederick Herschel* (New York: Arno Press, 1981), pp. 1–158.

8 Obituary, *Proceedings of the American Academy of Arts and Sciences*, v. 8, 4 June 1872, p. 470.

9 Letter, Maria Edgeworth to Harriet Butler, 3 December 1843. Transcribed in Christina Colvin, *Maria Edgeworth, Letters from England, 1813–1844* (Oxford: Clarendon Press, 1971), pp. 596–7.

10 Biographical note on John by Caroline Herschel, 27 May 1838. M1084, HRHRC. The reference is most likely to Wilhelm Müller (1783–1846), a Hanover mathematician, geographer, and astronomer who strengthened his friendship with Caroline when she returned to Hanover after the death of her brother.

11 Letter, Herschel to Babbage, October 1813. HS2:19, RSL.

12 Newton's *calculus of fluxions* reigned supreme in Britain, maintaining resistance to the more modern methods developed in Germany by Gottfried von Leibnitz and refined in France by Pierre de Laplace. Herschel was influenced in this question by the writings of the Cambridge mathematician, Robert Woodhouse. See M.V. Wilkes, "Herschel, Peacock, Babbage and the Development of the Cambridge Curriculum." *Notes and Records of the Royal Society of London*, v. 44 n. 2, July 1990, pp. 205–19.

13 Letter, Lady Elisabeth to Henry Talbot, 19 May 1817. LA17–25, FTM.

14 He had done well from the beginning. On finishing his first exam at Cambridge, John Herschel wrote to his father that "yesterday was my black Monday. For a fortnight before, I had been stuffing my memory full of all the algebraical formulae I could lay hold on, to thunder forth with Ciceronian eloquence. But when the time came, my courage became faint, and decreased gradually as it drew nearer. At length the dreadful sounds Assurget dominus respondent summoned me to the rostrum, where I was baited and badgered with fifty-one syllogisms against me and a geometrical moderator (infandum renovare solorem) for about 3 hours, when the good Gentleman was so kind as to dismiss me with a flaming compliment. I think I may safely say that I did not the whole time know a word I had said a minute ago, what with the eyes of half the University on one, and my own head spinning like a top." Letter, Herschel to his father, 5 February 1812. LO549, HRHRC.

15 Letter, Herschel to John William Whittaker, 10 January 1814. Library, St John's College, Cambridge.

16 Letter, Herschel to Babbage, 20 September 1814. HS2:30, RSL. To his friend, John Whittaker, he wrote that "upon my life it is an oppressive thing to be so deeply involved in scientific pursuits. I have not even had time to read the newspapers, or to debate in one single ode the exploits of the everlasting Wellington …" Letter, Herschel to John William Whittaker, 7 July 1814. Library, St John's College, Cambridge.

17 Herschel was quoting a Mr Flexney. *Diary*, 3 January 1820. W0002, HRHRC.

18 Letter, Herschel to Babbage, 14 July 1816. HS2:64, RSL.

19 Letter, Herschel to Babbage, 10 October 1816. HS2:68, RSL.

20 Charles Pritchard, *Monthly Notices of the Royal Astronomical Society*, v. 32 n. 4, 9 February 1872, p. 126.

21 Charles Babbage remembered that "the singular minuteness of the particles of bodies submitted by Dr. Wollaston to chemical analysis, has excited the admiration of all those who have had the good fortune to witness his experiments…." Some attributed Wollaston's success to unusually highly developed organs of sense, but Babbage knew that "it was a much more valuable property on which the success of such inquiries depended. It arose from the perfect attention which he could command, and the minute precision with which he examined every object … an object is frequently not seen, *from not knowing how to see it*, rather than from any defect in the organ of vision…." Babbage, *Sketch of the Philosophical Characters of Dr. Wollaston and Sir Humphry Davy* (London: printed by R. Clay, 1830), pp. 9–10.

22 Herschel, *Preliminary Discourse on the Study of Natural Philosophy* (London: Longman, Rees, Ormé, Brown, & Green, 1830), pp. 105, 108.

23 Herschel, *Preliminary Discourse*, p. 118.

24 Letter, Herschel to Babbage, 9 November 1818. HS2:97, RSL.

25 Herschel, *Preliminary Discourse*, pp. 299–300.

26 Henry Fox Talbot, *Some Account of the Art of Photogenic Drawing, or the Process by which Natural Objects may be made to Delineate Themselves without the Aid of the Artist's Pencil.* (London: printed by R. and J.E. Taylor, 1839.)

27 Letter, Herschel to Babbage, 12 August 1820. HS2:142, RSL.

28 Letter, Babbage to Herschel, 11 November 1817. HS2:88, RSL.

29 Letter, Edgeworth to Butler, 3 December 1843, transcribed in Colvin, *Maria Edgeworth*, p. 596.

30 Details of his instruments (and experiences) are recorded in his notebook, *JFWH's Tour in France 1821 July 21st to Aug 31st*. W0054, HRHRC.

31 Letter, Herschel to his mother, 15 August 1821. LO515, HRHRC.

32 Herschel observed that "mapmaking seems the rage in all parts though which I have passed, and road-making (of which in this part of the world I am sure there is great need) and a pretty general spirit of improvement is abroad." Letter, Herschel to Babbage, 3 October 1824, from Hanover. HS2:199, RSL. Herschel very occasionally was impressed by nineteenth century man's works. Writing about the topic of one of his camera lucida drawings, he spoke admiringly of "the Menai Bridge, one of the most stupendous works of art that has been raised by man in modern ages, consists of a mass of iron, not less than four millions of pounds in weight, suspended at a medium height of about 120 feet above the sea." Herschel, *Preliminary Discourse*, p. 60.

33 Letter, Herschel to James Gordon, 15 August 1821. Collection of John Herschel-Shorland.

34 Manuscript poem on Herschel's 1850 camera lucida drawing, *Cascade D'Enfer, Val de Lys, Bagneres de Luchon*. The Graham Nash Collection.

35 Letter, Herschel to his mother, from Chamouni, 15 August 1821. LO515, HRHRC.

36 Herschel notebook, *Tour in France*, 1821, 14 August 1821. HRHRC.

37 Letter, Herschel to Babbage, 2 December 1821. HS2:168, RSL.

38 Draft of letter, Herschel to Grahame, 2 May 1824. HS8:319, RSL.

39 In one camp were the followers of Abraham Gottlob Werner, the 'Neptunists,' who believed that the earth had once been covered with water and that various types of rocks had been deposited from the sediment of these oceans. Volcanos, and the products of them, were seen as merely localized and recent phenomena, the outcome of underground burning of decaying vegetation. Werner's was a very static view of the planet earth. But it was widely respected, particularly in religious circles, and his observations contained many valuable components. In the opposite camp were the followers of the Scotsman, James Hutton. His 1795 *Theory of the Earth* postulated a world that was in a constantly repeating pattern of change. Hutton was inspired by a chance observation of the roof of a salt mine in 1772. The turgid prose of Hutton's *Theory of the Earth* had the most influence via the more graceful writings of John Playfair. For Hutton and his followers, the major forces that shaped the earth were still going on and would continue to do so, on a time scale transcending man's imagination. Volcanos threw diverse matter out of the core and erosive forces wore this matter down and eventually put much of it into the sea.

40 Letter, Herschel to his mother, 8 June 1824. References to the camera lucida are sprinkled throughout his letters to his mother. On 17 June, he wrote from Naples that "at Puzzuoli I ran over the ruins and dispatched my Cicerone as soon as decency would permit, and took to my drawing board, for the spot is beautiful." Both letters, LO517, HRHRC. Herschel numbered his letters and obviously planned for his mother to keep them as a chronicle. Was the extensive reporting on the camera lucida solely John's

interest, or did it possibly reflect a more than ordinary interest that Mary Herschel herself took in sketching? Could she have been the unidentified tutor for her son's early drawings?

41 Letter, Herschel to Babbage, from Etna, 4 July 1824. HS2:197, RSL. A week later he complained good-naturedly to Babbage: "I have now made the tour of Sicily and I thank heaven it is done. If it be pleasure to ride from 30 to 50 miles a day over roads all but impracticable for mules, under a scorching sun with the thermometer at 86 and over wilds & wastes where no verdure is to been seen, but groups of Cactus & hedge-rows of majestic Aloes from 20 to 30 feet high to break the monotony – to be broiled all day and at night to be eaten – to sketch ruins in the Sirocco & with the fear of mal-aria before one's eyes – if this be pleasure, there is no doubt that I have been in Elysium for the last three weeks. But it is worth taking some pains & undergoing some hardships to have seen this curious & most interesting Country. I wish I had only been a month earlier – & had more time at my disposal." Letter, Herschel to Babbage, from Palermo, 11 July 1824. HS2:197, RSL.

42 "The Gigantic ruins of Selinunte in like manner, lie in a dreary solitude, infested by the Malaria, by ye sea side. A passing sail in ye offing now & then reminds one that there is a world without, full of life & activity, which else one might forget in the dreams of other times – & in the dead silence of the scene. Their ruins are indeed stupendous.... The ruins of ancient Agrigentum too stand now far aloof from the modern town wʰ has retreated from ye pestilential influence of ye air to ye summit of a hill 2 or 3 miles off. It is incredible what an awful air this circumstance gives them. One must be on ye spot to feel its full effect. It seems as if they were preserved as monuments of wrath – as if the curse which devastated still clove to them & caused them to be at once admired & shunned." Letter, Herschel to Sir William Watson, from Palermo, 16 July 1824. L0494, HRHRC. To his mother, he reported that "Girgente is a most curious place & full of ruins the Rocks being all honeycombed with houses &c and the Temples superb. I have crammed my drawing cases with views of them." Letter, Herschel to his mother, from Catania, 1 July 1824. L0517, HRHRC.

43 Letter, Herschel to his mother, 2 May 1824. L0517, HRHRC. Herschel respectfully called Giovan Battista Amici an artist in the traditional sense of the word (more closely allied to our present term of artisan). Amici, one of the finest opticians of Europe, was an accomplished camera lucida sketcher as well. His observations on Wollaston's instrument led him to design a more sophisticated variation of the device, one that Herschel came to favor.

44 Draft of letter, Herschel to James Grahame, from Munich, 18 September 1824. HS8:319, RSL.

45 Within the last two decades, prompted largely by a growing interest in photography, several biographical studies of this complex figure have been published. The standard biography is H.J.P. Arnold's *William Henry Fox Talbot; Pioneer of Photography and Man of Science* (London: Hutchinson Benham, 1977). Arnold's biography presents an excellent and detailed picture of the range of Talbot's interests and is (as Arnold hoped for) an essential starting point for further enquiry. Arnold's strong grounding in mathematics and politics is apparent. Much of the background information in the present study had its start in his work. Partially out of personal interests, and perhaps more to restore to Talbot's reputation areas of accomplishment that had been neglected, Arnold de-emphasized photography and attempted very little assessment of Talbot's aesthetic development. Largely un-illustrated, Arnold's text is complemented by Hubertus von Amelunxen's splendid *Die Aufgehobene Zeit; Die Erfindung der Photographie durch William Henry Fox Talbot* (Berlin: Dirk Nishen, 1988); an English translation was anticipated, but has yet to be published. The other major biography is by Gail Buckland. It supplies an enthusiasm for the quality of Talbot's pictures that is lacking in Arnold; however, its details are frequently suspect and poorly substantiated. Buckland's book, produced to high standards for its day, has a very useful range of illustrations: *Fox Talbot and the Invention of Photography* (Boston: David R. Godine, 1980). A stimulating consideration of literary influences on Talbot's photography is put forth in Mike Weaver's "Henry Fox Talbot: Conversation Pieces," *British Photography in the Nineteenth Century; The Fine Art Tradition* (Cambridge: Cambridge University Press, 1989), pp. 11–23. Insight into the important Science Museum Collection (now at the NMPFT) is provided in John Ward's essay in *Printed Light, The Scientific Art of William Henry Fox Talbot and David Octavius Hill with Robert Adamson* (Edinburgh: Scottish National Portrait Gallery, 1986). The late historian, Harold White, did a considerable amount of early research on Talbot. It was he who helped Miss Matilda Talbot collect and organize the jumbled collections within Lacock Abbey. Sadly, very little of his research ever made it to publication. The major account of his efforts is in Schaaf, *Sun Pictures III, The Harold White Collection of Works by William Henry Fox Talbot* (New York: Hans P. Kraus, Jr. Inc., 1987). Other biographies include one by the then-curator of the Fox Talbot Museum, Robert Lassam: *Fox Talbot Photographer* (Tisbury, Wiltshire: Compton Press, 1979). The French photo-historian, André Jammes, also did important early work. Unfortunately, his *William H. Fox Talbot, Inventor of the Negative-Positive Process* is flawed by having been first translated from French into German, and then German into English, without his corrections (New York: Collier Books, Inc., 1973).

46 Talbot was nearing his majority before the financial situation was stabilized. The details of this situation, along with consideration of the effects this had on Henry Talbot, is well considered in Arnold, *Talbot*, pp. 24–6.

47 Entry for 22 June 1808, *William Henry Fox Talbot's Journal*, 1806, 1807, 1808, 1809, 1810, 1811. FTM.

48 Further evidence that Henry himself had little enthusiasm for the "Fox" is revealed in a letter to his mother on the birth of his son. "You know we had fixed on the name Charles Henry, but if you wish it we can make it C.H.F.T. Constance says she is quite willing." Letter, Henry Talbot to Elisabeth Feilding, 5 February 1839. LA39–8, FTM. Perhaps it was out of deference to Lady Elisabeth that Henry signed some of his books and journal articles "H. Fox Talbot." The surname was never hyphenated but it is not unusual to see it so treated in secondary literature. In fact, the occasional library card catalogue has Talbot filed under 'F.' But this is not a new problem. Henry wrote from Naples to his mother that "I observe you always direct to me Fox Talbot by way of discrimination, but it does rather the contrary. For, the letters are here distributed from different windows, according to the different letters of the Alphabet, and the other day I found no letter for me under T, and accordingly asked for letters for Mr Fox when they immediately produced one from you." Letter, Henry Talbot to Lady Elisabeth, 27 February 1823. FTM.

49 Letter, Lady Elisabeth to Henry Talbot, 11 February 1821. LA21–6, FTM.

50 Letter, Lady Elisabeth to Henry Talbot, 11 February 1821. LA21–6, FTM.

51 Letter, Mr Hooker to Lady Elisabeth, 20 May 1808. LA08–2, FTM.

52 Reminiscence by Charles Henry Talbot, 13 November 1879. FTM.

53 Designated "P," covering from 6 February 1839 to 25 June 1840; and "Q," covering the period from 26 June 1840 to 23 April 1843. "Q" is the smaller of the two, with a rapid drop-off of information leading into 1842 and 1843. Both are now in the Talbot Collection of the NMPFT.

54 These started at least by the age of eight when a Mr Scott was his Drawing Master. Mentioned in a letter, Henry Talbot to Lady Elisabeth, 24 August 1808. LA08–7, FTM.

55 Entry for 9 May 1808, *William Henry Fox Talbot's Journal*, 1806, 1807, 1808, 1809, 1810, 1811. FTM.

56 Butler was a source of considerable inspiration for the brilliant young Talbot. As a student himself, Butler made the top of the mathematics honors list at Cambridge. He encouraged enquiry in the physical sciences among his charges.

57 Letter, Henry Talbot to Lady Elisabeth, 17 May 1812. LA12–14, FTM.

58 From a copy of a presently-missing letter from May 1812, quoted from Arnold, *Talbot*, p. 34. It is possible that Lady Elisabeth put a stop to the dangerous experiments, for Henry wrote her that he was "very much obliged to you for interesting yourself about my Chemistry; if you have written to Dr Butler indeed, you have done the only thing in the world that you ought not to have done. I am extremely sorry that you did not consult me first; this has entirely destroyed all my further amusement while here ... can you imagine how disagreeable it must be, to have a master privy to one's secrets? Either he will not all me to amuse myself for fear of my making dangerous experiments; or he will be talking to me about it before other

boys who plague one to death about it." Letter, Henry Talbot to Lady Elisabeth, 24 May 1812. LA12–15, FTM.

59 For a gentleman amateur scientist, the influence of having such a country residence should not be underestimated. Such houses were designed to be self-sufficient and thus had on hand diverse supplies, an ample kitchen (often the source of chemical sundries), and well equipped workshops. In the days before dedicated laboratories, the simple availability of space – very generous space – was helpful. When a relative died, Sir David Brewster wrote Talbot that he was going to take up residence at Belleville in Inverness-shire, where he would have "an uninterrupted passage within the house ninety two feet long, with an East Window at one end and a West one at the other. This length of transit for the Solar Ray was almost necessary in using the five feet Achromatic telescope which I have got the use of from Sir Jas. South." Letter, Brewster to Talbot, 8 July 1833 (by postmark). NMPFT.

60 "I am afraid you forget the Dutch proverb that Paint costs nothing. Quantities of things here are going to decay for want of it. The Dutch live in a climate as damp as ours, which made them find it out." Letter, Lady Elisabeth to Talbot, 14 December 1837. LA37–60, FTM.

61 Letter, Henry Talbot to Captain Feilding, 30 January 1824. LA24–12, FTM. At this time (not later), Henry employed the archaic spelling of "Laycock," a tradition that his mother was to maintain throughout her life.

62 Letter, Talbot to Lady Elisabeth, 28 November 1835. LA(H) 35–8, FTM. Talbot also revealed that "of course I have no thoughts of letting it before the time we agreed upon, that is three years from the present time." This assurance would have been especially important to his mother, for Lady Elisabeth had come to think of Lacock as home. When Captain Feilding died in 1837, she wrote to Constance that "Laycock Abbey is now more than ever endeared to me, & whatever there may be painful mixed with my attachment to that place, I am sure will be softened by the knowledge that you participate in some degree in my feelings...." Letter, Lady Elisabeth to Constance, 6 October 1837. LA37–54, FTM.

63 One album of Lady Elisabeth's sketches has been traced in the Lacock Collection and wants further study; it appears likely some of the drawings were made using optical aids. Although his grammar was to improve, Henry Talbot noted his mother's artistical efforts when he was eight years old: "have you finished the Cherry you was painting yet?" Letter, Talbot to Lady Elisabeth, 24 August 1808. LA08–7, FTM.

64 Letter, Henry Talbot to Lady Elisabeth, 24 March 1826. LA26–14, FTM.

65 In his diary for 2 April 1828, Moore recorded: "Have induced Caroline Fielding [sic] to undertake some designs for a volume of Legends I am about to publish with Power. Those she has already done promise very well." Quoted from Lord John Russell, Memoirs, Journal, and Correspondence of Thomas Moore (London: Longman, Brown, Green and Longmans, 1854), v. 5. Moore's inscription to the volume is "To the Miss Feildings this volume is inscribed by their faithful friend & servant. Thomas Moore." He credits "To another fair amateur I am indebted for the Drawings which illustrate the Legends; and it is but right to add, they are the young artist's first attempts at original design. T.M." Each of the nine engravings is signed "C.A.F. del." Thomas Moore, Legendary Ballads, Arranged with Symphonies and Accompaniments by Henry R. Bishop (London: J. Power, 1828). One of the ballads is "The Magic Mirror." It is a less elaborate variation of the story told in Henry Talbot's subsequent Legendary Tales, in Verse and Prose, Collected by H. Fox Talbot (London: James Ridgway, 1830). Writing from Florence in 1822, Horatia gleefully reported to their mother that "Caroline now draws landscapes from nature with M. Gherardi." Letter, Horatia Feilding to Lady Elisabeth, 1 July 1822. LA22–39, FTM.

66 Letter, Herschel to Babbage, from Entraigues, 25 September 1826. HS2:204, RSL. Indeed, in an 1866 essay, Sir John Herschel could claim that "though I have never been so fortunate as to have seen a volcano in eruption, or to have been shaken out of my bed by an earthquake, still I have climbed the cones of Vesuvius and Etna, hammer in hand and barometer on back, and have wandered over and geologized among ... nearly all the principal scenes of extinct volcanic activity in Europe." Herschel, Familiar Lectures on Scientific Subjects (London: Alexander Strahan, 1866), p. 1.

67 Letter, Herschel to Babbage, 12 February 1828. HS2:219, RSL. Reviewing Baron von Humboldt's Kosmos two decades later, Herschel (himself almost universally respected) emphasized the value he placed on harmony in human relations. To scientific attainments "must be added a knowledge of man and of his history in all its phases, social and political; a ready insight into human character and feelings, and a quick apprehension of local and national peculiarities. Above all things is necessary a genial and kindly temperament, which excites no enmities, but on the contrary finds or makes friends every where; in presence of which hearts open, information is volunteered, and aid spontaneously offered. No man in the ranks of science is more distinguished for this last characteristic than Baron Von Humboldt. We believe that he has not an enemy. His justice, candour, and moderation, have preserved him intact in all the vexatious questions of priority and precedence which agitate and harass the scientific world; and have in consequence afforded him innumerable opportunities of promoting the objects and befriending the cultivators of science, which would never have fallen in the way of a less conciliatory disposition, and of which he has not been slow to avail himself." Herschel, review of "Cosmos, Sketch of a Physical Description of the Universe. By Alexander von Humboldt, Vol. I. Translated under the superintendence of Lieut. Colonel Edward Sabine ...," The Edinburgh Review, v. 87 n. 175, January 1848, p. 173.

68 In 1861, Herschel compiled a list of all his publications to date. It was published as "A Complete Catalogue of the Writings of Sir John Herschel," The Mathematical Monthly, v. 3 n. 7, April 1861, pp. 220–7. This listing is currently being refined by Professor Michael Crowe of the University of Notre Dame, Indiana.

69 N.S. Dodge, "Memoir of Sir John Frederick William Herschel," Annual Report of The Board of Regents of the Smithsonian Institution ... for the Year 1871 (Washington: Government Printing Office, 1873), pp. 125–6.

70 Richard A. Proctor, Essays on Astronomy (London: Longmans, Green, and Co., 1872), p. 1. Herschel had little tolerance for poor writing. About his friend, Charles Babbage, Herschel complained that "he has just sent me a copy of his second paper in the Phil. Transactions, which is abstract enough to choke any reasonable man and to turn the brains of any analytical one who has contrived to escape madness hitherto." Letter, Herschel to Rev. Henry Wilkinson, 14 August 1816. Library, St John's College, Cambridge.

71 J.F.W. Herschel, "Light," dated 12 December 1827. Encyclopaedia Metropolitana, v. 2, 1830, pp. 341–582.

72 Herschel, recognizing that much was unsettled, drew on both the wave and particle theories and argued some points from the base of each. This attempt at balance during a time of great volatility in the field has led one scholar to charge that "Herschel's remarks are therefore incoherent: they cannot be consistently interpreted in either theory's vocabulary." Jed Z. Buchwald, The Rise of the Wave Theory of Light, Optical Theory and Experiment in the Early Nineteenth Century (Chicago: The University of Chicago Press, 1989), p. 295.

73 Herschel diary, 22 September 1828. W0010, HRHRC.

74 Herschel, Travel Journal XI: 1829–36. W0063, HRHRC.

75 Letter, Herschel to his mother, from Baden-Baden, 2 July 1829. L0521, HRHRC.

76 Letter, Herschel to his mother, 15 June 1829. L0521, HRHRC.

77 Letter, Maria Edgeworth to Harriet Butler, 3 December 1843. Transcribed in Colvin, Maria Edgeworth, p. 597.

78 For example, when Herschel detected ultraviolet rays recorded on a photographic paper based on a tincture of turmeric on 27 May 1841, he recorded in his research notebook that "MBH viewed it – saw it as described but she also perceived on the white paper the spectrum prolonged beyond the violet by a whitish gleam. This I could no how succeed in seeing." Experiment no. 1193, The Science Museum Library, London. An excellent self-portrait of Margaret is brought out in Brian Warner's editing of Lady Herschel; Letters from the Cape, 1834–1838 (Cape Town: Friends of the South African Library, 1991).

79 Copy of a letter, John Herschel to Margaret, 23 July 1830. L0537, HRHRC. Taken from Cicero's de Officiis, Herschel translated it as: "Before all other things, man is distinguished by his pursuit and investigation of TRUTH. And hence, when free from needful business and cares, we delight to see, to

hear, and to communicate, and consider a knowledge of many admirable and abstruse things necessary to the good conduct and happiness of our lives: whence it is clear that whatsoever is TRUE, simple, and direct, the same is most congenial to our nature as men. Closely allied with this earnest longing to see and know the truth, is a kind of dignified and princely sentiment which forbids a mind, naturally well constituted, to submit its faculties to any but those who announce it in precept or in doctrine, or to yield obedience to any orders but such as are at once just, lawful, and founded on utility. From this source spring greatness of mind and contempt of worldly advantages and troubles."

80 Letter, Darwin to Herschel, 11 November 1859. HRHRC.

81 Herschel, *Preliminary Discourse*, p. 219.

82 Herschel, *Preliminary Discourse*, p. 19.

83 Herschel, *Preliminary Discourse*, p. 22.

84 Herschel, *Preliminary Discourse*, pp. 104–5.

85 Herschel, *Preliminary Discourse*, pp. 133–4.

86 Herschel, *Preliminary Discourse*, pp. 14–16.

87 Augustus Frederick, the Duke of Sussex, "Presidential Address for 1833," *Philosophical Transactions Abstracts*, v. 3, 1830–1837.

88 Talbot, "Some Experiments on Coloured Flames." *Edinburgh Journal of Science*, v. 5 n. 1, March 1826, pp. 77–81. Herschel had encouraged Talbot: "I am very sure that an account of your interesting Expᵗ on the glass films will be accepted to Dʳ Brewster and I shall be happy to transmit it to him according to your wish." Letter, Herschel to Talbot, 12 January 1826. LA26–1, FTM.

89 Letter, Talbot to Herschel, 27 February 1826. HS17:259, RSL.

90 Letter, Herschel to Talbot, undated. NMPFT.

91 Talbot, *Legendary Tales, in Verse and Prose, Collected by H. Fox Talbot* (London: James Ridgway, 1830).

92 Herschel wrote to Talbot on 28 December 1830: "Nothing would be more agreeable to me than to sign your recommendation as an F.R.S., but that, at present I wish to avoid doing any thing that may appear to pledge one to the existing order of things in that institution, and have indeed for some time past and in repeated instances declined exercising the privilege of a member in that respect." Copy of a letter, Herschel to Talbot. HS25.1.15, RSL.

93 Letter, Talbot to Hooker, 27 February 1833. Royal Botanic Gardens, Kew.

94 Henry's cousin, Harriet Georgiana Frampton, had married into the Mundy family two years previously.

95 Letter, Constance Talbot to Henry Talbot, 7 September 1835. LA35–26, FTM.

96 Constance seems to have taken only a passing interest in the art until her husband was thrust into the limelight in 1839. At first, she was restrained by recent childbirth. In 1839, there were a very few references to her attempts at photography. An unusually detailed one in May made it clear that the start of her active involvement was recent: "I have been labouring hard at the Photographs without much success – for though some of the Pictures were pretty good I spoilt them afterwards with the Iodine. I ought to have begun my study of the Art while you were at hand to assist me in my difficulties. As it is however I shall have gained experience by my unsuccessful attempts, & therefore ought not wholly wasted my time & strength." Letter, Constance to Henry Talbot, 21 May 1839. LA39–39, FTM.

97 Letter, Talbot to Herschel, undated, probably 4 January 1826. Talbot started his letter with the statement that "there is one circumstance presented by the glass films which we examined yesterday, which still needs explanation. . . ." It is likely that this is the session mentioned in Herschel's diary for 3 January 1826. HS17:324, RSL.

98 An important reference work on Brewster is *'Martyr of Science': Sir David Brewster 1781–1868*, edited by A.D. Morrison-Low and J.R.R. Christie (Edinburgh: Royal Scottish Museum, 1984). His relationship to the emerging art of photography is explored in Graham Smith, *Disciples of Light; Photographs in the Brewster Album* (Malibu, California: The J. Paul Getty Museum, 1990).

99 Letter, Constance Talbot to Lady Elisabeth, dated "Monday" (15 August 1836). LA36–58, FTM. Brewster was equally pleased with the visit. A few hours after arriving at Lacock on 15 August, he wrote his wife that "this place is a paradise – a fine old abbey, with the square of cloisters entire, fitted up as a residence, and its walls covered with ivy, and ornamented with the finest evergreens." Mrs Gordon, *The Home Life of Sir David Brewster* (Edinburgh: Edmonston and Douglas, 1869), pp. 161–2.

100 Talbot became more careful of this after publishing two "Proposed Philosophical Experiments." One, a proposal for measuring the velocity of electricity, was promptly countered by Charles Wheatstone. Talbot had referred to Wheatstone's demonstrations at the Royal Institution. Wheatstone was perfecting these before publication, "but I regret that this delay should have occasioned my experiments to be so far misunderstood, that one of the earliest which suggested itself to me, and which I have always considered to be of primary importance in the series, should be proposed elsewhere, several months afterwards, as an experiment yet to be tried, and be represented also as having entirely escaped my attention." Talbot's other suggestion was for a means of ascertaining the depth of the ocean; a writer soon pointed out several major flaws in Talbot's thinking. Talbot had ended his first two proposals with "to be continued," but it is understandable that after this criticism the series was ended. *Philosophical Magazine*, 3ʳᵈ ser., v. 3 n. 14, August 1833, pp. 81–2; n. 15, September 1833, pp. 204–5; n. 17, November 1833, pp. 352–3.

101 This statement ignores the fact that much of Talbot's creative and original work was in mathematics. Nearly a third of his published papers (including the majority of his papers at the beginning and at the end of his career) dealt with mathematical questions.

102 Talbot, "Experiments on Light." *Philosophical Magazine*, 3ʳᵈ ser., v. 5 n. 29, November 1834, pp. 321–34.

103 Talbot, "Note on the Early History of Spectrum Analysis." *Proceedings of the Royal Society of Edinburgh*, v. 7 n. 82, 15 May 1871, pp. 462–3.

104 Talbot, "Some Experiments . . . ," pp. 77–82.

105 Letter, Talbot to Hooker, 8 March 1838. Royal Botanic Gardens, Kew.

106 See Talbot's letter to Sir William Hooker, 1 May 1838. Royal Botanic Gardens, Kew.

107 Letter, Talbot to Hooker, 18 May 1838. Royal Botanic Gardens, Kew.

108 Herschel withdrew the paper because he felt (wrongly, as it turned out) that he was on the verge of a breakthrough that would render obsolete its information. The manuscript was never destroyed. See Schaaf, "Sir John Herschel's 1839 Royal Society Paper on Photography," *History of Photography*, v. 3 n. 1, January 1979, pp. 47–60.

109 Letter to Sir William Herschel, 16 September 1908. NMPFT.

110 See H. Gernsheim's "Talbot's and Herschel's Photographic Experiments in 1839," *Image*, v. 8 n. 3, September 1959, pp. 133–7. This is repeated in (and widely quoted from) H. and A. Gernsheim's *History of Photography* (New York: McGraw-Hill, 1969).

111 Synthesized from transcripts of related broadcasts made on 8 May 1944 and 15 February 1950, supplemented by an undated wire recording made off the air sometime in 1950. FTM and Private Collection. A similar accounting is given in Matilda Talbot's *My Life and Lacock Abbey* (London: George Allen and Unwin Ltd., 1956), p. 18. Talbot's son, Charles Henry, remembered his father as "a man of a very kind and affectionate disposition, his affection for his mother having evidently been very great. He was also extremely sensitive. In his religious opinions he departed considerably from the doctrines in which he had been educated . . . in religious belief his tendency was conservative not subversive. . . ." From a manuscript reminiscence, dated 13 November 1879. FTM.

CHAPTER TWO

1 "Fixation des images qui se forment au foyer d'une chambre obscure," *Compte Rendu*, v. 8 n. 1, 7 January 1839, pp. 4–7. Daguerre has purposely been moved to the periphery in the present essay. The best assessment of his efforts remains Helmut and Alison Gernsheim's *L.J.M. Daguerre, The History of the Diorama and the Daguerreotype* (London: Secker & Warburg, 1956).

2 Talbot's dilemma is reviewed in Schaaf, "L'Amour de la Lumière: Herschel, Talbot, et la Photographie," *Les Multiples Inventions de la Photographie* (Paris: Association Française Pour la Diffusion du Patrimoine Photographique, 1989), pp. 115–24.

3 In his introduction to *The Pencil of Nature* (London: Longman, Brown, Green and Longmans, 1844).

4 This paper was published only in the abstract; for the full text, transcribed from Herschel's previously unpublished manuscript, see Schaaf, "Sir John Herschel's 1839 Royal Society Paper on Photography," *History of Photography*, v. 3 n. 1, January 1979, pp. 47–60.

5 See John H. Hammond, *The Camera Obscura, A Chronicle* (Bristol, England: Adam Hilger Ltd., 1981).

6 The situation is summarized in Schaaf, "The First Fifty Years of British Photography: 1794–1844," *Technology and Art, The Birth and Early Years of Photography*, edited by Michael Pritchard (Bath: The Royal Photographic Society, 1990), pp. 9–18. Skeletal outlines of the chemical and optical platforms for photography are well covered in the standard photographic histories. The technical background of photographic history, particularly for continental developments, is treated most fully in Josef Maria Eder (translated by Edward Epstein), *History of Photography* (New York: Columbia University Press, 1945). The standard comprehensive history is by Helmut Gernsheim, in collaboration with Alison Gernsheim, *The History of Photography* (New York: McGraw-Hill Book Company, 1969). Another perspective is Beaumont Newhall's *The History of Photography, from 1839 to the Present*, completely revised and enlarged edition (New York: The Museum of Modern Art, 1982). A more recent summary work is Naomi Rosenblum's *A World History of Photography* (New York: Abbeville Press, 1984). Especially valuable in assessing the chemical knowledge and advances of the period is J.R. Partington, *A History of Chemistry* (London: MacMillan & Co., 1964), particularly volumes 3 and 4. Two venerable works that place photography in the context of art are Aaron Scharf, *Art and Photography* (London: Allen Lane, The Penguin Press, 1968), and Van Deren Coke, *The Painter and the Photograph from Delacroix to Warhol* (Albuquerque: University of New Mexico Press, 1964). A recent examination of the broader influence of optical drawing instruments on artists is undertaken by Martin Kemp in *The Science of Art, Optical Themes in Western Art from Brunelleschi to Seurat* (New Haven and London: Yale University Press, 1990). The catalyst that brought the camera and the chemistry together to make photography – the need for images – is considered in: Peter Galassi, *Before Photography; Painting and the Invention of Photography* (New York: The Museum of Modern Art, 1981); Estelle Jussim, *Visual Communication and the Graphic Arts* (New York: R.R. Bowker Company, 1974); Richard Rudisill, *Mirror Image; The Influence of the Daguerreotype on American Society* (Albuquerque: University of New Mexico Press, 1971).

7 Fulhame, *An Essay on Combustion, with a view to a New Art of Dying and Painting, wherein the Phlogistic and Antiphlogistic Hypotheses are Proved Erroneous* (London: printed for the author, 1794). It was republished in Germany in 1798 and in America in 1810.

8 Elizabeth Fulhame's full name is revealed only in the Stationer's Hall registry of this, her only book. The spelling of her surname is unusual. Much of what is known about the person of Mrs. Fulhame was revealed in T.S. Wheeler and J.R. Partington, *The Life and Work of William Higgins, Chemist* (Oxford: Pergamon Press, 1960), n. 139, p. 121. An excellent summary of her work (sadly lacking in biographical detail) is by Derek A. Davenport and Kathleen M. Ireland, "The Ingenious, Lively and Celebrated Mrs. Fulhame and the Dyer's Hand," *Bulletin for the History of Chemistry*, n. 5, Winter 1989, pp. 37–41.

9 Rumford, "An Inquiry concerning the chemical Properties that have been attributed to Light," *Philosophical Transactions*, v. 88, 1798, p. 458.

10 As a physician, Dr Fulhame had observed the severe health hazards consequent on the normal means of production and had perfected a process that he claimed was not only less poisonous, but also more economical. Two letters from him to Lord Hawkesbury bear on this. On 10 June 1795, he said of his process that he "would rather bestow it on the nation, as were it established, my object, by which my profession as a physician led me, and which was to discover a wholesome and cheap process for making white lead would in some measure be obtained." The marginalia on this letter, and on a subsequent one, implies a number of meetings. Finally he wrote in desperation on 23 June 1795 that "as I have expended almost all my money in attempts to introduce this process, I entreat your Lordship to let me know if my proposal be acceptable, as should it be rejected, it will not be in my power to remain here many days longer." Add MS 38320 ff. 175, 185; The British Library.

11 Letter to Mr Pelham, Board of Trade, 7 July 1802. "My white lead has been examined by a Committee of the Institute at the head of which were Fourcroy, Bougaelin, Guyton, and an eminent painter." Add MS 33109, f278, The British Library.

12 Reviews and summaries include: *Gentleman's Magazine*, v. 65, June 1795, p. 501 ("An essay on *combustion*, by a *lady!*"); E. Peart, *On the Combustion and Properties of Water* (London, 1796); *The Monthly Review*, s. 2, v. 20, July 1796, pp. 301–4; Edward Bancroft, *Experimental Researches Concerning the Philosophy of Permanent Colours* (London, 1813); W.M. Toulmin, *Rational Amusement, Being a series of Curious and Instructive Experiments in Chemistry* (Calcutta, 1822).

13 "Observations on Mrs. Fulhame's Experiments on Gold and Silver Stuffs, and on the Theory of Combustion," *Ackermann's Repository*, v. 11, January 1811, pp. 10–13. In 1841, after the public announcement of photography, a dyer at Lyons reported that for years he had employed a process that sounded suspiciously like hers. See M. Lafouraille, "Photogenic Dyeing," *Magazine of Science*, v. 2 n. 93, 9 January 1841, p. 324.

14 Davy makes no mention of this in his *Syllabus* of the regular lectures and the structure of these makes it an unlikely fit. More likely he incorporated Wedgwood's work into his evening course on the "Chemistry of the Arts;" the introductory lecture of this series was given on 9 February 1802. Wedgwood's process was published in "An Account of a method of copying Paintings upon Glass, and of making Profiles, by the agency of Light upon Nitrate of Silver. Invented by T. Wedgwood, Esq. With Observations by H. Davy," *Journals of the Royal Institution*, v. 1 n. 9, 22 June 1802, pp. 170–4.

15 Some indication of Wedgwood's range, given in his own words, is in Margaret Olivia Tremayne, *The Value of a Maimed Life, Extracts from the Manuscript Notes of Thomas Wedgwood* (London: C.W. Daniels, 1912). A richly anecdotal source on the context of Wedgwood's family is by Barbara and Hensleigh Wedgwood, *The Wedgwood Circle 1730–1897* (London: Studio Vista, 1980).

16 Dr Darwin was the grandfather of Charles Darwin. Later, Thomas Wedgwood's sister, Susannah, would marry Dr Erasmus Darwin's son, Robert, and become the mother of Charles Darwin.

17 See Robert E. Schofield, *The Lunar Society of Birmingham* (Oxford: Clarendon Press, 1963).

18 Letter, Priestley to Wedgwood, 26 February 1792. MM5.31, RSL.

19 "Of Davy, it has been said that "he was born a poet and became a chemist by accident." George Peacock, *Life of Thomas Young, M.D., F.R.S, &c.* (London: John Murray, 1855), p. 470.

20 Letter, Thomas Campbell to Dr James Currie, 17 July 1803. Campbell added, however, that Wedgwood "is not happy. I thought till I saw him, that happiness was to be defeated by no other circumstances than weakness – vice – or an uncommanded temper." William Beattie, *Life and Letters of Thomas Campbell* (London: Edward Moxon, 1849), v. 1, pp. 461–4.

21 Coleridge, *The Friend*, new edition, v. 1 (London: printed for Rest Fenner, 1818), p. 249. Many unexplored references to Wedgwood will be found in Coleridge's notebooks.

22 Written in September 1806 to Josiah Wedgwood, recalling a meeting with Thomas four years earlier. R. B. Litchfield, *Tom Wedgwood; The First Photographer* (London: Duckworth and Co., 1903), p. 127.

23 Josiah Wedgwood wrote to Thomas Poole on 31 March 1801 that "Tom is with us here in rather a better state of health than before his journey to London, but not well enough to pursue his own speculations, or to attend to those of others." Add Mss 35045 f189, The British Library.

24 A relative unknown, Underwood merits further study. A brief contemporaneous account paints a colorful and engaging picture of a man of science and art, salted with a bit of flair. Abraham Raimbach was with Underwood in Paris in 1802 (but himself escaped before the arrests started). As he recalled in his memoirs: "Thomas Richard Underwood, draughtsman to the Antiquarian Society, and a clever painter in water-colours. He had a good deal of scientific acquirement, was a tolerable chemist and geologist, and, having an independence, pursued nothing as a profession. He married when very young a Miss Stageldoir, a dancer at Drury Lane Theatre, from

whom he soon separated. He died at Auteuil, near Paris, in 1836, and was stated to have offered, in his last illness, to submit to a most severe surgical operation, if there had been a reasonable probability of his life being lengthened a few weeks, that he might have an opportunity of witnessing the return of Halley's comet" (note, p. 73). Raimbach also observed that "Underwood became habituated to the French mode of living, and made only an occasional short visit to England" (pp. 74–5). *Memoirs and Recollections of the late Abraham Raimbach, esq., Engraver*, edited by Michael Thompson Scott Raimbach (London: Frederick Shoberl, Junior, 1843). If Underwood had had further thoughts on Wedgwood's approach, evidence for this might be found in French rather than English sources. J. Britton edited a volume of Underwood's memoirs: *A Narrative of Memorable Events in Paris ... in the Year 1814, being extracts from The Journal of a Détenu* (London: printed for the editor, 1828). Britton, in introducing Underwood's text, praised "the laudable and insatiable avidity with which that friend sought information on every subject of art, science, literature, and the political state of nations...." Prior to his travels with Wedgwood, Underwood had links with a number of artists in London, some of whom were subsequently interested in optical aids to drawing. See Dr Guillemard, "Girtin's Sketching Club," *Connoisseur*, v. 63 n. 252, August 1922, pp. 189–95; A.P.C., "Richard Thomas Underwood," *Connoisseur*, v. 64 n. 255, November 1922, pp. 154–7; A.P. Oppé, "Cotman and the Sketching Society," *Connoisseur*, v. 67 n. 268, December 1923, pp. 189–98.

25 Historians have maintained that the *Journals of the Royal Institution* had "only a very limited circulation" and "but a short life, and was not widely circulated," implying that Wedgwood's idea pre-deceased him there. See Gernsheim's *History*, p. 42 and Beaumont Newhall's *On Photography: A Source Book of Photo History in Facsimile* (Watkins Glen, New York: Century House, 1956), p. 13. But while it is true that the first issue was small, the journal was popular and was reprinted. How many copies or editions were made is not known. It appears that the first was published contemporaneously, printed by W. Bulmer and Co., Cleveland Row. Another, dated 1802 for the first volume, was "From the Press of the Royal Institution of Great Britain, W. Savage, Printer." There were ample opportunities for an experimenter to encounter Wedgwood's work elsewhere (this listing should be taken as indicative of the widespread publication of Wedgwood's attempts and is bound to be incomplete): *Annali di Chimica e Storia Naturale*, v. 21, 1802, pp. 212–18; *Annals of Philosophy*, v. 3, 1802, p. 151; *Nicholson's Journal*, v. 3, November 1802, pp. 165–70; *Bibliotheque Britanique* (Geneva, January 1803) v. 22, pp. 93–8; *Bulletin Des Sciences par la Société Philomathique*, v. 3 n. 69, 1803, p. 167; *Annales de Chimie*, v. 45, 1803, p. 256; *Annalen des Physik*, v. 13, 1803, pp. 113–19; Fredrick Accum, *A System of Theoretical and Practical Chemistry* (London, 1803, v. 1 pp. 122–4 and Philadelphia, 1814, v. 1 pp. 159–61); John Imison, *Elements of Science and Art* (London, 1803, v. 2), pp. 606–9 and new edition, 1822, pp. 328–9; *Journal für die Chemie, Physik, und Mineralogie*, v. 4, 1807; Benjamin Silliman, *Epitome of Experimental Chemistry* (Boston, 1810), p. 196; *Ackermann's Repository*, v. 2, October 1816, pp. 203–4); Hewson Clarke and John Dougall, *The Cabinet of Arts, or General Instructor* (London: T. Kinnersley, 1817), pp. 774–5; *Magazin for Naturvidenskaberne* (Christiania, Norway, 1824), pp. 23–8; John Webster *Manual of Chemistry* (Boston, 2nd ed., 1828), p. 432.

26 "Singular Method of Copying Pictures, and Other Objects, by the Chemical Action of Light," *Ackermann's Repository*, v. 2 n. 10, 1 October 1816, pp. 203–4.

27 Cited in earlier accounts, the original letter disappeared until it was rediscovered in 1965 by Dr D.B. Thomas; it is now in the Science Museum Library, London. See Arthur Gill, "James Watt and the Supposed Early Photographs," *The Photographic Journal*, v. 105, May 1965, pp. 162–3.

28 Carlisle's letter was written on 30 January, just days after he had seen the first photographs that Talbot exhibited to the public. "On the Production of Representations of Objects by the Action of Light," *Mechanics Magazine*, v. 30 n. 809, 9 February 1839, p. 329.

29 Samuel Highley, in proposing a national photographic library and museum in 1885, argued that "many specimens very illustrative will presently be swept away as rubbish." As an example, he claimed that "only last night I was looking at specimens of some of Wedgwood's experiments with

chloride of silver." Highley, "Needed, A Photographic Library and Museum," *The Photographic News*, v. 29 n. 1415, 16 October 1885, pp. 668–9. These fragile images remained visible nearly a century after they were produced!

30 Wedgwood, *An Account*, p. 174.

31 Wedgwood, *An Account*, p. 174. Some insight into Davy's character that bears on this question was given by Charles Babbage: "ambition constituted a far larger ingredient in the character of Davy, and with the daring hand of genius he grasped even the remotest conclusions to which a theory led him. He seemed to think invention a more common attribute than it really is, and hastened, as soon as he was in possession of a new fact on a new principle, to communicate it to the world, doubtful perhaps lest he might not be anticipated; but, confident in his own powers, he was content to give to others a chance of reaping some part of that harvest...." Charles Babbage, *Sketch of the Philosophical Characters of Dr. Wollaston and Sir Humphry Davy* (London: printed by R. Clay, 1830), p. 4.

32 Henry, Lord Brougham, *Lives of Philosophers of the Time of George III* (London: Charles Griffin and Company, 1866), p. 121.

33 The original terms of *hyposulphurous* or *sodium hyposulphite* are the source of our *hypo* today. Once the chemical character of this compound was more firmly established later in the 19th century, the proper term became *sodium thiosulphate*.

34 J.F.W. Herschel, "On the Hyposulphurous Acid and its Compounds" (communicated 8 January 1819), *The Edinburgh Philosophical Journal*, v. 1 n. 1, June 1819, pp. 8–29; "Additional Facts relative to the Hyposulphurous Acid" (communicated 15 May 1819), v. 1 n. 2, October 1819, pp. 396–400; "Some additional facts relating to the habitudes of the Hyposulphurous Acid, and its union with Metallic Oxides," (communicated November 1819), v. 2 n. 3, January 1820, pp. 154–6.

35 Hypo was first identified (but no more) by François Chaussier, "Sur un nouveau genre de combinaison du soufre avec les alkalis," *Bulletin des Sciences par la Société Philomathique*, v. 2 n. 9, 1799, pp. 70–1. In a companion article, Louis Nicolas Vauquelin contributed a "Notice sur le Sel nommé Hydrosufure sulfuré de Soude," p. 71.

36 Responding to a later challenge to his priority, Herschel pointed out that he "was the first to call the attention of chemists to that class of salts and their peculiar habitudes especially in relation to the insoluble salts of silver.... The very remarkable facts above described I have reason to believe attracted a good deal of attention at the time – & thereafterward the ready solubility of silver salts usually regarded as insoluble by the hyposulphites, was familiar to every Chemist...." This reply was prompted by a letter from Alfred Brothers to Herschel, dated 27 October 1864, saying that he was preparing a lecture on photography and had found a reference to Daguerre first using hypo. HS4:296, RSL. Herschel replied on 29 October 1864, defending his own priority. Herschel's reply is in the Brothers Collection at the Manchester Central Library. It was published in Brothers' "Note on the First Use of Hyposulphite of Soda in Photography," read at a meeting of the Photographic Section of the Literary and Philosophical Society of Manchester, 12 April 1866, *The British Journal of Photography*, v. 13 n. 315, 18 May 1866, p. 236. This wasn't the end of Herschel's troubles. Two years later, John Spiller claimed to have uncovered the first use of hyposulphite of ammonia in an 1825 book by Colin Mackenzie. Spiller, "Correspondence. Hyposulphite of Ammonia for Fixing," *The Photographic News*, v. 12 n. 499, 24 January 1868, p. 46. Herschel rebutted this in a letter of 25 January 1868: "In reference to the communication from Mr. Spiller in the last number (No. 499) of the Photographic News, on "Hyposulphite of Ammonia for Fixing," allow me to observe that the *whole* account of the experiment cited from 'Colin Mackenzie's Treatise' ... on the action of hyposulphite of ammonia on muriate of silver, is *copied verbatim* from my second paper on the hyposulphites in Brewster and Jameson's *Edinburgh Philosophical Journal* (1819), p. 396. "Correspondence. Hyposulphite of Ammonia," *The Photographic News*, v. 12 n. 506, 31 January 1868, pp. 57–8.

37 Wedgwood, "An Account ...," p. 174.

38 Manuscript in the Talbot Collection, NMPFT.

39 Herschel, "On the Hyposulphurous," p. 10.

40 Herschel, "On the Hyposulphurous," p. 11.

41 Herschel, "On the Hyposulphurous," p. 19.

42 J.F.W. Herschel, *Diary*, 1819. W0001, HRHRC.

43 Letter, Herschel to Babbage, 14 July 1816. HS2:64, RSL.

44 Two of Herschel's drawings (one in the Graham Nash Collection and one in the J. Paul Getty Museum), done at Dawlish during this visit, indicate the use of optical aids. One is likely a transfer employing a camera obscura. *No. 594, A Cave in the Cliff on the Beach, Dawlish, Devon*, exhibits unmistakable signs of having been made with a camera lucida.

45 Generally, these are dated, titled, and signed by Herschel and his use of the camera lucida is identified. Many of these drawings carry extensive annotations by him. Some notes were visual reminders, indicating colors or directions of light. Some were scientific (particularly geological) notations. In many drawings, the position of the prism of the camera lucida is recorded by a grid system: this permits re-creating the exact point of perspective. In 1861, nearing the age of seventy, Herschel collated more than 600 of his drawings done throughout his lifetime, inventoried in a manuscript notebook, *General list of all my drawings and sketches*. MW0019, HRHRC. Nearly half of these are in the Graham Nash Collection. Recently, the majority of this group was donated to the J. Paul Getty Museum. Some remain with the family, a group was given to the South African Library, and a few are scattered. See Schaaf, *Tracings of Light: Sir John Herschel & the Camera Lucida* (San Francisco: The Friends of Photography, 1989).

46 Wollaston observed the extra image formed at the line of the crack. John Ayton Paris, *The Life of Sir Humphry Davy* (London: Henry Colburn and Richard Bentley, 1831), v. 1, p. 148 *note*.

47 As a refinement, Wollaston added a small aperture: "in order to avoid inconvenience that might arise from unintentional motion of the eye, the relative quantities of light to be received from the object and from the paper are regulated by a small hole in a piece of brass...." Wollaston, "Description of the Camera Lucida," *Philosophical Magazine*, v. 27 n. 108, May 1807, p. 345. This pivoting paddle was not absolutely essential; Captain Basil Hall, the foremost advocate of camera lucida work, was deadset against it: "It will be found better in many respects, and far less fatiguing, always to keep both eyes wide open when this instrument is used; and I think the little black piece of metal, containing what is called the eye-hole, should be entirely discarded. This part of the apparatus is detrimental to an agreeable or proper use of the Camera, and is only useful in explaining the principle by which the position of the eye is regulated." Hall, *Travels in North America, in the Years 1827 and 1828* (Edinburgh: printed for Robert Cadell, 1830) 3rd edition, v. 3, *Appendix on the Use of the Camera Lucida*, p. 3.

48 Rev Henry Hasted, "Reminiscences of Dr. Wollaston," *Proceedings of the Bury & West Suffolk Archaeological Institute*, v. 1 n. 4 March 1850 (read 20 December 1849), p. 126. In Wollaston's "Description of the Camera Lucida," he explained that after attempting "to sketch various interesting views without an adequate knowledge of the art of drawing, my mind was naturally employed in facilitating the means of transferring to paper the apparent relative positions of the objects before me; and I am in hopes that the instrument which I contrived for this purpose may be acceptable even to those who have attained to a greater proficiency in the art, on account of the many advantages it possesses over the common camera obscura." *Philosophical Magazine*, v. 27 n. 108, May 1807, p. 347.

49 When Wollaston took out a patent for his invention in 1806, the nameless device had only the ungainly title of "An Instrument Whereby Any Person May Draw in Perspective, or May Copy or Reduce any Print or Drawing." Patent No. 2993, 4 December 1806, *The Repertory of Arts, Manufactures, and Agriculture*, 2nd series, v. 10 n. 57, February 1807, pp. 161–4. Somewhere in the six months before publicly unveiling his invention, Wollaston adopted the name camera lucida, but never explained the origin of the term. 'Camera lucida' is really quite appropriately descriptive; the most obvious explanation of the term's origin is that Wollaston contrasted his device with the dark workings of the camera obscura. Certainly, the term camera lucida was not an "inept choice" on his part, as is claimed in John H. Hammond and Jill Austin, *The Camera Lucida in Art and Science* (Bristol: Adam Hilger, 1987), p. 15. If not a contrast to the camera obscura, perhaps, since Wollaston was an astronomer, the profile of the camera reminded him of the Lion's Tail, which was called 'Lucida' in ancient times. It is also possible that Wollaston referred back to an unrelated 1668 invention by Robert Hooke, which had become known in dictionaries as a *camera lucida*. Ironically, Hooke called his invention simply a 'Light Room,' only to have an 18th century lexicographer translate this into Latin! Hooke, "A Contrivance to make the Picture of any thing appear on a Wall, Cup-board, or within a Picture-frame, &c. in the midst of a Light room in the Day-time ...," *Philosophical Transactions*, v. 3 n. 38, 17 August 1668, pp. 741–3. Hooke's 'Light room' (a device for optical illusion and entertainment) was first translated into the Latin *camera lucida* by George Lewis Scott in his *Supplement to Mr. Chamber's Cyclopaedia; or, Universal Dictionary of Arts and Sciences* (London: printed for W. Innys and J. Richardson, 1753), v. 1. Scott (1708–80), a Fellow of the Royal Society who introduced many scientific terms into the publication, was not overly pedantic; perhaps he merely felt Hooke's invention would be better placed in alphabetic proximity to the camera obscura. Many historians have blindly followed the dictionary definitions without reference to Hooke's original publication, therefore confusing Wollaston's and Hooke's inventions, which were completely dissimilar. One author has chosen to attribute the concept to Johann Kepler in 1611, but this claim is without foundation. Heinrich Schwarz, "Vermeer and the Camera Obscura," *Pantheon*, v. 24, 1966, p. 170. This claim is thoroughly refuted in Hammond & Austin, *Camera Lucida*, pp. 16–17.

50 The eye had to be situated right above the prism; consequently, the image of nature in the prism was always the same size. The stem supporting the prism was telescoping and the prism could be brought closer or farther away from the drawing board (a typical distance was about ten inches). If the tube were extended, the board was forced farther away and thus appeared smaller in relation to the fixed size of nature in the prism. Nature was then relatively larger, giving a telephoto effect. If the prism were brought in closer, a larger vista was fit into the confines of the drawing paper. Many cameras had markings on the tube to variously indicate optimum distances for copying, portraits, and landscapes. Wollaston claimed an angle of view of 70° to 80° was possible, but in practice incorporating this much involved constant shifting of the eye and was consequently very difficult. Some artists solved this problem by mounting their drawing table on a pivot and making successive sketches to build up a panorama. On 19 May 1837, Herschel recorded "Drawing & carpentering up the Panorama board wh seems likely to answer" (his panoramic camera lucida drawings are now held in the Cape Town Library). A "Plan of a concave table for taking accurate drawings with the Camera Lucida," devised by Joseph Bonomi, is shown in Catherine Delano Major's "Illustrating, B.C. (Before Cameras)," *Archaeology*, v. 24 n. 1, January 1971, pp. 44–51. The technical information given in this article, however, is not to be relied upon.

51 Quoted in Sir William Gell, *Reminiscences of Sir Walter Scott's Residence in Italy*, 1832. Edited by James C. Corson (London: Thomas Nelson and Sons, 1957), p. xiv. Because the words 'camera lucida' appear in the title, one of Hall's books frequently turns up in bibliographic surveys: *Forty Etchings, from Sketches Made with the Camera Lucida, in North America, in 1827 and 1828* (Edinburgh: Cadell & Co, 1829). Another important source is the *Appendix on the Use of the Camera Lucida* bound at the back of volume three of the third edition of Hall's *Travels in North America, in the Years 1827 and 1828* (Edinburgh: printed for Robert Cadell, 1830).

52 Herschel, *Preliminary Discourse*, p. 28.

53 Letter, Basil Hall to his sister Katy, from Philadelphia, 6 December 1827. MS3220, f143, The National Library of Scotland.

54 Hall, "Drawing and Description of the Capstan Lately Recovered from the Royal George," *United Services Journal and Naval and Military Magazine*, pt. 3, 1839, p. 379.

55 Hall, *Forty Etchings, from Sketches Made with the Camera Lucida, in North America, in 1827 and 1828* (Edinburgh: Cadell & Co, 1829).

56 In an 1830 letter from Paris, Hall wrote: "I wish your opinion upon Amici's Camera Lucida, which I understand you have used a good deal. I have become so extremely familiar with Dr. Wollaston's Camera Lucida, & am so entirely unconscious of difficulty, or of effort in using it, under any circumstances, that I am really not a good judge of their comparative merits ... I confess that I rather incline for Amici—as being the most easy for

beginners though it is probable that I shall always stick to my old friend." Letter, Hall to Herschel, 12 February 1830. HS9:165, RSL. Unfortunately, Herschel's reply to this letter has not been traced, for it would likely reveal the specifics of his working practice. The two friends exchanged other hints for using the camera. While the camera lucida itself was diminutive, the drawing board necessary to use it was a burden to a travelling man. When his brother James sent him a newly invented sketch book, Basil lost no time in telling Herschel about it: "the invention consists in packing up about 50 pieces of drawing paper into a solid substance exactly like a board, but fastened together only at the edges & capable of being separated by the insertion of a penknife." Thus, the paper became its own support. Letter, Hall to Herschel, 3 September 1832. HS9:171, RSL.

57 Amici, "Sopra le camere lucide," *Opuscoli Scientifici*, v. 3 n. 13, 1819, pp. 25–35.

58 Amici pattern camera lucidas are rarely met with. The prism head was bulkier than that of Wollaston's and some artists might have been reluctant to surrender the portability. However, the biggest barrier to the acceptance of Amici's was the added complexity of construction; it is not likely many were offered for sale. Wollaston's prisms were so simple that lapidaries could produce them in quantity. The biggest stumbling block in the manufacture of the Amici style was not the prism, but rather the glass plate. Its faces had to be exactly parallel and this was a surprisingly challenging production problem with the technology of the time. Amici made his by grinding a long wedge of glass. By cutting this into segments and cementing two portions of the wedge face to face, a strip of parallel glass would result.

59 As Sir David Brewster explained, "in using the ingenious camera lucida, invented by Dr. Wollaston . . . a practical difficulty has been experienced arising from the alternate appearance and disappearance of the point of the pencil by which the outline is traced . . . so that, by a slight motion of the eye, the pencil, or the ray, is seen indistinctly, according as the part of the pupil by which they are viewed becomes greater or smaller. [In Amici's design] as both the pencil and the rays are seen with the whole pupil, the object may be drawn with the greatest facility." "Professor Amici's Improved Camera Lucida," *The Edinburgh Journal of Science*, v. 3 n. 1, July 1825, p. 157.

60 Letter, Miss Savage to Samuel Butler, 11 October 1882. Henry Festing Jones, *Samuel Butler, Author of Erewhon* (London: MacMillan and Co., 1919), v. 1, p. 378.

61 Very few drawing instructors were as encouraging as was Samuel Prout: "the *camera lucida*, invented by the ingenious Dr. Wollaston . . . is extremely simple in its structure, and enables the operator to take views of buildings, trees, rocks, vessels, or any other objects that are not in motion, with the utmost accuracy. Indeed, so simple are its parts, and so easy of comprehension, that persons entirely ignorant of drawing, have, in a short time, become capable of producing, with a lead-pencil, outlines of regular and most difficult architectural subjects, the proportions of which are mathematically correct." *Rudiments of Landscape: In Progressive Studies. Drawn, and Etched in Imitation of Chalk, by Samuel Prout* (London: R. Ackermann, 1813), p. 16.

62 E.T. Cook, *The Works of John Ruskin* (London: George Allen, 1908), library edition, v. 35, p. 455. One morning in France, Ruskin recorded with disgust in his diary that he was "up rather late this morning, and lost time before breakfast over camera-lucida . . . ," p. 457.

63 Jones, *Samuel Butler*, v. 1, p. 391.

64 Letter, Talbot to Herschel, 26 October 1847. HS17:319, RSL.

65 Letter, William Horner Fox-Strangways to Henry Talbot, 10 June 1839. FTM.

66 Brewster, *The Stereoscope* (London: John Murray, 1856), pp. 171–2. Many of Chantrey's camera lucida portraits survive in the National Portrait Gallery, London. "In Chantrey's large establishment, which was in fact an art manufactory, where the powers of one master-mind, and the skill of many dexterous hands were exquisitely combined . . . he took, by means of the *camera lucida*, three outlines of the head of the sitter, viz., with profile, three-quarter, and front face. These drawings were at once handed to a workman, who, guided by them, 'built up,' in clay, the first rude figure of the bust." John Holland, *Memorials of Sir Francis Chantrey, R.A.* (London: Longman,

Green, Brown, and Longman, 1851), p. 295. George Dolland, a well-known optician, singled out Chantrey to make the camera lucida frontispiece drawing for his manual: *Description of the Camera Lucida, an Instrument for Drawing in True Perspective, and for Copying, Reducing, or Enlarging Other Drawings. To Which is Added, by Permission, a Letter on the Use of the Camera, by Capt. Basil Hall, R.N., F.R.S.* (London: Printed by Stewart and Murray, 1830).

67 "The Camera Lucida," *The Athenaeum*, n. 148, 28 August 1840, pp. 540–1.

68 Brewster, *A Treatise on Optics* (London: Printed for Longman, Rees, Ormé, Brown & Green, 1831), p. 333. When John Sell Cotman received a camera lucida as a gift from a patron in 1817, he wrote in amazement to Dawson Turner (who, it turned out, already employed one himself) that "they are used by all ye artists I find! Chantrey draws everything by it, even to the splitting of a Hair." H. Isherwood Kay, "John Sell Cotman's Letters from Normandy," *Walpole Society 1925–1926*, v. 14, p. 94.

69 Basil Hall's younger brother, James, an advocate and amateur painter, also employed the camera lucida, most notably in making a portrait of Sir Walter Scott. Described in Helen Smailes, "Thomas Campbell and the 'camera lucida': The Buccleuch statue of the 1st Duke of Wellington," *The Burlington Magazine*, v. 79 n. 1016, November 1987, pp. 709–14. The path was smoothed by Basil, who wrote in advance to the bard that "my brother, Mr. James Hall . . . does not (just now, at all events) wish that you should sit to him, but – not to mince the matter – that you should stand to him. His desire is, to make a sketch of you, from top to toe, exactly as you stand, stick & all, the veritable laird of Abbotsford. In order to be quite correct about this matter, he proposes, at my suggestion, I believe, to make the drawing alluded to, with the Camera Lucida, and the whole affair will not occupy above a quarter of an hour – or 20 minutes." Letter, Hall to Scott, 28 July 1830. MS 3919, f250, The National Library of Scotland. While Basil Hall was the most vocal champion of the camera lucida, his fellow countryman Robert Hay was its biggest patron. Hay privately supported a number of camera lucida artists in a series of expeditions in Egypt. He knew Talbot as well. Writing from Ancona to Lady Elisabeth on 24 March 1826, Talbot said that "Contini came last night, a little before me . . . he had a young English officer as his compagnon de voyage, who brought me a letter from Mr Hay. They travelled nine days & nights, & crossed Mt Cenis by moonlight." Further contact between them has not yet been established but their relationship was likely built on archaeological interests. LA26–14, FTM. The most accomplished of Hay's talented entourage was the Arabic scholar, Edward William Lane, but most unfortunately, few of his splendid drawings ever reached the public. Thus far, Lane is best known for his dashing appearance and his excellent translation of *One Thousand and One Arabian Nights*. Lane's mother, Sophia Gardner, was a niece of Gainsborough's, and Edward followed the family artistic tradition by joining his brother's lithography business in London. He eventually turned to engraving, and may have been introduced to the camera lucida as a means of transferring images to the plate. Declining health, however, forced a change of climate, and in 1825 he made the first of his visits to Egypt. "After two months spent in Cairo . . . Lane again visited the Pyramids, this time for a fortnight, armed with stores and necessaries for living, and with materials for drawing and surveying, above all the camera lucida, with which all his drawings were made." Stanley Lane Poole, *Life of Edward William Lane* (London: Williams and Norgate, 1877), p. 35. Unfortunately for the study of Lane's work, Poole (his great-nephew) reveals in his preface that he did not have "the smallest help from letters. Mr. Lane had a deep-rooted objection to the publication of letters meant only for private friends, and he unfortunately took care to have all his own letters from Egypt destroyed." Although a relative, Poole was fair in his assessment of Lane when he stressed that "in every thing he wrote, the prominent characteristic was perfect clearness, and nowhere is this more conspicuous than in the 'Description of Egypt.' But further, to prevent the scant possibility of mistaking the words, the work was illustrated by 101 sepia drawings, made with the camera lucida, (the invention of his friend, Dr. Wollaston,) and therefore as exact as photography could make them, and far more pleasing to the eye. Those whose function it is to criticise artistic productions have unanimously expressed their admiration of these drawings. And though

Lane would always say that the credit belonged to the instrument and not to himself, it is easy to see that they are the work of a fine pencil-hand, and could not have been done by any one who chose to look through a camera lucida. Altogether, both in drawings and descriptions, the book is unique of its kind. It has never been published." pp. 35–6. Sir William Gell, the classical archaeologist and traveller who employed it to illustrate his enormously popular *Pompeiana*, was another exception who was pleased to say so. The first edition carried a cautious note that "it may be proper to state, that the original drawings for this work were made with the *camera lucida*, by Sir William Gell." In later editions, this was proudly displayed as testimony: "The views and pictures have been uniformly made by the Author, as before, with the prism of Dr. Wollaston." Sir William Gell, F.R.S. F.S.A. &c. and John P. Gandy, Architect, *Pompeiana: The Topography, Edifices, and Ornaments of Pompeii* (London: Printed for Rodwell and Martin, 1817–19), p. xvi; 1835 edition (London: Lewis A. Lewis), v. 1, pp. xxiii–xxiv. During an 1824 trip to Naples, John Herschel dined with Gell (an old friend of his mother's), and surely they must have discussed the portfolio John was building. Letter, Herschel to his mother, 22 July 1824. L0517, HRHRC.

70 Niépce's contacts in Britain are explored in Schaaf's "Niépce in 1827 England," *Symposium 1985: Proceedings & Papers* (Bradford: European Society for the History of Photography, April 1985), pp. 112–9. Paul Jay, curator of the Niépce Museum, has written the definitive study: *Niépce: Genèse d'une Invention* (Chalon-sur-Saône: Société des Amis du Musée Nicéphore Niépce, 1988).

71 Both are in the Gernsheim Collection, HRHRC.

72 First revealed in Thomas Young's Bakerian Lecture (read 24 November 1803), and published as "Experiments and Calculations Relative to Physical Optics," *Philosophical Transactions*, v. 94 pt. 1, 1804, pp. 15–16.

73 William Hyde Wollaston, "On Certain Chemical Effects of Light," *Nicholson's Journal of Natural Philosophy, Chemistry, and the Arts*, v. 8, August 1804, pp. 293–5.

74 Herschel, *Diary*, 26 November 1823. HRHRC.

75 A good idea of the human concerns behind much of these troubles is displayed in D.L. Emblen's, *Peter Mark Roget, The Word and the Man* (New York: Thomas Y. Crowell Company, 1970); particularly chapters 12–14.

76 When the Committee of Papers meeting was postponed again on 13 December 1827, the Council resolved "that the Papers proposed, –&c to be considered by the Committee of Papers, shall be deposited in the departments of the Royal Society for inspection and perusal by the Members of Council, at least one week before the meeting of the Committee, and that notice of the Papers being so deposited shall be inserted in every Summons." *Minutes of the Council of the Royal Society, Volume X*, RSL. The 'Summons' to the members were ephemera and were not preserved by the Society. It is possible that copies exist in individuals' archives that might establish whether Niépce's paper received any hearing, but none so far have been traced.

77 Herschel recorded in his diary on 6 November 1828 that he "Saw Dr. Wollaston for the 1st time since his paralytic seizure." On the 15th, at noon, Herschel "called on Dr Wollaston to receive his signature to the A[stronomical] S[ociety] obligation book." Possibly he made a now-unknown portrait of the aging scientist, using the camera lucida; the same entry contains the cryptic note: "Camera Study 1½–3. ∼ 25·0." This means that the drawing took from 1:30 to 3 pm to complete, with the prism more than two feet above the sketch pad. This would have given a 'telephoto' effect appropriate to a head and shoulders portrait. *Diary*, 1828, HRHRC.

78 Frederick Scheer, *Kew and Its Gardens* (London: B. Steill, 1840), p. 36. Herschel attended at least one of these sessions (although clearly not the one Niépce spoke at) In Herschel's *Diary*, he noted on 28 May 1825 (a Saturday): "Be at Sir E Home's to go to Kew." W0007, HRHRC.

79 Letter, Evrard Home (the son) to Robert Brown, 17 December 1840. British Museum (Natural History).

80 "Advertisement," *Philosophical Transactions*, v. 117, 1827, p. iv.

81 This incident, which took place around the year 1800, is recorded "from an unpublished MS in his own handwriting." A group of men including Benjamin West, the President of the Royal Academy, Mr Banks, and Mr Cosway, a writer on painting, "having agreed amongst themselves that the representation of the crucifixion did not appear natural, though it had been painted by the greatest artist of his age, wished to put this to a test. They, therefore, requested me to nail a subject on a cross, saying, that the tale told of Michael Angelo and others was not true of their having stabbed a man tied to a cross, and then making a drawing of the effect." A murder within a hospital left no doubt that a Mr Legg would be found guilty and executed. Was he to become the first documented martyr to art historical studies? "A building was erected near the place of execution; a cross provided; the subject was nailed on the cross; the cross suspended; when the body, being warm, fell into the position that a dead body must fall into, let the cause of death be what it may. When cool, a cast was made, under the direction of Mr. Banks, and when the mob had dispersed, it was removed to my theatre. ... The cast is still in existence, and is preserved in the studio of Mr. Behnes." "Obituary, Joseph Constantine Carpue, FRS," *The Lancet*, v. 1, 7 February 1846, pp. 166–8.

82 This time in Talbot's life is poorly documented. He moved back to Lacock Abbey during the summer of 1827 and wrote to Herschel from there in October 1827. This is his last known letter to Herschel until 1833.

83 It was for Georgiana that Herschel had produced some of his most highly finished camera lucida drawings, and it was the loving relationship between her and her husband that Herschel hoped to find someday in a wife for himself. Herschel had promised Babbage's mother that "immediately after the last melancholy rites are performed [I will] prevail on him to accompany me to some quiet corner where we may find occupation for his mind, or by changes of place and scene and such slight exertion as travelling renders necessary, detach it from dwelling on it." Letter, Herschel to Mrs. Babbage, 31 August 1827. HS2:213, RSL. Charles Babbage, a spirited and brilliant man, had been Herschel's closest friend. He would continue on alone for another year of travels, but he never recovered from his wife's death. Progress on his calculating machine – his life obsession – was disrupted in spite of Herschel's attempts to keep it going during the inventor's long absence, and Babbage's personality soured so much that their friendship slowly eroded.

84 J.F.W. Herschel, "Light," dated 12 December 1827. *Encyclopaedia Metropolitana*, v. 2, 1830, p. 581.

85 Letter, Herschel to Babbage, 12 February 1828. HS2:219, RSL.

86 A balanced account of the relationship between Daguerre and Niépce is contained in Victor Fouque (translated by Edward Epstean), *The Truth Concerning the Invention of Photography* (New York: Tennant and Ward, 1935).

87 Davy, "A Discourse Introductory to a Course of Lectures on Chemistry" (delivered 21 January 1802), *The Collected Works of Sir Humphry Davy; Early Miscellaneous Papers from 1799 to 1805*, v. 2, edited by John Davy (London: Smith, Elder and Co., 1839), p. 320.

88 Copy of a letter, Herschel to William Whewell, 17 October 1826. HS20:240, RSL.

89 Experiment no. 996, notebook in the Science Museum Library, London.

90 Letter, Herschel to Babbage, 23 June 1831, RSL.

91 The experiment bears a striking similarity to the earlier and more familiar work with silver salts by Johann Heinrich Schulze. See Joseph Maria Eder (translated by Edward Epstean), *History of Photography*, (New York: Columbia University Press, 1945), pp. 60–3.

92 Herschel's *Diary*, 1831. HRHRC. The men referred to were probably Joseph Drinkwater, a chemist, and Robert E. Brown, a chemist and geologist. There is also a possibility that this was the botanist, Robert Brown, the subsequent owner of Franz Bauer's 1827 Niépce plates. Herschel also recorded in his diary that Brewster visited Slough on 29 and 30 June. Unfortunately, no written reaction by Talbot has been located. His diary for that period was a small one, and under Sunday 26 June he merely recorded that he had "Breakfasted with Mr Babbage – Brewster – Herschel – Brown." FTM.

93 A.B., "Influence chimique de la lumière et formation de la humboldtite neutre par un moyen photomètrique," *Journal de Pharmacie et des Sciences Accessoires*, v. 18 n. 3, March 1832, pp. 117–23. In fact, the light sensitivity of platinum salts had been investigated in 1826 and 1828 by Professor

Johann Wolfgang Döbereiner of the University of Jena; see Eder, p. 172 and 177.

94 J.F.W. Herschel, "On the Action of Light in Determining the Precipitation of Muriate of Platinum by Lime-water; being an Extract from a Letter of Sir John F. W. Herschel , K.H., F.R.S., &c. to Dr. Daubeny" (letter dated 12 June 1832 and read before the British Association 22 June 1832), *The London and Edinburgh Philosophical Magazine and Journal of Science*, v. 1 n. 1, July 1832, pp. 58–60.

95 Herschel's work was published in the *Philosophical Transactions*. See E.S. Cornell, "The Radiant Heat Spectrum from Herschel to Melloni. – I. The Work of Herschel and his Contemporaries," *Annals of Science*, v. 3 n. 1, 15 January 1938, pp. 119–37; D.J. Lovell, "Herschel's Dilemma in the Interpretation of Thermal Radiation," *Isis*, v. 59 n. 196, Spring 1968, pp. 46–60; E.F.J. Ring, "William Herschel: Pioneer of Thermology," *Thermology*, v. 2 n. 4, 1987, pp. 590–4.

96 Herschel, "On the Action," p. 59.

97 Herschel, "On the Action," p. 59.

98 Herschel, "On the Action," pp. 59–60.

99 Letter, Talbot to Herschel, 4 March 1833. HS17:268, RSL. Nearly twenty years later, Talbot would apply this stroboscopic effect in what is considered the first high-speed electronic flash photography. Talbot, "On the Production of Instantaneous Photographic Images," *The Athenaeum*, n. 1258, 6 December 1851, pp. 1286–7. Talbot said that "it will probably be in the recollection of some of your readers that in the month of June last a successful experiment was tried at the Royal Institution in which the photographic image was obtained of a printed paper fastened upon a wheel, the wheel being made to revolve as rapidly as possible during the operation." This type of phenomena had been of interest to him for some time. In his Notebook *M* in 1835, he postulated on a "Chamber illuminated w^th intermittent light. Let a partition be built across it. An argand lamp shines thro' a hole in this partition. A clock turns a wheel rapidly, which closes the hole during 9/10 of its revolution." Talbot suggested various entertainment devices and philosophical experiments that would benefit from this intermittent light. FTM.

100 Letter, Herschel to Talbot, 7 March 1833. LA33–8, FTM.

101 Letter, Talbot to Herschel, 9 March 1833. HS17:269, RSL.

102 Letter, Herschel to Talbot, 25 March 1833. LA33–14, FTM. Letter, Talbot to Herschel, 27 March 1833. HS17:270, RSL.

103 Letter, Herschel to Talbot, 30 May 1833. LA33–19, FTM.

104 Talbot, introduction to *The Pencil of Nature*.

105 A camera lucida is recorded in Talbot's "List of Books &c" that he left behind at Nice on 26 March 1822. LA22–9, FTM.

106 Letter, Caroline Mount Edgcumbe to Elisabeth Feilding, 8 October 1833, from Cadenabbia. FTM. They visited the Villa Carlotta, owned by the notorious art collector Giovanni Battista Sommariva (1760–1826). After his death, his son transferred some of the collection from Paris to Lake Como. See Francis Haskell, *An Italian Patron of French Neo-Classic Art, the Zaharoff Lecture for 1972* (Oxford: Clarendon Press, 1972).

107 Talbot *Diary*, 1 May–16 October 1833. FTM.

108 Talbot wrote to Captain Feilding on 4 October 1833, reminiscing about their travels and their stay at the Villa Serbelloni (near Bellagio): "Caroline recognised the red hangings of Horatia's bed, & the prints & engravings in my mother's room, unchanged." LA(H)33–17, FTM. Long after this, in 1847, Caroline wrote to Henry from Como: "Here we are again once more in dear beautiful Italy, looking just as it did in those happy days of Varese, whose distant blue mountains I had a glimpse of today...." Letter, Caroline Mt. Edgcumbe to Henry Talbot, 3 November 1847. FTM.

109 Letter, Caroline Mount Edgcumbe to Elisabeth Feilding, 5 December 1833. FTM.

110 Most importantly in an album in the Talbot Collection, NMPFT, and in the Royal Photographic Society, Bath.

111 Letter, Caroline to Lady Feilding, 8 October 1833. FTM. The Villa Serbelloni (now operated by the Rockefeller Foundation) and the Villa Melzi (its gardens now open to the public) form bookends for the village of Bellagio. Lady Feilding poured great energy into modifying the gardens at

Lacock. In this letter, Caroline mused that "I could not help thinking how much you would like to be taken as his head gardener & fac-totum to arrange that lovely place according to your own taste & cut walks wherever you had a fancy – the ground as mountainous as you could desire & magnificent old oaks, chestnuts, Pines & Cypress's ready made!" The picturesque aspects effects of such a scene would have contributed to Talbot's desire to record it. The area around Bellagio remains virtually identical to this day; the fortunate traveller might even catch the fireworks across the lake at Tremezzo, as Talbot's party did one evening.

112 This is one of a number of signed Constance Talbot sketches in an album in the FTM. Some of these drawings (less definitively the one of Villa Melzi) strongly imply the use of an optical instrument, quite probably the same camera lucida carried by her new husband.

113 Letter, Caroline Mt. Edgcumbe to Talbot, 11 February 1842. LA42–9, FTM.

114 Letter, Charlotte Talbot (later Traherne) to Henry Talbot, 17 March 1824. LA24–30, FTM. They were both quite interested in visual records at this time; Henry had just sent her a number of views of Edinburgh, although it appears possible from the context of this letter that they were commercial engravings. A camera obscura is listed, along with other scientific instruments, in Henry Talbot's packing list from Genoa, "Books for England, Oct. 11. 1823." FTM.

115 "I do not recollect which eye it was. That is, he must have seen very defectively with one of his eyes. He always used an eyeglass & sometimes spectacles. He had, I believe been short-sighted all his life, and first and last he managed to accumulate a great many glasses, but he had a way of accumulating things." Manuscript reminiscence by Charles Henry Talbot, dated 16 December 1879. FTM. This may be the foundation of an explanation for why Talbot initially had difficulty with spatial relationships in his drawings, yet eventually was able to exploit space very well in his photographs. Once he began to understand the two-dimensional representation that the camera presented to his paper, it must have been very similar to the way in which he normally saw the world.

116 That Talbot had excellent eye-hand co-ordination is evident from his work in microscopy and other areas. See his description of the delicate process of fabricating a luminous mantle in his "On the Nature of Light," *Philosophical Magazine*, 3^rd series, v. 7 n. 38, August 1835, p. 114.

117 Talbot, introduction to *The Pencil of Nature*.

118 "The Camera Lucida," *The Athenaeum*, n. 148, 28 August 1840, p. 540. Herschel had come to prefer Amici's style, which was more readily used. Talbot almost bought an Amici pattern camera lucida from Vincent Chevalier in 1826, but changed his mind at the last minute. It is shown on an invoice from Chevalier, 30 December 1826. It is listed as a "Camera Lucida d'Amici, de Modine" for 45 francs, but was crossed out on the bill and the sum deducted. FTM. It would not have helped for he still did not know how to draw.

119 The passage published in *The Pencil of Nature* was much stronger than that in an earlier draft: "... a scene displaying itself for the moment upon the paper in the focus of the camera, but soon to depart & leave behind no trace of its shadowy existence." Talbot Collection, NMPFT. Perhaps Talbot was not alone in these thoughts. The photographer and writer Vernon Heath was "accustomed to sketch a great deal out of doors, devoting myself chiefly to water-colour landscape work, using as a help the camera lucida invented by Dr. Wollaston." He found that by using it "a practical knowledge of perspective is acquired, not easily attained without some such assistance. This was a period long previous to the discovery of photography. How often, though, when using my camera lucida, and looking at the brilliant and distinct picture its prism had formed on the paper beneath it – how often did I wonder whether, within the realms of chemical science, there existed means by which that picture as I saw it could be retained and made lasting! Day after day I thought and dwelt upon this, as others no doubt had done before me." *Vernon Heath's Recollections* (London: Cassell & Company, 1892), pp. 47–8.

120 Talbot, "Facts relating to Optical Science, No. 1," *London and Edinburgh Philosophical Magazine and Magazine of Science*, 3^rd series, v. 4 n. 20, February 1834, pp. 112–14; "Facts relating to Optical Science, No. 2," 3^rd series, v. 4

n. 22, April 1834, pp. 289–90. His "Experiments on Light" was ready before the Royal Society in July 1834 and published in *Phil. Mag.*, 3rd series, v. 5 n. 29, November 1834, pp. 321–34.

121 Formerly in the Arnold Crane Collection. MS 84.XG.1003, The J. Paul Getty Museum.

122 In a further confusion of the record, Talbot recorded Monday 4 May. Unless he mixed up his dates (always possible), this could only be 1835. Thus, it is possible that this was further reading after his invention of photography. The interesting and wide-ranging work, *Wirkungen des Lichtes, Dargestellt und Erlautert von Dr. Gustav Suckow* (Darmstadt: Carl Wilhelm Leske, 1832), is evaluated extensively in Josef Maria Eder's *History of Photography*, translated by Edward Epstean (New York: Columbia University Press, 1945).

123 Talbot recorded attending this in his pocket diary for the period of 11 January to 8 August, 1834. FTM. Phillip's lecture was summarized in *The Athenaeum*, n. 334, 22 March 1834, pp. 227–8.

124 Whatever the topic, Faraday's attitude could hardly have been encouraging to Talbot when he wrote that "I am not prepared either to agree to or deny your reasoning. I am in doubt whether the action is of the direct chemical kind which you consider it but the doubt arises more from general notions than any particular reason and I have not time to think the subject over so as to say into what opinion of the causes which operate in the experiment I should finally settle." Letter, Faraday to Talbot, 26 May 1834. LA34–17, FTM.

125 It is possible the idea to float the printing paper on the solution was inspired by a Frenchman's means of producing negatives. Calvert Jones wrote Talbot on 2 December 1845 that Hippolyte Bayard "wets his paper for the Camera by having a flat pan containing the Liquid, and putting one side of the paper on it, after which he hangs the paper by one corner and lets the superfluous moisture pour back into the pan. I much wish we cd apply this or some other means, in order to obviate the cockling of the paper, which must in some degree occur, while we use brushes." LA 45–177, FTM.

126 Such a result may have discouraged many a previous worker. Samuel F.B. Morse, the painter and inventor who introduced the daguerreotype to America, had tried to invent photography during his student days at Yale. "Finding that light produced dark and dark light, I presumed the production of a true image to be impracticable, and gave up the attempt." *The New York Observer*, 20 April 1839.

127 Lady Feilding was already there and noted his arrival and departure in her diary for 1834. FTM.

128 Manuscript addendum to Talbot's 21 March 1839 "Note Respecting a New Kind of Sensitive Paper." Manuscript AP 23.32, RSL. The note itself was published in the *Proceedings of the Royal Society*, v. 4, 1839, p. 134.

129 Lady Feilding, who seemed quite fond of cemeteries, noted visiting Davy's grave on 31 August 1834, the day after Talbot arrived. *Diary*, 1834. FTM.

130 Eugene Ostroff has suggested that Talbot might have employed the method of etching a line in varnish to produce a copy of his own handwriting. However, the text of the print suggests another production method: "June 20th, 1835, written with a pencil of Tin. Lacock Abbey, Wilts...." See Ostroff, "Talbot's Earliest Extant Print, June 20, 1835, Rediscovered," *Photographic Science and Engineering*, v. 10 n. 6, November–December 1966, pp. 350–4.

131 Letter, Laura Mundy to Henry Talbot, 12 December 1834. LA34–47, FTM.

132 Letter, Constance Talbot to Henry Talbot, 7 September 1835. LA35–26, FTM. As in the appellation, 'Fox' Talbot, this playful description of Henry's cameras as 'mouse traps' has become a beloved visual pun within the literature of photography. However, this is the only instance of the word in any of their correspondence and Constance seems never to have repeated it. Henry certainly never employed it.

133 Notebook M, FTM.

134 In the collection of the FTM.

135 Introduction by Henry Gellibrand, Gresham College, 6 June 1635, to John Wells, *Sciographia, or the Art of Shadowes* (London: printed by Thomas Harper, 1635).

136 Perhaps Talbot sought to avoid association with what Henry Fuseli derisively called "the first essays of the art ... *Skiograms*, simple outlines of shade, similar to those which have been introduced to vulgar use by the students and parasites of Physiognomy, under the name of Silhouettes; without any other addition of character or feature but what the profile of the object thus delineated, could afford." Henry Fuseli, *Lectures on Painting, delivered at the Royal Academy March* 1801 (London: printed for J. Johnson, 1801), v. 1, p. 9. It is also possible that Talbot felt the term had been preempted by the recently announced puzzle in the form of an optically distorted painting. See "Miscellanea, *The Sciagraphicon,*" *The Athenaeum*, n. 320, 14 December 1833, p. 859.

137 In 1817, Lady Elisabeth wrote to Henry that she "saw last night at Sir Humphry Davy's a M. Biot just arrived from France to measure the variations of the Pendulum. Many other savants were there ..." Letter, Lady Elisabeth to Talbot, 19 March 1817. LA17–25, FTM. Jean-Baptiste Biot was later to become Talbot's most ardent and effective supporter in France.

138 Letter, Jane Davy to Henry Talbot, 2 February 1823. FTM.

139 Lady Jane Davy's visit is recorded in a letter from Constance to Henry Talbot, 3 October 1837. LA37–51, FTM. Sir Humphry's widow wrote to Lady Elisabeth in June 1845 to thank her for sending a part from *The Pencil of Nature*: "I am most extremely obliged to you for your generous & kind gift. Your written explanation puts matters very clearly. It is a pleasure to me to know how successful my old Botanical & astronomical friend of Nice days has been in his inquisitive scientific discoveries. I renew my thanks, & I hope next year I may in Park St. talk over 'Sunny Subjects' with Mother & Son." Letter, LA45–54, FTM.

140 Talbot, introduction to *The Pencil of Nature*.

141 The entry is not dated. *Diary*, May 1834. The J. Paul Getty Museum.

142 Notebook O, initially dated 31 March 1836, and carrying on into 1838. FTM. Sometime after 7 January 1838, Talbot made a sticky blue liquid and speculated that "if by this means we could cover the surface of a large lens with a blue film, it would concentrate only blue light, for chemical effects. Suppose this blue light converged on an object of which we wish to give a magnified representation by the method of shadows, it wd probably much exceed the effect of simple sunshine." There is also a notebook N, covering the period from October 1835 to 1836, but it is concerned almost exclusively with mathematical problems.

143 J.F.W. Herschel, *Diary*, 28 January 1837. HRHRC.

144 On reaching his new home on 1 February 1834, Herschel recorded in his diary that he was "occupied in unpacking, distributing, and arranging ... till 11. Then took a camera sketch of the superb Mountains in front of our house, got out a table and under the Shade of the fir trees before the house, with a gentle breeze and splendid blue sky, passed an hour & a half or 2 hours in drawing with great enjoyment." This, and numerous other references to Herschel's *camera lucida* work, are noted in *Herschel at the Cape: Diaries and Correspondence of Sir John Herschel, 1834–1838*. Edited by David S. Evans, Terence J. Deeming, Betty Hall Evans, Stephen Goldfarb (Austin: University of Texas Press, 1969).

145 In the collection of John Herschel-Shorland and the South African Library.

146 J.F.W. Herschel, *Diary*, 1837. HRHRC.

147 Letter, Herschel to Talbot, 27 March 1839.

148 Letter, Herschel to Talbot, 29 July 1837. NMPFT.

CHAPTER THREE

1 Quoted in Vernon Heath, *Recollections* (London: Cassell & Company, 1892), p. 49.

2 The first scientific notice of the invention of the daguerreotype was in a communication by François Arago, "Fixation des images qui se forment au foyer d'une chambre obscure," *Compte Rendu*, v. 8 n. 1, 7 January 1839, pp. 4–7. William Jerdan, the editor of the *Literary Gazette*, reprinted a 6th January letter from H. Gaucheraud which had appeared in *La Gazette de France*. The *Literary Gazette*, n. 1147, 12 January 1839, p. 28. Jerdan added that

"previously to receiving the above, we had written the following paragraph." Obviously, he had spotted some other account, although the information contained in it was garbled: "Nature Painted by Herself. A French journal contains a remarkable account of experiments with the *Camera Lucida*, the result of which is the exact and actual preservation of the impressions reflected by natural images on copper plates." Jerdan was plainly intrigued by photography from the start and attended as a guest at the reading of Talbot's first paper on photography to the Royal Society on 31 January. *Journal Book of the Royal Society*, v. 48, 1836–43, RSL.

3 Letter of 8 April 1839 from Talbot to the editor of the *Literary Gazette*, n. 1160, 13 April 1839, pp. 235–6. Talbot's dilemma alarmed others. An inventor of a new means of navigation immediately wrote to the President of the Royal Society that "the disputed priority of Invention between Mess^r Daguerre and Talbot imposes on me the necessity of troubling Your Lordship as President of the Royal Society with submitting from prudential motives a Prospectus of my discovery...." Letter, A. Mackenros, in Madrid, to the Marquis of Northampton, 16 February 1839. MC3.11, RSL.

4 Talbot, "Photogenic Drawing," letter to the editor dated 30 January 1839, *Literary Gazette*, n. 1150, 2 February 1839, pp. 72–4. Had Talbot in fact been engaged in drawing up his memoir <u>before</u> Daguerre's announcement? This is the only occasion (public or private) where he made such a claim. Yet, it would be unlike him to have actually fabricated such a story and his response in January was so prompt as to indicate that the material was fresh at hand. A manuscript in the Harold White Collection might be the draft of such an account; it is couched in terms that suggest it was written before an awareness of Daguerre's work. See Schaaf, *Sun Pictures III: The Harold White Collection of Works by William Henry Fox Talbot* (New York: H.P. Kraus, Jr., Inc., 1987), p. 79. Another possibility is an enigmatic, undated, manuscript mockup for a title page, written in Talbot's hand: "Preparing for publication, the method of Photogenic Drawing or Nature Painted by Herself, invented in the year 1833 and since perfected by H.F. Talbot Esq. F.R.S. including the Art of fixing the images formed by a Camera Obscura and by a Solar Microscope, upon prepared paper. By this invention a person altogether ignorant of drawing has the power of forming Exquisitely Finished Pictures of Natural Objects any number of which may be proceeding at the same time, & without requiring the presence of the Operator." Parts of the phrasing in this are not typical of the language that Talbot employed after Daguerre's announcement; the reference to "Painted" (instead of drawn) and the idea that several pictures may be taken simultaneously stand out. LAM-112, FTM. Additional elements of circumstantial evidence that Talbot may have rekindled his interest in photography shortly before Daguerre's announcement are provided by his photographic output. Only one *positively dated* Talbot photograph is known from 1836 (plate 24) and none from 1837 or early 1838. However, Talbot found it important to record the date of at least one photograph he produced in late 1838, now in the Royal Photographic Society (plate 36), dated 13 November. There is also a possible reference in a 26 March 1839 letter to the botanist Sir William Jackson Hooker. "I beg your acceptance of the enclosed Photograph, representing Camp. hederacea from bog on the summit of a mountain, Llantrissent Glamorgan. It was done with a November Sun." The photograph is no longer with the letter. (Talbot visited his Welsh relatives frequently and exchanged items of curiosity as well. Llantrissent is, in fact, in Monmouthshire, near Usk; perhaps Talbot meant Llantrisant, about ten miles from Cardiff). Royal Botanic Gardens, Kew.

5 Letter, Lady Elisabeth to Henry Talbot. Dated only "Sunday," this must be from early February 1839, most likely 3 February. She asked Henry to "tell me the result of the Royal Society, were you present when the specimens were exhibited?" LA39–4, FTM. With less of a personal stake in Henry's fame, her sister Mary Lucy Cole was more sympathetic and encouraging to Talbot: "I am glad M. Daguer [sic] roused you to life – you have too much Strangways blood in you to determine any thing till the last moment. I see it in other branches of the family to say nothing of personal observation on myself & daily lament the consequent loss of time & opportunity – every one seems struck with the marvellous of your discovery & Kit as much as any one." Letter, Cole to Talbot, 9 February 1839. LA39–11, FTM.

6 Letter, Talbot to Hooker, 23 January 1839. Royal Botanic Gardens, Kew.

7 Letter, Hooker to Talbot, 20 March 1839. Royal Botanic Gardens, Kew. Four decades later, the Scottish photohistorian, William Lang, Jr., reported to the Glasgow Photographic Association that he had "been informed that in an early number of the *Glasgow Mechanic's Magazine* there is to be found one of these Talbotypes, also issued in supplemental form, but this I have never seen." Could this supplement have been the outcome of Hooker displaying Talbot's example? Lang, "Photography and Book Illustration," *The British Journal of Photography*, v. 34 n. 1408, 29 April 1887, p. 263. It appears that the *Glasgow Mechanic's Magazine* was not published during this period. However, a possible explanation is suggested by another journal's recording of the title as the *Glasgow Merchants Magazine*, likely a more ephemeral publication (if it existed at all). "Silver Prints and Book Illustration," *The Philadelphia Photographer*, n. 299, 4 June 1887, p. 324.

8 Heath, *Recollections*, p. 49.

9 Talbot, letter to the editor, dated 30 January 1839, *Literary Gazette*, n. 1150, 2 February 1839, pp. 73–4.

10 "The New Art," *Literary Gazette*, n. 1150, 2 February 1839, p. 73.

11 Letter from Anthony Carlisle, dated 30 January 1839, "On the Production of Representations of Objects by the Action of Light," *Mechanics Magazine*, v. 30 n. 809, 9 February 1839, p. 329.

12 Talbot, *Literary Gazette*, 2 February 1839, p. 74.

13 Except as noted, this and all subsequent letters cited from Talbot to Herschel are in the Herschel Papers in RSL. All the Herschel to Talbot letters are in the Talbot Collection, NMPFT (formerly in the Science Museum Library, London). The rough drafts of Herschel's letters are in the Archives of RSL.

14 The Hydrographer for the Navy. Although the original note has not been traced there is a 23 January 1839 reminder from Beaufort to John Herschel, citing the previous note to Margaret. HS3:362, RSL.

15 *Diary*, 1839. HRHRC.

16 RSL.

17 The notebooks are in the Science Museum Library, London.

18 As was common practice, Herschel first recorded his experiments on scraps of paper (including the backs of envelopes) and then transferred the data to his main notebook. This extra step presented opportunities for later editing, of course, but Herschel was writing for himself, not for publication, and would have wanted the record to be accurate. Most of the rough notes must have been discarded immediately after transcription. A few survive, largely in the HRHRC. It appears that these escaped the fire because of the ephemera value to later generations of what was printed on them (which, of course, was what Herschel had found useless in the first place).

19 J.F.W. Herschel, "On the aberrations of compound lenses and object glasses," *Philosophical Transactions*, v. 111, 1821, pp. 222–67.

20 The full original manuscript (AP23.19) is preserved in RSL. A summary was published in the Royal Society's *Proceedings*, v. 4 n. 36, 31 January 1839, pp. 120–1.

21 It is fortunate that Talbot did not follow Sir Anthony Carlisle's line of reasoning; in reference to Wedgwood's experiments, Carlisle expressed the thought that "it would be serviceable to men of research if failing experiments were more often published, because the repetition of them would be thus prevented." Carlisle, "On the Production ...," p. 329. Herschel's attitude about constantly re-examining a problem was just the opposite. "Were they to have been proposed at once, we should, no doubt, have rejected them as such: but developed, as they have been, in the slow succession of ages, they have only taught us that things regarded impossible in one generation may become easy in the next; and that the power of man over nature is limited only by the one condition, that it must be exercised in conformity with the laws of nature." Herschel, *Preliminary Discourse on the Study of Natural Philosophy* (London: Longman, Rees, Orme, Brown, & Green, 1830), p. 66.

22 "Our Weekly Gossip," p. 96; "Scientific and Literary," *The Athenaeum*, n. 588, 2 February 1839, p. 97.

23 Letter, Biot to Talbot, 31 January 1839. Talbot Collection, NMPFT. Biot's original letters are in French; in most cases, I have followed the typewritten translations (not attributed, but apparently done some years ago by the

staff of the Science Museum Library, where the letters were originally held).

24 Letter to Alexander Herschel, 9 February 1872, collection of John Herschel-Shorland. As is understandable in decades-old memories, Maggie Herschel seems to have merged elements of more than one meeting with Talbot into a unified story in this letter. Still, her facts are consonant with those of other records, and it is significant that she remembered the tone of the meetings so clearly after such a passage of time.

25 This specimen is still attached to Herschel's notebook page, torn in half for the experiment, and carefully labelled. Herschel recorded that he left it exposed for a further fortnight after Talbot left. Curiously, with the evolution of trace chemicals over time, the figure of the plant is now almost equally visible on both halves. The Science Museum Library, London.

26 Notebook *P*. NMPFT.

27 Thomas Wedgwood, "An account of a method of copying paintings upon glass and of making profiles, by the agency of light upon nitrate of silver." Invented by T. Wedgwood, Esq. With observations by H. Davy, *Journals of the Royal Institution of Great Britain*, v. 1, 1802, pp. 170–4.

28 Talbot's choice of a root word for the art was challenged almost immediately. On 2 February, Charles Wheatstone wrote to Talbot expressing interest in his "photographic experiments." NMPFT. The first appearance of the word photography in print was in an article by Herschel's correspondent, the German astronomer Johann Mädler, on 25 February. It was traced in the *Vössiche Zeitung* by Dr Erich Stenger; *British Journal of Photography*, 23 September 1932, pp. 578–9. However, it is unlikely that this notice in a small provincial newspaper had much effect; the word entered the language when Herschel employed it on 14 March in his first presentation to the Royal Society on the subject. Herschel contributed regularly to the vocabulary of photography, including the terms 'snap-shot' and 'positive' and 'negative.' The latter he took by analogy with electricity. In his notebooks (but not to the public) on 16 and 19 April, he had thought of the still-cumbersome terms 'transitional photograph' for the negative and 'copies' for the prints. All this reflected a long-standing concern with precision in terminology. See his praise of "words and signs used in our reasonings that are full and true representatives of the things signified" and scorn of the "double or incomplete sense of words to which we must look for the origin of a very large portion of the errors into which we fall" in his *Preliminary Discourse*, pp. 20–1.

29 HS 17.281 bis, RSL.

30 Roget wrote a draft of his reply on 6 February on one of Talbot's letters: "I cannot undertake to say what course yͤ Council will take with regard to your paper. If it had been complete, I might have ventured to anticipate their prompt decision that it should be printed. But, in its present form, I fear there will be great difficulties in yͤ way of its publication yͤ Transactions. You are, no doubt, perfectly warranted in withholding from yͤ public the disclosure of yͤ processes of which you have described the results in that paper: but from what I can collect of yͤ opinions of the members of yͤ Council, I rather believe they would think it best to defer its publication until you can render it complete by yͤ communication of yͤ processes themselves. Perhaps, under these circumstances, you will deem it advisable to withdraw yͤ paper for the present, before a ballot is taken on the question of its publication." Letter, Talbot to Roget, 5 February 1839. MC3.5, RSL. Talbot responded in his letter to Roget, 6 February 1839. MC3.6, RSL.

31 A published footnote to Talbot's "On the Optical Phenomena of Certain Crystals" explained that "this paper appeared in the Philosophical Magazine for October 1836, *after* it had been ordered by the Council to be printed in the second part of the Philosophical Transactions for that year. The circumstance arose entirely from the mistake of the person to whom the superintendence of the printing both of the Transactions and Magazine is entrusted, and neither Mr. Talbot, the Council, nor the Officers of the Royal Society had any cognizance of the error till the paper appeared in the latter publication." *Philosophical Transactions*, v. 127, 1837, p. 25.

32 Letter, Talbot to Roget, undated, but sometime shortly after 7 February 1839. MC17.315, RSL. Brewster's letter (coming from Scotland) was dated 4 February 1839. LA39–7, FTM.

33 "Photogenic Drawing," *The Athenaeum*, n. 589, 9 February 1839, pp. 114–16. In their meeting on 14 February 1839, they resolved that "as it appears that since the last meeting of the Council, the paper by Mr H. F. Talbot lately read to the Society ... has been published verbatim in the Athenaeum weekly newspaper, the Council do not deem it expedient that it should be republished in the Proceedings of the Society." *Rough Minutes of Council, R.S.*, Dec. 8: 1836 to Nov. 11: 1841. RSL.

34 Henry Fox Talbot, *Some Account of the Art of Photogenic Drawing, or the Process by which Natural Objects may be made to Delineate Themselves without the Aid of the Artist's Pencil*. (London: printed by R. and J.E. Taylor, 1839.)

35 An excellent view of this is given in Anthony Dyson's *Pictures to Print; The Nineteenth-century Engraving Trade* (London: Farrand Press, 1984). Another perspective is in Jeremy Maas, *Gambart, Prince of the Victorian Art World* (London: Barrie & Jenkins, 1975).

36 The 'Scientific Meeting' referred to was the gathering of the *British Association for the Advancement of Science*, held at Birmingham in August. Talbot displayed many of his own photographs and read a paper on Daguerre's process at this meeting.

37 See Helmut Gernsheim, "Talbot's and Herschel's photographic experiments in 1839," *Image*, v. 8 n. 3, September 1959, pp. 133–7.

38 This was Herschel's experiment No. 1075, executed 9 September 1839, in which he successfully took a picture of his father's telescope by a laborious process of precipitating silver salts onto a glass plate.

39 3 March 1839, Notebook *P*. NMPFT.

40 A "Letter from a Painter" in 1810 that "the artist may be perfectly acquainted with all the *Materia Pictoria*, but he cannot be sure what he uses is genuine, although it was sold to him as such, and the appearance be beautiful.... Chemistry, which of late has been so astonishingly improved, serves in this instance only to adulterate or to imitate the productions of nature; it favours trade by making the materials cheaper, to the great injury of art." *The Artist*, v. 2 n. 12, 1810, p. 202.

41 This variability remains a stumbling block today for understanding and duplicating these early processes – our chemicals are just too pure to be historically correct. For example, gold and silver compounds were then made by dissolving coins (themselves of dubious composition) in acids (of uncontrolled purity). Even when detailed notes have been left by the photographer, it is unlikely that he or she knew more than a portion of what made up their formulations. Modern techniques of analysis applied to early photographs are similarly bound to be misleading. A trace showing of gold may mean that a photograph had been gold toned; equally, it may simply betray the fact that an old coin was impure.

42 Biot wrote two more letters in quick succession. On the 18th he warned Talbot that Daguerre was disclosing his process for paper photography (not the daguerreotype) that day. On the 24th, Biot wrote to say that "your two letters dated the 20th & 21st reached me yesterday ... having probably been held up at Dover on account of bad weather. Although I was pleased to receive them, they, nevertheless, at first caused me some embarrassment since I presumed that they might contain some information regarding your researches...." Daguerre had already disclosed the details of his paper so Biot thought of a compromise to protect Talbot. The day he received Talbot's letters Biot attended "one of our scientific meetings which are well-known to our mutual friend Sir John Herschell [sic]. It is called the Société Philomathique and many members of the Academy belong to it." After explaining the problem, Biot had the president open the two letters and read the contents aloud. Biot was delighted that "they contained a complete and detailed account of your process with authorization to communicate it to the Academy on your behalf." Talbot Collection, NMPFT.

43 The first was Biot's addition to "Procédé de M. Daguerre," *Compte Rendu*, v. 8 n. 5, 4 February 1839, pp. 170–3. More details were added in "Fixation des images de la chambre obscure," v. 8 n. 6, 11 February 1839, pp. 207–8.

44 W.H.F. Talbot, "An account of the processes employed in photogenic drawing," *Royal Society Proceedings*, v. 4 n. 37, 1839, pp. 124–6.

45 "Communication de deux lettres de M. Talbot à M. Biot, contenant l'exposition de son procédé pour faire le sensitive paper," *Compte Rendu*, v. 8 n. 8, 25 February 1839, pp. 302–5.

46 John P. Nicol, *Views of the Architecture of the Heavens*, 3rd edition (New York, 1840), p. 39.

47 Long before this, on 4 August 1814, Herschel had written to his friend Charles Babbage that "My dear sir, the world is run mad – Thermogen and Photogen will have their day at last. And ancient chaos will resume his sway and the chemical dance will be danced no longer to the music of the spheres, but to the <u>wreck of matter</u> and the crash of glass!" HS2.26, RSL.

48 "M. Biot communique l'extrait suivant d'une lettre que M. Talbot vient de lui addresser," *Compte Rendu*, v. 8 n. 9, 4 March 1839, pp. 341–2. Talbot's letter of 15 March, in response to what he had read in the 18 February *Compte Rendu*, was published the following week. *Compte Rendu*, v. 8 n. 10, 11 March 1839, pp. 409–12.

49 Talbot Collection, NMPFT.

50 Daguerre's paper process soon proved totally impractical. "Note de M. Biot sur un papier sensible préparé par M. Daguerre," *Compte Rendu*, v. 8 n. 7, 18 February 1839, pp. 246–7.

51 There is a notation on Talbot's letter in Herschel's hand: "Ansd Mar 2." This reply is also recorded in Herschel's diary for 1839. HRHRC.

52 Letter of 9 March 1839, written from London. Collection of John Herschel-Shorland. Talbot almost missed this chance to exhibit. Lady Elisabeth wrote to him on 28 February that "Lord Northampton was very civil but cool about my son's photographs, thinking they were in opposition to yours, and that <u>he</u> pretended to a discovery that was really <u>yours</u>. But upon finding out the jumble he sent his daughter to apologise for his stupidity in having forgotten that <u>you</u> were my son. <u>Now</u> he is anxious to have them, and you ought to be pleased that he did not like to hear of an interloper, nibbling away at your fame." Letter, Elisabeth Feilding to Henry Talbot, 28 February 1839. LAM-94, FTM.

53 Only an abstract of this text was published in the *Proceedings of the Royal Society*, and this abstract had some important defects; v. 4 n. 37, 1839, pp. 131–3. On p. 132, "hyposulphuret of ammonia" was printed as "hyposulphite." Another small change has misled a modern author into thinking that Herschel was unsure of the nature of the image. In his original manuscript, in reference to fixing, Herschel wrote that the light sensitive compound could be cleared "by washing with any liquid, which should not also dissolve and carry off the reduced silver or oxide of that metal deposited on the illuminated points." The writer of the abstract, on p. 132, changed this slightly but confusingly to "leaving the reduced, or oxide of silver, untouched." See the resulting confusion in the otherwise excellent article by T.H. James, "The Search to Understand Latent Image Formation," *Pioneers of Photography; Their Achievements in Science and Technology* (Springfield, Virginia: Society of Photographic Scientists and Engineers, 1987), pp. 47–57. Herschel's actual manuscript survives in the Archives of St. John's College Cambridge; the full text was published for the first time, along with a history of the manuscript, in Schaaf, "Sir John Herschel's 1839 Royal Society Paper on Photography," *History of Photography*, v. 3 n. 1, January 1979, pp. 47–60.

54 Benjamin Count of Rumford, "An Inquiry Concerning the Chemical Properties that have been attributed to Light," *Philosophical Transactions*, v. 88, pt. 2, 1798, pp. 449–68.

55 Sir John F.W. Herschel, "On the Action of Light in determining the Precipitation of Muriate of Platinum by Lime-water," *London and Edinburgh Philosophical Magazine*, n.s. v. 1 n. 1, July 1832, pp. 58–60.

56 These were preserved by Herschel in a booklet and are now in the NMPFT. Most are still strong images.

57 The *hydrosulphuret* was incorrectly printed as the *hyposulphite* in the abstract published in the *Proceedings of the Royal Society*, v. 4 n. 37, p. 132. Herschel corrected this in his own reference copy. No. 143, AC-S qQ113.H571m, HRHRC.

58 Victor Regnault, "De l'action du chlore sur les éthers hydrochloriques de l'alcool de l'esprit de bois, et de plusieurs points de la théorie de éthers," *Annales des Chemie*, v. 71, 1839, pp. 353–430.

59 The writer of the paper, Henri Victor Regnault, was later to become close friends and photographic partner with John Stewart, Herschel's brother-in-law, and would visit Herschel in England. Herschel formed a splendid collection of Regnault's fine work; they remain glorious and are now

60 divided between the Kodak Museum (in the NMPFT) and RSL.

60 W.H.F. Talbot, "Note Respecting a New Kind of Sensitive Paper," *Royal Society Proceedings*, v. 4, 1839, p. 134. The manuscript is in RSL.

61 Letter of 8 April 1839, to the editor of the *Literary Gazette*, n. 1160, 13 April 1839, pp. 235–6.

62 Letter, Talbot to Hooker, 26 March 1839. Royal Botanic Gardens, Kew.

63 Letter, Hooker to Talbot, 21 June 1839. Royal Botanic Gardens, Kew.

64 About a month later, around 22 April, Herschel recorded in his notebook a process by which "a nitrate of urea was obtained almost purely white in fine pearly scales and in much abundance and thus all the abominably nasty process of purifying foul nitr urea by xtalln is superseded."

65 See Rupert Derek Wood, "The Involvement of Sir John Herschel in the Photographic Patent Case, *Talbot v. Henderson*, 1854," *Annals of Science*, v. 27 n. 3, September 1971, pp. 239–64.

66 The artist William Havell and the engraver J.T. Willmore announced plans (never carried out) to patent a process of reproducing etchings on glass on photogenic drawing paper. This is discussed in the *Literary Gazette* of 30 March and 6 and 13 April 1839.

67 It is recorded in his diary in the HRHRC. Also, in Herschel's hand at the top of Talbot's 29 March letter in RSL is the notation "Ansd. March 31/39."

68 Letter, Margaret Herschel to Caroline Herschel, 28 April 1839. L0584, HRHRC.

69 W.H.F. Talbot, *The Antiquity of the Book of Genesis – Illustrated by Some New Arguments* (London: Longman, Ormé, Brown, Green & Longmans, 1839).

70 There is an envelope explaining this, dated September 1845, and two negatives of the bust of Patroclus with register holes. 1937–1540/1–3, NMPFT.

71 Notably in the NMPFT.

72 Herschel was a member of the Committee of Papers and was present when his paper was referred to publication on 11 April. He was also present at the meeting on 25 April, when he withdrew the paper, so his decision to do so must have been made between these two dates. Four other papers were withdrawn by other authors in this year alone.

73 "In the Photogenic or Sciagraphic process, if the paper is transparent, the first drawing may serve as an object, to produce a second drawing, in which the lights and shadows would be reversed." Talbot, Notebook *M*, around 28 February 1835. FTM.

74 The draft is in RSL.

CHAPTER FOUR

1 As in previous chapters, except where noted, all letters quoted from Herschel to Talbot are in the Talbot Collection of NMPFT, and all letters from Talbot to Herschel are in the RSL.

2 The fire, traced to a careless workman, occurred on 8 March and soon devoured the entire building. Daguerre was at that very time meeting with Samuel F.B. Morse (the American painter of telegraph fame) showing him some of his daguerreotypes. See Helmut and Alison Gernsheim, *L.J.M. Daguerre; the History of the Diorama and the Daguerreotype* (London: Secker & Warburg, 1956), pp. 87–8. The Diorama was an entertainment theatre with illusionistic scenes dependant on the effects of light. Herschel noted once in his *Diary*, that whilst in London he had attended both the "Cosmorama & Diorama with my Mor & Miss White – The latter 2 beautiful views of interior of Canterbury Cathedral & the Valley of Sarnen on the Lake of Lucerne. The effect of varying light & atmospheric effect on the scene inimitable." *Diary*, 13 February 1824. W0006, HRHRC.

3 Stewart, an apprentice printer in London who as a young man was tutored in sketching by Herschel, married Matilda Grahame on 15 May. Her father, James Grahame, was one of Herschel's closest friends, and was the one who had introduced him to Maggie. On 31 December 1838, Maggie wrote to Aunt Caroline that "John is doing very well in business in London, & is happy enough to be engaged to James Grahame's only daughter Matilda with whom he has been in love since he was <u>fourteen</u>, & <u>she</u> has been equally

attached to him. John Stewart was the husband whom Ja⁵ Grahame always wished for his daughter, so that the whole affair is rather romantic and every body is excessively pleased, except <u>Herschel</u>, who intended Matilda for his <u>own second wife</u> – Lest he sh⁴ challenge the bridegroom & run off with the Bride, I intend to accompany him to Nantes to witness the ceremony in May." Letter, L0583, HRHRC. Because of Matilda's fragile health, her father insisted that the couple remain in France. An indication of Stewart's photographic training is given in a 29 August 1851 letter from Herschel to his wife: "Fox Talbot writes to recommend John apply to Martens in Paris to teach him Talbotype. It is too late–first he has left Paris–second, he has already been taking lessons of Marten during his stay there." Collection, John Herschel-Shorland. Stewart became an accomplished photographer in the 1850s, forming strong associations with the French photographic community, particularly with Henri Victor Regnault.

4 Talbot was not the only one Herschel encouraged. James David Forbes, one of Scotland's top men of science, wrote to Herschel on 9 July: "I arrived the week after your departure [from Paris]. Through the kindness of M. Arago I saw the Daguerre specimens which indeed surpass all belief. I also saw Niepce's specimens – who was undoubtedly the originator of the thing though Daguerre improved it to such a degree as to perform in 5 minutes what before required 6 hours. The effect was the same however with the exception of the impossibility of catching transient lights, & also the Camera Obscura seems to have been far less perfect – the center of the picture being alone good." Letter, Forbes to Herschel, 9 July 1839. HS7:294, RSL.

5 An analysis of the effects of class on the professionalism of science in Britain is given in Morris Berman, "'Hegemony' and the Amateur Tradition in British Science," *Journal of Social History*, v. 8, Winter 1975, pp. 30–50.

6 Entries for 6 September and 15 to 30 September, 1839. Herschel Collection, the Science Museum Library.

7 M. Cauchy and M. Arago recalled Herschel exclaiming: "que les essais faits en Angleterre sont des jeux d'enfant en comparaison des moyens de M. Daguerre. M. Talbot lui-même sera bientôt de mon avis, car je vais lui écrit de venir voir ces merveilles." *Compte Rendu*, v. 8 n. 21, 27 May 1839, p. 838.

8 In his PS, Herschel said that "I enclose a little sketch of the 40 feet (as it now stands) made without hands, by Photography. It is the image fixed in focus of a lens." This was the forty foot telescope at Slough, made famous by the work of William Herschel, with the aid of his sister, Caroline. Letter, Margaret Herschel to Caroline Herschel, 26 June 1839. L0584, HRHRC.

9 Daguerre's efforts were in 1838 or very early 1839. There was a unique broadside in the Cromer Collection (passed on to the George Eastman House and subsequently destroyed accidentally while out on loan) that outlined this. In it, Daguerre announced that the subscription would open on 15 January with an exhibition of forty pictures, but this exhibition never took place. Beaumont Newhall has suggested that Arago intervened and that the broadside was never distributed. See his "An Announcement by Daguerre," *Image*, v. 8 n. 1, March 1959, pp. 32–6. This is examined in context in Newhall's *The History of Photography From 1839 to the Present*. Revised and enlarged edition. (New York: The Museum of Modern Art, 1982), p. 18.

10 The English editor of the *Literary Gazette*, William Jerdan, took credit (and probably rightfully so) for forcing Daguerre to acknowledge his debt to the work of one of his own countrymen, gloating about "the circumstances connected with the previous discoveries communicated to M. Daguerre, which were first stated in the *Literary Gazette*, and led to considerable controversy and no inconsiderable resentment on the part of the <u>Daguerrists</u> at the time, but were finally acknowledged, and their author made a sharer in the reward so justly and liberally assigned by the French government to M. Daguerre for his ingenious improvements, which carried the art so much nearer to perfection." These were recounted in the review of the first number of Talbot's *Pencil of Nature* in the *Literary Gazette*, n. 1432, 26 June 1844, p. 410.

11 Bayard had been working on a photographic process before 1839 and was able to show an independently invented paper negative before Talbot's working details were disclosed. Seeing the negative/positive approach as a disadvantage compared to Daguerre's, he invented a direct positive process <u>on paper</u> by early spring 1839. Arago, however, persuaded him to keep this a secret by supplying Bayard with some apparatus and encouraging him to

develop it further. Daguerre's announcement then totally eclipsed Bayard's efforts. There was contact both explicit and implied between Talbot and Bayard. See Nancy Keeler, "Souvenirs of the Invention of Photography on Paper: Bayard, Talbot, and the Triumph of Negative-Positive Photography," *Photography, Discovery and Invention* (Malibu: The J. Paul Getty Museum, 1990), pp. 47–62. Also, Schaaf, *Sun Pictures V, The Reverend Calvert R. Jones* (New York: Hans P. Kraus, Jr., 1990), pp. 17–29.

12 Letter, Elisabeth Feilding to Henry Talbot, 4 October 1839. LA39–52, FTM. Caroline Fox, a neighbor of Callcott's, wrote on 2 October 1839. LAM-89, FTM.

13 Letter, Talbot to Lady Feilding, 5 October 1839. The Royal Photographic Society, Bath. The Rev Vernon Harcourt's 1839 address to the BAAS was directed at rebutting what Arago had just claimed in an elegy of James Watt. In exasperation, the President of the Association exclaimed that "the zeal of M. Arago has carried him too far...." Harcourt, "Address of the President," *British Association for the Advancement of Science, Report for 1839*, p. 6. A broader assessment of Arago's contributions and personality is made by Roger Hahn: "Arago was at once volatile and warm-hearted in his personal relations. He either forged strong bonds with fellow scientists or engaged in sharp polemics that often were provoked by priority controversies.... He had a stormy relationship with Biot ... but it did not blind him to their scientific merits. In both his writings and his public appearances, Arago conveyed a contagious sense of excitement...." (p. 201). Even though his sight failed him later in life, "Arago never lost his mental energies and his ability to stimulate his colleagues and excite the public about the progress of science" (p. 203). *Dictionary of Scientific Biography* (New York: Charles Scribner's Sons, 1970), v. 1 pp. 200–3.

14 Letter, Margaret Herschel to Caroline Herschel, 14 December 1844. L0589, HRHRC.

15 Extensive references to this rivalry are given in Maurice Crosland's *The Society of Arcueil, A View of French Science at the Time of Napoleon I* (Cambridge: Harvard University Press, 1967). Crosland felt that Biot was primarily at fault, largely from his practice as a senior scientist of putting his name on other people's work. Of Biot's rival, he claimed that "Arago could never be considered in a dehumanized way as someone who produced scientific work. He had considerable personal qualities and the influence which he exerted depended as much on this as upon the quality of his scientific work. Arago made an excellent secretary by virtue of his wide grasp of science and his ability to handle men.... He quickly grasped the essentials of a memoir and with his powers of expression he was able to hold the attention of his colleagues and even their admiration" (pp. 462–3). Jed Z. Buchwald, while recognizing Biot's difficult temperament, still felt that his science was far superior to that of Arago. *The Rise of the Wave Theory of Light; Optical Theory and Experiment in the Early Nineteenth Century* (Chicago: The University of Chicago Press, 1989), pp. 86–8. As the infirmities of old age began to catch up to both men, their fundamental respect for each other re-emerged. Ironically for the introduction of photography, Arago and Biot patched up their difficulties in 1840, the year after Daguerre's and Talbot's announcements.

16 Herschel's comment, made on 24 May 1833 to his brother-in-law, is preserved in a manuscript notebook: *Anecdotes from John F. Herschel, recorded in our Uncle James Stewart's handwriting*. Collection, John Herschel Shorland.

17 Herschel, *A Preliminary Discourse on the Study of Natural Philosophy* (London: Longman, Rees, Ormé, Brown, & Green, 1830), p. 14.

18 Entry for 21 June 1839, Report Book 6, *Committee on Botany*, RSL.

19 Letter, Buckland to Talbot, 3 July 1839. LA39–46, FTM.

20 Robert MacCormick, *Voyages of Discovery in the Arctic and Antarctic Seas, and Round the World* (London: Sampson Low, Marston, Searle, and Rivington, 1884), v. 1, p. 281. This was apparently their only meeting, in spite of the fact that after conferring with Ross, MacCormick wrote excitedly to Talbot that he and Joseph Hooker would be pleased to "avail ourselves of your friendly aid, in an art which promises to be of incalculable value, in delineating the various objects of Natural History, which we may meet with during our voyage to the Antarctic Regions; more particularly, in obtaining faithful representations of those evanescent forms, inhabiting the Ocean, which this expeditious and beautiful process is so well fitted to

preserve." Letter, 31 July 1839. LA39–63, FTM. Joseph Dalton Hooker, the botanist for the trip, was the son of Sir William Hooker, the botanist whom Talbot had approached about producing a photographically illustrated book.

21 Letter, Herschel to Daguerre, 1 August 1839. MS 67390, the Wellcome Institution, London. Daguerre's reply, if any, is unknown, although it is likely that Herschel's letter reached him. The letter turned up in a sale of miscellaneous letters in Paris in the 1930s. On the day of Herschel's letter, the Council of the Royal Society "Resolved – That it be recommended to the Lords Commissioners of the Admiralty, that an apparatus on the principal of M. Daguerre be supplied to the Antarctic Expedition; and that application be immediately made to M. Daguerre to furnish such an apparatus." *Minutes of the Council*, RSL.

22 "Le Daguerréotype," *Compte Rendu*, v. 9 n. 8, 19 August 1839, pp. 250–67. It is likely that this delay was to allow Alphonse Giroux (a relative of Daguerre's wife) to complete the production runs of the 'official' camera, apparatus, and manual, in time for sale at the announcement. Each camera offered for sale was signed by Daguerre. Further details can be found in the Gernsheim's *Daguerre*, p. 94 *passim*. The Giroux rendition of Daguerre's camera was a high quality instrument and there is some evidence that Daguerre was almost as proud of it as he was of his daguerreotype process. In the broadside he intended to issue at the start of 1839, Daguerre explained his initial contact with Nicéphore Niépce: "He succeeded through many ever-varied experiments in obtaining nature's image with an ordinary camera obscura; but his apparatus not offering the necessary sharpness. . . . I contributed to the partnership a camera which I had modified for this use and which, by extending great sharpness over a larger field of the image, had much to do with our later success." Quoted from Newhall, "An Announcement by Daguerre," p. 35.

23 Letter, Talbot to Ross, 22 August 1839. Sabine acknowledged the letter the next day. Sabine 1683, RSL.

24 Copy of a letter, Beaufort to Herschel, 27 August 1839. Letter Book No. 9, p. 51, Hydrographer of the Navy, Taunton. Joseph Barclay Pentland was an Irish traveller and explorer who spent much of his time in Rome and earlier in Paris, where he had extensive connections. An example is given in a 10 January 1840 letter to Peter Mark Roget that "in consequence of a request made by Sir J. Herschel in the name of the R.S. to my friend Arago. . . ." MC3:63, RSL.

25 Letter, Thomas Best Jervis to Herschel, 14 September 1839. M0299, HRHRC.

26 Letter, Lubbock to Herschel, 11 October 1839. HS11:360, RSL.

27 These were ordered from Giroux and were the subject of considerable correspondence between Talbot and Lubbock. See, for example, Lubbock's letter to Talbot, 2 November 1839. LA39–71, FTM. Talbot's original Giroux camera was acquired by Harold White, sold to a private collector in South Africa, and is now in the Bensusan Museum in Johannesburg, South Africa.

28 On 18 October, Fox-Strangways enclosed "M^r Pentland's answer to my letter . . . I should think the additional mirror as useful for your method as for Daguerre's." The mirror was needed to correct the reversal of the image in the direct positive daguerreotype – it was not needed for Talbot's negative/positive system. Henry's uncle continued that "I will write a line to M^r P to approve of his sending it as he proposes. It will be better packed for travelling by coach than it could conveniently be for going in a Dispatch bag & will be safer as to its condition I should think. I will also write to the F.O. to have such a box when it arrives sent to Sackville Street & notice given to me." Letter, Fox-Strangways to Talbot, 18 October 1839. FTM.

29 Recorded in his research notebook. The Science Museum Library, London.

30 Recognizing the instability of lead, Herschel recorded in his research notebook on 14 June that "I therefore abandoned the use of lead as a matter of practice though theoretically speaking it is very important and adopted Talbot's paper with alternate washes of Nitr Silv & Mur Sod." The Science Museum Library, London.

31 Notebook *P*. Talbot Collection, NMPFT.

32 Talbot was given considerable support for this exhibit. The Secretary of the Model Committee, James T. Chance, offered to "provide a sufficient number of cases for as many drawings as you may be kind enough to bring: each case will be about 3 ft. high & 2 ft 6 in. wide: so that 6 of them would be equal to the superficial measurement required by 100 drawings." Letter, Chance to Talbot, 9 August 1839. LA39–61, FTM.

33 Ninety-three images were detailed in *A Brief Description of the Photogenic Drawings Exhibited at the Meeting of the British Association at Birmingham, in August* 1839, *by H.F. Talbot, Esq.* Talbot Collection, NMPFT.

34 *The Athenaeum*, n. 618, 31 August 1839, p. 643.

35 Talbot, "Remarks on M. Daguerre's Photogenic Process," *Transactions of the Sections, British Association for the Advancement of Science, Report for* 1839, pp. 3–5.

36 Talbot, letter of 21 December 1842, published in his "On the coloured Rings produced by Iodine on Silver, with Remarks on the History of Photography." *Philosophical Magazine*, 3^rd series, n. 143, February 1843, p. 97.

37 *BAAS Report*, 1839, p. 5.

38 One part he did catch, however, was prompted by an exchange between Talbot and James Forbes: "Mr. Talbot then gave some remarkable instances of the extreme sensibility of the paper he was able to produce, and said, that as the actual process of Daguerre had only been made public within the last few days, he had not been able to learn whether this sensibility could be surpassed. Some of the specimens exhibited in the Model Room had been completed in one minute, and some of the most finished in five. It was very remarkable, that time seemed to injure some, and some kinds of the paper recovered their whiteness again after having been blackened by exposure to light. Prof. Forbes, who had, within the last fortnight, witnessed the exhibition of Daguerre's method, gave some interesting details, particularly as to the rapidity and fidelity with which views upon the Seine had been copied; and concluded by saying, that he believed that artist prided himself nearly as much on the improvements he had made in the camera obscura, as on his skill in making the photogenic drawings, although these improvements had not as yet been made public." *The Athenaeum*, n. 618, 31 August 1839, p. 644.

39 Years later, Talbot remembered that "the first person who applied photography to the solar microscope was undoubtedly Mr. Wedgwood . . . but none of his delineations have been preserved, and I believe that no particulars are known. Next in order of time to Mr. Wedgwood's, came my own experiments. Having published my first photographic process in January, 1839, I immediately applied it to the solar microscope, and in the course of that year made a great many microscopic photographs, which I gave away to Sir John Herschell[sic], Sir Walter Calverley Trevelyan, and other friends. The size of these pictures was generally half that of a sheet of writing paper, or about eight inches square. The process employed was my original process, termed by me at first 'Photogenic drawing,' – for the calotype process was not yet invented. I succeeded in my attempts, chiefly in consequence of a careful arrangement of the solar microscope, by which I was enabled to obtain a very luminous image, and to maintain it steadily on the paper during five or ten minutes, the time requisite . . . the magnifying power obtained was . . . 289 in surface. The definition of the image was good. After the invention of the calotype process, it became of course a comparatively easy matter to obtain these images; and I then ceased to occupy myself with this branch of photography, in order to direct my whole attention to the improvement of the views taken with the camera." Talbot, letter to Samuel Highley, jun., 10 May 1853, read at the Twentieth Ordinary Meeting of the Society of Arts, *Journal of the Society of Arts*, 13 May 1853, p. 292.

40 Daguerre had, in fact, produced at least one solar microscope daguerreotype, a picture of a dead spider, which he displayed in January; obviously, Herschel never saw it. It was mentioned in Gaucheraud's letter of 6 January, originally published in *La Gazette de France*, and reprinted in the *Literary Gazette*, n. 1147, 12 January 1839, p. 28.

41 *Diary*, 1839. W0022, HRHRC. It appears that Herschel had taken the technical lead; five years later, Hawtrey reminisced that "I suppose you have added much to your discoveries in Photographic Pictures since you gave me a lesson in the Daguerreotype at Eton." Hawtrey was prompted to write when he "saw some Calographic pictures at Professor Wheatstone's

which seemed to me a great gain to the invention as far as art is concerned." Letter, Hawtrey to Herschel, 9 August 1844. HS10:172, RSL.

42 There is no record of Hawtrey's experiments in his papers at Eton and no mention of them in his biography by Francis St. John Thackeray, *Memoir of Edward Craven Hawtrey, D.D., Headmaster and Afterwards Provost of Eton* (London: George Bells and Sons, 1896). There is also no reference to his daguerreotyping activities in the account written by H.C. Maxwell Lyte, with illustrations by P.H. Delamotte, *A History of Eton College, 1440–1875* (London: MacMillan & Co., 1875). Surely, these two well-known photographers would have recognized the significance of any trace of daguerreotype whilst researching their volume. If notice of it had been deemed inappropriate for the *History*, they would have found another forum for publicizing Hawtrey's activities.

43 The next time Herschel invented a process with similar duality, Talbot suggested a name: "as your new process involves a very remarkable peculiarity, viz. the change from negative to positive of the same photograph, I should wish the name given to it be one allusive to that fact, and if you are not yet decided upon your nomenclature I would suggest that the above peculiarity might be concisely and clearly expressed by the name of Amphitype. The Greek name for "to change" is somewhat too long for convenient use ... unless abbreviated into allotype; but the other is more classical." Letter, Talbot to Herschel, 29 March 1843. HS17:315, RSL.

44 The progress of the demolition was recorded in Herschel's diary for 1839. W0022, HRHRC.

45 The camera lucida also came into play. Basil Hall wrote to Margaret Herschel that "I cannot tell you how sorry I am to hear that the great telescope stand has been taken down as I had set my heart on making such a Camera sketch of it as never was seen before – & now never can be seen. Nevertheless, as Sir John – obviously out of envy – has not chosen that the Wollaston Camera work should come into competition with his Amici work – has chosen to steal a march on me & pull down his apparatus – in order to prevent my sketching it, I must even see what I can do with the Tube – & so, with your permission (I won't ask his) I'll bring my Camera with me & see what I can do with the things which remain." P.S. to letter, 11 December 1839. HS9:190, RSL.

46 These are preserved in the Herschel Collection at NMPFT. Most of the paper negatives, as well as the glass ones, are circular, falling into two general size categories. No explanation for this has been found but the hand cutting (particularly in the case of the glass ones) would have been so tedious as to have been necessitated by a physical constraint. It would be logical to assume that Herschel employed a circular telescope tube to rig up a makeshift camera – it is even possible that he used a reflector telescope to gain short exposures. Unless a special holder were fashioned, the size of the negative would have been tightly restricted.

47 The original negatives are in the Herschel Collection, NMPFT. At the instigation of the family, John Werge made twenty-five prints from one of the negatives in 1890. Each of these prints was mounted on an explanatory text and framed in wood from one of Herschel's telescopes. They were distributed to family friends and interested institutions and many survive today, some in their original frames.

48 After reviewing Herschel's approach, Hunt confessed that "frequent trials of these and other methods, have not enabled me to add any thing to the above directions." Hunt, *Popular Treatise on the Art of Photography* (Glasgow: Richard Griffin and Company, 1841), p. 72. However, a decade later, Hunt recommended several practical refinements that thickened the silver coating. He also noted that "Mr. Towson employed glass plates prepared in this manner with much success...." Hunt, *Photography: a Treatise on the Chemical Changes Produced by Solar Radiation, and the Production of Pictures from Nature by the Daguerreotype, Calotype, and Other Photographic Processes* (London: J.J. Griffin & Co., 1851), p. 92. In his 1841 book (on p. 22), Hunt revealed that "Mr. John Towson of Devonport ... pursued cojointly with myself, a most extensive series of researches on photographic agents...." Towson moved to Liverpool shortly after this and made a number of important contributions to science (see his entry in the *Dictionary of National Biography*). Although none of his photographic work is known to still

survive, it was widely known to his contemporaries. When Mr Corey read a paper on the history of photography to the Historic Society of Lancashire and Cheshire in 1858, he said of Towson that "not a single day lapsed in the year 1838 [sic] in which he was not making experiments with Mr. Hunt, while he was also in constant communication with Sir John Herschel and the Honourable Mr. Fox Talbot ... he produced a photograph on glass, which is still in existence and which, at the time, was sent by him to Sir John Herschel...." *Liverpool and Manchester Photographic Journal*, n.s. v. 2 n. 7, 1 April 1858, pp. 81–2. At a meeting of the Photographic Society of Scotland, Thomas MacKinlay "stated that Mr. Towson ... had, in conjunction with one of the Herschels, produced positive photographs direct in the camera, by a blackened chloride impregnated with an acidulated iodide, both on glass and paper...." *The Photographic Journal*, v. 5 n. 77, 21 January 1859, p. 154. In their obituary of him, *The British Journal of Photography* (*BJP*) appears to have merged some of Towson's accomplishments with suggestions he first learned from Herschel: "he was the first to direct the attention of photographers to the fact that the luminous and chemical foci were not of the same length, a knowledge of which fact at a later period enabled Dr. Draper, of New York, to take the first photograph from life. He was also the first to devise the means of taking a photographic picture on glass, and the use of the reflecting camera." *BJP*, v. 28 n. 1079, 7 January 1881, p. 12.

49 Related by Professor Alexander Herschel, "On some Original Glass Photographs produced and preserved by the late Sir John Herschel, Bart., from his earliest Experiments on the Chemical Properties of Light," *The Photographic Journal*, v. 15 n. 234, 15 June 1872, pp. 153–5. Herschel's son heard this anecdote from someone present at the time (perhaps Margaret Herschel) and assumed that Talbot would recall it. Alexander Herschel also confirmed that "the early photographs on glass were made in the course of some original experiments to determine the action of organic or other ingredients in paper capable of producing a somewhat inconsistent degree of sensitiveness which it exhibited when prepared in the method first adopted by Mr. Fox Talbot with chloride of silver."

50 Talbot, Notebook P, 3 March 1839. NMPFT.

51 Talbot had taken an interest in this fringe effect long before he saw a daguerreotype. Looking at a landscape through a telescope, "when the sun is about to emerge from behind the crest of pine trees on the cliff's summit, every branch and leaf is lighted up with a silvery lustre of indescribable beauty. But it will be seen, by observing the trunks of the trees and the larger branches, that this silvery light forms only a *margin* to every object: it is only their *outline* which is luminous." Talbot, "Remarks upon an Optical Phenomenon, seen in Switzerland." *Philosophical Magazine*, 3rd ser., v. 2 n. 12, June 1833, p. 452.

52 Although I cannot agree with many of his interpretations, useful factual information on the patent situation is contained in Rupert Derek Wood's "The Daguerreotype Patent, The British Government, and The Royal Society." *History of Photography*, v. 4 n. 1, January 1980, pp. 53–9.

53 Helmut and Alison Gernsheim write with some passion about this episode in their *History of Photography* (New York: McGraw-Hill Book Company, 1969), pp. 130–2. Greater detail, including some of the relevant correspondence, is given in their earlier work, *L.J.M. Daguerre, The History of the Diorama and the Daguerreotype* (London: Secker & Warburg, 1956), p. 139 passim.

54 Whether it was the result of the press of circumstances (which were considerable), or a natural sense of caution in legal matters, Herschel did not reply to this or any of Talbot's subsequent letters for some time. He wrote in the corner of Talbot's letter "Ansd Dec 4/39." HS17:297, RSL.

55 Herschel noted in his diary on 6 September that his existing water prism "leaked sadly." He then "constructed a new water prism with iron checks defended by wax + Turpentine Resin Cement from oxidation – it promises well." W0022, HRHRC.

56 Herschel Collection, the Science Museum Library.

57 Herschel Collection, the Science Museum Library.

58 Letter, Talbot to Sir John Lubbock, 8 October 1839. Lubbock papers, LUB T22, RSL.

59 *Daily Telegraph*, 27 September 1877, p. 5.

60 Talbot's use of the bust is discussed in Eugenia Perry Janis, *The Kiss of Apollo; Photography & Sculpture 1845 to the Present* (San Francisco: Fraenkel Gallery, in association with Bedford Arts, 1991), pp. 12–13.

61 Elisabeth Feilding, *Diary*, 12 April 1840. FTM.

62 Letter, Herschel to Thomas MacClear, 22 July 1844. L0242, HRHRC. Previous to the Penny Post, a complicated system existed where few letters were prepaid, the charges were high, and distances were taken into account. This was especially difficult for the growing numbers of Irish living in England. Rowland Hill's answer was a prepaid, uniform, inexpensive rate. In spite of considerable opposition from the bureaucrats, it was passed in 1839 and finally established on 10 January 1840.

63 Talbot pocket diary, 1839. FTM. This was a distinct contrast with what was expected just a few years previously. When Giovanni Amici visited London in 1827, Herschel insisted that "you must take up your residence at our house . . . if you are obliged to be in a hurry, you can easily reach London in two hours & a half or 3 hours from hence." Letter, Herschel to Amici, 29 June 1827. Amici Archive, Biblioteca Estense, Modena. Around the time when Herschel was demonstrating the light sensitivity of platinum salts to Talbot, Herschel found it noteworthy to record the improved service in his *Diary*: On 4 March 1831, from London he "left by a Bath coach at 6 & reached Brentford . . . took up Zephyr & came on to Slough, arrived at 9." On 28 March he "Drove Zephyr up to town . . . NB end of Slough to Hyde Park Corner 2ʰ 45ᵐ." *Diary*, W0014, HRHRC.

64 Letter, John Herschel to Caroline Herschel, 28 February 1840. L0585, HRHRC. The authorities at Eton College soon thereafter dropped their objections, and a special railway station was built at Slough. Each building had a separate entrance and suite for her Majesty, and a dedicated train was kept in the ready, available on five minutes notice. The royalty's use of the railway, of course, was an important advertisement. Apologizing to an unidentified woman friend for not stopping by, Herschel complained that "it is one of the ill effects of the railroad which by rendering it practicable to come up to Town on any especial business and return immediately, and by multiplying those calls ad infinitum curtails opportunities of devoting the intervals of actual business in Town to seeking & enjoying the sight of friends." Letter, 13 November 1839. L0749, HRHRC.

65 Previously known as *Moorhouse*, it was owned by a descendant of Lord Cuthbert Collingwood (the vice-admiral who succeeded the wounded Nelson). Herschel obtained from the seller permission to re-name the house after the commander.

66 Letter, Margaret Herschel to Caroline Herschel, 8 March 1840. L0585, HRHRC.

67 Letter, Margaret Herschel to Caroline Herschel, 4 May 1840. L0585, HRHRC.

68 Letter, Margaret Herschel to Caroline Herschel, 8 March 1840. L0585, HRHRC.

69 Herschel, "On the Chemical Action of the Rays of the Solar Spectrum on Preparations of Silver and other Substances, both metallic and non-metallic, and on some Photographic Processes," *Philosophical Transactions*, v. 130 pt. 1, 1840, p. 6.

70 Herschel wrote over the date; it might be either the 26th or the 27th.

71 Herschel, "On the Chemical Action . . .," p. 1. As he had written a decade before, Herschel believed that "Whenever, therefore, we would either analyse a phenomenon into simpler ones, or ascertain what is the course of law of nature under any proposed general contingency, the first step is to accumulate a sufficient quantity of well ascertained facts, or recorded instances, bearing on the point in question. Common sense dictates this, as affording us the means of examining the same subject in several points of view; and it would also dictate, that the more different these collected facts are in all other circumstances but that which forms the subject of enquiry, the better; because they are then in some sort brought into contrast with one another in their points of disagreement, and thus tend to render those in which they agree more prominent and striking." Herschel, *Preliminary Discourse*, p. 118.

72 This desire to have others build on his work was a genuine one for Herschel. He was frustrated by a lack of time to pursue the enquiries himself. As he had stated in his *Preliminary Discourse*, "we must never forget that it is principles, not phenomena, – laws, not insulated independent facts, which are the objects of enquiry to the natural philosopher. As truth is single, and consistent with itself, a principle may be as completely and as plainly elucidated by the most familiar and simple fact, as by the most imposing and uncommon phenomenon. The colours which glitter on a soap-bubble are the immediate consequence of a principle the most important from the variety of phenomena it explains, and the most beautiful, from its simplicity and compendious neatness, in the whole science of optics. If the nature of periodical colours can be made intelligible by the contemplation of such a trivial object, from that moment it becomes a noble instrument in the eye of correct judgement; and to blow a large, regular, and durable soap-bubble may become the serious and praiseworthy endeavour of a sage, while children stand round and scoff, or children of a larger growth hold up their hands in astonishment at such waste of time and trouble. For the natural philosopher there is no natural object unimportant or trifling. From the least of nature's works he may learn the greatest lessons." *Preliminary Discourse*, p. 13.

73 In his *Diary* for 16 February 1839, Herschel found his "retransfers much improved. Landscapes &c. Mezzotints especially good. . . . Got from town 2 very thick Plates of glass to bear a hard squeeze & urge home the engravings to be copied &c." W0022, HRHRC.

74 The significance of Smyth's experiments is traced in two articles by Schaaf: "Piazzi Smyth at Teneriffe: Part I, The Expedition and the Resulting Book," *History of Photography*, v. 4 n. 4, October 1980, pp. 289–307. "Part II, Photography and the Disciples of Constable and Harding," v. 5 n. 1, January 1981, pp. 27–50.

75 Copy of a letter, Herschel to Whewell, dated February 1840. HS22:41, RSL.

76 Henry Talbot was amazingly unconcerned to physical damage to his negatives. He sometimes savagely clipped the corners of the paper in removing the negative from the camera. At other times, his negatives were cut free-form into implausible shapes, in no discernible way related to aesthetic considerations. Constance chastised him for folding some of his negatives before posting because these creases showed up in the prints. Caroline pointed out that "the less you double them up the better – you might send them between two cards." Letter, Caroline Mt. Edgcumbe to Henry Talbot, 4 November 1843. LA43–85, FTM. But he remained indifferent. This was especially a shame since Talbot was becoming so good at photography.

77 "Fine Arts, Graphic Society," *Literary Gazette*, n. 1217, 16 May 1840, pp. 315–16. The Graphic Society encouraged its members and visitors to show "rare and interesting Works of Art" at its Conversazioni; in 1849, they made Talbot an Honorary Visitor.

78 Notably in two albums assembled by Lady Elisabeth, now in the NMPFT.

79 Letter, John Herschel to Caroline Herschel, 10 August 1840. L0585, Herschel Collection, HRHRC.

80 Robert Hunt was soon to become the first historian of photography, an active experimenter, and eventually an antagonist to Talbot. Like many early photographic inventors, he started with a direct positive paper. On 19 April, Herschel had written to Talbot enclosing some "specimens from Mr Hunt a Chemist at Devonport who has been working very successfully at the Photographic processes using papers initially black which light whitens. They appear to me to promise so well that I could not resist sending them. . . ." The literature on Hunt is woefully inadequate. Some indication of his range is given in James Yingpeh Tong's introduction to the facsimile edition of Hunt's 1841 *Popular Treatise on the Art of Photography* (Athens, Ohio: Ohio University Press, 1973).

CHAPTER FIVE

1 Letter, Talbot to Sir John Lubbock, 8 October 1839. LUB T22, RSL.

2 On 3 October, Talbot recorded the suggestion in his research notebook: "Portraits. take 1 inch lens belonging to microscope, form d.type picture, & throw magnified image of the same on paper. This diminishes the time of the

person's sitting, at ye expense of the subsequent operations." Talbot, Notebook *P*, Talbot Collection, NMPFT.

3 Herschel, "Note on the Art of Photography," 14 March 1839. Quoted from Schaaf, "Sir John Herschel's 1839 Royal Society Paper on Photography," *History of Photography*, v. 2 n. 1, January 1979, p. 58.

4 Talbot, Notebook *Q*, Talbot Collection, NMPFT.

5 Thus, Talbot himself started a practice of intensifying negatives that persists to this day. For a discussion of some of the ethical questions involved in this, see Schaaf, *Sun Pictures III, The Harold White Collection of Works by William Henry Fox Talbot* (New York: Hans P. Kraus, Jr., Inc., 1987), pp. 19–21.

6 "R. Phillips, on Chemical Affinity, &c.," *The Athenaeum*, n. 334, 22 March 1834, p. 227. Talbot recorded attending this lecture in his pocket diary for the period of 11 January to 8 August 1834. FTM.

7 Talbot, Notebook *M*. The dating of this passage is uncertain. The flyleaf on this notebook is inscribed "H.F. Talbot, Lacock 4ᵗʰ December 1834; the internal dating is mixed and passages were apparently inserted later. The present quote appears after an entry for 2 February 1835; it is also preceded by short notes for 2 February 1836 and 7 January 1836 (entered in that order). 1835 is the most likely date for the present entry. FTM.

8 H.F. Talbot, "On the Nature of Light," *Philosophical Magazine*, 3ʳᵈ series, v. 7 n. 38, August 1835, pp. 113–56.

9 Talbot, "Remarks on M. Daguerre's Photogenic Process," *British Association for the Advancement of Science Report*, 1839, p. 5.

10 The two processes, while similar in effect, were chemically different. Talbot's calotype relied on what is now known as *physical development*. Light reduced the silver salts to minute particles of silver (usually invisible). The gallic acid and silver nitrate developer built up additional silver on this invisible base. By analogy, this is similar to what happens in a phonograph – the tiny amount of electricity generated by the vibration of the needle is amplified electronically to produce a useful output. In the case of silver photography, the degree of amplification can be in the order of millions of times. Modern photographic materials use the related concept of *chemical development*. Again, light produces a microscopic 'seed' of reduced silver; the chemical developer (which contains no silver) then causes the remaining silver salts in the paper to be deposited around this. Herschel was well aware that this differed from what took place with the daguerreotype. Contrasting his direct use of the photographic properties of mercury with Daguerre's use of the element, he pointed out that "as an agent in the Daguerreotype process, it is not, strictly speaking, photographically affected. It operates there only in virtue of its readiness to amalgamate with silver, properly prepared to receive it." Herschel, "On the Action of the Rays of the Solar Spectrum on Vegetable Colours, and on some new Photographic Processes," *Philosophical Transactions*, pt. 1, 1842, p. 213.

11 Herschel, *Preliminary Discourse*, p. 8.

12 The Reverend Joseph Bancroft Reade was a primary claimant to this discovery. When Talbot ran into opposition to the renewal of his calotype patent, Reade published "On Some Early Experiments in Photography, Being the Substance of a Letter Addressed to Robert Hunt, Esq." *The London, Edinburgh and Dublin Philosophical Magazine and Journal of Science*, 4ᵗʰ series, v. 7 n. 46, May 1854, pp. 326–31. Reade's contributions are discussed in depth in Rupert Derek Wood's "J.B. Reade, F.R.S., and the Early History of Photography. Part 1. A Re-Assessment on the Discovery of Contemporary Evidence;" "Part II. Gallic Acid and Talbot's Calotype Patent." *Annals of Science*, v. 27 n. 1, March 1971, pp. 13–83. Also see Wood's "Latent Developments from Gallic Acid, 1839," *The Journal of Photographic Science*, v. 28 n. 1, January/February 1980, pp. 36–42.

13 Humphry Davy, "Observations on Different Methods of Obtaining Gallic Acid." *Journals of the Royal Institution*, v. 1, 1802, pp. 273–5.

14 Letter, Herschel to Talbot, 28 February 1839. Talbot Collection, NMPFT.

15 Letter of 22 June 1841, RSL.

16 Herschel, "On the Chemical Action of the Rays of the Solar Spectrum on Preparations of Silver and other Substances, both metallic and non-metallic, and on some Photographic Processes," *Philosophical Transactions*, v. 130 pt. 1, 1840, p. 8. Herschel had mentioned his work with the gallates in his first presentation on photography to the Royal Society in 1839. The full text of

this was not published at the time, and the reference to the gallates was omitted from the account in the *Proceedings*. For the original reference, see Schaaf, "Sir John Herschel's . . .," p. 58. In a subsequent paper, Herschel explained that "the gallic acid itself (whose singular properties, in conjunction with nitrate of silver, have been developed by Mr. Talbot, as the basis of his all but magical process of the calotype*) is affected also negatively by light. *Preparations of the gallic acid in conjunction with silver, are noticed by me in my former paper as forming a 'problematic exception' to my general want of success in procuring at the very outset of my photographic experiments (in February 1839), papers more sensitive than the simple nitrated or carbonated ones. The problematic feature consisted in spontaneous darkening of the papers laid by to dry in the dark, so at least then considered, but really arising doubtless from light incident on them in their preparation." Herschel, "On the Action . . .," p. 197.

17 Letter, Talbot to Lubbock, dated "Thursday Evᵍ" (28 March 1839). LUB T-20, RSL.

18 Talbot, Notebook *Q*. Talbot Collection, NMPFT.

19 On 27 October 1840, at a meeting chaired by Michael Faraday, the Committees of Physics, Meteorology, and Chemistry met jointly and "took into consideration the reference of the council of the 15 October, respecting the award of the Rumford Medal. Resolved that by circumstances M. Daguerre's eminent discoveries in Photography being in the opinion of the committee excluded from the award of the Rumford Medal, the committee declined recommending his paper on that subject for the present biennial award. The following names were proposed: Sir John Herschel, Mr. Fox Talbot, M. Biot, M. Regnault." *Committee of Chemistry, 1838 to 1849*. Benjamin, Count Rumford wished his medal to be awarded every two years to "the author of the most important discovery or useful improvement which shall be made or published by printing, or in any way made known to the public in any part of Europe during the preceding two years on heat or on light, the preference always being given to such discoveries as shall, in the opinion of the President and Council, tend most to promote the good of mankind." In fact, it was awarded irregularly (and only once between 1818 and 1832). There is no record of why the Council decided Daguerre should be excluded. Jean-Baptiste Biot was finally awarded this Rumford Medal for his research connected with the circular polarization of light. At a meeting the same day of the Committee of Physics, chaired by Professor Forbes, it was "resolved that Sir J. Herschel's paper on the Chemical action of the rays of the solar spectrum be recommended to the Council for the Royal Medal." *Minute Book, Committee of Physics, 1839–1845*. RSL. The Royal Medal that year was given "for the most important unpublished paper in Physics, communicated to the Royal Society for insertion in their Transactions after the termination of the session in June 1837, and prior to the termination of the Session in June 1840." *Philosophical Transactions*, v. 128, 1838, p. viii.

20 Letter, Margaret Herschel to Caroline Herschel, 13 December 1840. L0585, HRHRC.

21 Letter, Brewster to Talbot, 20 January 1840. Talbot Collection, NMPFT.

22 Patent No. 8842. This covered the calotype process (not by name) and Talbot's direct positive process. Also tacked on were four rather impractical proposals: a 'poor man's daguerreotype' forming images on copper; a lead-plated image on silver; extremely thin electro-deposited silver photographic plates; and a means of transferring an image from paper to metal. These last four, apparently thrown up as competition to a now-dead daguerreotype, were dropped in a disclaimer filed by Talbot on 8 March 1854.

23 Talbot, letter to the editor, dated 5 February 1841, "Calotype (Photogenic) Drawing," *Literary Gazette*, n. 1256, 13 February 1841, p. 108.

24 So important was this for Talbot that he immediately dispatched a portrait made in one minute to the French Academy. See "Lettre de M. Talbot à M. Biot, relative a des dessins opérés par les radiations, sur des papiers impressionnables," *Compte Rendu*, v. 12 n. 11, 15 March 1841, p. 492.

25 Talbot, Notebook *Q*. Talbot Collection, NMPFT.

26 Talbot, letter to the editor, dated 19 February 1841, "Calotype (Photogenic) Drawing," *Literary Gazette*, n. 1258, 27 February 1841, pp. 139–40.

27 Letter, Butler to Talbot, 25 March 1841. LA41–22, FTM.

28 Many of the photographs that Talbot referred to in these letters can be traced to present collections. These particular prints were sold in the 1958 Sotheby's sale of Herschel's effects and are now in the HRHRC.

29 This contentious subject is covered in Rupert Derek Wood, "The Involvement of Sir John Herschel in the Photographic Patent Case, *Talbot v. Henderson*, 1854." *Annals of Science*, v. 27 n. 3, September 1971, pp. 239–64. An additional publication by Wood is *The Calotype Patent Lawsuit of Talbot v. LaRoche*, 1854, second impression (Bromley, Kent: privately published, 1975).

30 Letter, Biot to Talbot, 24 January 1841. Translated from the original French. Talbot Collection, NMPFT.

31 Letter, Biot to Talbot, 9 February 1841. Translated from the original French. Talbot Collection, NMPFT.

32 Letter, Biot to Talbot, 16 March 1841. Translated from the original French. Talbot Collection, NMPFT. This was a portrait of Nicolaas Henneman in front of the cloisters at Lacock Abbey. A print of this image (Plate 71), with French annotations, is in the Talbot Collection, NMPFT.

33 Christie offered to read Talbot's paper at the beginning of April if Talbot could get it to him quickly enough. Letter, Christie to Talbot, 21 March 1841. LA41–20, FTM.

34 "Lettre de M. Talbot à M. Biot, sur la confection des papiers sensibles," *Compte Rendu*, v. 12 n. 25, 7 June 1841, pp. 1055–8.

35 Letter, Biot to Talbot, 14 June 1841. Translated from the original French. Talbot Collection, NMPFT. Biot continued that "fearing that I should not be sufficiently occupied in the making of photogenic pictures with the samples of your paper which you sent me, I gave them to one of my youngest colleagues, M. Regnault, a clever physicist as well as an experienced chemist, who had already made, for his own interest, some very successful Daguerreotype proofs. You can therefore rest assured that your samples will be very well used." A decade later, Henri Victor Regnault was to work closely with John Stewart, Herschel's brother-in-law, in paper photography. Some of the resulting Stewart and Regnault productions were amongst the favorite prints in Herschel's collection.

36 As was routine, the original manuscript was marked as received and initialled by Samuel Hunter Christie; curiously, however, no date of receipt is given. RSL.

37 "Fine Art. Calotype (Photogenic) Drawing," *Literary Gazette*, n. 1273, 12 June 1841, p. 379.

38 Notably George Smith Cundell. See his "On the Practice of the Calotype Process of Photography," *The London, Edinburgh, and Dublin Philosophical Magazine*, 3rd series, v. 24 n. 160, May 1844, pp. 321–32.

39 According to their *Minutes*. RSL.

40 Talbot wrote to John David Roberton on 29 June (MC3.178); a draft of Roget's reply to Talbot on 30 June survives (MC3.179); and Talbot replied to Roget on the same day (MC3.180). RSL.

41 Talbot, "An Account of Some Recent Improvements in Photography," in the *Proceedings of the Royal Society*, v. 4 n. 48, 1841, pp. 312–15.

42 Throughout this fray, Talbot never lost sight of just who was his true opponent. In a postscript to Herschel, he added that "it is a nice point to determine which is the most sensitive to light, my Calotype paper, or the Daguerreotype improved by Claudet's process. I am sensitive to simple moonlight; he has not yet made the trial, which I throw out as a challenge to all photographers of the present day: viz. that I grow dark in moonlight before they do."

43 Herschel continued: "But the fact is that the Council of the R.S. though composed for the most part of individuals who mean nothing but what is good – are yet as a body strangely apt to get into tempers for want of due consideration of the hearing of cases which come before them. A great deal of time is frittered away at their meetings in very unimportant points of domestic management while the business of their Committees of papers on which so much of the well being of the Society really depends is put off till the last moment and then hurried through – as it would appear in this case, too carelessly. I have on a great many occasions felt disposed to complain of the inconsequent and indefinite way in which the business of that council is conducted. It is a body very difficult to keep right without expecting irritations and perpetual remonstrance. Nevertheless as I do not believe they go intentionally wrong, or have any partial bias, I am always grieved at their mistakes and anxious to see them leniently regarded. On this occasion it is quite impossible that any slight can have been intended – and I would gladly hope that you may be disposed to regard the whole affair as a mere gaucherie."

44 In a postscript, he added that "I ought to mention that I have not communicated with Mʳ Talbot my intention of bringing the point again before the Council nor is he aware of my writing this nor has he expressed a wish that I should do so." Draft of a letter, Herschel to Lubbock, 10 October 1841. HS11:369, RSL.

45 Letter, Lubbock to Herschel, 15 October 1841. HS11:370, RSL.

46 Printed by J.L. Cox & Sons, 75 Great Queen Street. An identical text was issued later under the new title, *The Process of Talbotype (formerly called Calotype) Photogenic Drawing*, printed by J. & H. Cox, Brothers, 74 & 75 Great Queen Street. The first time Cox is listed this latter way is in the *Post Office London Directory for 1845* (the entries for which would have been made up during the Autumn of 1844); it is likely that the second edition was printed for use at Henneman's printing establishment in Reading.

47 Letter, Margaret Herschel to Caroline Herschel, marked "recd Ap 19" [1841]. L0585, HRHRC.

48 Letter, Margaret Herschel to Caroline Herschel, 10 May 1841. L0585, HRHRC. Talbot was not the only one having troubles with stability. Maggie also said that "it is quite the fashion now to have one's portrait taken by the Daguerreotype process, & my brother John [Stewart] submitted himself with all patience for the appointed time that he might send his portrait to his young wife in France – When the fond & anxious lady opened the parcel, frame, glass, and plate were all safe but alas! the delineation was gone, for the stupid people had not properly fixed the impression." Of course, if one were a scientist rather than a loved one seeking a personal memento, these changes could be interesting in themselves. Talbot even suggested to Herschel a means of accelerated aging: "The slow changes which take place in your photographs during several months are certainly very remarkable; do not you think they might be hastened by constantly keeping them in a warm place, or in a reservoir filled with some gas or other?" Letter, Talbot to Herschel, 29 March 1843. HS17:315, RSL.

49 This reply to Talbot's letter of 25 July is available only in draft form and is undated. HS17:310bis, RSL.

50 Herschel, "On the Action of the Rays of the Solar Spectrum on Vegetable Colours, and on some new Photographic Processes," *Philosophical Transactions*, pt. 1, 1842, p. 191.

51 Talbot explained to Herschel that "about a year ago Mʳ Wheatstone & myself independently arrived at the idea or invention, of constructing telescope mirrors by taking electrotype copies from an original mirror. . . . I took out a patent for the invention . . . my chief object . . . was to establish my claim to the invention, altho' I was not aware that it had occurred to anyone else but Mʳ Wheatstone."

52 Copy of a letter, Herschel to Mary Somerville, 17 March 1844. HS22.148, RSL.

53 One example is recorded in Herschel's *Diary* for 15 October 1829: "The Somervilles called & passed an hour at Slough. Shewed them the spirituous tincture of Violet Tricolour and the Rosellate of Potash." W0011, HRHRC. Mary Somerville, one of a handful of women writers on science at the time, was a close friend of the Herschels. Herschel communicated her "On the Action of the Rays of the Spectrum on Vegetable juices," and extract of a letter from Somerville to Herschel, dated 20 September 1845 from Rome: *Philosophical Transactions*, v. 136, 1846, pp. 111–20. An important collection of her papers, including notes on her experiments on light in Rome in 1845, was at Somerville College, Oxford; it is currently on deposit at the Bodleian Library. References to Herschel and his contemporaries can be found in a memoir by her daughter, Martha Somerville, *Personal Recollections from Early Life to Old Age, of Mary Somerville* (Boston: Roberts Brothers, 1874).

54 Notable examples are in the HRHRC and in the Museum of the History of Science, Oxford.

55 On 23 July, Herschel submitted a number of specimens to accompany his postscript. One caption in his hand labels "Specimens of Chrysotype, or Aurophotography...." The second name was not used elsewhere. The examples Herschel submitted nearly 160 years ago are still quite fresh and strong. PT23:12, RSL.

56 An improved fixing method for the chrysotype was given in Herschel's postscript added 29 August 1842 (pp. 209–10).

57 Alfred Smee, "On the Ferrosesquicyanuret of Potassium," *Philosophical Magazine*, 3rd series, v. 17 n. 109, September 1840, pp. 193–201.

58 Smee had written to Herschel on 8 January 1842, thanking the senior scientist for "sending a copy of your paper on the action of the sun's rays.... I feel certain that the prismatic examination of the properties of the sun's rays will eventually give us a clearer insight in the mysterious workings of both than any other set of experiments we institute." RSL. Smee was the chemist to the Bank of England. In 1841, at the age of twenty-three, he was elected a Fellow of the Royal Society. Smee had written about photogenic drawing in the *Literary Gazette* in 1839, and included a process for electrotyping daguerreotypes in his 1841 *Elements of Electro-Metallurgy* (London: E. Palmer). In the 1850s, he became engaged in aspects of stereo photography, and later was an avid gardener. An informative biography of him was written by his daughter, Elizabeth Mary Smee Odling, *Memoir of the Late Alfred Smee, F.R.S.* (London: George Bell and Sons, 1878).

59 Letter, Smee to Herschel, 10 May 1842. RSL.

60 Draft of a letter, Herschel to Smee, labelled in Herschel's hand: "substance of letter to Smee, June 15/42." RSL.

61 Letter, Smee to Herschel, 29 September 1842. RSL.

62 As he had written in his *Preliminary Discourse* a decade before, "the question 'cui bono' to what practical end and advantage do your researches tend? is one which the speculative philosopher who loves knowledge for its own sake, and enjoys, as a rational being should enjoy, the mere contemplation of harmonious and independent truths, can seldom hear without a sense of humiliation. He feels that there is a lofty and disinterested pleasure in his speculations which ought to exempt them from such questioning.... If he can bring himself to descend from this high but fair ground, and justify himself, his pursuits, and his pleasures in the eyes of those around him, he has only to point to the history of all science, where speculations apparently the most unprofitable have almost invariably been those from which the greatest practical applications have emanated." *Preliminary Discourse*, pp. 10–11.

63 See Schaaf, *Sun Gardens; Victorian Photograms by Anna Atkins* (New York: Aperture, organized by Hans P. Kraus, Jr., 1985).

64 Letter, Talbot to Herschel, 21 March 1839. RSL.

65 John George Children, "Lamarck's Genera of Shells," *The Quarterly Journal of Science, Literature, and the Arts*, v. 16, 1823. The 256 original drawings that Atkins produced for this left the family at some point near the turn of the century. In 1973, they turned up with a bookseller and are now preserved in London in the Zoological Department of the British Museum (Natural History).

66 Letter, Children to Talbot, 14 September 1841. FTM. The famous optician Andrew Ross supplied many early photographic lenses. Henry Collen was the first calotype portraitist in London.

67 Dated 20 October 1841. From a manuscript volume assembled by Anna Atkins around 1853: *Poetry &c by My Beloved Father John George Children, Esq. Collected in love and reverence by his grateful sorrowing child, A.A.* HRHRC.

68 Letter, Children to Hooker, 3 October 1835. The Royal Botanic Gardens, Kew.

69 For a good analysis of the factors that promoted women's entry into this field, see D. E. Allen, "The Women Members of the Botanical Society of London, 1836–1856," *The British Journal for the History of Science*, v. 13 n. 45, 1980, pp. 240–54.

70 See Allen, "Women Members," pp. 240–54. Much of the information on Atkins contained in this article was derived from inaccurate secondary sources.

71 *Annals of Natural History*, v. 4 n. 23, November 1839, p. 212.

72 A.A. [Anna Atkins], *British Algae, Cyanotype Impressions*. 3 volumes. (Halstead Place, Sevenoaks: privately published, 1843–53).

73 One of these was Anne Dixon. See Schaaf, *Sun Gardens*, pp. 35–6.

74 At a time when batteries were scientific curiosities but the only practical source of electrical power, John George Children had constructed the largest one in England, a monster that required 945 gallons of acid. This huge battery had 21 cells of copper and zinc plates, each of 32 square feet surface area. In his research program, Children had constructed batteries with up to 1,250 cells. See, for example, his "An Account of Some Experiments with a Large Voltaic Battery," *Philosophical Transactions*, v. 105, 1815, pp. 363–74.

75 Letter, Herschel to the Secretary of the Physical Committee, 1 June 1842. MC 3.218, RSL.

76 Letter, Margaret Herschel to Caroline Herschel, 8 February 1843. L0588, HRHRC.

77 On 14 October 1843, Herschel wrote to the Royal Society, returning the money. "After carefully considering the various requisites to be combined in the instrument in question, and making careful drawings of all its parts which I placed in the hand of one of our most eminent opticians, I found to my surprise that the expence of completing, in the effective manner proposed, the merely mechanical part of the apparatus would of itself absorb the whole amount of the grant, leaving nothing for the optical portion. Considering what was best to be done under these circumstances, I resolved to attempt by the aid of such workmen as I could find in my own immediate neighbourhood, and working under my constant inspection, the execution of the parts in detail, and by remodelling the design as far as possible without sacrifice of efficiency to bring its execution within the compass of their powers. In this a certain progress was made, but very slowly, and more than a year was lost in this manner when the elaborate memoir of M. Becquerel on the fixed lines in the Photographic and phosphorescent spectra fell into my hands. The research of these lines in the Photographic Spectrum had formed one principal part of the design I had in view in the construction of the instrument...." As a result, Herschel's "enquiry must thenceforth take a new direction – involving probably a change of methods of observation, and requiring instrumental aids of a different nature." MC3.306, RSL.

78 Letter, Margaret Herschel to Caroline Herschel, 10 May 1841. L0585, HRHRC.

79 Letter, Herschel to his wife, 10 August 1841. L0539, HRHRC. This already impossible situation for Herschel was to get progressively worse. By 1844, mentioning in a postscript in a letter to Talbot about "a very curious photographic novelty occurred to me a day or 2 ago," that "I have however long given up any but occasional and accidental experiments of this kind." Letter, Herschel to Talbot, 13 September 1844. LA44–61, FTM.

80 The photography section was one component of Hunt's *Researches on Light, an Examination of All the Phenomena Connected with the Chemical and Molecular Changes Produced by the Influence of the Solar Rays; Embracing all the Known Photographic Processes, and New Discoveries in the Art* (London: Longman, Brown, Green, and Longmans, 1844). Earlier, Hunt had published his *Popular Treatise on the Art of Photography, including Daguerréotype, and All the New Methods of Producing Pictures by the Chemical Agency of Light* (Glasgow: Richard Griffin and Company, 1841); a second edition was published a decade later.

81 In London, Talbot had licensed Henry Collen to practice calotype portraiture but failed to give him the technical and marketing support that would have been required for success. See Schaaf, "Henry Collen and the Treaty of Nanking," *History of Photography*, v. 6 n. 4, October 1982, pp. 353–66; and, "Addenda to Henry Collen and the Treaty of Nanking," v. 7 n. 2, April–June 1983, pp. 163–5. Even the dynamic scientist and daguerreotypist, Antoine Claudet, was unable to make calotype portraiture a commercial success. Claudet has yet to be adequately served in the literature. Both Claudet and Collen remained close friends with Talbot, however. Calotype portraiture was to flourish only in Scotland and then only due to a particularly fortuitous partnership. See Sara Stevenson, *David Octavius Hill and Robert Adamson* (Edinburgh: National Galleries of Scotland, 1981).

82 For a more complete picture of the production of this pivotal book, see Schaaf's introductory volume to H. *Fox Talbot's The Pencil of Nature*;

Anniversary Facsimile. (New York: Hans P. Kraus, Jr. Inc., 1989).

83 Letter, Talbot to Herschel, 7 December 1839. HS17:299, RSL.

84 Twenty years after this, in speaking of Herschel's cyanotype process, Talbot recalled that "a lady, some years ago, photographed the entire series of British sea-weeds, and most kindly and liberally distributed the copies to persons interested in botany and photography." Talbot, "On Photography Without the Use of Silver," *The British Journal of Photography*, v. 9, 9 December 1864, p. 495. All but one part of Talbot's copy of *British Algae* is still preserved at Lacock, even to the inscribed wrapping papers. Talbot reciprocated with *The Pencil of Nature*, but the present whereabouts of Atkins' copy is unknown.

85 Letter, Talbot to Snow-Harris, 27 February 1843. MS 21557D, The National Library of Wales.

86 Letter, Hunt to Talbot, 30 March 1843. LA 43–43, FTM. A year later, on 13 February 1844, Hunt wrote again with the same suggestion. This letter was described in E. P. Goldschmidt's Catalogue 52, *A Collection of Early Photographs and Books Commemorating the Centenary of Fox Talbot and Daguerre, 1839–1939*, item 136: "Apparently Robert Hunt suggested mentioning Fox Talbot's 'Pencil of Nature' in his Manual of Photography which was just seeing through the press. Fox Talbot says, however, that it would not be published for some time and I think it could not be mentioned with advantage.'" Ernst Weil acquired this letter from Goldschmidt, and in turn traded it to Miss Matilda Talbot (through Harold White) for some original photographs from Lacock Abbey. It has not yet been located at Lacock.

87 The book referred to was Alois Senefelder's *A Complete Course of Lithography . . .*, translated by A.S. (London: printed for R. Ackermann, 1819).

88 Letter, Fox-Strangways to Talbot, 1 March 1844. LA44–13, FTM.

89 Talbot, Notebook *P*, entry for 23 September 1839. Talbot Collection, NMPFT.

90 Gibbon said that in describing Louis IX "the noble and gallant Joinville . . . has traced with the pencil of nature the free portrait of his virtues as well as of his feelings." George Parker was the first to expose this connection with Gibbon in a letter to the *Photographic Journal*, v. 115, n. 4, April 1975, p. 184. Jerdan employed it in the *Literary Gazette*, n. 1150, 2 February 1839, p. 74.

91 Letter, Talbot to Caroline Mt. Edgcumbe, 30 March 1844. FTM.

92 Letter, Talbot to Horatia Feilding, 25 February 1844. LA 44–8, FTM.

93 Letter, Longman to Talbot, 24 February 1844. LA 47–7, FTM. Longman later proposed "sending it round with a Prospectus of 'The Illuminated Books,' if this meets with his approval. In this case we should require 5000 Copies. . . . Letter, Longman to Cox, 14 March 1844. FTM. Talbot asked Cox the same day to "pray inform Mssrs. Longman that I agree to what they propose, & think it likely to be very advantageous." George Eastman House.

94 Letter, Brewster to Talbot, 18 April 1844. Talbot Collection, NMPFT. When reviewing the first five numbers of *The Pencil*, Sir David (with a reputation for harsh judgments) said he "cannot withhold our admiration of the genius and patience with which he has overcome difficulties which many of his friends thought to be unsurmountable in the production of such a work." *The North British Review*, v. 7 n. 14, August 1847, p. 479.

95 Near the end of the century, Benjamin Cowderoy, a later manager for Talbot at Reading, recalled this social problem well: "In the later 'forties' the stock of pictures grew to inconvenient proportions in the hands of such a gentleman as Mr. Talbot, occupying a high position in aristocratic society. In those days ladies of title had not condescended to the profession of milliners, nor did the younger sons of dukes enter mercantile offices, and so Mr. Talbot's labour and distractions during the years of incubation of the new art were followed by perplexity and embarrassment through the accumulation of merchantable products which the usages of society would not allow him personally to 'liquidate.' Nevertheless, such 'liquidation' was to be desired in view of the large pecuniary sacrifices that had been made in their production. It was at this period that (through a common friend) my business connection with Mr. Talbot commenced." Cowderoy, "The Talbotype or Sun Pictures and the Jubilee of Photography," *Photography*, 6 June 1895, pp. 361–3.

96 Letter, Talbot to Jerdan, 23 June 1844. HRHRC.

97 Letter, John Henderson to Sir Benjamin Stone, 2 May 1898. Private Collection, England. Henneman was under active investigation by the late

Arthur Gill. There is an error in Gill's title as published, for Henneman died in 1898: "Nicholas Henneman, 1813–1893," *History of Photography*, v. 4 n. 4, October 1980, pp. 313–22; "Nicholas Henneman P.S.," v. 5 n. 1, January 1981, pp. 84–6.

98 Talbot wrote to Constance on 25 November 1839, advising her "to pay a visit to the Adelaide Gallery . . . and see M. Daguerre's pictures there, which are executed by himself," he asked her to make sure to "let Nicole know of them in case he should like to spend his shilling in viewing them, & tell him they are not the same as what he saw when in Town with me last month." Letter, LA(H)39–2, FTM.

99 Charles Porter, whom Talbot was concerned that he couldn't keep sufficiently busy. Constance defended him, saying that "we <u>do</u> set Porter to work at other things besides the Drawings." Letter, 7 July 1841, LA 41–46, FTM. The Talbots and Henneman always referred to him as just 'Porter' and his identity is something of a mystery. H.J.P. Arnold concluded that he was a young native of Lacock Village. *William Henry Fox Talbot: A Research Note* (Havant, Hampshire: privately published, 1986).

100 This is somewhat ambiguous but there is no subsequent record of further payments. Talbot, *Memoranda* notebook (May 1840–April 1844), FTM. Talbot's notebook *Nicholls Account* is filled out in Henneman's hand. It shows that by 1843 Henneman was purchasing chemicals, paying porters for admission to buildings, and paying travel expenses (presumably all with Talbot's money). FTM.

101 This was the same line that had chased Herschel into Kent. The financial arrangements and ownership of the Reading Establishment were never stated explicitly but aspects were suggested in the correspondence. On 23 May 1846, for example, Talbot made a note to himself that "I am to repay to Henneman the sum he pays for Rent & rates except 15£. But I want first to know on what security of tenure he now holds the premises?" LA 46–67, FTM. The last entry in Nicholl's account book is at the beginning of January 1844 when he recorded "2 months rent of house at Reading" and "6 months wages to Porter." Notebook, *Nicholls Account*. FTM.

102 The name *Reading Establishment* was retrospectively applied. Henneman set up at No. 8 Russell Terrace (now 55 Baker Street) but this location was a mystery for many years until Marcus Adams and Cecil Blay of the Reading Camera Club and Harold White positively identified it in 1951. A commemorative plaque placed on the house appears to have been the source of the *Reading Establishment* title. Sadly, Henneman is omitted totally: "Here W.H. Fox Talbot F.R.S., Father of Modern Photography, Conducted His Reading Establishment, 1844–5." See the "Unveiling of Fox Talbot Commemoration Plaque," *Reading Camera Club Programme, W. H. Fox Talbot Commemoration, 9ᵗʰ June, 1951*." An undated calling card from the Harold White Collection simply read "Mʳ N. Henneman, Calotypist;" in this particular example, the address was written in by hand. The *Reading Directory* for 1847 carried a listing for Henneman's "Patent Talbotype Establishment," a phrasing likely established by Benjamin Cowderoy. An important reference for the Reading Establishment is V.F. Snow and D.B. Thomas, "The Talbotype Establishment at Reading – 1844 to 1847," *The Photographic Journal*, v. 106, February 1966, pp. 56–67.

103 "Saw N's Establᵐᵗ 8 Russell Terrace." Talbot notebook, *London* (May 1843–May 1844). FTM.

104 Letter, John Henderson to Charley (Charles A. Henderson, Glasgow), 13 December 1892. Private collection, England.

105 Letter, Henderson to Sir Benjamin Stone, 2 May 1898. Private collection, England.

106 "On Tuesday evening a lecture was delivered to members upon a new branch of discovery in the arts, 'Photography,' by Mr. Henneman . . . This discovery, and the further improvements by the author, formed the subject of the lecture. Mr. H. described the principles and effects of this most singular art in terms which, not withstanding his being a native of another country, were clear, concise, and intelligible. He illustrated his description of the process by taking upon a sheet of sensitive prepared paper an impression made from a plaster cast, which was illuminated by an oxy-hydrogen flame, and which, by a lens, was reflected into a camera obscura. Mr. H. is a very skillful operator, and an agent of Mr. Talbot's in carrying out the beautiful results of this delightful art. We understand that the last improvement gives an impression in two seconds of time. The

calotype portraits and views which were exhibited were most beautiful, rivaling the finest engravings and drawings. The lecture was received with great applause." "Literary and Scientific Institution," *Reading Mercury*, 26 April 1845. The *Berkshire Chronicle* of 26 April 1845 similarly reported that "Mr. Henneman gave an interesting lecture on photography, with experiments, which highly gratified the audience."

107 Invoice in Henneman's hand, 5 September 1844. LA 44–55, FTM.

108 Letter, Constance to Lady Feilding, dated 2 February. 1844 is the only logical year. LA 46–23, FTM.

109 "Photography," *Reading Mercury*, 4 May 1844.

110 "Photography, Sun Printing," *Reading Mercury*, 13 July 1844.

111 This attribution was suggested to me almost simultaneously by Dr Phoebe Stanton, Professor Emerita of Art History, Johns Hopkins University; and Prof. Michael Twyman, Department of Typography & Graphic Communication at the University of Reading. It was confirmed by the Jones scholar, Dr Michael Darby, of the Victoria & Albert Museum. Jones (1809–1874) designed and printed lithographs for Longmans during the 1840s; he also lithographed labels for the Huntley & Palmer Biscuit Company in Reading. The format of the *Pencil's* cover resembles Plate 8 in Jones' *Designs for Mosaic and Tessellated Pavements* (London: John Weale, 1842). It is described in the folio as "a pavement, suggested by the interlacing patterns of the Moorish Mosaics. The border is formed of quadrilateral tesserae, and the center of rhomboids, of equilateral triangular pieces." Prof. Twyman has traced key stylistic elements of the cover (botanical and geometric) to Jones' illustrations for Lockhart's *Spanish Ballads* (1841, 1842). Jones continued these themes in his well-known 1856 *Grammar of Ornament*.

112 Invoice of 28 June 1844. LA 44–28, FTM. Caoutchouc, or India rubber, is often confused with gutta percha. It is a natural resin from South American trees that was fairly new to the binding industry at the time. Tarrant employed it to construct what we would now term (ludicrously) a "perfect binding." The resin dried to form a rubbery substance, thus making it useful for holding in the pages. Unfortunately, it continued to dry out and within a few years released the pages.

113 Letter, Fox-Strangways to Talbot, 10 June 1839. FTM.

114 The Angel was one of the numerous coaching inns that were declining rapidly with the advent of the railways. If one can dodge the morning traffic in High Street, the view is much the same today. The early 18th-century stone that Talbot worried about has been re-faced. The building on the right remains, as it was in Talbot's day, a coffee house (now minus its chimney). St Peters in the East has become the library for St Edmunds Hall. The Angel Inn is the new home of the famous marmalade maker, Frank Cooper's, Ltd.

115 *The Art-Union*, v. 6, 1 August 1844, p. 223.

116 In contrast to the stability portrayed in Plate I, the Boulevard des Capucines has changed considerably. According to Nancy Keeler, Madame Costnoble's "Bains des Capucines, élégance et comfort," along with the eighteenth-century *hotels privés*, were demolished in 1862 to make way for the creation of the Place de l'Opèra.

117 *Literary Gazette*, n. 1432, 29 June 1844, p. 410.

118 *The Art-Union*, v. 6, 1 August 1844, p. 223.

119 "Just Published, Part I, of The Pencil of Nature, by H. Fox Talbot, Esq." Longman's announcement pamphlet, June 1844. Her pencil was certainly augmented, however, for in June 1844 Talbot paid his bookbinder, Alfred Tarrant, for "touching up 150 each of 3 plates." Invoice, Alfred Tarrant to Talbot for Part 1, 28 June 1844. LA 44–28, FTM.

120 Many of the original pieces of this Dresden are on display at Lacock Abbey. When a tourist purloined one in the 1950s, he managed to make a clean escape – Talbot's picture has yet to have its day in court.

121 *Literary Gazette*, n. 1432, 29 June 1844, p. 410.

122 Patroclus was all but lost when the late Harold White came across it around 1950: "the plaster bust of Patroclus I found under a heap of rubbish in the brewery, covered with a patina of dust and muck which gave me several hours effort to remove to avoid damaging the delicate and damp plaster beneath." Letter from White to John Ward of the Science Museum, 15 April 1980. White's daughter, Patricia, then a little girl, remembers that the task was accomplished mostly with old toothbrushes.

123 *Literary Gazette*, n. 1432, 29 June 1844, p. 410.

124 *The Spectator*, v. 17 n. 838, 20 July 1844, p. 685.

125 *The Critic*, n.s. v. 1 n. 1, 15 August 1844.

126 "The Talbotype, Daguerreotype Engraving, &c.," *The Morning Herald*, no. 19,399, 6 November 1844, p. 5.

127 Letter, Talbot to Jerdan, 23 June 1844. HRHRC.

128 This was in reference to Talbot's second book, *Sun Pictures in Scotland*. Letter, William Horner Fox-Strangways to Lily (Lady Elisabeth), 20 May 1845. LA45–42, FTM.

129 *Literary Gazette*, n. 1432, 29 June 1844, p. 410.

130 *The Athenaeum*, n. 904, 22 February 1845, p. 202.

131 *The Athenaeum*, n. 927, 2 August 1845, p. 771.

132 *The Athenaeum*, n. 904, 22 February 1845, p. 202.

POSTSCRIPT

1 Letter, Talbot to Charles Feilding, 27 May 1808. LA08–4, FTM.

2 Herschel, "Sonnet On burning a parcel of old MS," Collingwood, March 20, 1841. Manuscript notebook, *Poetical Pieces*. W0250, HRHRC.

3 Emphasis added. Herschel, "Instantaneous Photography," *The Photographic News*, v. 4 n. 88, 11 May 1860, p. 13.

4 N.S. Dodge, "Memoir of Sir John Frederick William Herschel," *Annual Report of The Board of Regents of the Smithsonian Institution . . . for the Year 1871* (Washington: Government Printing Office, 1873), pp. 125–6.

5 MW0019, HRHRC. The final entry in his list is for a camera lucida sketch taken on the lawn of his Kent home on 14 June 1870, at the age of 78.

6 Talbot, letter of 30 January 1839 to the editor of *The Literary Gazette*, n. 1150, 2 February 1839, p. 74.

7 Smyth had not practiced photography since Herschel sent him early examples to the Cape of Good Hope. Although surprised when Herschel recommended him to the Admiralty as "an expert photographer," he rose to the challenge. See Schaaf, "Piazzi Smyth at Teneriffe: Part 1, The Expedition and the Resulting Book," *History of Photography*, v. 4 n. 4, October 1980, p. 289.

8 Letter, Cameron to Herschel, 31 December 1864. Reproduced in facsimile in Colin Ford, *The Cameron Collection; An Album of Photographs by Julia Margaret Cameron Presented to Sir John Herschel* (London: The National Portrait Gallery, 1975), pp. 140–1.

9 On seeing his own portrait, Herschel told Cameron that "You are too bountiful! How shall we all ever thank you enough for these superb things? As for my own poor wizened self I must leave Lady H. when she returns . . . to speak for herself. Thou musical trios are I really think the most exquisite pieces of Photography that have ever been done." Letter, Herschel to Cameron, 1 June 1867. Smithsonian Institution. A comparison between Cameron's portrait of Herschel and his earlier wedding portrait is most striking; see plates 9 and 10.

10 Herschel, "Stanzas on the breaking up of the meeting of the B[ritish] A[ssociation] [for the Advancement of Science] at Newcastle. Aug 25/38." *Poetical Pieces*.

11 Copy of a letter, Herschel to Talbot, 29 February 1848. HS23:14, RSL.

12 Herschel, *Diary*, 1853. W0036, HRHRC.

13 This and other problems are discussed in Schaaf's *Introductory Volume to the Anniversary Facsimile of H. Fox Talbot's The Pencil of Nature* (New York: Hans P. Kraus, Jr. Inc, 1989), pp. 38–42.

14 This death knell for silver is explored in Nancy Keeler's "Illustrating the 'Reports by the Juries' of the Great Exhibition of 1851; Talbot, Henneman, and Their Failed Commission." *History of Photography*, v. 6 n. 3, July 1982, pp. 257–72.

15 Talbot died while writing a supplement for the second edition of John Thomson's translation of Tissandier's *History of Photography*. His son, Charles Henry Talbot, completed it the best that he could. A brief context for photoglyphic engraving is given in Schaaf, "A Wonderful Illustration of Modern Necromancy; Significant Talbot Experimental Prints in the J. Paul Getty Museum," *Photography, Discovery and Invention* (Malibu, California: The J. Paul Getty Museum, 1990), pp. 31–46.

Index